GALWAY OF THE RACES
SELECTED ESSAYS

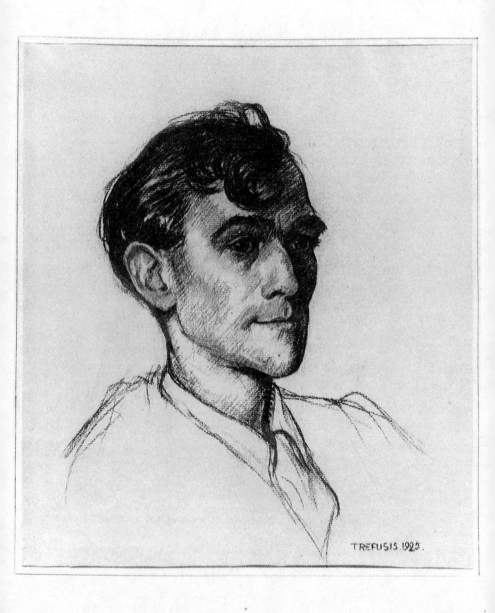

TREFUSIS. 1925.

GALWAY OF THE RACES

SELECTED ESSAYS

ROBERT LYND

EDITED AND INTRODUCED BY
Sean McMahon

THE LILLIPUT PRESS
1990

First published in 1990 by
THE LILLIPUT PRESS LTD
4 Rosemount Terrace, Arbour Hill,
Dublin 7, Ireland

A CIP record for this
book is available from
the British Library

ISBN 0 946640 48 3

ISBN 0 946640 49 1 (pbk)

Jacket design by The Graphiconies
Set in 11 on 13 Ehrhardt by
Seton Music Graphics Ltd of Bantry
and printed in England by
Billings & Sons Ltd of Worcester

CONTENTS

ROBERT LYND:
AN INTRODUCTION

An English examiner once wryly suggested that, much as he admired Robert Lynd, the young men and women of Ulster should be made aware that there were *other* essayists. This recommendation in a report of the late 1940s on the Northern Ireland Senior Certificate illustrates Lynd's fame and popularity as a writer by the time of his death in 1949, and the degree to which he has been forgotten in the forty-odd years since.

It is also a reminder of the central place once occupied by the essay in the study of English literature. A promenade from Bacon to Priestley took in Addison and Steele, Goldsmith, Lamb and Hazlitt, Leigh Hunt, Dickens in the 'Boz' of his sketches, De Quincey, Robert Louis Stevenson, Chesterton and Belloc, and E. V. Lucas. The form was popular with teachers and pupils alike, and young people were encouraged to practise it. Lynd was the most agreeable and emulated of models, and contemporary attitudes were reflected in examination questions in which polemical and scientific topics were heavily outnumbered by subjects such as 'Butterflies', 'Detective Stories', 'Trains' and 'Birthdays'.

The essay form pre-dated the novel and enjoyed recurrent periods of popularity, its most recent 'silver age' culminating in the Harmsworth revolution of the late 1890s. A new literacy had been created by the 1870 Education Act in England, periodicals needed copy, and many who never would have read a novel became regular readers of these popular journals. Not all the material was of the highest standard and one can sense a weariness and a perfunctoriness in the genre that incensed

Bloomsbury. Virginia Woolf, herself an essayist, used to refer in her letters and diaries to 'scribblers and second-rate writers in second-rate clothes'. Her husband, Leonard Woolf, did Lynd more justice, however, when he described him as 'one of those impeccable journalists who every week for thirty or forty years turn out an impeccable essay . . . like an impeccable sausage about anything or everything or nothing'.

The popular essay largely disappeared with the popular magazine. Lynd's career with the *New Statesman* from 1913 to 1945 and his personal following probably preserved a little the life of the form. In 1964 Michael Hamburger wrote, 'The essay is just as outmoded as the art of letter-writing, the art of conversation and the art of walking for pleasure,' but it remains a healthy and idiosyncratic expression of personality, and is even regaining some of its old strength in the work of modern practitioners such as P. J. Kavanagh of the *Spectator*, Hubert Butler, Edward Hoagland, and in the higher reaches of modern critical discourse. Few contemporary writers, however, have the opportunity or the leisure that enabled Lynd to compose his impeccable pieces, let alone have them preserved in thirty printed books, as his were. He served the essay at its best, a minor art-form, a dialogue between writer and reader, unselfconsciously popular. He could count on a shared culture, an appreciation of the idiosyncratic and certain standards of behaviour. Even in his purely literary essays he disdained footnotes or references, and in the personal ones such glossing would have seemed an impertinence to reader and writer alike.

The thirty collections, published between 1908 and 1945, contain not only a store of excellent writing but an oblique social history of the period and components of an informal autobiography. All three aspects are represented in this spare selection. Yet because the man and his work have largely disappeared from view, the following sketch of Lynd's life and professional career is needed by way of an introduction to the writings.

I

Robert Wilson Lynd (the 'Wilson' was his paternal grandmother's surname) was born in Belfast on 20 April 1879, the elder son and second of seven children of the Rev. Robert John Lynd DD, a Presbyterian minister who served his year as Moderator of the Church in Ireland in 1888. The Lynds were of Huguenot extraction, refugees from the St Bartholomew's Night Massacre of the late sixteenth century in France. Once settled in Scotland each generation produced its divine. Those in the paternal line were nearly all ministers from the time Robert's great-great-grandfather, Charles, blown off course *en route* for Larne, landed in Lough Swilly and settled in Rathmullan. His son, also Charles, was born in 1681 and ordained minister for 'Fannet' (Fanad) in 1708. He became fluent in Irish for pulpit and propaganda (a linguistic skill his greatgrandson also acquired for similar purpose, though he never preached). He moved to Coleraine in 1728 and published an anti-Seceder tract, 'A Short and Plain Vindication of Several Spiritual Principles, especially of the Conditionality of the Covenant of Grace', in 1749. Lynd's father, Robert John, born in 1833 at Killure, near Coleraine, was the son of a farmer, John Lynd. He was educated at Queen's College, Belfast, and the Presbyterian Assembly College, and ordained at Whiteabbey, Co. Antrim, in 1856.

The Belfast Street directories for the period give his home addresses as The Manse, Whiteabbey; 3 Brookhill Avenue, Cliftonville Road; 34 Elmwood Avenue; and Viewmount, Windsor Avenue. His business addresses, so to speak, were Whiteabbey, Berry Street and, finally, May Street Presbyterian churches. The last was regarded as a plum appointment though in time the middle-class move to the suburbs depleted his congregations. The church, city-centred and grandiose, had been built by subscription for the Rev. Henry Cooke (1788-1868). This charismatic leader had almost single-handedly destroyed the radical '98 tradition of the Belfast Presbytery and established the Presbyterian Church as a supporter of unionism

every bit as stalwart as the Church of Ireland. In his 1907
booklet *The Orangemen and the Nation*, Lynd, writing as
'Riobárd Ua Fhloinn', observed:

Why is it then that Orangemen are less national today than they were a
hundred years ago? I can see no reason for it except that they are less
consciously Irish than they used to be. And this, I believe, is largely owing to
the influence of the Reverend Dr Cooke. The people of Belfast put up a
statue to Dr Cooke. But Dr Cooke, as far as I can see, did as much to de-
Irishize the Protestant North of Ireland as Daniel O'Connell did to de-Irishize
the Catholic South.

This memorial statue stands in College Square right at the gates
of Lynd's school, 'Inst', and he would have had a daily reminder
of the baneful power and influence of 'The Black Man', as the
statue has been known to generations of Belfast citizens.

Lynd *père* was more liberal and gentle and little given to
political involvement, though his obituary in the Belfast *News
Letter* (19 November 1906) praised his public stand against
Home Rule. Even his year of Moderatorship was uncon-
troversial. His one recorded public pronouncement was on
welcoming the newly appointed Assistant Professor of Hebrew
at Assembly College. He urged the man, Thomas Walker, to
remember that the Bible was the inspired word of God and
admonished him not to follow 'the wild and improbable theories
of the higher critics nor reject the old merely because it is old'.
(This, properly laicized, might well have summarized his son's
attitude to literary criticism.) Two years later, at the Jubilee
Assembly, he read a paper on 'The Place and Work of the
Presbyterian Church in Ireland'. A typical admonition occurs
near the close:

The unholy flame of party and sectarian strife has too often burned in the
midst of us. We have forgotten our responsibilities to our country and our
countrymen, and the commission which we have received to conquer this land
for Christ has too often remained for us a dead letter.

Lynd was born in the Brookhill Avenue house, but it is
Elmwood Avenue that is the scene of his earliest memories.
This street of tall Victorian houses lies very close to the

Queen's College which became his university and which in 1946 awarded him the degree of D. Litt. (*honoris causa*). He was living there as a child when a mad bull raged loose and had to be shot. He remembered his nurse being sent to fetch him home from kindergarten on the occasion:

It seems to me, as I look back on it, curiously illogical to have hurried us off home in this fashion, now that the bull was dead. . . . Some days afterwards, when I went round the shops with my mother, we called at the butcher's to order a sirloin. . . . 'Tell him, not from the mad bull,' I asked her earnestly. . . . I went about for a time in almost as great dread of mad bulls as of Papists. ('School', 1924)

In the same essay, he describes how at the age of five 'I was taken to a kindergarten run by two German ladies and asked to read something about a spider from a *Nelson's Royal Reader*, so that it might be seen for what class I was fitted.' It was in Elmwood Avenue too that on nights of storms the children were brought down to the safety of the sitting-room for fear the chimney would be blown through the roof. Lynd writes so feelingly about wind-strengths and storms that he seems to have remained a confirmed anemophobe all his life.

His mother was Sarah Rentoul, the daughter of the Rev. John Rentoul of Ballymoney, Co. Antrim. She and her sisters ran a private school for girls at Knock, Belfast, where, in keeping with the social attitudes of the time, good manners and deportment took precedence over examination success. Her forebears had come from Manorcunningham, Co. Donegal, but Lynd's rustic memories seem to be all of counties Derry and Antrim.

In those days a city lad was regarded as very deprived if he had no country cousins. Lynd returned in his later essays to the farms at Killure and Beleeny and to his experiences of Sabbath journeys by trap along the Lower Bann river. In 'Looking for an Ancestor' (1924), he recalls his pride in reading the speeches at the dedication to his grandfather of the Rentoul Clock in Ballymoney. It was in uncles' farms that he formed his abiding love of chickens and horses: 'I used to go up to the house of God seated behind a dark brown horse with a star on his

forehead, holding the reins and clicking him into a trot with my tongue' ('Horses', 1925). In the essay 'Aunts' (1937), included in this selection, the country memories reach a paradisal level with expertly driven gigs and farmhouse feasts 'with three kinds of jam, four kinds of baked bread and all manner of cakes'. A less happy memory of childhood was that of the Presbyterian Sabbath. He was very glad of any means of mitigating the severity of the long, unco pious day.

I had an aunt, I remember, who liked to encourage her nephews and nieces to learn the psalms in the metrical versions by heart, and who would offer me a shilling if I had learnt a psalm by the end of a Sunday afternoon. As play was forbidden on Sunday, this seemed to me a not quite intolerable way of passing the time away. ('Pocket Money', 1936)

II

Lynd went to the Royal Belfast Academical Institution (known to all as 'Inst') in September 1890 when he was nearly eleven and left in June 1896. The school had been founded in 1810 and had a record of excellence and egalitarianism. Lynd remained fond of his old school, and at least two essays were specifically in praise of it: 'The School Cap' (1926), and 'The Old School Tie' (1936), a title then without pejorative connotation. In this second essay he writes, '. . . the love of school was in my blood. Years before I went to it, I longed to go to it, as I afterwards longed to go to Rome and Florence.' He loved Latin and Greek, subsequently his degree subjects, but

never found it easy to sit in a room in the evening and read school books and write stuff in exercise books. I always knew that there were several of my fellow-schoolboys roaming about the streets and I could not bear to be wasting time over a grammar when there was better company to be had outside.

He was clever without being intolerably industrious. Perhaps the best summary of his approach to the business of school was in the judgment made at the time that his friend Sam Porter's Greek proses were more accurate but Lynd's more like what a

Greek would have written. His teacher was Robert Millar Jones, who afterwards married Lynd's eldest sister, Laura.

He was not a perfectly behaved student. The Opera House and the Theatre Royal had Friday matinées and he could often be found sitting in one or other of the galleries entranced but not entirely free from Presbyterian prejudice against the stage. It was here that a great, unconsummated love affair began. His heart was completely lost to Marie Studholme, one of the most popular actresses of the nineties. Her grandest part was in *The Toreador*, the last play put on at the Gaiety Theatre before it closed in 1902. Lynd, then among other things a drama critic, saw its closing production.

Of music-hall artistes first enjoyed as a truant, from Marie Lloyd and Lottie Collins to Little Tich and Vesta Tilley, he wrote:

Their songs are the only poetry that many of us remember. I myself know scarcely twenty lines of Shelley or Wordsworth by heart but my head is full of such lines as Eugene Stratton's:

My gal she's a high-born lady.
She's black but not too shady,
Feathered like a peacock, just as gay;
She's not coloured, she was born dat way.

('Enchantment in the Music Hall', 1923)

They were days of innocence, indeed.

In the Inst *School News* for Christmas 1949, the year of Lynd's death, some reminiscences are printed by way of memorial tribute. In one by 'J Y' (identified by the present principal, Tom Garrett, as J. Young, Christian names counting for little to school annalists), he is described as having

a slim boyish figure in a pepper and salt suit, the Inst cap on the back of his head, and his hands (generally) in his pockets. . . . He was an omnivorous reader – not a student – and we both haunted the Linenhall Library. . . . In his conversation he was Socratic, a questioner of all conventions, already a personality.

The description of the reader who was not a scholar is a recurring one and may explain some of the characteristics of his

later literary criticism. It is clear, however, that he could have
been a scholar, had he wished. In his final year, when he was a
prefect, he won the Steen Prize for Greek.

At Inst he met James Winder Good (1877-1930), who
became his closest friend, and as a kind of adopted 'uncle
Seumas' was a lay godfather to each of Lynd's daughters, Sigle
(b. 1910) and Máire (b. 1912). He was older than Lynd, the son
of an RIC head constable who had come to Belfast. He was an
eminently suitable companion for Lynd: they shared a passion
for the works of Stevenson and Kipling. (As a boy, Lynd had
waited impatiently for books by 'Tusitala' as they were
published. His favourite was *Treasure Island* which appeared
when he was four.)

I noticed a boy with a grave face and hair of a Munster blackness looking on
and, under his arm, one of those grey paper-backed volumes in which the
early work of Rudyard Kipling first reached the West. I cannot remember
whether I spoke to him, but it was impossible at that time to remain
unacquainted for long with a fellow-schoolboy who read Kipling or
Stevenson. ('Nostalgia', 1941)

Good was an *aficionado* of riots and he had come to live in
the best place, for Belfast, then as now, was the riot capital of
Western Europe. He was a born journalist and, as his friends
realized, his description was 'ten times better than any riot'. On
night wanderings through the otherwise safe city both discovered
their nationalism, but it was a non-partisan, non-violent
nationalism which they maintained all their lives. Good was a
Parnellite at school and when that cause was lost remained a
Redmondite. After work with the *Northern Whig* he joined the
staff of the *Irish Independent* and was Irish correspondent of the
New Statesman, the radical journal for which, as 'YY', Lynd
wrote his weekly essay.

Inst also confirmed in Lynd his love of sport. Each of his
collections of non-literary essays has sporting elements. One,
published in 1922, was called *The Sporting Life and Other
Trifles*, the 'other trifles' forming a decided minority. His
apostrophe of Sam Lee, J. H. Robb and Alec Montgomery in
'The School Cap' is simply a communicated statement of

excited approval. When he went to Twickenham he used to shout at the top of his voice, 'absolutely inaudible to everyone but himself', as his sometime assistant, the novelist and television executive Norman Collins, recalled in a 1966 BBC programme ('Portrait of Robert Lynd', produced by the Ulster author John Boyd). Rugby was his favourite sport but he loved them all and was to write sparklingly about boxing, soccer, cricket, hurling and tennis. He especially loved racing (see his classic 'Galway of the Races' below) and gambled regularly. A copy of Ruff's *Guide to the Turf* was always to be found destroying, with much other paraphernalia, what should have been the impeccable line of his expensive suit.

<p style="text-align:center">III</p>

Lynd matriculated in June 1896 and became a student at the Queen's College, Belfast, in October of that year. He seems not to have opted for honours but used the system of 'narrowing the field' that was current then. In his first year he took Latin, Greek, English, maths and experimental physics. In the second year, 1897-8, the scientific subjects gave way to the compulsory 'philosophic' subject, with Lynd opting for logic. In his final year he dropped English and graduated with an ordinary degree in Classics in 1899. He was twenty years old and he knew his career was to be literary. In the circumstances the dismissal of English Literature may seem strange. At Inst, too, he figures not at all in the prize-lists of the English department. Then as now Eng. Lit. was not a highly regarded subject but for different reasons: it was marginal compared with the ancient classics which were still thought of, not without reason, as the best preparation for any career.

It was at Queen's that Lynd's socialism and nationalism were forged. Though economic conditions were somewhat better than in Dublin, the plight of the unskilled workers and the unemployed was sufficient to make any sensitive young man anxious to seek a social remedy in socialism. A majority of

unskilled workers, and almost all the skilled, were Protestant; conditions for Catholics were grim. This polarization began as a tactic in the 1850s and developed during the next three decades. Catholics formed about one-third of the urban population and it was expedient to keep them depressed. During the 1860s and '70s the number of Orange Lodges in the city trebled and they were the source of well-organized resistance to amelioration of any kind. The sectarian rioting which was sparked off again in 1886 occurred not as a result of Randolph Churchill's playing of the threatened 'Orange card' or his inflammatory visit to Belfast but because of a cocky remark by a Catholic in the shipyards. When Arthur Balfour played his Orange card in 1893, the Order responded with blind, atavistic loyalty.

In opting for 'Irish solutions to Irish problems' Lynd was simply reverting to an old Presbyterian tradition, lost due to the persuasive powers of Cooke and such firebrands as Johnston of Ballykilbeg. Redmondism held little appeal so Sinn Féin, Arthur Griffith's party, eventually proved the most congenial.

The Ulsterman who had the greatest effect upon Lynd was four years his junior. Bulmer Hobson (1883-1969) was a Quaker from Co. Down who was imbued with the doctrines of Wolfe Tone and had a genius for organization. He lost several jobs as an apprentice printer because of his membership of the Gaelic League (begun in 1893) and he founded the youth movement that became Na Fianna Éireann. He was also one of the fathers of the Ulster Literary Theatre, famous for his remark, as he and a friend left Dublin by train after a theatre visit, 'Damn Yeats! We'll write our own plays.'

Another prominent literary nationalist figure was Alice Milligan (1865-1953), who with her friend Anna Johnston ('Ethna Carbery') ran the periodical *Shan Van Vocht*. This became James Connolly's best advertising medium as he strove to organize Labour in the North. It was in response to one such advertisement that Lynd, James Good and Sam Porter came to meet the Labour leader at the sparsely attended initial meeting of the Belfast Socialist Society.

In his essay 'On Wearing a Collar' of twenty-five years later, laughing at the House of Lords for reminding its guests to wear their collars and trousers, Lynd wrote:

I do not remember ever to have forgotten to wear a collar, except deliberately. That was when I was nominally a student and shortly after I had become a passionate advocate of democracy. I do not know why at the age of eighteen it should seem democratic to wear a neck-cloth instead of a collar, and a corduroy cap, and to smoke plug tobacco in a clay pipe with the red hand of Ulster embossed on the bowl. It was certainly a dubious advertisement for socialism and merely served to convince anyone who took notice that one's creed was the result of mental disorder.

I remember also making it a point never to shave on Sundays. It seemed to me monstrous that the middle classes should all look so extremely respectable on Sunday that no one who was not equally respectable would dare to be seen in the same church with them. Hence I decided to make my tiny contribution to the brotherhood of man by reducing the respectability of the church I attended as far as was in my power. I could think only of two ways – to turn up late and to turn up unshaved. I carried out my programme with all the greater ardour because I detested early rising on any day, and particularly on a Sunday, and as for shaving, even now, if there were any alternative to it except growing a beard, I should never let a razor into the house.

Times have changed, however, and I with them. You will no longer see me on a Sunday morning standing up in the back pew, like a long, cadaverous gaol-bird who has just recovered from a wasting illness in a Bolshevik hospital.

What is not made clear in this excerpt is that the church was May Street Presbyterian and that the minister was his father. Such behaviour in the eyes of a Presbyterian congregation must have had the same quality of heinousness as when, in Haworth, 't'Vicar's Pat' was carried home nightly to the Rev. Patrick Brontë, late of Annalong, Co. Down.

Robert John had a further affront to countenance. By this time almost all the Lynds, Annie and Ina, Dolly and Laurence the twins, and Lucie, the youngest, had become firm republicans too. When the anti-Home Rule father came into the living-room the conversation, which was usually about Irish culture and politics, would cease. Only Laura, the eldest of the family and wife of Lynd's old classics master, R. M. Jones, remained unionist but, as she insisted, *liberal* unionist. Probably to their mutual relief it

was not until 1888, when Lynd had left, that Jones became principal of Inst, serving with such distinction until 1925 that he became known as the 'second founder of Inst'.

Politics aside, Lynd was still a lover of literature and the classics without necessarily loving the writing of Greek proses. In 'The Student' (1924), he recalls ruefully how his regularly resolved night-watch ambition of becoming a master of knowledge and character faded with the morning:

There would be someone in the porch of the college who would meet one in an idle mood and insist on a walk along the tow-path of a canal or who had been reading a book and wanted to argue that no one existed but himself, or who believed that Thoreau was a better writer than Emerson, or that *The Shop Girl* was a better musical comedy than *The Geisha*.

His favourite poetry at the time was Browning's and 'he used [to] read it aloud and talk about it till all hours. I often wondered how he managed to rise in the morning for lectures.' The memoirist for his Queen's days was W. R. ('Daddy') Gordon, who afterwards became art master at Inst, made a bust of James Good that according to Lynd made him look a bit like Oliver Goldsmith, and was the sort of character that only a school with the magnanimity of Inst could tolerate. Gordon's short memoir in *School News* recalls, almost inevitably, a riot in which he and Lynd were caught up. It was Mafeking Night, nearly a year after Lynd's graduation, and they found themselves in a baton charge in York Street. Lynd had learned survival techniques from James Good but Gordon was only a tyro.

Though the noise was terrific I was unaware that anything was wrong when Lynd shouted in my ear, 'Run, for God's sake!' I'll never forget the tall lanky figure in front of me with the tails of his long, heavy overcoat flying in the wind: then he gave me a dressing down for not keeping my eyes about me.

Belfast matter for a May evening! In tribute to that friendship Lynd grafted on to Gordon an odd literary fame. Some years later, when he needed to write a *Daily News* review and wished to preserve the appearance of editorial non-participation, he invariably used the name W. R. Gordon. It was done with his

old friend's permission, of course, but Lynd often ascribed to him knowledge and opinions that Gordon might not have recognized.

('Daddy' Gordon later set up a professional art studio. He was in great demand as a painter of processional banners, working with non-sectarian zeal for both Orangemen and Hibernians. Once, when some nationalists came to collect a finished banner, they looked at work in progress on an Orange one. 'You know, Mr Gordon,' said one, examining King Billy's white steed, 'I don't think you've got that horse's leg right.')

In 'The Professor' (1925) and 'Dislike of Professors' (1939), Lynd has left a pen-portrait of his Greek teacher, Sir Samuel Dill. Dill had been an old boy of Inst but seemed in Belfast to have 'the air of a banished man. If he talked to you about yourself he had but one message – "Escape. Fly while there is time!"' – a message which Lynd was not at the time disposed to heed, finding a walk down North Street on a Saturday night as exciting and as satisfying as 'most of the things that used to happen under the shadow of the Parthenon'.

Dill, like Lynd's other academic hero, his professor of English, Samuel James McMullen, despised examinations and those hapless people whose presence in lecture-halls was only for that mundane purpose. He found it hard to conceal his contempt for the theological students who needed a pass in Greek; McMullen was equally offensive to his mathematical students who were dismissed to their faces as 'intellectual barbarians'. These men were useful, perhaps necessary, counters to the rigorous piety and instinctive pragmatism of the milieu in which Lynd had grown up. Typically, as a student he hated note-taking, just as, as a writer he eschewed the blemish of annotation. This suited McMullen, whose lectures on Gray might end with Turgenev and for whom *Macbeth* prompted an account of the Newtownstewart murder case. Dill, on the other hand, required not only note-taking but palpable evidence of note-taking. Lynd, with typical oblique courtesy, used to make many illegible scrawls on paper and throw them into the fire when he got home.

Lynd was lucky to have such guides to the greater and the lesser Parnassus, and he knew it. Certainly they provided him with the knowledge and love of literature that informed his whole life and left him ready and able, like that other Irish Grub Street denizen, Oliver Goldsmith, to adorn anything he touched.

IV

When he left Queen's in 1899 Lynd's first job was with the *Northern Whig*, an independent Protestant paper whose banner motto was '*Pro rege saepe, pro patria semper*'. Belfast had not much to offer and Lynd was not really a reporter. His radicalism, too, would inevitably have jarred on his editor, however liberal he may have been by Belfast standards. Soon he left for London, the Mecca of all who would live by the pen, though a man so acquainted with Dr Johnson should have been under no illusions about the facts of the hack's way of life.

His route to London was via Manchester, where for three months at the end of 1900 he worked on the *Daily Dispatch*. His style proved 'too flowery' for a daily paper. In London from 1901 to 1908 he 'lived hungrily on freelance journalism and the conversation of friends', as his first regular chief, R. A. Scott-James, later wrote of him in the *Dictionary of National Biography*. One of these friends was Paul Henry, the landscape artist, with whom Lynd shared a studio in Kensington and to whom *The Sporting Life*, his 1922 volume of essays, was dedicated with the words, '. . . because of the amusing days when we lived together in the same studio and owed money to the same milkman'. Henry gave the following account of the young Lynd:

He was tall and growing rapidly. His careless and shambling gait had early indicated the student's stoop that was so marked in his later years. I noticed him first as a boy with a fund of merry laughter indicated by his wide and sensitive mouth. This mood in him gave way to a brooding languor which never left him during his long life. At that time Robert looked like a young colt whose legs had not yet grown properly used to the weight of its long body. At times his young mind speedily outdistanced its fellows in the quality

of his mental awareness. I had never heard him called a brilliant student: he was too busy living. Being intensely alive was all that was to be demanded of young colts. (*Further Reminiscences*, 1973)

This capacity for awareness was the quality which, according to his brother-in-law Alex Foster, husband of his favourite sister, Annie, most characterized Lynd. In the 1966 broadcast Foster said:

I sometimes think about Robert that it's the same thing as Bagehot said about Shakespeare, he had an experiencing mind. Things that perhaps you and I wouldn't notice, would register in Robert; he would have a vivid impression of it. And then, of course, he could write . . . like an angel.

His angelic writing brought in at the start little cash. His first regular job was for *Today*, a twopenny weekly in which he was paid thirty shillings a week for writing essays, dramatic criticism and gossip – a salary raised to £2 when he also contributed short stories. This wage, adequate by Edwardian standards, was supplemented by book reviews for a journal called *Black and White*.

He had been asked to write for *Today* by a remarkable character, Ladbroke Black, who had been appointed co-editor of the weekly which had been run by Jerome K. Jerome of *Three Men in a Boat* fame. Black had met Paul Henry in Paris, and, calling at the Kensington basement studio, discovered that Lynd was 'nominally a journalist but was in fact doing nothing'. He immediately asked him to send contributions to a feature called 'Club Chatter'. Lynd said he had never been in a London club in his life and that 'Pub Chatter' was more within his reach. 'That'll do all right, old chap; we're a democratic paper!'

He took all the copy Lynd sent, accepting even a piece on a savage tribe that ate sand (found by the random picking of a book from the card index of the public library) and called 'The Dirt Eaters'. Once, he asked Lynd to do a piece on the Boat Race: 'We go to press before the race but you can do it from your imagination.' Even Lynd was unequal to that task. Instead he did a piece on street preachers which so impressed Frank Rutter, Black's co-editor, that he took him on the staff to do all

those journalistic chores. He may never have seen the Boat Race, but a sixth-former whose pleasure it was to roam the streets of late-nineteenth-century Belfast was a very Boswell of street preachers. His favourite was Sammy Thompson, whose cry was 'There's no laughing in Hell, boys!' and who was a master of such rhetorical tricks as groaning, 'Here am I denouncing high pocrisy and me wearing a dickey and pretending it's a white shirt' ('The Street Preacher', 1924).

Lynd's responsibility for drama criticism meant that he saw, among the drift of Edwardian melodramas, the early work of his countryman Bernard Shaw. Those were the years of *John Bull's Other Island*, *Man and Superman*, *Major Barbara* and *Caesar and Cleopatra*. Lynd had more than a patriotic fondness for Shaw, as the essay 'G. B. S. as Idol' (included in this volume) shows. (A decade later, when Shaw proved too rationally anti-war for British opinion, Lynd wrote in the *Daily News* that the lines drawn seemed to be: the Allies versus Germany, Austria, Turkey and Shaw.) Encouraged by Black, he also ghosted a number of books including the autobiography of a convict and a veterinary manual on training horses.

The one flaw that Lynd found in Black was a virtue that he himself was never to possess: Black liked all copy to be in punctually. In this respect Lynd was the bane of all his editors:

I have often trembled as I lay in my Hampstead lodgings [by then Lynd lived at 9 Gayton Road] on the morning of going-to-press day and heard him rushing up the stairs to put the inevitable question: 'Got your article finished?'
'It's under way,' I would quaver from beneath the blankets.
'You mean you've got the title written,' he would say disgustedly. Then, suddenly, the reign-of-terror frown would vanish, and he would leave the room laughing at his own perspicacity and the hopelessness and the helplessness of his friends.

The essay on Black is called 'Over the Stile' (1941). He had, as Lynd says, a genius for helping lame dogs. 'Black was not only a man who helped lame dogs over stiles: he pushed them and, if necessary, carried them, over stiles.' The essay ends with the meditative sentence: 'I have often wondered what would have happened to me if I had never met him.'

As it happened it was another essayist, A. G. Gardiner, who, prompted by one of Lynd's London Irish friends, Alice Stopford Green, employed him in 1908 on the paper that was to be his permanent place of employment for the next forty years. As 'Alpha of the Plough', Gardiner had published a number of books of light essays, but it was as editor of the Quaker *Daily News* that he was persuaded by Mrs Green that his literary editor, R. A. Scott-James, needed an assistant. The days of living on 'bread and jam and whiskey' were over. He and his girl were not after all going to marry on 'a disappearing income of a guinea a week'. He became literary editor in 1913 and stayed with the paper when it became the *News Chronicle* in 1930, continuing to work for it until the year of his death.

<center>V</center>

Edwardian London had its share of indomitable Irishry: Yeats, when he was not at Coole Park; T. W. Rolleston, like Lynd a journalist; their friend Alice Stopford Green, whose *The Making of Ireland and its Undoing* (1908) enraged many English reviewers, and who was a kind of queen in exile, her house a rallying place for those Irish who felt the burning of a national ideal after years of despairing somnolence. Pádraic Ó Conaire worked for the Ministry of Education; Michael Collins and P. S. O'Hegarty were employed by the Post Office; Frank Fahy, who founded the Gaelic League in London, was also a civil servant. The League was the unifying factor and those who were not students of Irish were teachers. Another Irish institution was the Irish Literary Society which grew out of Fahy's Southwark Irish Literary Club. It was established by Fahy and Alice Green and served as a kind of London office of the Irish Literary Revival. Margery Foster, in her book *Michael Collins – The Lost Leader* (1971), records how Collins invariably greeted Lynd at meetings of the ILS with the friendly jibe, 'And how is the non-conformist conscience today?'

(There is a story, which may not be apocryphal, that Ó Conaire, who like Fahy was a native speaker and a tireless Gaelic League teacher, was asked to sit an examination for promotion in the civil service. He offered Irish as one of his subjects and the Commissioners with charming assent arranged that their Patrick Conroy should be supplied with a paper of appropriate standard. The League teacher Pádraic Ó Conaire was suggested as an appropriate setter and marker. He was happy to oblige for the fee and, finding a mistake in a *sineadh fada* [accent: lit. 'long stretch'], gave Patrick Conroy only 99 per cent.)

Ó Conaire and Lynd were to remain friends. One of the papers preserved by Lynd's daughter is a note in Irish written on 21 May 1915, inviting him to an evening out:

> A Riobáird, a chara,
> An féidir thú mhealladh as an teach
> aon oidhche? Beidh suipéir & greann
> againn san Cheshire Cheese wine cellar
> an 6adh lá de mheitheamh & béadh fáilte
> mhór romhatsa & roimh do bhean: an dtiocfaidh
> tú? Cáirde liomsa & leatsa an comhluadar bhéas
> ann. Beidh aithne agat ar a bhfurmhór.
> Mise
> Pádraic Ó Conaire.

(Dear Robert,
Can I coax you out of the house for a night? We're having supper and crack in the Cheshire Cheese wine cellar on 6 June and you and your wife would be very welcome. Will you come? The company will consist of friends of us both. You'll be acquainted with most of them.
Yours
Pádraic Ó Conaire.)

One of the main League venues was St Andrew's Hall behind Oxford Street, where Lynd learnt Irish with such skill and

success that he soon became a teacher. As was the custom, he spent some time in one of the newly established *coláistí samhraidh* (summer colleges). His choice was Cloughaneely, near Falcarragh in Co. Donegal, and there he met a fellow-student who had none of the same linguistic skill but had invented an Irish name for himself, Ruairí Mac Éasment. Casement later became Lynd's pupil at the League classes. Another who learnt his first Irish from Lynd was the English-born Aodh de Blacám (Hugh Black), who later put his knowledge to good use in *Gaelic Literature Surveyed* (1929).

Meanwhile, at home in Belfast, a movement known as the Dungannon Club had been founded by Bulmer Hobson. He had joined the Irish Republican Brotherhood in 1905 and with a fellow-member, Denis McCullough, he established the movement which 'set itself the task of uniting Protestant and Catholic Irishmen to achieve the independence of Ireland'. The name recalled the Tyrone town's association with the activities of the Irish Volunteers of the 1780s which had led to the establishment of Grattan's Parliament. The organ of the Dungannon Club was *The Republic*, a weekly which began publication on 13 December 1906. It was started with a total capital of £60 and it lasted till May of the next year. Lynd wrote most of it and like all contributors was unpaid. A feature of the publication was its use of satirical cartoons that were sold separately as postcards. The main artists were the four Morrow brothers, one of whom, George, afterwards became art editor of *Punch*. Lynd is credited by Hobson with two excellent cartoons: one, captioned 'The Wild Geese', shows MPs of the Irish Parliamentary Party heading to Westminster to agitate for an Irish parliament at home; the other, 'John Bull's Famous Circus', has John Bull as ringmaster and barker offering such attractions as Redmond's 'Sleight of Hand', 'Wire Pulling' by Sir Anthony MacDonnell and Birrell's 'Comic Clowning'.

Lynd was already a socialist but his nationalism was not fully realized until he was living in England. He described his 'conversion' in 'Arguing' (1936):

My conversion to nationalism was more rational, but, even so, it was not the result of other people's arguments. I had come to England from the north of Ireland, believing in my simplicity that the English spent their days and nights thinking out plans for the welfare of Ireland – for improving the land system and the education system, and for draining the regions of the Bann and the Barrow. To my surprise, I found that the English were a very practical people who had enough problems of their own to solve without spending sleepless nights over the drainage of the Bann. Most of them seemed to look on the Irish as a pampered people living largely at the expense of the English taxpayer. Finding that they regarded Ireland mainly as a nuisance, I concluded in the course of a few months that it would be better for the country to be governed by people who were, at least, interested in it.

The alignment of *The Republic* with the emerging Sinn Féin movement was certainly due to Lynd's influence. His was the voice claiming in the second issue that 'compared with Sinn Féin, every other Irish agitation is the merest squib'.

The most significant publication of the Republican Press, an offshoot of *The Republic*, was the 38-page pamphlet *The Orangemen and the Nation*, previously mentioned. It is an elegant piece of persuasion, logical and reassuring:

If the Orangemen would only let the scales of sectarian prejudice fall from their eyes, and would only open their ears to the voice of the country instead of to the voices of false-tongued lawyers and ambitious politicians, would they not feel equally insulted, as Irishmen today, at being considered 'so weak, helpless and ignorant that they can neither support nor legislate for Ireland without British aid'?

(The quotation marks enclose part of a resolution made against the Act of Union in 1800 by Loyal Orange Lodges Nos. 382 and 390.) The sentences, unusually strong and lapidary for Lynd, are like hammer-blows:

England's game in Ireland has always been to whisper one suspicion in the ear of the Protestant and another suspicion in the ear of the Catholic, until the two of them become irritated with each other, almost to the point of murder.

And later, returning to the theme of the Irish language:

The Irish language and the Irish people are the products of the same air and the same soil. The Irish language belongs to the people of all races who inhabit Ireland just as the English language belongs to the people of all races who inhabit England. . . . If a country imports a language from abroad it will import everything else from abroad.

The pamphlet reads remarkably like the essays that Thomas Davis used to write for the early numbers of *The Nation* and probably shared the same fate of being read and valued almost entirely by the converted. That Lynd was influenced by Davis is clear not only from the mimetic style but also from this account in his third published book, *Rambles in Ireland* (1912):

And of the small towns there was none to which I looked forward more eagerly than Mallow. I wanted to go there, not out of veneration for the memory of the Rakes of Mallow, immortalized in the song, but because the prophet of all that is best in modern Ireland was born there.

His sketch of Davis's life and thought is masterly, probably because they had so much in common, including an unrelenting pursuit of freedom and an abhorrence of physical violence:

the Phoenix Park murders . . . are the sort of crime which a school of nationalists educated in the lofty principles of Davis could only commit if they were driven temporarily mad.

His other political mentor was Arthur Griffith, the subject of one of his essays, 'Arthur Griffith: The Patriot' (1934), included here, written a dozen years after Griffith's death. Lynd was absolutely convinced that it was passive resistance, allied to the 'national parliament set up in Dublin, national law courts set up and obeyed throughout the country, national police parading the streets within sight of the official police', that had brought the last insurrection to its successful conclusion.

Lynd and P. S. O'Hegarty became the London delegates of Sinn Féin though they were irregular attenders at meetings. Lynd continued to advocate a Gandhian approach. He felt that non-violent struggle would not only preserve the unity of the country but provide a greater problem for the British, who could easily suppress an armed uprising but who were no match for an Irish character stronger than guns. He also knew that violence would further alienate the unionists.

Lynd continued to admire and respect those people he knew who felt that armed struggle was the only way, while remaining convinced that they were misguided. His friendship with Casement continued after Cloughaneely, and 'Hibernia Rediviva'

(1908), contained herein, describes a visit they made to Toome Feis in 1906. He was among the most active petitioners for Casement's reprieve in 1916. In a letter to *The Nation* of 13 May of that year he wrote:

As the case of Sir Roger Casement is at present *sub judice* I do not propose to discuss the question of his guilt or innocence in regard to the accusations made against him. But I must protest when one of the least self-seeking, most open-handed of men – a man who has lived not for his career but for the liberty of those who are oppressed and poor and enslaved – is dismissed with all the clichés of contempt. . . . Even those who, like myself, have been diametrically opposed to his recent policy, can never lose our admiration and affection for everything in him that is noble and compassionate.

In organizing the petition for Casement's release Lynd found that the evidence of Casement's homosexuality produced in court made it difficult to get signatories. Joseph Conrad was one previous admirer who declared himself revolted by the revelations from the Black Diaries. Alice Green established a fund to fight the case, contributing £400 herself. Lynd gave four guineas, a considerable sum for a working journalist. Cadbury, the Quaker owner of the *Daily News*, sent £400 and Arthur Conan Doyle an admirable £700.

Lynd and Mrs Green visited Casement in Brixton Prison and were in court during his trial. There was nothing that could be done to save him. When the execution was carried out on 3 August 1916, Lynd was grief-stricken. (It was, according to his surviving daughter, one of three things that nearly broke his heart; the second was the Civil War in Ireland, the last a more private grief.)

As the Irish troubles continued some of Lynd's English friends began to lose patience. Scott-James, his chief until 1913, was one who quarrelled with him over Ireland. Another was E. C. Bentley, the inventor of the clerihew and author of the classic detective story *Trent's Last Case* (1913). However, his writings (and presumably his conversations) about Ireland were utterly rational. He describes his most specifically political book, *Ireland a Nation* (1919), as a 'cold-blooded appeal to reason on behalf of Irish nationalism'. It was dedicated to

Clifford Sharp, his editor on the *New Statesman*, a friend who could take on the logic of the Irish argument. In the chapter on 'The Insurrection of 1916' Lynd stated:

> The courts-martial converted the revolt of a minority into an episode of national history. They made people who had looked on the insurrection with detestation see the leaders in the blazing light of martyrdom. . . . Probably . . . not a single one of the soldiers who sat on the fatal courts-martial had ever read a line of Irish history. If they had they would never have dared to order a shot to be fired.

In his essay 'Valediction' (1936), Lynd recalls Sharp's reaction to the executions of the 1916 leaders: 'What could rebel leaders expect?' Yet he listened to the 'martyrdom' argument and logically denounced the executions in the next edition of the journal.

The introduction (included here) to James Connolly's book *Labour in Irish History*, which was published in 1916 after Connolly's death, epitomizes Lynd's nationalism. The opening sentence, 'James Connolly is Ireland's first socialist martyr,' is uncompromising. It shows Lynd first as the friend faithful in spite of disagreement about policy, second as a fearless speaker-out about Ireland, and lastly as a logician. Just as Carson's and the UVF's facing-down of the Asquith government in 1912 made, he believed, Easter Week inevitable, so, as AE put it, the employers in the 1913 lock-out became the 'blind Samsons pulling down the pillars of society'.

In one oblique way Lynd made a direct contribution to the Rising. An essay he wrote in 1915, 'If the Germans Conquered England', described the resulting Teutonism of the free country: the gradual erosion of English history and destruction of its heroes with replacement by German equivalents.

> Gradually it would become an offence to use English as the language of instruction; in another generation it would become an offence to use it at all. . . . Thus if England could only be got to submit, would she be gradually warped . . . she would be a nation of slaves, even though every slave in the country had a chicken in his pot and a golden dish to serve it on.

It was fine, close-argued, hard-hitting stuff. A reprint was made compulsory study for officer cadets at Sandhurst. It was, after

all, a statement of the principles of patriotism. And what the obtuse War Cabinet did not realize, but the Irish Volunteers clearly did, was that it described England's treatment of Ireland in every detail, *mutatis mutandis*. The Easter Week rebel newspaper, *Irish War News*, printed the piece almost in full.

In the 1920s Lynd continued to plead Ireland's case in the *New Statesman* and the *Daily News*. During the Black and Tan campaign Dublin Castle used to publish a kind of score sheet of outrage and counter-outrage called the *Weekly Summary*. It had advised the new force to make Ireland 'an appropriate hell for the Sinn Féiners' (a Sinn Féin which Lynd was not part of and one which, in his view, was untrue to its earlier principles). He was literary editor of the *Daily News* and as 'YY' in the *New Statesman* wrote a weekly essay, which in the words of his last editor, Kingsley Martin, 'was neither wholly literary nor political but almost as good as Lamb'. When stung to instant response, however, he wrote to the papers like any other indignant reader but with, perhaps, a better hope of having his letters printed. He wrote to the *Daily News* about the *Weekly Summary* incitements and said that they had the desired result of making the Black and Tans feel towards their Irish enemies as men feel towards wild beasts.

When the Civil War was over and the Free State established he kept in close touch with his Irish friends, was a frequent visitor and holiday-maker there and returned regularly to Irish themes in his essays. He had great love for the Ulster unionists whom he knew through and through, but felt great sadness at their rejection of a nationhood and expressed sharp though muted contempt for the politicians who continued to manipulate them. His fellow-Ulsterman, St John Ervine, whose unionism had been reinforced by the events of 1916, recognized him as a worthy adversary. They regularly crossed swords in print with Ervine ending up by admitting Lynd's 'intolerable tolerance'.

Lynd understood like few other commentators just how resolute the Civil War, with its internecine violence, had made the Ulster unionists; while remaining a republican he had a sympathetic understanding of his Ulster Protestant brothers. He

may have been, in his wife's phrase, 'an escaped Presbyterian', but as that escaped son of the Church of Ireland Louis Mac-Neice has said: 'The woven figure cannot undo its thread.'

VI

Lynd met Sylvia Dryhurst in September 1904 at St Andrew's Hall. He was twenty-five and she was sixteen and they fell in love. She lived in Hampstead and was the younger daughter of Alfred Robert Dryhurst ISO, administrative secretary of the British Museum, and Nannie Robinson, a talented governess from Dublin. NFD, as she was known, was artistic, supplementing her income by selling *objets d'art* and hand-painted Christmas cards. She was a suffragette, an anarchist, founder with Gordon Craig, Ellen Terry's son, of the Purcell Operatic Society – very much the Shavian New Woman. (Indeed Shaw was a regular visitor to her Hampstead home as he had been to her mother's house in Dublin and it is not too fanciful to see her as one of the models for Ann Whitefield in *Man and Superman*.)

NFD was wooed by Roy Dryhurst, an early Fabian, and had two daughters, Norah and Sylvia. By the time that the girls had reached grammar school age she was deeply in love with Henry Nevinson, editor of *The Nation*. When this came to light her husband insisted only that he should be responsible for the education of Norah, who was sent to the conventional South Hampstead High School for Girls, while Sylvia, under her mother's care, went to the new and unorthodox King Alfred School. There she realized her artistic capacity and went on to the Slade, a perfect grounding for the future poet, novelist and reviewer. She never quite learnt to spell, like another former art student, W. B. Yeats, and had occasion to be glad of Inst's emphasis on classical accuracy as Robert corrected her copy and proofs. She also had an interest in the stage, attended RADA and won a small part in a Beerbohm Tree production. This provided the background for a novel, written in her early

thirties, called *The Swallow Dive* (1921). Gordon Craig, who described Sylvia as 'a strange and beautiful child', was moved to do a drawing of her. She was to put this perfectionist into her earlier novel, *The Chorus*, published by Collins in 1916. During her teens she exchanged a series of charming letters with the poet and playwright Padraic Colum, with whom she had fallen in love briefly.

The Dryhursts lived for all of their married life at 11 Downshire Hill. Lynd was in digs in 9 Gayton Road, Hampstead, when he met Sylvia. He was on good terms with his future father-in-law and in the essay 'I Am Taken for a Pickpocket' (1922) describes an amusing incident on an Italian holiday that they shared.

Arthur Ransome, in his posthumously published *Autobiography* (1976), writes about visiting the Dryhursts and meeting Lynd:

Mrs Dryhurst and her two daughters, Norah and Sylvia, were passionately Irish. Robert Lynd lived close by and he and Sylvia were friends of mine for nearly fifty years, indeed until they died. Mrs Dryhurst had a 'day' (I forget which it was) and on that day her drawing-room was full of young people who, if not Irish, at least had no objection to Home Rule. There were always more of us than there were chairs, and poets used to read their poems aloud while we sat on the floor. At about six o'clock Mr Dryhurst, who had never been quite forgiven for being English, used to come home from the British Museum, open the drawing-room door an inch or two, enough to look in on the Irishry, and disappear again at once.

The effect on Lynd of all this *jeunesse dorée* can be imagined. Psychologically it was light-years from May Street and the austerity of his upbringing. He was never entirely depresbytried; he may have 'escaped', but certain instincts die hard. Lynd was as keen a theatre-goer as Belfast ever spawned but drew the line at having a fiancée on the stage, even with Mr Tree. He wrote two essays with the title 'Should Kissing on the Stage be Stopped?' In the second, dated 1941 when he was sixty-four, he wrote of the first: 'I should probably never have written the article but for the fact that I was deeply in love with a beautiful young actress and could not bear the thought of her being embraced, even in make-believe.'

Robert maintained an Elian detachment in his persona 'YY'. Just as Lamb distanced his sister Mary Ann as Cousin Bridget, so he used to refer to his daughters, Sigle and Máire, whose sayings and adventures gave him much copy, as his nieces, and to their daughters as grandnieces. The actress referred to, unquestionably young and beautiful, is Sylvia and not Marie Studholme, the *spéirbhean* of his youth and early bachelordom.

During the four-year delay imposed by the Dryhursts on their courtship, Robert and Sylvia corresponded daily, a tribute as much to the efficiency of the four-times-daily postal deliveries as to their devotion. Sylvia was kept short of money for a stamp and anyway she was often too impatient to post and dropped her daily love-letter into 9 Gayton Road on her way home from King Alfred, the Slade and finally RADA. One of these letters survives, a penitent one from Robert apologizing for bad temper. It is dated 25 Eanair '08 and timed 4.30 a.m.: 'I'm afraid I'm more in love with you than ever – in love with you childishly, manlily, motherlily, fatherlily, grand-fatherlily, and every other way possible.' Even in a love-letter the critic and bookman could not help but surface. Before the final plea for forgiveness and after the lover's admission that he felt 'the absolute folly of not accepting your moods and minds as gifts of the Gods – offering thanks for them all', comes a discussion of why she likes Turgenev's *On the Eve* and he *Fathers and Sons* the better.

The occasional use of Irish in their correspondence became more common. A letter written to Sylvia in Dublin when she was showing off her first child Sigle to her Dublin grandmother concludes, 'le grádh mo chroidhe dhuit./ Do Rab.' (The Lynd grandparents were both now dead. Sarah, Robert's mother, had died in 1896 of a heart attack sustained when running for a train. Robert John died on 17 November 1906.) The Lynds took the Irish language question seriously. When the children were born they were taught Irish and after necessity and practicality made English their tongue they still bade their parents goodnight and goodbye in the first language.

In 1908, when Robert had secured his permanent job of assistant literary editor of the *Daily News* and had his first

book, *Irish and English*, published, the Dryhursts no longer considered them 'penniless journalists' and permission was granted for their marriage. Sylvia had begun to review for *The Nation* and throughout her life was a regular critic for *Time and Tide*, the *Daily News* and the *Observer*. Robert's second book, *Home Life in Ireland*, was commissioned by Mills and Boon. Their wedding took place in the Hampstead Registry Office on 21 April 1909, the day after Robert's thirtieth birthday. Sylvia was not quite twenty-one. The 1908 book had been dedicated to Sylvia Dryhurst; *Home Life in Ireland* had the more companionable inscription: 'For Sylvia Lynd'.

They spent their honeymoon in Achill, the first of many Irish holidays, and on their return enthused so much about the beauty and the light to Paul Henry that he went there and stayed for seven years. Any quarrels about Sylvia's truncated stage career were curtailed by her becoming almost immediately pregnant with Sigle, who was born on the last day of February, 1910. Her name, the Gaelic version of Sheila as it was then spelt (with an aspiration mark on the 'g'), caused some difficulty and rare mirth when she went up to Oxford as an undergraduate. A friend, Alec Peterson, then at Balliol and later head of the Education department, was so used to all who saw her name written pronouncing it to rhyme with 'wriggle', that he wrote the following *strophe juste*:

> If you put out a figle
> To get acquainted with Sigle
> She turns with a weila
> And calls herself Sheila

During her literary career with Gollancz, the *Daily Worker* and the *Architects' Journal*, she called herself Sheila, but her obituary printed in *The Irish Times* in 1976 correctly designates her as Sigle Wheeler.

The Lynds lived first at 3 Hampstead Mansions but had moved to 14 Downshire Hill, a few doors from Sylvia's parents' house, before Sigle was born. The second child, Máire, was

born on 2 March 1912. That same year one of Robert's most enjoyable books, *Rambles in Ireland* (from which 'Galway of the Races' is taken), was published by Mills and Boon and dedicated to Annie Lynd, his sister (mother of Christine Hetherington). A pattern of life began to emerge that was to continue for nearly forty years, with some disruption from two World Wars. In 1913 Robert began contributing a weekly essay to the *New Statesman*. His *nom de plume*, 'YY', may have signified 'too wise' but no one can confirm this. That year he was made full literary editor of the *Daily News*.

The Lynds made a striking couple. Sylvia, beautiful and elfin, was an expert needlewoman, a charming hostess, a fine lyric poet. She was a gentle but firm critic and when the Book Society was founded in 1929, she joined J. B. Priestley, the novelist Rose Macaulay, and the President of Magdalen College, Oxford, on the selection committee, which met monthly under the chairmanship of Hugh Walpole.

Robert was also strikingly handsome, tall and self-consciously so, for he stooped. He had a corkscrew curl over one eye and a permanent cigarette in his mouth. (He was a 100-a-day man, a factor in his death from emphysema in 1949.) Richard Church, who edited a collection of literary essays, *Books and Authors* (1952), taken mainly from the middle-brow literary journal *John O'London's Weekly*, described him as having extraordinarily handsome eyes and a Fra Angelico profile, while J. B. Priestley who, like many another young hopeful, had been given literary work at the start of his career by Robert, said he looked rather like a ruined saint but 'there was rather more of the saint than the ruin about him'. Apart from regular visits by Robert to Fleet Street pubs, the Lynds' social life was spent in each other's company. They held and attended literary parties, sometimes as many as three in one night. And in the early days there were causes to fight for. P. S. O'Hegarty, Robert's fellow-delegate to Sinn Féin, inscribed his *History of Ireland Under the Union* (1922) to Bulmer Hobson and Robert with the words, 'In memory of the forty-and-odd years ago when the world was our oyster and Ireland was the world.'

In 1913 Casement had visited the Hampstead home bringing the two-year-old Sigle Óg, as he called her, a Swiss cow-bell. She always remembered his beard. Robert sang as lullabies to the girls his favourite songs, 'The Castle of Dromore' and 'My Lagan Love', and sometimes in a less Celtic mood, the music-hall song, 'There's No Place Like Home – But I'm Afraid to Go Home in the Dark'. Sylvia disapproved of that one. (Its title was based on the last utterance of O. Henry, the rackety American short-story writer, who had died the year of Sigle's birth.) James Winder Good ('Seumas') bought them dolls on their birthdays and used to send them postcards. One, addressed to Sigle from the Pas-de-Calais, described her father taking a swim: 'You would enjoy seeing your father go in and today half Paris seemed to have come down to revel in the new attraction to the "plage".' On the same holiday Robert wrote to his mother-in-law, NFD, in Irish but the message was the usual postcard stuff, complaining of heat and fatigue. In 1920, when the girls were told that their godfather Seumas had died and left them a little money they agreed to give it to the woman Good had been living with and who had no other income.

Sylvia had three miscarriages some years after Máire was born and settled into a pattern of illness which recurred every few years. Máire, who was always known to the family as BJ ('Baby Junior'), believes it was Crohn's Disease, a genetic illness which was not identified until 1945 and which gave rise to distressing symptoms that baffled her doctors. Both Robert and she were somewhat hypochondriac. He was notably fond of patent medicines and had an unfortunate addiction to home medical encyclopaedias, usually called *The Family Doctor*. Máire recalls hysterical diagnoses with book in hand and the relief when he decided that Sigle had not got meningitis after all. He and Sigle escaped the great influenza scourge at the time of the Armistice of 1918 which laid Máire and her mother low. The remedy for that was a diet of raw onions! Like many others then, the Lynds were half-joking enthusiasts of M. Emile Coué (1857-1926), whose doctrine of 'auto-suggestion' was supposed to improve health. Couéists were expected to face a mirror in

the mornings and say, 'Every day, and in every way, I am getting better and better.' This power of positive thinking did not preclude superstition, especially in Sylvia, who would not walk under ladders or kill spiders but loved white heather. Their children's upbringing reflected the Lynds' own ideals. Poetry was read and songs were sung. The folk-tales of Ireland (especially as told by Lady Gregory), Shakespeare, Swinburne, R. L. S., were part of a literary childhood. Yet nature and the countryside were part of the rearing too. Sylvia was an involved mother who could be strict; she chose the girls' clothes right up till the time they went to Oxford, dressing them alike – one dark and one fair – as a matching pair. Their homes were full of books and both parents had the habit of quoting aloud. When the parents were away they wrote letters to the children full of descriptions of the birds and flowers they had seen. In May 1919, while they were visiting the Dublin grandparents, Robert wrote to BJ: 'Grandpa sent your photos to-day, and Mammy liked some of them so well that she began talking to them. The photos were shy, however, and did not answer. . . .' Two years later, while Sylvia was convalescing in St Ives, Cornwall, he wrote to both: 'Good fathers don't write to their children because they don't like their children to hurt their eyes with trying to read letters. But good children always write to their father because they have so much to say that they can't help it. . . .' The letter continues with descriptions of hawks, curlews and a fight between a seagull and a cormorant. There is mention, too, of flowers – scabious, campion and betony – and of a sailor in the north of Russia who grew a beard that had sixteen different colours. Sylvia was ill again in 1927 when BJ was fifteen and in a letter written from Lynton, Devon, on 16 October 1927, Robert describes the sweet-pea still in bloom in the hotel garden and ivy-leaved toadflax on the wall: 'I wish we could all come here in the Easter holidays though the tea is vile and the coffee is viler; you and Sheila could ride the little Exmoor ponies.' The letter ends with a time-honoured parental hope that 'you are both finding Latin and Algebra easy in my absence'.

Máire also remembers an admonition written on the nursery blackboard: 'No faces till March'. She did rather good faces at the age of six, one modelled on Tenniel's Mock Turtle. As in any well-regulated home, Lewis Carroll was a constant resource. In a letter from New York in July 1936 Sylvia describes it as being 'like a city in *Through the Looking Glass*, when all the candles grew up to the roof'.

Sigle was very much her mother's daughter, extrovert and brilliant. Máire, quiet by choice and nature, had more of her father in her. Certainly she appreciated the typically repeated paternal jokes more than Sigle, who used to get very cross at the endless repetition of her father's silly question, 'Whether would you rather or rather would you whether?'

The family continued to live at 14 Downshire Hill after the outbreak of the First World War. In his collection *If The Germans Conquered England* (1917), the essay 'White Citizens', included here, describes Lynd's medical examination at call-up and his rejection. Apart from constant shortages and hospital trains arriving at Victoria Station, life was not intolerable. Another essay, 'The Darkness', was chosen by Sir Henry Newbolt for his *War Anthology*. It described a London that had not been seen before:

Certainly the first searchlight that waved above London was wonderful. That made the darkness – and Charing Cross – beautiful. . . . Sometimes on misty, moisty nights, the searchlights lit up the sluggish clouds with smudges of gold. It was like a decoration of water-lilies on long stems of light.

Later, with a poor sense of prophecy, he declares, 'The London of the searchlights and the Zeppelins will not be forgotten in sixty years.'

The Zeppelin raids were watched by the family in Hampstead with some equanimity. Máire remembers seeing the kind of scene described by her father as they sat sipping cocoa. In 1917, when daylight raids began, the Lynds decided to take the children out of the range of the silver fish. They lived in St Ives, Lyme Regis, Abinger Hammer and finally, in 1918, settled in The Stone House, Steyning, Sussex. The children, now aged eight

and six, loved the country and developed their preoccupation with birds and flowers in earnest. The house had a cellar and had been used as a lock-up and imaginative children reared on books made the most of its dramatic possibilities. Chanctonbury Ring was close at hand and it was there they heard their first nightingale and below, beside the mill stream, saw their first kingfisher. There, too, they held their funeral ceremonies for any dead birds they found in the garden and chanted 'Fidele' from *Cymbeline* over the tiny graves.

Robert travelled to London several times a week, staying with the Dryhursts and beginning to drink whiskey again. (He had been a regular drinker in his younger days but had given it up after meeting Sylvia.) J. C. Squire (later Sir John) was literary editor of the *New Statesman* in those years and Sylvia used to complain, 'Jack Squire taught Robert to drink.'

In 1922 the Lynds returned to London and had a flat at 32 Queen's Gate in a building which housed the almost non-existent Georgian embassy. The children greatly missed the country. As Máire recalls: 'It was a horrid change in that Queen's Gate flat, after the happy four years in the country, learning the names of flowers and stars and learning the songs of birds with our parents and playing garden cricket. We were sad without our lovely garden and our black cat, Peter.'

Eventually, in 1924, the family moved back to Hampstead to 5 Keats Grove where they lived until Sylvia's death in 1952. Sigle, now Wheeler, then kept the house until retirement with her husband to Tully Cross, Co. Galway, followed by her illness and death in London in 1976.

VII

The Lynd marriage was on the whole serene. They were largely self-sufficient. Sylvia was more outgoing, consciously extrovert and a lively conversationalist; Robert grew increasingly silent as the years went on. He remained true to his liberal-socialist principles but stopped short of the party-line Marxism of his

daughters from their maturity. Sigle relinquished her commu-
nism after the invasion of Hungary in 1956 but Máire retained
hers in spite of, as she puts it, 'difficulties'.

In 1920 Sylvia fell very ill. At the time her ailment was
called rheumatic fever but her daughter believes it was an
especially virulent attack of Crohn's Disease, a notoriously
psychosomatic condition, brought about by an unhappy and
almost certainly unconsummated love affair. The children were
only eight and ten years old but they were conscious of unchar-
acteristic unhappiness in the Steyning household and of a father
normally quiet becoming pathologically silent. Sylvia was in bed
for six months and during that time wrote a poem called 'The
Shepherds of the Flowers' which was addressed to the girls.
The conceit that they tended the flowers is elaborated in a kind
of prayer to them:

> Run to your flocks, and say that one
> Who as they love it loves the sun,
> Humbly desires that they will make
> Their Spring a late one for her sake.
> Say that in weakness and long pain
> More than a season she has lain
> Holding in hope but one small thing:
> She should be well to see the Spring.

Máire remembers offering some kind of animistic silent prayers
and 'Mammy got better.'

Sylvia did recover and Robert, too, became his own self
again. Certainly the books of the early twenties are among the
funniest (and the sunniest) of all he wrote. Sylvia began to
preside again over her literary evenings with candle-lit suppers
and black velvet gowns. For twenty years and more her guests
included many of the leading literary figures of Britain and
Ireland. H. G. Wells was a visitor and erstwhile host. Victoria
Glendinning describes in a magazine article a dinner in a
London restaurant in 1917 where Rebecca West and the Lynds
were joined by Wells and Arnold Bennett. Bennett was rather

drunk and rude but Wells was better mannered, 'full of deliberate impudences in his talk but not gauche and intentionally boorish like Bennett'. Sylvia was 'rather horrified' that Wells had come at all. She liked and admired Rebecca but she liked Wells's wife as well and thought that the lovers ought not to appear together in public. Convention required these things to be kept in 'neat compartments', as she wrote in a letter to her mother.

On his first visit to the Wellses Robert was introduced to the pianola and had to have one. The family were to pedal their way through many a Beethoven symphony and Mozart overture. Another snapshot view of the Lynds is to be found in Beatrice, Lady Glenavy's memoirs, *Today We Will Only Gossip* (1962). They were staying with the Campbells when one of the guests, Iris Tree, said that an Irishman's love affair was a 'flash in the pan' and then back to the sporting page of the *Evening Herald*:

Sylvia said ruefully, 'Robert never left the sporting page.' Robert laughed his almost silent laugh. I never knew a quieter laugh than Robert Lynd's; his speech was almost as inaudible, which was a pity as he said such good things.

Regular visitors to 5 Keats Grove included A. P. Herbert, the divorce reform agitator, J. B. Morton, the columnist 'Beachcomber' of the *Daily Express* who wrote comic songs about such artefacts as the Blackwell Tunnel ('That's the place for me!'), Rose Macaulay, Victor Gollancz, the left-wing publisher who became Sigle's employer. An excerpt from Sylvia's diary for 21 October 1935 describes a typical evening:

How did the party end? First with the arrival of Victor [Gollancz]. Then with a grand confusion as to who should take the Beerbohms home. Finally Lionel [Hale] did and the Davieses [Margaret Kennedy of 'The Constant Nymph'] drove off with Sheila and left the Herberts behind, whom they should have taken too. This was bad staff work on my part. Then Robert insisted on bringing everyone who remained in again and a fierce argument about communism began between Alan [Herbert] and Victor with me putting in my oar in the cause of peace and occasional hope of bed. Alan was a bit tight and rather rude. Peace being more or less preserved by 2 a.m., Rose [Macaulay] rose to go. Then her car wouldn't start. Then everyone went to push it – I sat quietly talking to Victor, who ceases to bluster and becomes nice when he is alone (Alan kept calling him and communists generally 'Smug' in a very annoying way) – Alan fell into the area but luckily did not hurt himself badly.

Then we all had to push. Then the car was run down the hill – then – at last it was off – Rose and Bryan Guinness – Ruth and Victor – the Herberts in a taxi all the way to Hammersmith thanks to my meddling alas.

Victor Gollancz in his memoirs, *Reminiscences of Affection* (1968), records that 'there was a hard core, a crowd of casuals, and an occasional star'. Louis MacNeice lived for a year or two at 4a Keats Grove and came to their Sunday evenings.

It was said that no Irishman who appeared at the Lynd house was ever turned away. The 'easiest touch in Fleet Street' was just as soft at home. The most famous Irish guest of all was James Joyce. He and Nora Barnacle finally decided to get married after living together for thirty-six years. The ceremony took place on 4 July 1931 at Kensington Registry Office (Nora taking the name 'Gretta Greene' in an attempt to avoid publicity) and they had their wedding lunch at the Lynds' house afterwards 'along with their strangely silent grown-up children'. The event was recalled by Máire Gaster in a piece for *Writers & Hampstead* (ed. Ian Norrie). The real celebration was held a few days later. Sigle and Máire, helped by Douglas Jay and Goronwy Rees, prepared the fairy-lights, with night-lights in the coloured glass jars along the flower-beds and Chinese lanterns hung in the weeping ash.

Sometime after midnight . . . we all went into the drawing-room . . . and then James Joyce went to the piano. . . . He sang 'Phil the Fluther's Ball' and I particularly remember the sad and beautiful 'Shule Aroon' –

Gollancz has left a description of Joyce's voice:

Against his own low accompaniment he recited, though that is not the word, 'Anna Livia Plurabelle'. He neither spoke it nor sang it: he used something like the *sprechstimme*, or pitch-controlled speech, familiar from *Moses and Aaron*, and other works by Schoenberg. And the sound of it was lovely beyond description.

The house was full of books for both were reviewers as well as writers and books became the life of the daughters. Sigle, after being sent down from Somerville for failing her Physics prelim, went to work with Gollancz and was active in promoting his Left Book Club, begun with Harold Laski and John Strachey

in 1937. She had become a member of the Communist Party in 1934 and was active in party work all over London. She joined the *Daily Worker* and worked as woman's editor and features editor until the 1956 Hungarian crisis. From 1957 until 1972 she was news editor of the *Architects' Journal*. Máire got a Third in Greats (there were Fourths at the time) and joined Heinemann as a publisher's reader in 1934, staying for over forty years.

Once, their great-aunt Maria arranged for the girls to be presented at court but it was against the family's republican principles. Yet it is certain that Sylvia would not have resisted too much if pressure had been kept up. Another time Robert was asked to write a tiny little book for Queen Mary's dolls' house. Máire always hoped that it was principle and not laziness that prevented his doing so. His bibulous friend Jack Squire had no such compunction and provided his own dwarf volume; *post hoc*, if not *propter hoc*, he became Sir John.

VIII

Lynd always said he hated the task of writing: he never used a pen or pencil without a sense of effort. His main weekly effort was his 'YY' essay for the *New Statesman* though each Saturday he provided a light piece for his own paper. The writing of the *NS* essay was ritualistic and remembered with some awe by his later editors and assistants.

It was written on a Wednesday, rather late for comfort but he had a specially privileged position. According to Kingsley Martin it was quite illegible. (Copies of early letters I have seen confirm this.) His left hand indentation grew with each line, making his copy look like an inverted right-angled triangle with the margin as hypotenuse. There was only one man at the printer's who could read it but, as Martin said in the 1966 broadcast, 'We wouldn't have dared to cut his delicate elaborate prose even if we could have read it, but we couldn't.'

Larry Morrow, of the family who contributed to *The Republic*, described the actual writing:

He always started to write on the dot of three o'clock. He'd usually have made up his mind the night before on the subject-matter, and one of my jobs was to get from the library newspaper-cuttings relating to whatever he was writing about, and usually a whole stack of dictionaries and encyclopaedias from which he would usually make ironical quotations. No telephone calls were to be put through to him nor would he allow interruptions of any kind, except when I brought him his four o'clock cup of weak tea. And at 5.15 almost precisely, the famous essay would be finished, and he and I would be off in a cab to the *New Statesman* offices in Great Queen Street where a messenger boy from the printer's would be waiting impatiently for the copy.

Morrow had become his assistant in 1924. He had been working in Dublin as literary editor of the *Freeman's Journal*, the paper founded in 1763 by Charles Lucas and Henry Brooke as the Patriot Party's organ, when it was taken over by the *Irish Independent* and Morrow found himself out of a job. He recalled in an unpublished letter, 'I was jobless, married and with Christmas only three days away.' Within twelve hours he received a telegram from Lynd asking him to come at once to be assistant literary editor with the *Daily News*. It was not until months later that he discovered that Lynd had had the job specially created for him as soon as he heard of the death of the *Freeman*.

In 1941 Kingsley Martin asked Lynd to do his piece fortnightly instead of weekly, alternating with James Bridie, the Scots dramatist. Bridie's first essay never appeared because of the threat of a libel action and Lynd resumed 'YY' for another four years until the essay was finally dropped. C. H. Rolph, Martin's biographer, described the end of the association with the words, 'Robert Lynd, who died four years later, was – and is – irreplaceable.' Martin always regretted his decision, especially because of 'YY's readers, who had frequently sent Lynd acid-drops or gifts of snuff-boxes to celebrate his comic failure to stop smoking.

Lynd took on a lot of work, probably too much for his own good. The recurring sicknesses, both real and imagined, were expensive in the years before the Welfare State. Symptoms of imaginary illnesses are just as debilitating as those of the real thing. Both Lynds complained of heart pains and more or less assumed that they had poor health. Sylvia was always regarded as 'delicate'. Lynd's lungs were not able to withstand the daily

dose of one hundred cigarettes, and the bottle of whiskey also had its effect.

Another strain on the pocket was Lynd's generosity. He had clients as his hero Dr Johnson had. He was known to leap from a bus to help one of his charges whom he had not seen for some time. Once, Norman Collins tried to relieve him of one of his hangers-on. 'There was one old fellow who came about once every three months because he said he had a dying mother in Dublin, and on every occasion Lynd used to give him a couple of pounds.' Collins was young, brash and efficient, and instead of giving the man the money bought him instead a third-class ticket to Dublin. Lynd was almost angry and very unhappy for the poor man: 'Still, if he goes back to the agency and explains the circumstances they'll give him the cash. You see it's the cash he really wants.'

Another time, on a bitterly cold night as Lynd and Collins left Bouverie Street, he stopped to talk to the newspaper-seller on the corner. (Lynd was noted for buying papers at corners even though all the papers were delivered to his office each day.) He kept turning round, saying he would not be long, and at the end a pound note changed hands, a considerable sum then. 'He's a very old friend of mine and he's having a lot of trouble with his wife at the moment.'

The money for these hand-outs and the daily bets was carried in the Savile Row suit (which Sylvia teased him into buying) worn abominably. In his deloodering way he preached fiscal wisdom – a wisdom he obviously lacked himself – to his juniors. (He never quite lost his Belfast accent and like the rest of his countrymen had no great Jamesian sense of distinction between 'should' and 'would' and pronounced the 'h' in 'where' and 'why'.) Lionel Hale, who joined him as assistant in 1934, used to receive advice about the disposition of money.

He claimed great regularity about money. One had the happy job of being a kind of personal squire to him because really there were times when he wasn't fit to be out alone. He was perfectly liable . . . to put his shoes on the wrong feet if Sylvia hadn't been there – he'd be thinking about Milton or Charles Lamb or somebody.

But money, he claimed great regularity about that too because one used to be sent down to cash a cheque for ten pounds from the *News Chronicle* cashier, and you'd bring back these ten notes and he would immediately start putting a note into every pocket – and what pockets they were! They were full of unanswered letters and correspondence and tips on the Derby and every conceivable thing that a man of letters would carry about – he was certainly a man of letters, his pockets were full of them.

He found ten pockets and put a pound note in each, and when I said that was a chancy way of going on, he was as severe as he had ever been with me. He said, 'My dear boy, you don't seem to have any sense of prudence. . . . If anyone picked my pocket, think – there are a lot of pick-pockets about, it's a wicked world, you know! If they picked this pocket, say, well all they would get is one quid, whereas you, now, doubtless take £10 and put it all in one pocket – eh, then they pick your pocket and you've lost it all. I really do think that even a literary man like yourself ought to be more practical and more business-like.'

Collins remembers going to the tailor's to collect one of these suits:

It looked absolutely perfect, and the heartbreak on the face of the tailor when he saw that Lynd wanted to transfer everything he was carrying in his old suit including Ruff's *Guide to the Turf*. As a result he came out in a brand new suit looking as though it was a very, very old one.

Larry Morrow described him as having a strikingly noble head with a touch of Dante and a touch of the noble redskin.

Right to the end he kept a corkscrew curl hanging over his forehead that should have been and indeed was a gift to any caricaturist [for instance, his friend David Low]. . . . At least an hour of the working day was spent in the study of racing form and deciding what horses to back. The *Daily News* once bought him a greyhound which he ran for a couple of seasons at the White City but which was never even placed in a race.

On the centenary of Lynd's birth the Irish journalist Patrick Scott wrote an appreciation in *The Irish Times* which contains a recollection of Lynd's practical, witty kindness. He had landed in London in 1933 to try to crash the literary scene, just as Lynd had thirty years before. He went to see him with a letter of introduction and was greeted with a diagnosis of utter depression and the Ulster quip, 'Were you ever in Larne on a wet day?' A meal and sound advice to go home followed:

Go home to Belfast. Life is too tough here for an inexperienced Irishman. Get on a local paper, read all you can get your hands on about the history, economics and language of your country. Contact me in four years and with the experience gained in the meantime Fleet Street could benefit from your efforts. . . . Willie Conor [Lynd's Belfast artist friend who painted the portrait which used to hang in the Linenhall Library] will advise you. Beannacht Dé leat.

Scott took the advice and made a career for himself in Irish journalism and television; he did not meet Lynd again until Queen's conferred the honorary degree in 1946.

IX

When the Second World War broke out Robert was sixty and Sylvia fifty-one. They had been convinced that the Munich Agreement was meaningless. As Patrick Campbell wrote home, 'Only the Lynds believe there will be war.' Part of the war was spent in the village of Forest Green near Dorking in Surrey. Robert travelled twice a week from Oakley Station to the City. His local at Forest Green was The Parrot and one night sometime in 1944, walking home in the black-out from his usual evening drink, he was knocked down by a motor-cycle. (During the war headlights were covered except for a small cross of light.) He had several ribs broken and describes his pre-NHS convalescence in Mount Alvernia Nursing Home in the essay 'In and Out of Bed' (1945). It was run by Franciscan nuns and he was reluctant to tell the sister what religion he was, temporizing with, 'My father was a Presbyterian.' He could not say plain 'Presbyterian'; besides he admitted to having knelt to the Pope and kissed his ring.

Despite the humour and light note of the essay the detail of the fourteen pillows and the 'donkey' under his knees indicates his difficulty in breathing and a growing deterioration in health.

After this, active literary life gradually ceased. He stopped writing 'YY' in 1945 and became part-time at the *News Chronicle*. When he finally retired on 20 April 1949 he had

become even more silent and withdrawn. He had been presented with one of the new television sets, and he and his grandchildren, Tim and Nancy Wheeler, Lucy, Polly and Nicky Gaster, appreciated together the finer points of 'Muffin the Mule'. Towards the end Sylvia wrote some of his copy.

That autumn Sylvia was being nursed for another flare-up of her condition and when Robert took ill he had the nurse's services too. His GP, appropriately called Dr Johnson, used to come two or three times a week and hold his hand as he grew weaker. He died on 6 October 1949. He had always had a fear of premature burial nourished by close reading of Robert Louis Stevenson's *The Master of Ballantrae*. Sylvia remembered this and keeping an old promise had a vein opened to make quite sure he was dead. At his own request he was buried in Belfast.

The funeral at Belfast City Cemetery was attended by a remarkable array of dignitaries: Sam Porter, once Robert's schoolfriend and then Lord Chief Justice; his successor Robbie Lowry, Robert's nephew; Seán MacBride, the son of Maud Gonne, then Minister for External Affairs in the Coalition government and on his first visit to Belfast; Conor Cruise O'Brien, his assistant, then at the Department of External Affairs and husband of Lynd's only niece, Christine Foster; Col. J. O'Sullivan representing the President, Seán T. Ó Ceallaigh; Inst was represented by the principal, registrar, head boy and prefects.

Later at a memorial held in St Dunstan's in the West, 'the writers' church', J. B. Priestley made a moving and amusing speech. John Dulanty, who was Irish ambassador and had regularly sung Percy French songs at 5 Keats Grove, had sent the embassy car to take Máire and her husband Jack to Euston. On the morning of 10 October there was a service in May Street Churchyard, in a sense the Lynd family church, conducted by the Rev. Wylie Blue (a figure with a much more public and charismatic persona than its turn-of-the-century incumbent).

In November 1951 Alex Foster secured from the General Purposes Committee of the Belfast Corporation a commitment to erect a memorial plaque to Lynd on the wall of his birth-

place in Brookhill Avenue, but as late as 1965 he was still trying to interest bodies including Queen's and CEMA (predecessor of Northern Ireland's Arts Council) in the project, with no success. There is a fine head in the Queen's Library sculpted by Lady Kennet, the widow of Scott of the Antarctic. Lynd's best memorial, however, is to be found in his works.

X

Lynd wrote in all thirty books (a list of them is given below). He was also a generous writer of introductions to other people's work, including Peadar O'Donnell's *Islanders* (1927), Nora Connolly O'Brien's life of her father, *James Connolly: Portrait of a Rebel Father* (1935), Robert Greacen's anthology, *Northern Harvest* (1944) and Mary Webb's novel, *Precious Bane* (1924). Choosing a representative selection from such a store has been unusually difficult. Most people who are aware of Robert Lynd think of him as an Elian essayist, and indeed about two dozen of his books consist of collections of the 'YY' pieces which made him famous. Yet he was a sensitive critic, finding in literature pleasure, wisdom and spirituality, and a frame in which to compose the unruliness of life. The ordinary man was his study and this ordinary man, who Lynd along with G. K. C. would insist was an extraordinary man, found nothing alien or exclusive about the work. The section called 'The Witness' contains those essays which show this extra-ordinariness of life and his joy in birds, flowers, children, sand-hills and tobacco.

The essays in 'Writers and Their Trade' are taken mainly from the collections of reviews and essays written for the *Daily News/News Chronicle* and for *John O'London's Weekly*. The order is chronological by subject rather than composition.

Lynd's Irish dimension is embodied in 'Ireland and Her Authors'. Though he lived for fifty years out of his native country, he returned again and again as he grew older to consider it and his early life, as if seeing them clearly for the first time. He once wrote an essay with the cheering title 'The

Importance of Leaving Things Out' (1931). I have had to leave
much out, not only from the work but from many tributes paid
by those who loved the quiet Irishman, from Max Beerbohm's
'love at first sight', to A. G. Gardiner's 'eloquent listener'. Per-
haps the final word should come from Alex Foster, writing for
the Inst *School News*:

One's last memory is of Robert in his own hospitable house, surrounded with
shelves crammed with books. He was a great smoker and his long body would
be half-hidden in wreaths of tobacco smoke. He would be talking of Ireland or
football or Shelley or Eugene Stratton. Perhaps he would be smoking in
silence. But whether he spoke or was silent, one could not but feel that here
was a very rare and delicate spirit, indeed a really great man.

THE PUBLISHED WORKS OF ROBERT LYND

Irish and English, 1908; *Home Life in Ireland*, 1909; *Rambles in Ireland*, 1912; *The Book of This and That*, 1915; *If the Germans Conquered England*, 1917; *Old and New Masters*, 1919; *Ireland a Nation*, 1919; *The Art of Letters*, 1920; *The Passion of Labour*, 1920; *The Pleasures of Ignorance*, 1921; *Solomon in All His Glory*, 1922; *The Sporting Life and Other Trifles*, 1922; *Books and Authors*, 1922; *The Blue Lion*, 1923; *The Peal of Bells*, 1924; *The Money Box*, 1925; *The Orange Tree*, 1926; *The Little Angel*, 1926; *Dr Johnson and Company*, 1927; *The Goldfish*, 1927; *The Green Man*, 1928; *It's a Fine World*, 1930; *Rain, Rain, Go to Spain*, 1931; *Both Sides of the Road*, 1934; *I Tremble to Think*, 1936; *The Cockleshell*, 1937; *In Defence of Pink*, 1937; *Searchlights and Nightingales*, 1939; *Life's Little Oddities*, 1941; *Things One Hears*, 1945.

Posthumous volumes: *Essays on Life and Literature*, Introduction by Desmond MacCarthy (selected with Sylvia Lynd), 1951; *Books and Writers*, Introduction by Richard Church, 1952.

ACKNOWLEDGMENTS

The editor would like to express grateful thanks to Eddie MacIlwaine of *The Belfast Telegraph* and Kevin Myers of *The Irish Times* and to the many kind people who responded to requests for information, especially Diarmaid Mac Dáibhéid, Mr and Mrs McRitchie, Ruairí Ó Bléine and Trevor West; to Robert Greacen; to Hilda McDowell; to Róisín Duffy and Pat Loughrey of BBC (N.I.); to John Boyd; to Christine Hetherington, Robert Lynd's niece, and Peter Wheeler, his son-in-law; to my colleague, Jo O'Donoghue; to my publisher, Antony Farrell; to my copy-editor, Angela Rohan; to John Killen of the Linenhall Library for advice and assistance in tracing texts; and primarily to Robert Lynd's daughter, Máire Gaster, for exemplary help and guidance.

The excerpts from the radio programme 'Portrait of Robert Lynd' are printed by permission of the BBC.

The assistance of the Arts Council of Northern Ireland in the publication of this book is gratefully acknowledged.

PART ONE
IRELAND AND HER AUTHORS

1

THE ORANGE IDEALIST

THERE WAS ONCE A WOMAN – I knew her well, for she helped to nurse me – who believed in her heart that God was an Orangeman. She also believed that a strong family likeness existed between Satan and the Pope of Rome. She was a mild woman, thin and worn about the cheeks, and inestimably patient under a child's buffetings. She had the gentlest of eyes behind her black-rimmed spectacles. Her face was saintlily sad under a bonnet rich in a widow's bugles. Yet, much as she looked the part, she was no self-torturing ascetic. She had a dear regard for snuff, a little nasty-smelling parcel of which always lay on the nursery chimney-piece. She indulged, too, in the luxury of ideals. She dreamed from morning till night of an Ireland out of which all the Catholics had been driven, and in which Protestants would be able to live without the fear that at any hour evil-eyed people might sweep down upon them and cut their throats. So far as I could gather, Catholics – or Papishes, as she preferred to call them – had no definite object in life but to cut the throats of Protestants. Being a Protestant, I naturally went about the streets in a state of considerable trepidation. Every one whom I met and who had at all a doubtful cast of face, I put down at once as a Papist and hurried past, with a horrified, dry feeling at the back of my mouth. One day, at a time when the town was in a flutter of riotous excitement, I was going to school with my sister, when we found ourselves in the middle of a great crowd, shouting and rushing hither and thither. I had no doubt in the world that the campaign of throat-cutting had begun. 'The Papishes have risen!' I cried to

my sister, and, hoping that she would follow me, made helter-skelter for home. My sister, being of a less bigoted and fearful turn of mind, went on to school; and she was right, for the crowd was only running to a fire. She was less intimately instructed than I, however, in the wicked designs of the Catholics, for my nurse had no mind to waste the stores of her wisdom on a mere girl.

There is a book which has afforded entertainment to many broad-minded grown-up people. The name of it is 'Forty Coming Wonders', and the author a Mr Baxter, who does not like Catholics or socialists, and who has a habit of prophesying the date of the end of the world. This book my nurse reverenced next to the Bible. There were pictures in it representing lions or tigers or some such beasts, each of them provided with seven or more heads. She spent hour after hour gazing at these and puzzling out to herself the points of resemblance between the many-headed beasts and the Church of Rome. She loved, too, to sit in a rocking-chair beside the fire, with its tall wire screen, and read out the most horrible details of the massacres of St Bartholomew's Day.[1] Every tale, of course, found its local habitation in my mind, and the world became to me a place which only a kind Protestant English government prevented from becoming a shambles. This gentle woman was herself full of butcherous thoughts enough. She loved no song so well as 'The Protestant Boys', and the version she sang of it – a version very common in the North of Ireland – portended a sufficiently drastic doom for the Catholics. Her thin face lit up with a sort of delight as, with her arms wrapped round me, she shrilled out the chorus. It ran like this:

> Slitter, slaughter,
> Holy Water!
> Sprinkle the Papishes every one!
> And that's what we'll do,
> And we'll cut them in two,
> And the Protestant Boys'll carry the drum!

I was trained up in this song, an infant Hannibal,[2] pledged to eternal enmity towards Rome. Every opportunity was taken to strengthen me in this vehement faith. Our favourite recreation soon came to be a walk down Sandy Row,[3] a territory, as I recall it, of low-built, white-walled Orange dwellings, where my nurse had many friends. She took us to a house in the neighbourhood with a regularity we loved, and set us down in front of the fire with cakes of potato bread in our hands. Over the fireplace, a coloured delph image of William the Third stood – a necessary idol in every true Orange household. I learned to worship that image, as I am afraid I did not worship God. I looked reverently upon King William, sitting there on his delph horse with the air of a man leading an army to victory, as an heroic person who had somehow or other saved my family and myself from being foully murdered.

Every year in the North of Ireland a day is set apart for the worship of King William. On the Twelfth of July, the Orangemen remember how years and years ago Protestant William chased Papist James from the banks of the Boyne, and can scarcely contain themselves with delight in consequence. As the great day approaches, the town becomes dazed at night with the thud of drums here, drums there, drums everywhere. Over the Orange streets broad arches are hung, rich in tags of orange and blue paper and in garlands of orange lilies, and containing pictures of King William and instructive scenes from Irish history. Mottoes are set in them, eloquent about 'civil and religious liberty', and calling upon true Protestants to remember sundry things for which 'our fathers fought and died'. My nurse was not a person to allow me to forget. On the eve of 'the Twelfth', as it is called, she led me into the noisy country of the arches, and, taking me into a dark little shop, bought me a paper orange sash for a penny. In some years, when money was abundant, she provided me with a shilling drum as well: she never let a year pass without seeing that I had, at least, a tin whistle. She was an infectious propagandist. She was, for the time being, a saint admitted to the splendours of Paradise, or – a better simile – a war-horse smelling the battle not too far

off. As for me, she led me into every extravagance of enthusiasm. She had often taken me by the hand and pointed out the huge drums in the Orange procession, showing me with a thrill of pride in her voice the drumheads bespattered with blood from the wrists of the maddened drummers. Every drummer, as he flogs his instrument in a kind of Bacchanalian frenzy, feels himself in duty bound to gash and cut his wrists on the wooden rim, and if the drumhead be not red with blood by the end of the day, he looks askance at himself as one who has not offered due sacrifice to King William's pious, glorious, and immortal memory. Naturally, it was the earliest ambition of my childhood to be an Orange drummer. I could achieve no bloody feats, however, on my fragile shilling instrument. Consequently, I had to go elsewhere to obtain the required training for my future profession. I found a hard enough substance in the kitchen table. Night after night, I stood before it, hammering my tiny wrists upon its square corners, until the skin was red and bruised and aching, and uplifting what lusty voice I had in a rapturous singing of 'The Protestant Boys', or 'The Boyne Water'. I do not know if I ever actually succeeded in making the blood flow. I hurt myself sufficiently, however, to feel mighty proud and Protestant for several days afterwards.

The Twelfth of July I loved more than Christmas Day. On the Twelfth thousands and tens of thousands – nay, hundreds of thousands – of Orangemen marched forth, with banners rioting in the wind and drums roaring. Every man in the gaudy and haphazard army wore a tasselled sash, curiously coloured, about his shoulders. Here and there a fellow carried a wooden Bible on a wooden pole. Others walked along the sides of the procession with a sort of spear in their hands, and woe to any man who tried to cross from one side of the road to the other until the procession had gone completely by. At a few yards' distance from each other, fife band and brass band flung different tunes into the air, horrible as the warring of creeds. Cromwell and King William, in all sorts of odd shapes and attitudes and colours, looked down from countless banners, and other flags showed Queen Victoria presenting a Bible to a

humble heathen king, with 'The Secret of England's Greatness' as a motto at the foot of the picture. Flute-players, drunk with their own music, walked backwards in an odd kind of dancing step before the drums, grotesque Orpheuses in their Sabbath clothes. Everywhere was loud din and colour – the din and dust and colour of war, and the curiously angry brows of men with haunted imaginations. Beautiful in my strip of orange paper, terrible with my shilling drum, a dangerous flute peeping from my pockets, I was led out by the hand to watch the passing of these mighty Joseph's-coated warriors. If I had not yet ridden the goat, as they say of those who have been initiated into the Orange order, I was an Orangeman at least in my beating pulses and along my quivering spine. When the carnival had gone by, I was trotted back to the nursery, and coached in the story of a few more massacres. I learned how the Orangemen had beaten the Catholics into the waters of the Lough, and I praised them for it. I heard of innocent girls shot, and of little boys cut down in open daylight as they were running messages for their parents. The police I was taught to distrust as men who were Fenians at heart, and I admired an Orange assault upon a police-barracks more than the storming of Sebastopol.[4] Like nearly all Protestant children brought up in an Ulster town, I came to look on Catholics as a kind of wild beasts to be avoided, if not exterminated. There was a very mild old Catholic gentleman, who lived two doors away from our house. I often burst into tears when he stopped and spoke to me in the street.

HIBERNIA REDIVIVA

SOME TIME AGO I went to Toome, a crossroads village sitting on the edge of Lough Neagh, where the Bann slides into it, old and silver and silent. When I arrived, the Feis of the Country of Owen[1] was in progress. Every part of Ireland almost has its Feis in these days, and hither come the men and women from the hills and river-banks, some striving to catch the last strains of the swan-song of an Ireland that is in the act of death, and others intent upon hearing the more cheerful and lark-like music of a new and beautiful Ireland that is in the act of being born. One meets here antiquaries, hoary and hobbling, and loving the native language only for the flavour of its roots. Mixed with them lurch young men, their hands in their pockets and caps set well back on their skulls, who speak Irish because it is sweet and homely on their lips, and full of variety as an Irish day.

As one approached Toome, squeezed in a narrow wooden box made to look like a railway-carriage, one could never have guessed at the great doings that were afoot. One by one, crooked men had stumbled into the carriage, bearing crooked sticks and with crooked rags of beard drooping from their chins. There was a certain grand wild air about them, with their irresponsible, soiled tailcoats and their hats of bygone shapes and ages. One realized that they would be great men in a fight, but one felt that straitened means and a potato diet had stolen away from them the dreams for which alone a man goes out and fights gloriously. A huge fellow, leaning on a stick that stood sheer between his knees, droned out in a monotone – the monotone

that always comes from living too long with the silence of open nature – a tale of an uneven battle between some friends of his and the police. Inquisitive and strange-eyed like children, the others bent forward to catch the story. One of them, a red pumpkin of a man, whose goods lay on the rack above him tied in a red spotted handkerchief, chuckled delightedly as each point was reached in the story's progress. A young man beside me, hatted like a student from Paris and with memories in his eyes, drew out a pipe and a box of matches. 'I see', said a neighbour, smiling and tapping him on the knee, 'that you don't use Irish matches.' The young man smiled back as he puffed a flame into his pipe. 'No,' he said, 'I follow Swift's advice, who told the Irish to burn everything English except the coals'; and he showed an English name on the back of the matchbox. The crooked men with the crooked sticks threw a perplexed glance at the young man, as though attempting to get at the heart of the new argument. Gathered in their lips were smutty clay pipes, mutilated as to the shank, and clouds of glory mounted in a sudden path of sunlight above their marvelling heads.

Toome was overspread with clouds of a different sort when I arrived there. Soft and pervasive, a greyness moved between the green fields and the sun, and the roads lay deep in a garnish of mud. One became aware of a shouting in the village, a hoarse and voluble shouting, and one wondered if, after all, this could be the voice of new Ireland. As one drew nearer the crossroads, however, one recognized that it was the clamour of the old world, mumping for pennies at the heels of the new, and shrieking the grand quality of its dulse and its monstrous yellow man,[2] its roped football and its rifle range, its cheap cakes and its fairings. In the middle of the road, a girl whose loose tangles of hair showed under her shawl of applegreen, stood in huge boots, and ground 'Down at the Old Bull and Bush' out of a piano organ. She seemed beautiful, and had brown and simple eyes. She was an Italian in a striped skirt, and she spoke English with a grave Belfast accent. Some feet away, a couple of old ballad-singers, beshawled and snuff-stained, shook their grey hairs and their withered cheeks, as

they piped a barbarous tune. One of them had a blackened eye; the other a hand claw-like in its desire of gain; and as they stood there, empty husks of life that may once have been sweet and beautiful, one moved away gladly to the new Ireland, aflutter with its green badges, gay in the return of its speech, and loud with songs that came out of the rivers and the light before civilization had made men barbarous. A handful of pipers swept down the road, mighty proud of themselves and the tunes they were playing. Out of a field came a troop of boys, glowing and sweating and dangerous with their hurling sticks. Close by, a number of wooden platforms rose from the grass, and a tumult of farmers and gentlefolk, of pleasant-faced enthusiastic girls, and students, and labourers, and clergymen, stood around on the soaked earth and clapped their hands as a song was well sung or the steps of a dance neatly executed. For here was a Hellenic festival; contests of music, of sport, of what not. Child vied with child in lilting an old country tune into the wind. A tall, thin boy, with medals on his chest, who had travelled many miles from the sea, showed that he could whistle an Irish air better than all his inland-bred rivals. In dancing, too, he excelled, as another excelled in singing, or in story-telling, or in playing the fiddle. A red priest in a Trilby hat announced the names of the prize-winners from the stage to the wet-footed and happy crowd. In the last competition of the day, a company of shy boys and pert mites of girls came up so that it might be seen which of them was dressed in the most winning and simple way. A long shed covered an exhibition of local industries. Here a strange old woman, her face palsied beyond all power of laughing, walked up and down before some dusty hand-looms, moaning over the days when weaving was an art and cloth was made that could last a lifetime.

In the evening, we all went over the river and down a side-path to the Temple of Liberty.[3] The Temple of Liberty is a ruin, a mortar-faced affair set in a field among trees. Once a man lived in this part of the country who believed that all men should have liberty to express their opinions without being knocked on the head for it. Consequently he bequeathed to his

countrymen this now shattered building, whose title in full is the Temple of Liberty, Learning, and Select Amusement. Over the entrance are many curious busts, Grattan's[4] and Cobden's[5] and Kosciusko's.[6] On one side is the ill-modelled image of a dog, all body and no legs, labelled 'Watchfulness'. On the other side a lamb, with tin ears sprouting from its head (one of them a lop ear), looks innocently down over the word 'Harmlessness'. Inside, through the holes of the roof, swallows come and beat perplexedly against the windows. Old and highly coloured frescoes, misrepresenting all the known gods and goddesses from Aphrodite to Robert Burns, are falling in flakes from the panels of the damp walls. Comically housed like this, the people from the hills and the river banks sat with alert ears and eyes and hands, and listened to merry tunes or to the laments for the old heroes, laments that are songs less of despair than of battle and triumph. Here and there, a fine bit of singing was greeted with a Gaelic shout. On the next evening, a company of young players from Belfast came down to the Temple, and won an even more lavish greeting for the drama that is now growing, like a fruit exposed to the sun, all over Ireland.

Back in the hotel, a piano was beaten with power. Crowds moved with a great confusion of tongues in the hall, and called helplessly for sleeping-room. In one parlour, three young men solemnly and mournfully sang 'Who Fears to Speak of Ninety-Eight?' from a single ballad-sheet. Elsewhere a silver-toned boy was busy upon a song in which an anti-Irish Marquis of Waterford was pictured 'cleaning up the devil's delph' in a region better suited to him than Ireland. Late into the night, everybody sang and laughed and prophesied with delight about the Ireland that was going to be. Gradually the silence came. Those who had glasses before them drained them in a last toast. On sofas, on chairs, on floors, men looked around for a place where they might pass the night. One brave youth stood in the hall and slept. He was still standing, sleeping on his feet, when the earliest of us came down for breakfast the next morning.

3

GALWAY OF THE RACES

GALWAY IS A GREY CITY set among abounding waters. It gives the impression, at any rate, of a stony permanence that refuses to be destroyed though the tides of sea and river swirl about it and, as you cross the outer bridge, seem to be rushing through its foundations and gushing out of its walls. Historians of the old-fashioned sort tell you that Galway is not an Irish city. It is true enough that it first appears in the records after the Normans had come to it with their energetic genius for towns and systems. But nothing remains of the Normans now save dust and stones. It was in vain that they wrote up on the western gate of this medieval fortress of theirs the fantastic prayer: 'From the fury of the O'Flaherties, good Lord, deliver us.' The O'Flaherties, or what the O'Flaherties stand for, are its supreme distinction now.

I do not mean that the Irish have made Galway a positive expression of their genius, an imaginative and symbolic city. Fortune has seen to it that that was impossible. But I do mean to say that amid the solid ruins of this city, amid this scene of abandoned greatness, the Irish have found their most interesting encampment on a large scale. Galway is Irish in a sense in which Dublin and Belfast and Cork and Derry are not Irish but cosmopolitan. Its people, their speech, their dress, their swarthy complexions, their black hair, their eyes like blue flames, excite the imagination with curious surmises. Galway city – technically, it is only Galway town – is to the discoverer of Ireland something like what Chapman's *Homer* was to Keats.[1] It is a clue, a provocation, an enticement.

Not that it has preserved itself inviolate from respectability and shoddy and the invasions of twentieth-century commonplaceness. There are plenty of dull shops in it, besides the older houses with the towering grey walls, severe in their ruins. The main street through which the creeping tram winds is, in spite of an occasional piece of surviving majesty, unimpressive enough. And I am sure that besides dull shops and dull streets Galway has its share of dull people. One hears a good deal of the petty social snobbishness that divides the genteeler part of the inhabitants into rival clubs in which, as a local man put it to me, 'twopence looks down on three-halfpence', after the manner of the civilized.

Many travellers, I am afraid, are disappointed in Galway when they arrive and find it so full of houses one might see anywhere and people one might see anywhere. It does not meet one with the open-bosomed generosity that one had learned to expect from descriptions of it as an historic Spanish city with streets of courtly marble houses. It is a 'wild, fierce, and most original town', said Thackeray;[2] but, when you visit it, you find that it is wild, fierce, and original only in pieces, and those not the most immediately obvious pieces, and you have at first a feeling of disenchantment. You look round you again, eager to see those wonderful-looking people of whom Mr and Mrs S. C. Hall[3] wrote: 'The dark features and coal-black hair of the people indicate their Spanish descent; and they are, for the most part, so finely formed, so naturally graceful, that almost every peasant girl might serve as a model for a sculptor.' Ah, well; you turn your eyes to the wrinkled old woman who sits huddled in her shawl on the pavement by her basket of dulse and halfpenny oranges, and you see that she has very little hair of any sort at all, and that her figure is as graceful as the gnarled body of a tree. And the next woman you meet is a barefoot pedlar who tries to sell you cockles or, in default of that, to joke a beggar's penny out of you, and you notice that the skin of her face is inflamed, that she breathes spirits, and that her teeth are yellow. The next moment, a young woman passes you, and she is so respectable that her clothes seem like

a uniform: if she has coal-black hair, there is no beauty in it, for she has made herself as lifeless, as empty of glow, as a wooden figure. And so, though pretty women are numerous here above most towns, you go from depth to deeper depth of disappointment. Such is the penalty of living in an age of realism. If one woman in a thousand is beautiful, if one street in a city channels some tide of loveliness and colour, philosophers learn to be grateful and to say that the world is good.

When last I arrived in Galway it was the day after a bank holiday and the day before the races. Our reception at the railway station was certainly such as was likely to give strangers the impression that they had arrived at a 'wild, fierce, and most original town'. It was one of those scenes of indiscipline which are common in a country where the people are not allowed to make law and order for themselves, and therefore seem to look on law and order as a foreign and superfluous thing. We got out of the train into a crowd where men were pushing hither and thither with the turmoil of cattle in a panic. To attempt to reach the luggage where it had been pitched on to the platform was like thrusting one's way into a football scrimmage. Tall wild men – self-constituted porters – battled over to it with sticks, and English visitors shoved towards it with damnings and indignant faces. One of the tallest and wildest of men managed to tug our luggage out of the middle of the fight, and, calling up an ally to take one of the bags, he set off ahead of us for the hotel where we intended to put up.

At the door of the hotel stood a stout man in a cap, a sociable-looking man with a grey moustache, and obviously the landlord.

'Go mbeannuighidh Dia dhuit,' said I, as he nodded to us; 'teastuigheann seomra uainn.'

'Eh?' he said, bending his head forward and looking uncomfortable; 'Eh?'

'Teastuigheann seomra uainn,' I repeated: 'Nach bhfuil Gaedhilg agat?'

His eyes shifted nervously, as though he would have liked to escape.

'I don't know much Irish,' he muttered in an absent-minded way; and, looking down the hall, called: 'Mary! The fact is,' he went on, 'I'm not sure – I never like to turn away a Gaelic Leaguer – it's the week of the races, do you see, and we have to charge extra for the rooms. Mary!' again; then to the men who were carrying our bags: 'Put those down a minute. We'll see what can be done, Mr–' He raised his voice inquisitively to learn my name. I told him; then he went off to see what could be done. In a minute or two he came back and told us that if we were willing to pay something extra – I forget how much – we might send our bags upstairs.

The hotel had not yet become a house of confusion. It was filling rapidly, however, mostly with muscular young men in caps, who went upstairs into the dusty air of the dining-room and waited patiently, reading dusty old numbers of illustrated papers, till one of the girls in the house would bring in an overloaded tray of ham and eggs and fresh bread and jam and tea. Our luggage was taken up to one of a row of box-bedrooms arranged along a passage – boxes divided from each other by thin wooden partitions, and with doors that would only keep shut if you put a chair or a bag up against them. The bed was in need of clean sheets. The room gave the impression that a minimum of labour and of thought had been wasted upon its bareness. Probably it would not be in use, except during the time of the races, from one year's end to the other. From the festal untidiness of bedroom and eating-room we soon escaped into the dusty streets – the dustiest in Ireland – with their sprinkling of hands-in-pocket expectant idlers. . . .

St Nicholas's Church seemed the best place of refuge from the immediate century. Grey and stumpy, and aspiring to no beauty save that of age, crowned with a belfry capriciously set there like the final ornament on a child's house of bricks, it looked like a little Tibet of challenge to the explorer approaching its ring of rubble wall. From inside the church came the sound of a harmonium. Not a sacred or even a sentimental sound, but the sound of a harmonium being used as a toy, or at least as a puzzle. Two little girls in wide-brimmed hats moved a yard or

two away from the instrument self-consciously when we entered, and a small lively man, wrinkled and merry-eyed like a sailor, ceased lifting mats and dusting pews and came over to us. Like other people, I often resent the insistent friendliness of sextons. But in St Nicholas's the sexton is a boon. Without him one would miss a good many of the significances of the place. Not that there is not a great deal of public and accessible history in the stones of the building. In so far as it is the mortuary of the Tribes, for instance, he who runs may read. Everybody knows how, soon after Galway was walled in about 1270, it was settled in by a number of exclusive families and came to be called after them the City of the Tribes. The names of the tribes, Norman and Welsh and Saxon in origin for the most part, are immortalized in the unmusical and unimaginative rhyme:

Athy, Blake, Bodkin, Browne, Deane, Darcy, Lynch,
Joyce, Kirwan, Martin, Morris, Sherrett, French.

Here in this bare old church is a house of monuments to these long since Irishized families. Them you can see for yourself, even without the presence of the sexton, with his running commentary of 'the antiquaries say'. But, rich as they are, these are not the secret treasures of the church.

Of all the tombs which the sexton points out to the stranger, the most interesting to me are the flagged graves let into the floor, where the dead businessmen of a more bustling Galway are buried with the emblems of their trade or of the Resurrection – scissors and boots and crowing cocks – carved on the stones. For most of these you have to look under the mats where, on Sundays, the feet of the infrequent worshippers tread. Look at them closely, for they are one of the vindications of Ireland. Politicians try to persuade us that Belfast is the only part of Ireland where industry and commerce are natural. This is, of course, not true, as the visitor to historic Galway will soon discover. The enterprise, the spring-time vigour, of Belfast are splendid. But we must remember that Belfast and the neighbouring part of Ulster are the only places in Ireland where enterprise and spring-time vigour were not suppressed

by law. If Belfast linen had been put under the same penalties as Galway wool, we should have had no populous thriving Belfast to praise today. There is an idea abroad among those who do not know Irish history, that the Gaelic Irishman is born without the virtues which enable a man to labour and to pay his bills. So persistent has been the defamation of Ireland, indeed, that even since Mrs Green[4] has given us the facts, in her great study of the medieval civilization of Ireland, *The Making of Ireland and its Undoing*, people go on writing as though Ireland had never produced a race of craftsmen and merchants of her own, but had been a mere precinct of religion and cattle-thieving except for the industrious invaders who settled behind the walls of her towns and created beautiful and useful things, to make the name of the country known in every port of Europe. . . . Well, the industry of the invaders was soon suppressed, from London, too. But Mrs Green has proved very clearly that the old Irishman and the new Irishman fell in an equal ruin in Galway and the other towns when the great imperial laws against work were put into operation.

The one world-famous man whose bones lie in the Church of St Nicholas was not an old Irishman, but a new Irishman, and his memory lives not because he was a great trader but because he slew his son. This was Mayor James Lynch Fitzstephen, a commercial prince of the fifteenth century, by whose labours trade and hospitality were greatly increased between Galway and Spain. He would probably have lived unknown to history if he himself had not made the voyage to Spain and brought back with him a young Spanish gentleman, the son of one of his hosts, on a visit to Ireland. Lynch had a son of his own, impulsive and riotous. Between the latter and the Spaniard a jealous quarrel broke out about some woman, and it ended with young Lynch giving a stab to his rival, so that he died. He at once surrendered to justice, and his father was the magistrate who tried him and sentenced him to death, in spite of the prayers of the townspeople, who seem to have liked the young man well. Nor was this the whole of the elder's iron righteousness; for, when no one could be found in Galway

to carry out the sentence, Lynch hanged the boy with his own hand.[5]

On the wall which encloses the churchyard, a stone marks the spot where this ancient piece of justice was done. It is aptly carved with a death's-head and crossbones, and under these the motto: 'Remember Deathe, Vaniti of Vaniti. And Al Is But Vaniti.'

If you let the sexton take you up to the bell-tower and show you Galway and its streets from that height, you will as likely as not get the impression that you are looking out upon a city where the very houses are death's-heads. Skulls of lofty mansions, the windowlessness of which gives an appearance as of empty eye sockets, line the streets in graveyard ruin. Other buildings lie in stony masses, like bones heaped and mixed together in an old tomb. No one who has not seen Galway from a height like this can realize to the full what an air the place has of a town awaiting a blessed resurrection. Little of the grand life has been left here. Emptiness sits in the places of abundance. Tall and smokeless chimneys rise everywhere, giving the town at noonday the appearance that other cities have at dawn. So hollow of joy and vigour does this grey town look from the tower of St Nicholas that it has been likened fitly enough to a scooped-out egg-shell. Flour-mills, factories – how many were there even thirty years ago that are now silent behind cobwebs and broken windows! The old sexton gave us figures, and they stay in my memory – for unhappily I have not the genius for note-taking – as a ratio of about twenty to three. As he told us of the decline of the population of the town, Catholic and Protestant alike, a funeral procession moved across the bridge by the jail, with mourners riding after it on slow horses under the branches of the trees.

When we came down from the tower, we went round some of the ruined streets, past many a modern house with an old stone bearing some tribal coat of arms let into the wall over the door, and climbed the steps of an ancient broken castle, in which a man and a small boy were busy among cases of type, setting up the pages of a weekly newspaper. But, as I have said

before, I do not want to give any one the impression that
Galway is all dead. There are tobacconists' shops and grocers
and drapers and public-houses, and a book-shop where you can
buy *Jane Eyre* (in a sixpenny edition) and the novels of Mrs
Henry Wood.[6] . . .

In the evening the hotel became a house of crowds, and
crowds within crowds. As each new train arrived, ones and twos
and threes of men and women, with their coats and sticks and
baggage, seemed every minute to be projected into the already
overcrowded dining-sitting-room, with the air of bewildered
sheep. They sat down, as they came in, at the disordered tables,
where pieces of broken bread, knives, forks, spoons, empty
unwashed glasses, stains, bottles of sauces, and the remains of
earlier meals gave the appearance of a battlefield where hunger
had been worsted, but not without casualties. Pots of tea, bottles
of stout, glasses of whiskey – or rather bottles of whiskey, for the
guest was decently given the bottle to help himself – rashers of
bacon, fragments of fowl, steaks, loaves, jam-dishes, rattled in on
loaded trays as the new guests arrived, and at each of the tables
and corners of tables a mumbled conversation would begin.

In crowded hotels – at least in some parts of Ireland – the
conversation often begins in this muttering shyness. Here and
there a loud voice rises courageously, from the first bite, but, as
a rule, people are too self-conscious – too conscious, rather, of
the presence of neighbours with a possible gift for satire – to
talk freely till their blood has been warmed. Even excited and
angry arguments are carried on, with an infinity of facial expres-
sion and gesture, in the voices of conspirators. Thus, in an Irish
hotel, a stranger often might well feel that he was in the midst
of a plot – that each corner of the room was conspiring against
him: for though every one resents the curiosity of his
neighbour's ears, his own eyes are continually darting glances
of curiosity all round him. Solitary persons occasionally come
and look through the door, and shy of so many eyes, slip
quietly off to the less dreadful discomfort of their bedrooms.

For myself, I am always in these places wishing the floor
would open and swallow me. It is an awful thing to go to

bed at ten. But amid the murmuring plots of an hotel sitting-room it may be even a more trying ordeal to sit up. One had to fly somewhere out of that prison of constraint and low voices. Consequently, to bed – to bed in the little wooden box where the door would not keep shut.

To bed, but not to sleep. Everywhere, as well as in the sitting-room, these mumbled conversations seemed to be going on, broken now and then by the voice of some confident fun-poking young man, a girl's titter, and little bass growls of laughter. People stopped just outside one's door and entered into conversations that seemed to last for hours. The clock struck, the clock struck again, and still the house was a house of subdued narratives, excited as a school that is going to break up the next day for the summer holidays. As time wore on we would hear good-nights interchanged, and a last call of 'See you in the morning,' and the leap of heavy boots up the stairs, or their tramp along a corridor, would be the preliminary to a lull. But new sturdy ghosts would arrive, and the conversations would go on. Gradually, towards the small hours, the good-nights increased in frequency, and with each of them one seemed to be let down another step towards silence. Where men mumbled before they now spoke in whispers. Soon the creaking of boards under huge boots became a startling interruption. It affected the imagination like the tramping of the warder past a corridor of prison cells – a tramping and banging to an end of silence. One ceased to hear the whispers save as the fall and ebb of little lulling waves. Tramp, tramp, tramp, tramp. Door-bang. Again the little lulling waves, waves. Tramp, tramp, tramp, tramp. Door-bang. The little waves are lapping my face. They are rising above my ears. The tide is nearly full. Tramp, tramp, tr ____. Even Galway ghosts can keep me awake no longer.

Next morning was filled with sun. It was one of those happy, gold mornings when the farmer's daughter dresses in white. Galway rose to meet it in a garment of dust. Her streets, sabbatic-looking with all the principal shops closed, had none the less a certain keen vitality, as country people came in to view them before going to the races, and young racing enthu-

siasts ran about looking for a newsagent's or a barber's. Within a few minutes of the arrival of the Dublin train, there was hardly a paper to be had. Small energetic boys refused to sell you an *Independent* for a halfpenny today. It was Galway's one chance in the year of selling in the dearest market; and even the halfpenny paper was raised to a penny. Near the newsagent's shop a barber's pole slanted out over the pavement, and with a file of other bearded pards I went in to get shaved.

Every chair in the place had already an occupant being violently lathered or scraped in front of a mirror. The long bench against the wall was filled with young men, smoking and reading papers or yawning post-alcoholic yawns, and at the far end of the form, in contrast to us all, sat a peasant in a tam-o'-shanter, lean-faced, dark, wind-inured, with long hair pouring over his ears – a man from the Aran Islands, I think, in an ungainly grey homespun coat and yellowish-grey trousers – a man who, with his eagle nose and his thrust-out chin, had a curious look of Dante. As I sat waiting, I was especially fascinated by one of the five or six barbers who were performing their lightning labours with more energy than skill or gentleness on the faces of their patients. He was a stout, round man who, as he set to his work with his shirt-sleeves rolled high up, looked more like a blacksmith than a barber. Or perhaps I should say like a butcher. Or perhaps a stableman. Possibly he did actually belong to one of these professions, and had only taken to barbering in order to meet an emergency. Anyhow, he used the soap-brush and the razor like a man who was playing a mischievous game rather than a professional. If he pushed the soap into a nose or eye or ear, he began to shake with cheerfulness: his puffy red cheeks, his big rough moustache, his comfortable stomach, all appeared to be sharing in some secret merriment. As for the razor, he used it as though he were currying a horse. He made one drag across the face from ear to chin, and another drag down the throat, and after about four drags sponged off the soap and the blood and said 'Fourpence, please!' with a genial twinkle, as though you, being a sportsman, could feel no offence because of a few wounds contracted in

honourable battle. One young man rose from the chair and looked in the mirror at the torn skin of his cheek and the blood pouring from a great gash in his chin.

'I'll remember you this day month,' he said to the barber, as he wiped his face with a towel.

'What do you mean?' said the jolly fat barber.

'I say I'll remember you this day month,' repeated the other grimly. 'You've left your mark, never fear.' And he paid the barber what he owed him and probably a little more.

'No offence,' said the barber gaily, pocketing the money; 'Thank you, sir,' and the young man went out. 'Bloody fool!' said the barber, looking round us with a laugh.

I will confess that I did not laugh. My own turn had not arrived yet, and I dreaded to come under the razor of this good-humoured butcher as I would dread being charged down and mutilated by Cossacks.[7] As a matter of fact, when my turn did come, and this particular barber said: 'Next, please!' invitingly, I was dishonest enough to look the other way while an impatient stable-boy unscrupulously dashed for the empty chair. I am afraid he was pachydermatous and did not suffer as he ought for his greed.

Meanwhile a lean young barber at the other end of the room was looking with dismay at the shaggy mane of the Aran man.

'Hair-cutting's sixpence today,' he said warningly, wishing probably neither to cut the islander's hair nor to let him in for the double prices of the day.

The islander twisted his gloomy, beaked face into an 'Eh?'

'Hair-cutting's sixpence today,' repeated the barber in deliberate tones, as though speaking to a deaf man or to one who did not understand English.

'Sixpence?' the other repeated, a puzzled and threatening look coming into his face; 'Go ahead,' and he settled himself, a little offendedly, into his chair.

After that, luckily before the stout barber had finished with his last victim, another chair was empty, and a little spry barber was apologizing to me and asking for the loan of the paper 'just for a second', before beginning to shave me. He was an averagely

good barber – as good as could be expected when one is being shaved, as it were, in a tumult. But when I got out into the air again I breathed deeply and gladly, like a man who has escaped from a tight corner.

Galway was by now filling with cars from the ends of the earth. Everybody was getting ready to go to the races. Youths in caps stood round the steps of our hotel and welcomed noisily any new friend who came up to join their group. One youth, with his cap over his eyes, would scrimmage into the group on his toes, like a footballer, while his arms embraced all the necks near him, and he demanded musically: 'Has anybody here seen Kelly—K—E—double L—Y?' Then another figure, hands in pockets, would come up to shouts of 'Paddy!' 'Hilloa, Paddy!' 'Where the bloody hell have you been, Paddy?' And Paddy, closed in by questioning faces, like the examinee in the game of Oranges and Lemons, would confess with a grin of imitation shame: 'Bejasus, I haven't been sober for a week.'

His confession would be received with mighty interest and chaffing interrogations on his adventures, until Billy hove in sight. Then the cry of the pack would go up: 'Billy!' 'Hilloa, Billy!' 'Where the bloody hell have you sprung from, Billy?' And so ancient friendships would be exuberantly renewed and old meetings on half the racecourses of Ireland be recalled.

Everybody was now flying or making ready to fly to the racecourse, which is about two miles to the east of the town. Every man who owns a vehicle of any sort in that part of Ireland, even if it is only a dilapidated and out-of-fashion side-car inherited from a long-dead great-grandfather, brings it to Galway at the time of the races and excitedly sells seats on it for as much as he can get for them. Monstrous brakes that must date from the old days before railway trains, and that appear never to have had the dust and mud taken off them since – the very reins and harness seeming to be an affair of patches and pieces of string – rumble into Eyre Square at one corner and out again at another. Little low dirty cars with sloping backs, and drawn now by a horse from the plough, now by some old pensioner from the stable, with all its bones

showing, follow in the dusty procession, and are as sure of clients as the brisker cars with the well-fed and sinewy animals. Endless seems the line of these vehicles that marches down the hill, while the hoofs of walking horses kick up the white dust from the broken road, and drivers, cars, and horses one by one, get to look as if they had come from the yard of a busy flour-mill.

Thinner and thinner became the population of the town as holiday-makers with excited eyes, after shouting bargains with the extemporized jarveys, leaped on the long chain of cars or scrambled into the brakes. The air was full of thrills. Aged paupers leaned against the railings of the Square gardens, twisted sticks propping them up or tucked under their arms, and watched the bold youths and the gay white maidens drive off, a multitudinous pilgrimage to a multitudinous paradise. My landlord, standing on a doorstep and making introductions like a master of ceremonies, looked out on the gaiety of it all, contented as a pigeon watching a river go by. He wasn't going to the races himself, but all his family was going.

'You're driving to the field, Mr Lynd?' he asked me.

I told him we were. He nodded intelligence. 'I'd advise you, Mr Lynd,' he said in a kindly voice, 'to get a seat on one of them brakes. There's less chance of accidents. A horse in a car would be more apt to stumble.'

One could certainly imagine the horses in the cars stumbling or bolting or playing any sort of wild destructive tricks in those exciting streets. Many by this time had made the circuit to and from the course several times already, and patterns of sweat were showing on their bodies under the harness, and the wind was roaring in a few broken specimens as in the throat of an old man. Our only chance of getting a car – for our landlord's luxurious gloom was not to intimidate us – was to go and meet the vehicles as they came into the town.

'How much?' a bristly chinned man in a white coat would ask an approaching driver, who would lean over, his face thrust forward greedily, and say:

'A half-crown apiece.'

'Guess again,' the man with the bristly chin would reply, his eyes wandering to the next car.

'I'll take you for two shillings,' the driver would offer.

'I wish you may get it,' says the man with the bristly chin, and turns to his haggling with the next carman.

We got on the side of a car and began our rush for the field. We stopped to take other passengers up before long, and soon even the well of the car had a young man with a briar-pipe sitting on it. Off we dashed out of the town and up the long hill after all the horsed vehicles of Connacht, swaying and swinging past the stone walls of the fields and the grassy roadsides thick with a low rain of dust. Our speed was only limited by the speed of the car that went before. It was our glory to come so near it that our horse's mouth would be within biting distance of the hindmost occupant of it. If possible, we refrained from passing it – just kept the horse's muzzle boastfully threatening the dangling legs of some poor fellow who dared not take his eyes off it even for a moment's look at the scenery. Now and then, to be sure, a motor-car would toot by, and following a bad example, we too would pass a less impetuous neighbour; but on the whole we followed the ancient fashion of politeness till we arrived at a gap in a wall which admitted us across a quarter of a mile of fields to the racecourse.

The racecourse, with its grandstand and its hurdles and banks and wall-jumps, lies, a crooked loop, on a hillside. It is a very beautiful world of grey and blue that you see from it – grey of stone and gull and cloud, blue of sky and hillbound bay with the white island lighthouse rising among the waters. Going over the fields, one sees a long line of emptied cars along the sky-line returning to Galway by another route, and the clear air is full of the murmur of holiday – of bookmaker and fruit-seller and showman with coconut shies and Aunt Sallies.[8] Some cars drive over the fields and take up their stand near the bookmakers opposite the winning-post. Here high iron railings cage the democracy on one side of the course, while on the other side the grandstand is full of the movement of fashion and field-glasses. About a hundred yards from this, at the bottom

of a slope, the cheap lemonade sellers and mirth-providing showmen have pitched their tents, and between this and the course itself constant rivers of the aimless, the older men in tailcoats and wide-awakes, are wandering. The bookmakers who have fixed up their stands like a thousand auctioneers in a clump near the railings draw all eyes and a good many pockets as the time for a race approaches. They are on the whole a serious and businesslike-looking set of men. There are none of the comedian sort of bookmakers here such as I have seen on an English course. They do not, however, avoid checks in the pattern of their clothes, and they have, most of them, the air of men who take a materialistic and cunning view of life.

'Six to four against Marcella! Six to four against Marcella, and five to one bar one!' rose the clamour from them, like the barking of dogs round a pond; and, as the clerk registered each innocent bet in his long ledger, the odds against the favourite would come down, and the master-bookie would make a change on the board of prices with a bit of chalk. 'Five to four against Marcella! I'm giving five to four against Marcella!' he would drone monotonously, allowing himself no quirks of humour or fancy.

One of the bookies, a big round-whiskered man with a crimson face, check trousers, a coachman's broad black hat, and with a case of field-glasses slung round his shoulders, bawled the words apoplectically. Another, narrow of temples, dull of eye, with a fan of sallow nose intensifying the lean appearance of his solemn face, contrived to speak the words with almost no expression at all: he was more colourless than his dust-coat, much more so than his pale brown hat. Another, at once respectable and boozy-faced, with a pink flower in his velvet-collared coat, offered the odds sulkily but energetically from his fat mouth. And country boys moved in and out among them smilingly but withholdingly, having no florins to risk on blood horses. An occasional lady, masterful in a tweed hat and jacket, came forward and got a receipt for a bet, and the population of the town billiard-rooms nipped up by ones and twos and backed their own cunning against the cunning of the furtive-

eyed bookies. When the horses came out and began cantering down the course with little swift trial thuds, the bookies raised their voices to a higher note and began shouting feverishly like prophets. It was as though they were calling to the crowd to repent while there was yet time.

Out would come a jockey in a costume, half cherry-coloured and half blue, with an orange-peaked, chocolate-coloured cap, and would bolt down the course with head lowered on the back of a huge bay. The crowd began to rush to the railings and get commanding positions, to look over hats and shoulders, to struggle into rifts in the human mass, to leap on to the few cars that had come up there, to fly from the bookies who clamoured like a lot of gulls as they offered a last chance of a bet.

'Evens on Marcella! I'll take evens on Marcella!' they shouted, as though the end of the world might happen the next moment and it would be a good thing to have put money on Marcella before you died. Red, yellow, orange, blue, green, indigo, violet – purple, mauve, maroon, grey, black, white, brown – stars, stripes, bars – jockeys in costumes of every colour and every pattern now flocked on to the course, looking like a school of circus boys, and, after a preliminary breather, ambled back up the hill with humped shoulders. Then, as grey-shawled women elbowed their way forward to the railings and old men in tam-o'-shanters with smiles on their wrinkled faces made room for them, the animals gathered at the starting-post and curveted and champed and turned their heads, waiting till the bell rang.

The bell rang. The horses broke away like a whirl of autumn leaves and swept past us thunderously. As soon as the bell rang the clamour of the bookies died away like a sound in a dream or like a wave that had broken. It was as though the world were filled suddenly with an intense silence, though now and then, as Marcella leaped a bank with the grace of a hare, or Jumping Jehosaphat, bundling in her wake, scrambled over a stone wall, you would hear a grunt, a sort of stenographic soliloquy, coming out under the field-glasses of some bookie, and buzzing arguments would begin and cease among the

crowd as to whether it was Marcella that was leading after all, or whether it was Lame Duck, whose rider and Marcella's wore scarcely distinguishable colours. Ten thousand eyes clung to the leaders of the straggling line of horses that galloped the ups and downs of the long course, clearing gate and bank and green-branched hurdle, lessening in number as an occasional rider might despair and fall out, disappearing from sight behind some hillock, coming into view again in a new and exciting order, a royal line of gay colour and lovely movement. It was through a crowd intent like this upon thrilling events that a barefooted woman moved with a basket of fruit on her arm, offering plums for sale in the shyest voice imaginable. She was sad-faced under her shawl. 'Anny plums?' she intoned in a sing-song voice, her eyes moving from indifferent face to indifferent face; 'Anny plums?'

It was a note of sweet music in the buzzing atmosphere. It was business, but, like the selling of sweet lavender in the streets of London, it was business to a tune. 'Anny plums?' she almost whispered, as though it were possibly indecent – and it was – to suggest that a man might want to eat plums while the fate of his half-sovereign hung in the balance. Then she was out of sight in the crowd. But still, ever and anon, her 'Anny plums?' rang out like a little mounted bell. Then it was drowned in the rising growl of a crowd shouting the names of horses near the winning-post into the air. Or rather I should say of the sporting minority of the crowd, for the average Galway-man – at least, the Galway peasant – is little ruffled by the excitements of a flash-past of horses whose names he has learned for the first time from a neighbour's racing-card. He watches it critically as he might look at a neighbour's pig. He seems to bring his quiet subliminal self, not his tumultuous surface self, to the contemplation of these steeplechasing circus boys. And it is no wonder, for, with the big cage of railings in front of him and a disappearing racecourse to right and to left of him, he can only follow a race in fragments. That is why so many of the crowd gradually get tired and dander down the slope towards the booths and stands of the uproarious showmen.

Here tents had been set up with a two-days' licence to sell liquor. Other stalls were heaped with halfpenny cakes with a snow of red and white caraway seeds on them, rocks of vile yellow sweetstuff, penny packets of biscuits – such biscuits! – penny bottles of lemonade, and all those other gaieties of the stomach which are only tolerated because they are associated with holiday. While we were standing at one of these places buying biscuits, a dirty-cheeked baby leaned over from the arms of a beggarwoman and held out a half-chewed pig's foot towards the mouth of my companion.

'Ah, ma'am,' said the mother, with a proud smile, 'he's mad for mate; you could never tire him giving him mate. Tell the lady', she said, giving him a hugging shake, 'what a terror you are for mate, Michael.'

I confess to a certain squeamishness as I watched the baby filthying its mouth with that odious piece of carnality, but at the same time by an irresponsible association of memories the latter called up a summer day ten years before when on a Twelfth of July holiday I had marched with the Belfast Orangemen (not as one of them, alas, but as a stranger!) out to the field of assembly, and there, amid the colours and excited din of loyalty, had seen a stall of trotters bearing the motto: 'Liberty, Equality, and Pigs' Feet'. After that, I looked more tolerantly on the infant and the pig's foot it was sucking.

There were pitches of recreation as well as refreshment on the Galway racecourse. Painted wooden images of men rose in little companies in front of a screen of sacking and leered invitation at one, while viragoes with red faces, thick necks, and tousled lint-coloured hair screamed at all present to come and have a shy at the wooden figures, which collapsed at the hinged middle if struck hard with a ball between the eyes. If you have never seen a tinker woman scream, you can have no idea what a grotesque symbol of hubbub she makes. She begins by throwing her lawless head back, with her hands on her hips, and shouting 'Ha! ha! ha!' – not as a laugh, but as three distinct heaven-splitting syllables – or hell-splitting, if you like, for it sounds like the mirth of the damned. 'Ha! ha! ha!' she yells; 'ha! ha! ha!

Come on, come on, come on. Come on, all you Galway blazers
and sportsmen. Three shots a penny. A penny for three shots.
Here you are, young gentleman!' she goes on, never lowering her
voice, as a country boy takes three balls from her hand. 'Here you
are. Three shots at the old man's coconut. And *mind the baby*!'
 One really has to underline the woman's humour in order to
give an impression of its hysterical shrillness.
 'Ha! ha! ha! you're a divil at it! Ha! ha! you're a divil at it,'
she keeps yelling as the balls begin to fly. 'One shot more, and
a man's down! And mind the baby! Ha! ha! you're a divil at it!
Ha! ha! ha!'
 No doubt this pseudo-frenzy produces its effect. If you have
from half a dozen to a dozen women and men howling at you
in rivalry the information that you're a divil at something or
other, and appealing to you with wild cries to mind the baby,
you can scarcely help being drawn into a little ring of excite-
ment, and, once you are there, a terrific showwoman will as
likely as not either blandish or shame you into trying to knock
down her painted dolls and win her poisonous cigars.
 But there were other games besides the various sorts of Aunt
Sallies and the kindred coconut shies. There were card games
and trick-o'-the-loop games, and there was the game in which
you throw rings at a stand full of walking-sticks and attempt to
win one of the latter as a prize.
 The game around which the greatest crowd had gathered was
one that I had never seen before. Here a man knelt on the grass
a few yards from you, his face disguised in blackness and grins,
his head stuck with feathers, like a cheap imitation of a Red
Indian, and allowed you to throw things at him at two shots a
penny. His friend, a dark-faced little fellow with a twinkling eye,
in a peaked cap, took the money and gave you the balls to throw
while he tried to keep too enthusiastic sportsmen from over-
stepping the mark. I do not think the balls in question were
anything harder than rolled-up stockings, or that the game was
more cruel than a pillow-fight. But I have seldom seen a game
enjoyed more furiously. Two sportsmen were allowed to throw
at a time, and it was the black man's duty by dodging and

ducking and catching the balls in his hands to prevent his face from being hit. The crowd, gathered up into the shape of a tortoise, swayed and swung round the combatants and laughed uproariously as a blow just missed the feather-surrounded face. Occasionally the throwers, getting excited, would run in over the mark and attempt to punish the man at close quarters. But the little smiling fellow in the peaked cap always brought them back in the best of humour with the phrase, 'Fair's fair,' and, as soon as either of the balls was out of play, he thrust it at someone in the crowd, saying: 'Come on, boys, come on. Keep the divilment going.'

He was the only showman in the place who was not shouting. As he stooped, picking up the balls, in the thick of the eager crowd, he seemed to be giving the impression that we were playing a secret game which might be stopped by the police at any moment. He contrived in this way, as he bounded about after the balls with constantly bubbling laughter, to make his innocent game as exciting as cock-fighting. He seldom winked up with a 'Keep the divilment going!' but some victim fell into his merry snare.

Not far off, in a space between two tents, an old countryman in a faded high hat was the centre of a group of boys who seemed to be getting ballads out of him. Unfortunately, he was rather drunk, and they were beginning to be tipsy too, so that there was more handshaking than singing done. He sang to them mournfully in Irish, and they shook hands with him and with each other over that. He sang – or rather alternately moaned and skirled – a scarcely recognizable version of 'The Boys of Wexford', and at the end of almost every line he had to stop to shake hands with the young fellows one after the other in an exaggeration of the country fashion. As soon as he had slobbered one song out of his scraggy and ulcerous face, a volley of demands for a dozen other songs showered down on him. One big, square-headed boy, with red hair and freckled face, remains in my mind with especial vividness, as he kept insisting with self-conscious awkwardness to the singer: 'Give us "The Men of the West". Give us "The Men of the West".'

I do not wish to give the impression, however, that Galway was a scene of much drinking on the day of the races. I never saw a soberer holiday crowd anywhere. Compared with a bank holiday crowd on Hampstead Heath, for instance, it was almost sabbatarian in its decorousness. In Ireland, however, one drunk man is as conspicuous as a thousand sober ones. Drunk, he forgets his shyness; he asserts his individuality. But he is, comparatively speaking, a rare bird and an exception for all the show he makes. I stress this point because the next scene to which we moved on had another tipsy man for its central figure.

He was a middle-aged farmer in a blue tailcoat and bowler hat, and a long reddish beard seemed to connect him with respectability. He was standing at one of the Aunt Sally pitches where sticks were used instead of balls to hurl at the figures, and when the showman, red-nosed and whitened like a clown, but in an ordinary bowler hat and blue suit, went in his shirt-sleeves to collect the used sticks at the back of the stand, the farmer signalled to him with imperative good humour to remain where he was and become a living target. The showman got behind one of the figures and grimaced out provocatively. The farmer flung a stick at him; the head ducked and bobbed out, a second after, all smiles. The farmer went to the corner of the roped-in pitch and made faces and threatening gestures at the showman, who put his five fingers to his nose insultingly. Two sticks were swiftly and successively hurled from this point of vantage, the clown just escaping the second by the skin of his teeth – or rather by the skin of the tip of his ear.

The farmer, highly delighted to have come so near his aim, bought some more sticks from the showman's wife, who looked a little uneasy and disinclined to give them to him, and he then began a new policy of lobbing them up into the air so that they might drop on the man at the other side of the figures. At this the showman twisted his face into more exaggerated contortions than ever. Putting his thumbs into the armholes of his waistcoat and getting down into a sitting posture, he hopped in and out among the figures like a dancing dog. The farmer, with a childish laugh, stepped over the cord, and he, too, got into a

sitting posture and hopped like a dancing dog towards his enemy, his coat-tails dragging on the grass. The showman hopped towards him, grinning, and put his hands above his ears like the horns of a cow and wagged them. The farmer, with a drunken imitation of the other's grin, also gave himself a pair of horns or donkey's ears – or whatever his hands were meant to represent – and wagged them. In this way, they hopped, one hop at a time, round and round each other, till the farmer took the showman's hat off, as though he were doing a funny thing, and the showman took the farmer's hat off, as though he were doing a funnier thing still. After this, the farmer got excited, and it was time for the friends of both parties to step in and prevent a quarrel.

When we came away they were both standing in the middle of a clutching crowd, the farmer gesticulating wildly and the showman parodying each excited gesture in an extravagant way that amused everybody but the farmer, who was certainly hard to please.

By this time most of the crowd were straggling back to various points beside the course in order to see the race for the Galway Plate, which is, I believe, the great race of the meeting. Priests in their rook-black garments moved among peasants in their grey tailcoats or white woollen jackets – bawneens, as they are called – and horsy men in leather gaiters hurried with whiskey-bitten faces past slow-moving countrywomen in heavy grey and brown shawls. Ordinary people like you and me made for our places, a many-coloured mob in all sorts of overcoats and serges and tweeds and bowlers and straw hats and slouch hats and caps. We gathered in knots on every little prominence on the hillside, and got our foreheads tight up against the high bars of the railings, or hung and hustled on the backs of those who had in good time seized the front places near where the bookies bellowed. Here men, women, and children now darted in every direction and cross-direction, like flies in the sun, one to lay a bet, another to whistle and push after a friend, another to get a place. The bookies were once more screaming like sea-gulls. The big round-whiskered man with the crimson face and

the check trousers alone did not seem to have redoubled the vehemence and shrillness of his shouting. It was not for want of will, however. He was still apoplectically offering odds with a facial earnestness worthy of a better cause. He was redder than ever and, as he addressed the crowd, he kept clenching and swinging his fist in an angry gesture of helplessness. But, struggle as he might, he no longer brought forth a huge mountain of a voice as he had done earlier in the day. His 'I'll take six to four! I'll take six to four!' had dwindled into a little hoarse, husky, squeaking mouse. You saw it rather than heard it as it issued from that labouring, perspiring, check-breeched frame. 'I'll take six to four! I'll take six to four!' It was like a whisper, a death-bed saying, a strangled confession. No one, having seen the slow martyrdom of the man, could ever afterwards look on bookmaking as an idle trade. The other bookmakers, however, hurled a stormy sea of voices about us to make up for the soundlessness of this one. Beggars, slipping through the clamour and bustle, would beg you for a penny for the love of God, and fruit-sellers still sought a market for their plums and oranges with modest voices. One of the beggars in especial, a woman with Gorgon locks of iron-grey hair flaunting on a head that had once been black as night, made herself noticeable. Her shoulders covered with a brown Galway shawl, she had a hard though beautiful face and the evil eye of the insane. Her skin was yellowish-brown and weather-softened. As she begged, she had a voice as gentle as the light in a church, and it was as good as being in church to hear her mingling her thanks with holy names. But a gauche big farmer's son in a white coat, with a party of two young women and a boy watching the races from a car, had stridden past her roughly on his way to a shouting bookmaker's, and had answered her without manners as he pushed his way back past her insistent 'I ask your honour in the name of God to help a poor woman.' I do not know what he grunted at her under his ill-tempered moustache, but it brought the evil out in her face very markedly, and she began to abuse him in many words I do not remember and many others I dare not print. It was the very

pollution of a disordered mind that she poured over him as he stood sheepishly and resentfully at the side of the car and damned her into himself and said nothing. Crooking two of her fingers, she put them into her mouth and cast a spittle at him with a gesture, cursing him, turning a tributary stream of abuse on 'the lady on the car', and winding up with shrieking what seemed to be either an accusation or a prophecy of grossly immoral conduct on the part of the young farmer.

Luckily, the bookies were making such a noise that you couldn't have heard all that was going on unless you had had a thousand ears. Even so, when the woman moved away from her victim, muttering and shouting by turns, and came up against me, and asked me in a gentle voice for a penny, I consulted my safety and bought her silence. It only encouraged her, however. She began to praise my personal appearance loudly, in the most embarrassing way, and then she began to praise the personal appearance of my companion too. She shrieked out a most damaging comparison, on the score both of good looks and generosity, between the young farmer and his friend on the one hand and my companion and me on the other. I confess I am as greedy of flattery as any man living, but this witch was not using the other man as a pedestal for me: she was using me as a knobby stick for the other man. I rejoiced when the horses in the big race came out on the course and were the signal for a feverish uproar among the bookmakers, who were ravenous for the last bets before the horses started. So many things were being growled, shouted, whanged and husked at this time, that you could hear none of them distinctly at all. Amid the noise and shock of the cavalcades of shouting, the crimson-faced man in the check trousers could no longer be heard even as a whisper. He was now simply an inflammation and a death-rattle.

I will not attempt to describe the race that followed, because it did not mean anything to me. There were about a dozen horses in it, and, as to which was which, before I would have been able to learn the marks and the jockey colours of half of them, the race could have been run twice over. The only way

in which I have ever been able to get any plan or sense in a
race is to back some one horse and to follow its fortunes single-
mindedly till the winning-post is reached. It is only by doing
this that I have ever been able to appreciate the logic as
opposed to the aesthetics of horse-racing. As I was an observer,
not a gambler, at the Galway races, I missed this interest. The
race was to me simply like the bolting of a number of horses
with curiously coloured boys on their backs.

Ah, no. That is not quite true. I loved the beating of the
ground under their hoofs as they swept past from the starting-
place. I was excited enough a minute later, when one of the
curiously coloured boys lost his seat and tumbled to the ground
with a skelter of hoofs flying away from him. I was sick with
alarm as half a dozen men ran out and gathered the boy up and
half carried him, half helped him to limp, towards the grand-
stand. 'They say he's never sober,' I heard a voice beside me
commenting. 'He's destroying himself with drink,' said another
contemptuously. 'Divil the smarter jockey in Ireland',
continued the chorus, 'if he could keep off the drink.' When
the jockey had been taken into the enclosure and the gates shut
after him, and we could turn our attention to the race again,
his horse, rid of its burden, had dashed in front of its rivals,
and was leading the way nobly. Whoop, it was over a fence,
and galloping like a hare towards the next jump. One by one
the others rose and fell in its wake, up and down like little
dark, silent waves, and off at the gallop after their riderless
leader. People began to jeer, to cheer. Was it going to finish
the course by itself and come in first in the race? Another
hurdle was leapt. Then, before it had galloped much farther,
the horse seemed to question itself. It broke into a trot; it
looked about it; it turned; it questioned the world. It began
quietly to trot back in the direction from which it had come,
till someone ran out, caught it by the bridle, and led it back to
the stable.

As for the other horses, they bounded past us this time with
a fiercer thunder, the race being twice round the course. It was
then a case of Amber Dick and Pollyoolley getting ahead of the

rest, and tugging turn by turn into the first place, like squalls overtaking each other on a rough sea. Or you might compare Amber Dick, as he shot ahead, to a wave's tongue darting up the strand. And you might think of Pollyoolley as sweeping after him remorselessly like an argument that is better than another. The one took his jumps, clawed up like a crab; the other, sprawling. They were only the same in hanging on to each other's breaths breathlessly, down the slopes, along the levels and up the hills. Then they disappeared round a corner, a clump of seven other horses rolling at their heels. When next they came into view they were making straight for the winning-post, and the excited elements of the crowd had poured like a sudden froth out of the enclosure, out of the strand, and over the bar to meet them. They were like an advance guard of ancient Britons rushing out wildly to challenge a Roman legion. They were shouting, waving hats, standing on one foot, cramping up their bodies as though the straining of their sinews could give speed to their favourites. They had their arms in the air; they had their mouths open, yelling. One of them, a cane in one hand and a bowler in the other, had his arms stretched out to their full extent, and beat a kind of frenzied time with them like the leader of an orchestra. If frogs exercised with dumb-bells, they might, I imagine, go through some of the same sawing, circling, and squatting movements as did this young man's arm and body. Then suddenly his hat was flung high, and he was lashing the ground with his stick, as a shrill shout went up into the air and drove all the larks helter-skelter half a county away. It was a roar as from a relieved city. Amber Dick had won, and amid disconsolate jockeys, sweating horses, and tempestuous friends, was mobbed, gravely pacing to his stable.

Then began the rush to the bookmakers for payment of debts, and the hurry across the fields to where two dusty cavalcades of vehicles were preparing to take us back along either of the rocky roads to Galway at a considerable reduction on the fare for the outward journey.

Car swung after car down the ruts in white clouds, and brake thundered slow thunder after brake, while ragged children

stood in the ditches and cheered us as we went by. It would be
in keeping with the traditional accounts of such occasions if I
described the procession bolting down the road to Galway at
breakneck speed, but it would not be true. The cars did not
drive particularly fast for Irish cars. They jolted along at an
honest pace enough, and if any of the horses were apt to
stumble, it must have been through weariness or age, not
through reckless driving.

We were in the advance guard of those who got back to the
town. Most of the people seemed to be staying for the last race,
and, if we hurried away, it was only because we loved food
more and sport less than the vast majority of the men and
women who went to the races on the hillside. When we got
back to the hotel, a squinting woman with a handkerchief round
her head and with a bulging wet sack lying on the ground at her
feet was beginning a heated argument with the landlord. It
seemed that she had sold a two-stone bag of cockles to an
English visitor at the hotel, who, having indulged a little too
freely in the wine of the country, had flushed into a generous
mood and had bought the entire sack from her. This done,
however, he had bumped precipitately up the stairs to bed,
leaving her to store the cockles where she could. She, of course,
was for setting them down in the hall of the hotel. But the
landlord, rightly surmising that an Englishman sober might have
some difficulty in finding a use for an enormous load of cockles
that he had bought when drunk, sent her off to the railway
station, advising her to put the sack in the gentleman's name in
the left luggage office. She trudged off, sickle-shaped under her
dank load, but apparently the clerk in the station eyed her load
with the same suspicion as the landlord, for ten minutes later
she was back at the hotel, a trader doing her best under
difficulties to deal honestly by a client.

'Well, would he not take them?' said the landlord in apparent
surprise as the cockles were once more flung on his doorstep.

'It's perishable goods he says they are,' replied the woman in
the high voice of a fishwife. 'It's no use, sir, I'll have to leave
them here. There's no other way out of it.'

'And what – what reason did he give for refusing to take in the cockles?' asked the landlord, dumbfounded by the railway company's insolence.

'Amn't I after telling you', retorted the woman, 'that he said cockles was perishable goods? "It's no use," says he, and he seemed to think it was trying to play a trick on him I was. "I'm not going to have them here", says he, "for to go bad on me and raise the divil's own smell through the whole station." An' that's the way it is, your honour. If I can't leave them here, I don't know what to do. Ah, now, there's room plenty in the hotel,' she went on, picking the bag up and making towards the door with it.

'Wait, wait!' cried the landlord, putting up his hand. He looked back along the hall and up the stairs as though half expecting to see help coming from that quarter. 'I don't know, I'm sure,' he muttered. Then, half to himself and half confiding to me: 'It's an English gentleman', he said, 'who has come to Galway for to see the races. The fact is, he has been enjoying himself – he has – he's a little bit fresh. I can't for the life of me make up whatever he bought these cockles for. Maybe it's a taste for cockles he has – for by all accounts they have a taste for a strange lot of things in England that we wouldn't put up with in Ireland – or maybe he'll have forgotten all about it by the time he wakes up, and then I'll have to get a young lad to carry the stuff off the Lord knows where, for it's not so easy as you might think to get rid of a sack of cockles that would be going worse every minute.'

'It was a fair purchase,' the woman broke in shrilly. 'Call the gentleman out and ask him wasn't it a fair purchase.'

The landlord took a step or two out, and looked up into the blue sky where wings of cloud were gathering.

'Didn't I tell you', said he, with his eye on the clouds, 'that the gentleman required a little rest after his long journey?'

'Ah, well,' observed the woman resignedly, 'he paid for the cockles anyway, and I'll leave them here for him.' And she flung them against the wall of the hotel. 'I'm tired looking at them,' she said.

The landlord was an obliging man and capitulated on terms. If the woman would carry the cockles inside, and leave them at the back of the kitchen door, he would see what could be done. So we made way, and the woman once more took up her wet burden, and dragged it up the step and down the hall and out of sight. And what the last end of those cockles was I do not know under heaven till the present day.

Soon, cars and brakes were unloading themselves all around us, and young men and maidens were promising to see each other again at some church bazaar, announcements of which were swinging on scrolls across the streets. For ourselves, we decided, when we had had a heteroclite meal, to go out on the tram to Salthill – the watering-place suburb which lies about two miles along the north side of Galway Bay. It was not an easy job to get on to the cars, however. Everybody who was not going to the bazaar or going home was going to Salthill. Each tram as it came up was seized by a lawless crowd, and, though there was a great notice in the windows – IN ORDER TO PREVENT OVERCROWDING IN THESE TRAMS, WHICH IS CONTRARY TO LAW, DURING THE GALWAY RACES THERE WILL BE NO FARE LESS THAN 3D. BY ORDER – everybody took for granted that the tramway company was only putting up its prices like all the other concerns in the town as a matter of good business, and we broke the law in such regiments that it is a wonder we did not break the horses' backs too.

In Salthill itself, when you get there, there is little to do. There are new stuccoed houses in it and a long cement walk above the sea where the wind can blow mighty cold after the sun has gone down. The chief distinction of the place is the number of old women who sit out under the gable-ends of some of the houses in companies. They look like some scene of Dutch life as they take the evening air in their wealth of petticoats and dark knitted shawls, sewing, talking, getting amusement out of some broken-down singer who pauses to sing them inappropriate songs. These clumps of old people are, I believe, not residents, but country folk who come from all parts to get health from the waters and the briny air of Salthill. I do not

know whether Salthill is now the resort of all classes to the extent to which it used to be, but the poor still seem to flock to it. Miss Callwell, in *Old Irish Life*, tells of the martyrdoms that used to be undergone in order that the ailing poor might be brought to this health-giving shore. 'One poor man', she writes, 'carried his wife, who was recovering from a severe illness, nearly fifty miles upon his back, to bring her to the sea, supporting her and the children who accompanied them by begging from house to house along the road. "Och, but he dearly earned me," said the wife afterwards, when happily she was restored to health and strength.' Salthill looks as though to some of its pilgrims such heroisms were still possible. . . . It was wet and windy enough that night to kill anybody but a confirmed invalid. . . . We crowded inside the tram on our way home. A man at the far end became violent against the conductor, who wanted to prevent him from smoking his pipe. The conductor was young and nervous, as well as officious, and gave in. . . .

JAMES CONNOLLY: AN APPRECIATION[1]

JAMES CONNOLLY is Ireland's first socialist martyr. To say so is not a rhetorical flourish. It is simple historical fact that must be admitted even by those who dispute the wisdom of his actions and the excellence of his ideals. He died as a witness to his faith in the brotherhood of man as he wished to see it brought into being and shape in Ireland. Of all the leaders of the insurrection of Easter Monday, 1916, he was most in the tradition of Wolfe Tone and the United Irishmen. Wolfe Tone and the United Irishmen raised in Ireland the banner of the French Revolution. They were European as well as nationalist in their ideas, and none the less nationalist for being European. They believed in liberty, equality and fraternity, not as a piece of inky or street-corner cant, but as the three golden essentials of the common-wealth. They were Revolutionists both in theory and practice. They 'rejoiced', as the Volunteers of Belfast said, in 'this resur-rection of human nature', and they desired to bring about a similar resurrection in their own country. Since their time, Irish nationalism has seldom been revolutionary in the French sense. Fenianism aimed at political rather than social revolution. The Land Leaguers were modified revolutionaries on the social side, but modified constitutionalists in politics. The Young Ireland movement was Liberal rather than revolutionary, though it ended in a swift, tiny and impossible appeal to the sword. O'Connell, Butt, Parnell and Mr Redmond, though they are as far apart from each other in most respects as the four corners of the world, may all be classed as constitutionalists to the marrow of their bones. Among the great Irishmen of the nineteenth

century, indeed, there is only one who seems to have accepted the full inheritance of the French Revolution. This was James Fintan Lalor,[2] that strange, bitter-tongued hunchback of genius – 'deaf, near-sighted, ungainly and deformed' is Sir Charles Gavan Duffy's[3] description of him – who came out of the shadows in the time of the Great Famine and proclaimed his revolutionary faith in the pages of *The Irish Felon*. It was Lalor's ideas, according to Mr Standish O'Grady,[4] which, passing over with Mitchel[5] and others to America, were ultimately the source of the land-gospel preached in Henry George's *Progress and Poverty*.[6] But Lalor, unlike Henry George, wished to arm his ideas with a sword.

Any man [he wrote] who tells you that an act of armed resistance – even if offered by ten men only – even if offered by men armed with stones – any man who tells you that such an act of resistance is premature, imprudent, or dangerous – any and every such man should at once be spurned and spat at. For, remark you this and recollect it, that *somewhere*, and *somehow* and by *somebody*, *a beginning must* be made and that the *first* act of resistance is always, and must be ever, premature, imprudent and dangerous. Lexington was premature, Bunker's Hill was imprudent, and even Trenton was dangerous.[7]

One begins to understand the philosophy which underlay the events of Easter Week as one reads these perilous sentences. Connolly deliberately and consciously took up the mantle which fell sixty-seven years ago from Fintan Lalor's shoulders. And he took it up not only as a citizen of Ireland but as a citizen of the world. 'Fintan Lalor, like all the really dangerous revolutionaries in Ireland,' he once wrote, in a sentence in which he seems to be justifying his own attitude, 'advocated his principles as part of the creed of the democracy of the world, and not merely as applicable only to the incidents of the struggle of Ireland against England.'

These are two questions that bewilder many people as they consider the last act of Connolly's career. They ask wonderingly how it came about that so good a European as Connolly could remain apparently indifferent to the German menace to European liberty. The second thing that puzzles them is that a man

not merely of high character, but of strong intelligence, of experience of affairs, of, on the whole, orderly thought and speech – in fact, a man with his head as sound as his heart – should have consented to throw himself into a design so obviously incapable of success as the Easter Rising. As to the former question, the answer is probably simple enough. Connolly could not interest himself very deeply in a war which he interpreted, I imagine, as a struggle between one group of capitalist governments and another. If he could dismiss the Home Rule party and the Irish Unionist party equally as capitalist nuisances, both of which would inevitably take the same anti-popular side in the day of the grand class war, we may be sure that the German War appeared to him as a mere riot among the governments of Europe without significance for the labouring poor. It is clear at any rate that he did not agree with those of us who took the view that a victory for Germany which would give her mastery of the sea would end in a German conquest and colonization of Ireland, which would be still more efficiently destructive than the English conquest. He was so intensely preoccupied with the necessity of getting rid of the twofold burden of foreign rule and capitalism and establishing a free nation in Ireland, that a hypothetical German conquest may have seemed to him merely a phantom. In any case the whole energy of his mind had always been absorbed in the struggle between governments and peoples, not in the struggle between governments and governments, or even in the struggle between peoples. Probably he would have denied that a war between two real democracies was possible. And indeed if European society had been based on the socialist principles advocated by Connolly, even a blind man must see that the present war would never have taken place.

As to Connolly's motives in leading his followers into a hopeless insurrection, the words I have quoted from Lalor may provide us with a clue to an explanation. Some of the insurgent leaders, like P. H. Pearse, were dominated by a semi-mystical theory that it is the duty of every generation of Irishmen to shed their blood for Ireland until their country is free. They

feared that the Irish nation would perish unless some redeeming blood was shed for it in each new generation.

Their conception of a rising, one fancies, was in the nature of a sacrifice rather than of a victorious war. How far idealists have the right to make sacrifices which involve the sacrifice of so many other lives – how far, especially, they have the right to do so without having first obtained the sanction of the nation to which they belong – will always be a matter of dispute. But I am concerned here with discovering the insurgents' point of view rather than with criticizing it. Either to condemn or to justify them without having done one's best to understand their point of view would merely be to blur an important page of Irish history. Connolly, then, seems to me to have been governed by several considerations. In the first place he believed in violence as a method as sincerely as any old-fashioned warrior. He was a militant by instinct and philosophy. His *Labour in Irish History* is in great measure a history of the militancy of the Irish poor during the last two centuries. He rejoiced more over one little agrarian outbreak that the ordinary man has never heard of than over continents subdued by the white man's sword. He saw in every such outbreak the expression of the poor man's will to live. That an insurrection should fail did not depress him more than that a wave should break on the shore. He saw insurrection following insurrection apparently in vain, like wave following wave, but he still had faith in the hour when the tide would be full. Perhaps he was of an opinion similar to that of the Italian revolutionist who said: 'Italy will never live till Italians learn to die.' Connolly may have thought that socialist Ireland would never live till socialist Irishmen learned to die. If this view is correct, he regarded violence as a form of education, and the first blow as the first lesson for those who struck it.

But I cannot help thinking that there must have been despair as well as hope in his attitude in those last days. Like Lalor he was the child of a time of despair. Lalor's creed was affected by the spectacle of an Ireland tortured and laid waste by the potato famine – an Ireland in which more human beings perished of hunger and fever than would have been likely to

perish in any rebellion. Connolly's creed in the same way must
have been influenced by the spectacle of the perennial disaster
of Dublin slum life – disaster embittered by the failure of the
industrial war begun by Mr James Larkin.[8] Some readers may
remember that, during the great lock-out, the poet 'AE'[9] fore-
told the success of the employers in their policy of starving the
Dublin poor would necessarily lead to 'red ruin and the
breaking-up of laws'. 'AE' wrote a famous 'open letter' to the
employers in which he declared:

The men whose manhood you have broken will loathe you, and will always
be brooding and scheming to strike a fresh blow. The children will be taught
to curse you. The infant being moulded in the womb will have breathed into
its starved body that vitality of hate. It is not they – it is you who are blind
Samsons pulling down the pillars of social order.

Many men claim to have foretold the Easter insurrection.
Even Lord Midleton[10] – whose advice, if it had been taken,
would merely have produced an insurrection ten times more
wide-spread and more bloody – has publicly given himself the
airs of a prophet. But I think the sentences I have quoted from
'AE' were the most truly ominous that were uttered. It is a
bitter reflection that they fell on many deaf nationalist, as well
as unionist, ears. There is a popular idea abroad that the Easter
Rising was unforeseeable, that it was a rising without a cause,
that it was a rebellion for rebellion's sake. Statesmen and editors
like to comfort themselves with the thought that they at least
are free from bloodguiltiness in regard to it. But this is a mere
wearing of blinkers. The only case against the rebellion is, not
that it was a rebellion without a cause, but that it was more
likely to injure than to help forward the cause of Irish freedom
in which the insurgents so insuppressibly believed. I do not
expect the insurgents themselves to take that view of it. But
that is the case against the Rising from the point of view of
those who were opposed to it both before and after the event.
As for the causes of the Rising they are as plain to anyone who
looks for them as the Sugarloaf. One of them was British
unionism using Carsonism[11] as a spearhead to aim a deadly

blow at the national life of Ireland. The other of them was Irish capitalism using Murphyism[12] to crush the insurgent Irish poor. As for Carsonism, it not only came as a challenge to the Irish people to arm: it also burst open the gates through which a flood of arms began to pour into the country. After the gun-running at Larne and the Curragh mutiny[13] no Irish nationalist who was not a pacifist could avoid the conclusion that to fail to arm would be to leave Ireland with nothing but newspaper articles between her and the bullets of her enemies. There was never a people, I am sure, which was driven more slowly and reluctantly to learn the use of the rifle. Before the rich clubmen of London began to ship bales of cheques over to Belfast to buy arms for the Ulster Volunteers, Ireland was as blissfully addicted to constitutional politics as to the teapot. Old Fenians despaired, seeing her, as they thought, perishing of constitutionalism as of some kind of pernicious anaemia. When Ulster armed, and Leinster, Munster and Connacht went on as usual with the day's work, many Englishmen smiled and said that it was obvious Ireland did not want to have Home Rule half as strongly as Ulster wanted not to have it. They said that the arming of Ulster was the measure of the intensity of her feelings. What alternative was left to nationalism except to show that they too had feelings which could be recognized two or three hundred miles away as worthy of respect? Then came August 1914, and England began a war of the freedom of small nationalities by postponing the freedom of the only small nationality in Europe which it was in her power to liberate with a stroke of the pen. She called for a united front in the Three Kingdoms, but she would not consent to a united front of free institutions in the Three Kingdoms. She left Home Rule in a state of suspension, which was apparently meant to enable nationalists to pretend: 'All will be well at the end of the war,' and to enable Ulstermen also to pretend (in an entirely opposite sense), 'Yes, all will be well at the end of the war.' Thus, at the outbreak of the war, while England was given a great ideal, Ireland was given only a lie. Thousands of Irishmen, no doubt, insisted on making the great ideal their own, and in dying for it they have

consciously laid down their lives for Ireland. But others were unable to see the ideal for the lie, and they too of set purpose laid down their lives for Ireland. To blame Ulster for all this is sheer dishonesty. It is not Ulster, but the British backers of Ulster, who must bear the responsibility for all that has occurred within the last four or five years in Ireland. Ulster would have come to terms with the rest of Ireland long ago if the unionist leaders and the cavalry officers of the Curragh had told her plainly that she could no longer reckon on their support. The Ulster problem is at bottom not an Irish problem but an English problem; and it is for England to settle it.

It is not, I admit, primarily, as the antagonist of what may be called Carsonism that one thinks of Connolly. It was against Murphyism that he fought most of his battles – except the last. At the same time, one cannot ignore Carsonism in writing about him, because it was Carsonism which taught him how to create his Citizen Army, and it was Carsonism which prepared the way for the creation of the Irish – popularly called the Sinn Féin – Volunteers, in alliance with which the Citizen Army fought through Easter Week. People are still arguing as to whether the Easter Rising was a rising mainly on the part of the Irish Volunteers or mainly on the part of the Citizen Army. I know one distinguished Irishman who contends that it was the Citizen Army which supplied both the driving force and the majority of the men. He estimates that altogether there were about 1100 men engaged in the Dublin Rising, and that of these about 800 were followers of Connolly. Connolly, he declares, hoodwinked the authorities by never allowing more than a hundred of his men to appear in public at a time, with the result that the police came to regard them as a small and negligible body. This may be true, but I can find no one else who is of the same opinion. On the other hand, it is commonly held that, though Connolly did not provide the mass of the insurgents, he provided the immediate impulse of the insurrection. His soul was on fire not merely with an ideal, like the souls of most of the other leaders, but with the visible wrongs of thousands of men and women thrust back by the triumph of

the Dublin employers to the edge of starvation and despair. I do not mean to say that the other leaders were untouched by these wrongs – Pearse especially is said to have absorbed the social ideals of Connolly in recent years – but none of them descended into the hell of Irish poverty with the same burning heart. Connolly has written the Inferno of Irish poverty in *The Re-Conquest of Ireland*, which was first published in 1915 as a sixpenny pamphlet in a red paper cover with a design in stars and swords. *The Re-Conquest of Ireland* is Ireland's case against Murphyism. I have heard it said that Mr W. M. Murphy is a good employer as Dublin employers go, and I am willing to believe it. But who can doubt that the triumph of Murphyism in the great lock-out of 1913-14 meant the triumph of a system which perpetuates conditions of poverty and misery utterly abhorrent to the modern civilized man? To Connolly, Dublin was in one respect a vast charnel-house of the poor. He quotes figures showing that in 1908 the death rate in Dublin City was 23 per 1000 as compared with a mean death-rate of 15.8 in the seventy-six largest English towns. He then quotes other figures showing that while among the professional and independent classes of Dublin children under five die at a rate of 0.9 per 1000 of the population of the class, the rate among the labouring poor is 27.7. To acquiesce in conditions such as are revealed in these figures is to be guilty of something like child-murder. And to Connolly capitalist society as he saw its effects in Ireland was simply organized child-murder. We endure such things because it is the tradition of comfortable people to endure them. But it would be impossible for any people that had had its social conscience awakened to endure them for a day. Connolly was the pioneer of the social conscience of Ireland. He was, like many pioneers, rude and destructive in some of his methods. But let those blame him who have realized with the same passion of unselfishness the lot of the poor child born into an inheritance of not enough food, not enough clothes, not enough warmth, not enough light, not enough air, not enough laughter, not enough cleanliness, not enough of anything except hunger and sickness and funerals. Connolly gave

up his life to the fight with the evil conditions which exacted this tribute of human victims. His death was a prophecy of the liberation of an earth which only a system of imperialism and capitalism – aided, to be sure, by the Devil – keeps from being a home of kings and heroes and golden plenty.

Connolly had behind him a long record of apparently hopeless work for socialism in Ireland before he came into prominence as Mr Larkin's second-in-command in the Irish Transport Workers' Union. The first that I ever heard of him was when, as a student in Belfast, I belonged to a small socialist society which met in a dusty upper room, illuminated by candles stuck in empty gin-bottles. One of the members used to bring copies of Connolly's paper, *The Workers' Republic*, to sell at our meetings. But most of us, I think, were indifferent to what we regarded as sentimental nationalism. We rejected almost unanimously a proposal to adopt as our colours orange and green, and as our crest the clasped hands of the United Irishmen. We were doctrinaire internationalists in those days, and scarcely realized, as many of us now do, that imperialism equally with capitalism means the exploitation of the weak by the strong. Socialism seemed to us like a creed for the world, while we regarded nationalism as a mere noisy indulgence in flags and bands not different in kind from the patriotism of London stockbrokers. Connolly's lesson to Ireland was the essential unity of the nationalist and socialist ideals. Socialism with him was not a means towards a vast cosmopolitan commonness. It was a means towards a richer individual life both for human beings and for nations. True internationalism, he saw, involved a brotherhood of equal nations as well as a brotherhood of equal citizens. He afterwards propagated his theories in a paper called *The Harp*, and on the platforms of the organization called Cumannacht na hÉireann or (in English) the Socialist Party of Ireland. The Irish Transport Workers' Union, the famous Liberty Hall organization, in which he became the leading figure after the departure of Mr Larkin, was a grand attempt to introduce nationalism into trade unionism. Connolly was anxious to see workers in different countries

helping each other, but he believed that the workers in each country had their own special problems to face, and that for this reason they should be organized on a national basis. Thus he asserted the independence of Irish labour, but he had no objection to calling in the aid of English labour against the Irish capitalist, and, we may be sure, he would not have grudged any help that the Irish workers could give English labour in similar circumstances. It was one of the strange ironies of modern Irish life that, during the Dublin lock-out, Irish Tories appealed to the workers to reject English aid and interference as something foreign and un-Irish. Connolly was too pro-English as well as too pro-Irish for the Tories. During the lock-out, indeed, he was opposed equally in unionist, Redmondite and Sinn Féin circles. He – or rather he and Mr Larkin – had the intellectuals and the poor on his side, but he had all the press and all the parties against him. There were scenes of almost riotous fury when at the height of the crisis the Larkinites attempted to send off a number of destitute Dublin children to be cared for in hospitable English homes till the starvation was over. It was, I think, a mistaken policy, but nothing can excuse the campaign of falsehood and frenzy set on foot by those opposed to it. One would have thought from some of the rumours that were spread, that it was a plot to convert Irish children to Agnosticism or to kidnap them into the white slave traffic. Sheehy-Skeffington[14] was a prominent figure on the side of the Larkinites during the scenes of street violence which followed. He too, like Connolly, was a herald of the next generation, and was always charging with the destructive torch of his courage into the thick of the sectarian and party animosities of his day.

Connolly, however, was not a heretic, a lonely lover of the unpopular cause, to the extent to which Skeffington was. He was less of an intellectual and more of a practical statesman. He saw that a hundred good causes go to the building of a nation, and he desired that they should all march forward not as rivals but in union. He believed in a co-operative commonwealth in which the ideals of Sir Horace Plunkett,[15] the Gaelic Leaguer, the Suffragist, the Republican, the Christian, and the Sinn

Féiner should all be harmonized. Though he advocated the class war, he was interested in other things besides the class war. He aimed, like Sir Horace Plunkett, at the reconstruction of Irish civilization, but he aimed at its reconstruction on the basis of the civilization which had given Ireland a place in the community of nations before the Dane and the Norman had laid it waste with fire and sword. He wanted to go back as well as forward to the Golden Age – to recover the old Gaelic fellowship and culture of which Mrs J. R. Green[16] is the historian. Democracy did not mean to him a hard-and-fast theory or an invented political machine. It meant the rediscovery of an ancient justice to see socialism not as something imported from the Continent but as a development of the best tradition of Irish life.

In favourable circumstances, I imagine, he would have sought to achieve his dream not with the rifle but with the vote. I have called him a militant, but he was also a man ready to do his utmost by peaceful methods till he felt that no way was left open to him but the way of violence. *The Re-Conquest of Ireland* is in part taken up with the recommendation of the ballot-box to Irish workers. But it was obvious that all the ballot-boxes in Ireland at the time of the strike were no remedy against immediate economic disaster. And, after the failure of the strike, the economic disaster of the Dublin poor must have seemed irretrievable by anything short of a miracle. Connolly saw the strong growing stronger and the weak growing weaker, and he may have thought that all that was left for a brave man to do was to put himself at the head of the weak and to lead them in one last desperate assault on the invincible powers of evil. The alternatives that presented themselves to him were, in his view, to go down fighting or to go down without striking a blow. And he was not the man to go down without a blow. This question of Connolly's mood and purpose in the insurrection is one to which one returns in perplexity again and again. Did he expect to win? Did he expect the Germans to send assistance over the wreck of a defeated British Navy? Did he imagine that Ireland would rise and defeat the most gigantic British Army that is known to history? Did he believe that a

rifle was of any avail against modern artillery? I have discussed
these questions with many people, and everybody has his own
answer. The most convincing answer I got was from T. M.
Kettle when I saw him for the last time in Dublin in July. 'No,'
he said, 'I don't think Connolly expected to win. Connolly was
a man of brains. It seems to me that if you want to explain
Connolly, you can only do so on the lines of that poem of
Francis Adams's,[17] 'Anarchists'. You know it, don't you?'

"'Tis not when I am here,
 In these homeless homes,
Where sin and shame and disease
 And foul death comes.

'Tis not when heart and brain
 Would be still and forget
Men and women and children
 Dragged down to the pit:

But when I hear them declaiming
 Of "liberty", "order", and "law",
The husk-hearted Gentleman
 And the mud-hearted Bourgeois,

Then a sombre hateful desire
 Burns up slow in my breast
To wreck the great guilty Temple
 And give us rest!'

'Connolly', he went on, 'felt the intolerable outrage of the
triumph of –

The husk-hearted Gentleman
 And the mud-hearted Bourgeois.'

Then Kettle repeated with that deliberate passionate
eloquence, which made his melancholy seem at times not a
weakness but a power, the last verse of the poem:

'– a sombre hateful desire
 Burns up slow in my breast
To wreck the great guilty Temple
 And give us rest!'

That seems to me to be the true interpretation of the last passion of James Connolly.

No, not the last. There was one more passion to come. Wounded and with a leg shattered, Connolly, who was Commandant-General of the Dublin Division of the Republic Army was taken prisoner. He was not among the first of the leaders to be shot. It was understood that there was a feeling against the execution of a wounded man. The Austrians a few weeks later caused a thrill of horror by executing one of their rebel Italian subjects who happened to be badly wounded. In England as well as Ireland there were numerous appeals for clemency in the case of Connolly and John MacDermott.[18] The *Irish Independent* – alone among the nationalist papers, I think – warned the government against clemency as a peril. In the result Connolly was taken out and shot. His conduct during his imprisonment and at his execution is said to have made a deep impression on the soldiers. Like Roger Casement, he died without bitterness. He bequeathed a creed and an example not only to Ireland but to the world.

Here then is a book of the ideas for which he lived and died. It is a book of a hard-working propagandist, not of a leisured scholar; but none the less it is a book of infinite importance to Ireland. *Labour in Irish History* is a bold and powerful attempt to write a chapter of history that had never been written before; and *The Re-Conquest of Ireland* is a documented account of the exploitation of the Irish people, Catholic and Protestant, both in the past and in the present. One does not need to accept the point of view of the insurgent leaders in order to realize the value of Connolly's work as a socialist historian and propagandist. Syndicalist, incendiary, agitator – call him what you will: it still remains true that his was the most vital democratic mind in the Ireland of his day.

5

THE WORK OF T. M. KETTLE[1]

TO HAVE WRITTEN books and to have died in battle has been a common enough fate in the last few years. But not many of the young men who have fallen in the war have left us with such a sense of perished genius as Lieutenant T. M. Kettle, who was killed at Ginchy. He was one of those men who have almost too many gifts to succeed. He had the gift of letters and the gift of politics: he was a mathematician, an economist, a barrister, and a philosopher: he was a Bohemian as well as a scholar: as one listened to him, one suspected at times that he must be one of the most brilliant conversationalists of the age. He lived in a blaze of adoration as a student, and, though this adoration was tempered by the abuse of opponents in his later years, he still had a way of going about as a conqueror with his charm. Had he only had a little ordinariness in his composition to harden him, he would almost certainly have ended as the leading Irish statesman of his day. He was undoubtedly ambitious of success in the grand style. But with his ambition went the mood of Ecclesiastes, which reminded him of the vanity of ambition. In his youth he adhered to Herbert Spencer's[2] much-quoted saying: 'What I need to realize is how infinitesimal is the importance of anything I can do, and how infinitely important it is that I should do it.' But, while with Spencer this was a call to action, with Kettle it was rather a call to meditation, to discussion. He was the Hamlet of modern Ireland. And it is interesting to remember that in one of his early essays he defended Hamlet against the common charge of 'inability to act', and protested that he was the victim, not of a vacillating will, but of the fates.

He contended that, so great were the issues and so dubious the evidence, Hamlet had every right to hesitate. 'The commercial blandness', he wrote, 'with which people talk of Hamlet's "plain duty" makes one wonder if they recognize such a thing as plain morality. The "removal" of an uncle without due process of law and on the unsupported evidence of an unsub-poenable ghost; the widowing of a mother and her casting-off as unspeakably vile, are treated as enterprises about which a man has no right to hesitate or even to feel unhappy.' This is not mere speciousness. There is the commonsense of pessimism in it too.

The normal Irish man of letters begins as something of a Utopian. Kettle was always too much of a pessimist – he himself would have said a realist – to yield easily to romance. As a very young man he edited in Dublin a paper called *The Nationalist*, for which he claimed, above all things, that it stood for 'realism' in politics. Some men are driven into revolution by despair: it was as though Kettle had been driven into reform by despair. He admired the Utopians, but he could not share their faith. 'If one never got tired,' he wrote in a sketch of the International Socialist Congress at Stuttgart in 1907, 'one would always be with the revolutionaries, the re-makers, with Fourier[3] and Kropotkin.[4] But the soul's energy is strictly limited; and with weariness there comes the need for compromise, for "machines", for reputation, for routine. Fatigue is the begin-ning of political wisdom.' One finds the same strain of melancholy transmuting itself into gaiety with an epigram in much of his work. His appreciation of Anatole France[5] is the appreciation of a kindred spirit. In an essay called 'The Fatigue of Anatole France' in *The Day's Burden*[6] he defended his author's pessimistic attitude as he might have defended his own:

A pessimism, stabbed and gashed with the radiance of epigrams, as a thundercloud is stabbed by lightning, is a type of spiritual life far from contemptible. A reasonable sadness, chastened by the music of consummate prose, is an attitude and an achievement that will help many men to bear with more resignation the burden of our century.

How wonderfully, again, he portrays the Hamlet doubts of Anatole France, when, speaking of his bust, he says: 'It is the face of a soldier ready to die for a flag in which he does not entirely believe.' And he goes on:

He looks out at you like a veteran of the lost cause of intellect, to whose soul the trumpet of defeat strikes with as mournful and vehement a music as to that of Pascal himself, but who thinks that a wise man may be permitted to hearten himself up in evil days with an anecdote after the manner of his master Rabelais.

Kettle himself practised just such a gloom shot with gaiety. He did not, however, share Anatole France's gaiety of unbelief. In some ways he was more nearly akin to Villiers de l'Isle Adam,[7] with his religion and his love of the fine gesture. Had he been a Frenchman of an earlier generation, he would have been famous for his talk, like Villiers, in the cafés. Most people who knew him contend that he talked even better than he wrote; but one gets a good enough example of his ruling mood and attitude in the fine essay called 'On Saying Good-bye'. Meditating on life as 'a sustained good-bye', he writes:

Life is a cheap *table d'hôte* in a rather dirty restaurant, with Time changing the plates before you have had enough of anything.

We were bewildered at school to be told that walking was a perpetual falling. But life is, in a far more significant way, a perpetual dying. Death is not an eccentricity, but a settled habit of the universe. The drums of today call to us, as they call to young Fortinbras in the fifth act of *Hamlet*, over corpses piled up in such abundance as to be almost ridiculous. We praise the pioneer, but we praise him on wrong grounds. His strength lies not in his leaning out to new things – that may be mere curiosity – but in his power to abandon old things. All his courage is a courage of adieus.

This meditativeness on the passing nature of things is one of the old moods of mankind. Kettle, however, was one of the men of our time in whom it has achieved imaginative expression. I remember his once saying, in regard to some hostile criticisms that had been passed on his own 'power to abandon old things': 'The whole world is nothing but the story of a renegade. The bud is renegade to the tree, and the flower to the bud, and the fruit to the flower.' Though he rejoiced in change as a politician, however,

he bewailed the necessity of change as a philosopher. His praise of death in the essay I have just quoted from is the praise of something that will put an end to changes and good-byes:

There is only one journey, as it seems to me . . . in which we attain our ideal of going away and going home at the same time. Death, normally encountered, has all the attractions of suicide without any of its horrors. The old woman –

an old woman previously mentioned who complained that 'the only bothersome thing about walking was that the miles began at the wrong end' –

the old woman when she comes to that road will find the miles beginning at the right end. We shall all bid our first real adieu to those brother-jesters of ours, Time and Space; and though the handkerchiefs flutter, no lack of courage will have power to cheat or defeat us. 'However amusing the comedy may have been,' wrote Pascal, 'there is always blood in the fifth act. They scatter a little dust in your face; and then all is over for ever.' Blood there may be, but blood does not necessarily mean tragedy. The wisdom of humility bids us pray that in that fifth act we may have good lines and a timely exit; but, fine or feeble, there is comfort in breaking the parting word into its two significant halves, à Dieu. Since life has been a constant slipping from one good-bye to another, why should we fear that sole good-bye which promises to cancel all its forerunners?

There you have a passage which, in the light of events, seems strangely prophetic. Kettle certainly got his 'good lines' at Ginchy. He gave his life greatly for his ideal of a free Ireland in a free Europe.

This suggests that underlying his Hamlet there was a man of action as surely as there was a jester. He was a man with a genius for rising to the occasion – for saying the fine word and doing the fine thing. He compromised often, in accordance with his 'realistic' view of things; but he never compromised in his belief in the necessity of large and European ideals in Ireland. He stood by all good causes, not as an extremist, but as a helper somewhat disillusioned. But his disillusionment never made him feeble in the middle of the fight. He was the sworn foe of the belittlers of Ireland. One will get an idea of the passion with which he fought for the traditional Ireland, as

well as for the Ireland of coming days, if one turns to his rhymed reply to a living English poet who had urged the Irish to forget their history and gently cease to be a nation. The last lines of this poem – 'Reason in Rhyme', as he called it – are his testament to England no less than his call to Europeanism is his testament to Ireland:

> Bond, from the toil of hate we may not cease;
> Free, we are free to be your friend;
> And when you make your banquet and we come,
> Soldier with equal soldier must we sit,
> Closing a battle, not forgetting it.
> With not a name to hide,
> This mate and mother of valiant 'rebels' dead
> Must come with all her history on her head.
> We keep the past for pride:
> No deepest peace shall strike our poets dumb:
> No rawest squad of all Death's volunteers,
> No rudest men who died
> To tear your flag down in the bitter years,
> But shall have praise, and three times thrice again,
> When at the table men shall drink with men.

That was Kettle's mood to the last. This was the mood that made him regard with such horror the execution of Pearse and Connolly, and the other leaders of the Dublin insurrection. He regarded these men as having all but destroyed his dream of an Ireland enjoying the freedom of Europe. But he did not believe that any English government possessed the right to be merciless in Ireland. The murder of Sheehy-Skeffington, who was his brother-in-law, cast another shadow over his imagination from which he never recovered. Only a week before he died he wrote to me from France: 'The Skeffington case oppresses me with horror.'[8] When I saw him in the previous July, he talked like a man whose heart Easter Week and its terrible retributions had broken. But there must have been exaltation in those days just before his death, as one gathers from the last, or all but the last, of his letters home:

We are moving up tonight into the battle of the Somme. The bombardment, destruction, and bloodshed are beyond all imagination, nor did I ever think that the valour of simple men could be quite as beautiful as that of my Dublin Fusiliers. I have had two chances of leaving them – one on sick leave and one to take a staff job. I have chosen to stay with my comrades.

There at the end you have the grand gesture. There you have the 'good lines' that Kettle had always desired.

ARTHUR GRIFFITH: THE PATRIOT[1]

BETWEEN THIRTY AND FORTY years ago a little man in pince-nez sat in a little upstairs room in a mean street in Dublin, and, surrounded by a litter of newspapers and correspondence on his desk and on the floor, made plans for the resurrection of his country. He looked as little of a dreamer as an ordinary French politician. He seldom made any display of enthusiasm, and he did not take the display of enthusiasm by other people very seriously. He seemed to regard eloquence as one of the vices of his countrymen, and to think that the country would be greatly benefited if speech-making ceased and demonstrations with bands and banners were abolished. He himself cultivated the reticence of a Parnell. He was one of the most profoundly emotional men in Ireland, but his emotions were kept under iron control. One had only to look at his abnormally developed jaw muscles and his square, powerful shoulders to realize the strength of will that lay behind his habitual quietness.

It required more than ordinary strength of will to set out hopefully on the task which he had undertaken. He possessed neither money nor a popular following; and most people who had heard of his paper[2] – and they were a small minority of his countrymen – were convinced that he would never be anything more than an insignificant doctrinaire with a gift for saying bitter things about England and the Parliamentary Party. His few adherents were called 'rainbow chasers' by some and 'cranks and soreheads' by others. They included, it is true, a number of city councillors as well as a number of poets; but, for the most part, the country remained perfectly indifferent to them.

Arthur Griffith was not in the ordinary sense of the word an extremist. He believed that the extremist policy of physical force by which the Fenians had hoped to win the freedom of Ireland could result only in defeat and in a reaction which would weaken the Irish power of resistance for another generation. On the other hand, he believed that the policy of sending a delegation to Westminster to ask for reforms and for half-measures was humiliating and was turning Ireland into an English province. The Irish nation, he held, could be saved only by a policy which combined the pugnacity and pride of Fenianism with a constructive national movement which, unlike a physical force movement, could not be crushed at a blow.

He discovered his policy while reading – some say, misreading – Hungarian history. He based it, not on theoretic republicanism, but on a demand for the return of the Constitution of 1782.[3] Or it might be more accurate to say that he proposed to set up an Irish parliament without England's consent, to establish Irish law courts, to build up national industries, to make the schools centres of Irish culture, to make every county and district council what was called an 'outpost of Irish nationhood'. The name of the policy was altered after a time from the 'Hungarian policy' to the 'Sinn Féin policy', and by 'Sinn Féin' Griffith did not mean national selfishness, but national self-confidence and national self-dependence. He held that Ireland need not wait to be a nation until it obtained the consent of the British Parliament, but that every individual Irishman was the Irish nation in little – that it was in his power immediately to begin to rebuild the national life of his country, and by combination with others equally devoted and determined ultimately to regain its liberty.

Now it so happens that, but for that policy, the Irish Free State would not be in existence today. Many people seem to think that the Irish Free State was won by physical force assisted by the sympathies of those in England and in other countries who were outraged by the methods of the Black and Tans. The truth is, however, that what brought the last insurrection to a

successful issue was that, unlike all other Irish movements of the kind, it was based on, or, at least, allied to, the passive resistance movement of Arthur Griffith. After the release of the 1916 prisoners, it is doubtful whether a new physical force movement could have been organized with any hope of success, if the framework of passive resistance had not been planned and brought into existence – a national parliament set up in Dublin, national law courts set up and obeyed throughout the country, national police parading the streets within sight of the official police. It was this framework of passive resistance that enabled the Irish national movement to reorganize in the years after the war.

It is all the stranger to remember that a little before the war both Sinn Féin and the Irish Republican Brotherhood seemed to most people to be on the point of death. It has been said that at the time all the members of the Irish Republican Brotherhood could have been crowded into a concert hall and, Griffith's attempt to run a daily paper having failed, his small party seemed to be disappearing for ever. The hope of Home Rule made the mass of nationalist Irishmen indifferent to all rival policies. If Ulster had not armed it is possible that the ordinary Englishman today would never have known that such a policy as 'Sinn Féin' existed.

It was of Griffith the man, however, not of his policy, that I thought when I read that last Sunday a procession of his fellow-countrymen was forbidden to lay flowers on his tomb. History, I believe, will regard him as the greatest constructive mind – or, at least, the most effective constructive mind – that was ever devoted to Irish politics. His mind was in one sense narrow: he was capable of bitter injustice to political opponents. At the same time, he had a large-minded conception of nationality and wished to create an Irish civilization that would be as acceptable ultimately to the old unionists as to the nationalists. Politically, he preached hatred of England, but he looked forward to peace with England as the ideal. 'I want peace with England,' he declared in one of his speeches, 'but first let England take her one hand off Ireland's throat and her other

hand out of Ireland's pocket.' He automatically in the meantime took sides against England in international politics. His paper was suppressed during the war as a seditious organ. He immediately brought out another paper, *Scissors and Paste*, consisting exclusively of passages from the English press which had already been passed by the censor. He made these innocent passages look so seditious that *Scissors and Paste* was also suppressed.

He took no part in the Rising of 1916, and, it is believed, was not in favour of it. He was arrested all the same, however, and kept in solitude in Wandsworth Jail apart from the other prisoners as a specially dangerous revolutionary. He was the most cheerful of prisoners and made no attempt to prove his innocence. When he was offered his liberty on condition that he would sign a paper promising to abstain from revolutionary activity, he asked to be allowed to read it and then quietly tore it in pieces and threw it on the ground as his answer.

When he was allowed to mingle with his fellow-prisoners in another jail, his calm cheerfulness did much to make prison life bearable to them. He was most cheerful when there was least obvious reason to be cheerful. He was equally imperturbable in Dublin in later years when men in his position lived in constant danger. High-strung, like all great journalists, he was, nevertheless, incapable either of panic or of despair, and the worse Dublin Castle behaved, the more confident he became of the approaching freedom of Ireland. When the Treaty came he was realist enough to see that here was a measure of freedom which, apart from the secession of the Six Counties, in effect repealed not only the Union but the Conquest. His fight for the Treaty and the strain of seeing a civil war raging over what seemed to him to be an empty phrase, just at the moment of triumph, killed him. Like John Mitchel,[4] he 'cared not twopence' for republicanism in the abstract; he cared only for the freedom of his country. One can scarcely think of him, indeed, without thinking of Mitchel – Mitchel of whom he once wrote: 'When the Irish Nation needs explanation or apology for John Mitchel the Irish Nation will need its shroud.' History, I imagine, will speak in the same terms of Arthur Griffith.

G. B. S. AS IDOL

I AM SURE no one would have been more sceptical than Bernard Shaw himself if, at the beginning of the century, a gipsy fortune-teller had told him that he would live to be one of the most popular writers in England. Then and for many years afterwards he had an unrivalled capacity for infuriating the ordinary Englishman into searching in his vocabulary for epithets violent enough to be flung at the most conceited imposter and mountebank of all time.

The ordinary Englishman, it is true, knew little about him; but some of the audacious sayings of G. B. S. had begun to creep into the newspapers, and people found it hard to be patient with a man who seemed not only to be a socialist, an atheist, and an all-round crank, but to take a particular pleasure in abusing Shakespeare and suggesting that he could write better himself. One night, I remember, when I was crossing in the boat from Liverpool to Belfast, I introduced two men to each other, one of whom foamed at the mouth, as the saying is, about some remark of Shaw's that had recently been quoted in the press. 'Do you hate Shaw?' the other asked, his eyes brightening. 'I loathe and detest him,' replied the first. 'Shake hands,' said the other warmly, and they wrung each other's hands like men swearing blood-brotherhood.

I myself never shared the common antipathy to Shaw. When I heard of him first, I was a devoted and, indeed, a devotional reader of the *Clarion*, in which A. M. Thompson,[1] writing on the theatre over the pseudonym 'Dangle', made frequent lauda-tory references to him; and I was not so badly shocked as I

might otherwise have been when I came on the famous dramatic criticisms signed 'G. B. S.' in the *Saturday Review*. It was certainly startling to find a journalist 'giving cheek', as it were, to Shakespeare; but this was the most amusing 'cheek' of the kind I had ever read. One enjoyed it as one would have enjoyed a sparkling heretical speech by a youth of enormous talent at a college debating society. In such circumstances it scarcely matters what side the speaker takes or whether he is entirely serious. One is carried away by the brilliance of the performance.

As a regular galleryite in the local theatre, hungering for news of the great plays and players of London, I was, of course, immensely interested in Shaw's criticisms; but I delighted in them chiefly because of the character G. B. S., who appeared in them, as at an earlier age I had delighted in the very different character R. L. S., who appeared in the writing of Stevenson.

When I first came to London in 1901, or whenever it was, it was Shaw, of all the great inhabitants of the place, whom I most wished to see. As a boy I had worshipped Joseph Chamberlain,[2] but now I would have walked miles farther to see Shaw than to see Chamberlain. The first time I saw him, I think, was when he gave a Sunday afternoon lecture on Shakespeare in the smaller St James's Hall. The subject he discussed was *All's Well That Ends Well*, which most of the audience, I am sure, like myself, had always found one of the least enjoyable of Shakespeare's plays. Shaw, however, proved to his own satisfaction and to the great entertainment of the rest of us, that it was one of Shakespeare's most remarkable achievements, infinitely to be preferred to such pot-boilers as *Twelfth Night* and *As You Like It*, and that in his heroine of the play Shakespeare had anticipated the New Woman of our own time – an emancipated woman doctor. He also portrayed her as the eternal feminine who, like the later-born Ann Whitfield in *Man and Superman*, pursues her mate without ruth and without rest. The notion that it is the woman who pursues the man, not the man the woman, was then a novelty that, played with by Shaw, kept his audience in a long succession of ripples of laughter.

The next time I saw him, he was speaking in Queen's Hall at a meeting held to protest against Tsarist Russia's barbarous treatment of its revolutionaries. The previous speakers had been ablaze with passion and rhetoric, when Shaw, stepping towards the edge of the platform and standing with one arm akimbo, set out to prove that they had all been denouncing the Tsar and his government for the wrong reasons, and suggesting quite a number of different reasons for condemning them. And with such skill did he press his arguments that the same people who had been applauding the rhetorical earnestness of the earlier speakers were even more delighted as with characteristic comic seriousness Shaw turned them inside out.

Later came the great Vedrenne-Barker[3] season of matinées at the Court Theatre at which play after play of Shaw's was produced. I was lucky at the time, for I was writing for a paper everybody on the staff of which, except myself, detested the theatre, so that I slipped into the job of dramatic critic. I was still young enough to think and feel in superlatives; and I have never come out of the theatre with more superlatives ringing in my brain than after the first performance of *John Bull's Other Island*. I remember declaring in my criticism of the play that not since Aristophanes had anything to equal it been written for the comic stage. I had not even a nodding acquaintance with most of the plays that had been written for the comic stage since Aristophanes, but that did not matter. I was convinced that Shaw was the greatest of living writers, and that he could hold his own in comparison even with the mighty dead.

It was a few years after this that I first met him. He had come to a week-end party, organized by the Webbs,[4] at the Beacon Hotel at Hindhead, and I, too, was a member of the party. After dinner on Saturday evening, Sylvia came up to me and said: 'Come and be introduced to Bernard Shaw.' As I went into the lounge and approached the tall figure standing by the fireplace, I trembled with excitement – the excitement of joy – as never on any other occasion in my life have I trembled before mortal man. My heart was like a singing-bird; and fortunately Shaw did nearly all the talking, for I doubt whether

I could have articulated more than a very short sentence, so great was my ecstasy. Then, when, after a few minutes, he said: 'Do you feel disposed for a walk?' it was as if I had been shot upwards from the sixth heaven into the seventh. As I hurried to get my hat, I remember hoping passionately that he would not, before I returned, have asked someone else to join us. To go for a walk with Bernard Shaw, and to be the only person going for a walk with him – outside the realm of love, what could life offer better than that?

As we walked, I soon found that Shaw wore seven-league boots, and that he could apparently see in the dark. We reached the common, and he took me by invisible ways through the deep night at a pace that I could not have kept up with if my strength had not been made as the strength of ten by walking beside a god. And all the time he talked – delightful natural talk about people, especially the Webbs and his wife (whom he always spoke of simply as 'Charlotte'5), and his plays, and all sorts of things. I use the word 'natural' because no man commonly accused of being a *poseur* ever talked with less affectation than Shaw. He may have claimed in print to be in some aspects superior to Shakespeare, but in conversation he is the least 'superior person' who ever breathed.

The explanation of this is that he is one of the most good-natured men alive. He gives himself generously in his conversation to his listeners, and, though he enjoys charming them, you would never suspect him of setting out deliberately to charm them. His charm is of the essence of his nature. Otherwise how could he have achieved his enormous popularity in spite of the fact that he repeatedly outrages the finer feelings and the deep-seated beliefs even of many of his idolaters?

Some people attribute his readiness to be interviewed by the press on every conceivable subject from 'What do you think of Buddhism?' to 'What is your favourite pudding?' to his love of advertisement, and he certainly began his career with the determination to advertise himself, his beliefs, and his wares. At the same time, the journalist who goes to see him soon becomes aware of the exceptional courtesy and kindness of the

man. I remember being sent to interview him at Torquay after the outbreak of war in the summer of 1914. He asked me to go up to his suite in the hydro, where Mrs Shaw was sitting, and said: 'Why should you bother with this interview? Sit down there and talk to Charlotte, and I'll write something myself.' And while Mrs Shaw and I talked he sat with a pad on his knee, writing at full speed, and joining in the conversation when he felt inclined, for apparently he can write and listen and talk at the same time. When he had finished he handed me a wonderful article with not a word said about the price to be paid. Next morning we had another seven-league-boot walk along the uneven coast path, in the course of which I gathered that Napoleon had won the battle of Waterloo.

Do I still idolize him? I certainly think that, of all prose-writers whose work I know, he is the most secure of immortality. I occasionally wobble in regard to this, but when I see one of his plays again, I am astonished to find how fresh it remains, how much less dated than I expected. His opinions on religion and politics often goad me into contradiction; but his genius, to my mind, is that of an artist, not of a sage. As a man – well, how can I ever forget my ecstatic experience at Hindhead? I remember it as Wordsworth remembered the daffodils, and, as I remember it, I wouldn't change places with Wordsworth.

WILLIAM BUTLER YEATS

W. B. YEATS, before he died, had become one of the most famous of poets, some of whose work at least was known to every schoolboy and schoolgirl. Yet, until he was middle-aged, he received only the most grudging reward from the world to which he gave so ungrudgingly of his art. 'Until I was near fifty,' he once said, 'my writing never brought me more than two hundred a year, and most often less.' Such was his comparative poverty, indeed, that in 1910, when he was forty-five years old, he was compelled to accept a Civil List pension of £150.

He was a pure artist, above most of his literary contemporaries. And he was not only a great artist himself but a great missionary of art, devoting himself to the founding of a literary and dramatic movement that was to make his country honoured among the nations. Most people, looking at him in his early life, with his long black hair, his loose tie, and his pale hands, would have thought that here was an unpractical dreamer unfit for the business of organization. But Yeats possessed boundless spiritual energy and enthusiasm and was at the same time as hard-headed as any business man in committee work. He once said: ' I would rather see a young writer a drunkard than serving on a committee'; but he was thinking at the time of young writers who join political societies. He himself created through committees no less effectively than as a poet.

I have dwelt on this side of Yeats's character because he was one of the few men of the first genius who have set out deliberately to create a national literature. And, if the Irish literary revival is one of the most famous events of our time, it is to the

passion and propaganda of W. B. Yeats that most of the praise must be given. From a superficial glance at his earlier poems, one might have thought that he was one of the unlikeliest of men to create a new and distinctive Irish literature. There were Pre-Raphaelite influences in his work which, one would have said, reflected the taste of sophisticated London rather than of the Irish people, and the 'pale brows, still hands, and dim hair' that appear in his verse suggested an imagination grown weary rather than rejuvenescent. Yeats, however, drew imaginative vigour from the face of the Irish countryside, from Irish legends and the stories handed down in the houses of the poor, and – it should never be forgotten – from Irish politics. Had it not been for his friendship with the old Fenian, John O'Leary,[1] and his interest in revolutionary politics, Yeats might well have been a poet of smaller stature than he ultimately became.

He himself rebelled repeatedly against this absorption in politics. There was a time when he maintained that for an artist politics are impure, and when some of his old associates thought of him as a renegade. In one of his poems he speaks bitterly of the patriotism on which he had spent so much of his life:

> All things can tempt me from this craft of verse:
> One time it was a woman's face, or worse –
> The seeming needs of my fool-driven land;
> Now nothing but comes readier to the hand
> Than this accustomed toil. When I was young,
> I had not given a penny for a song
> Did not the poet sing it with such airs
> That one believed he had a sword upstairs;
> Yet would be now, could I but have my wish,
> Colder and dumber and deafer than a fish.

It was probably the divided, tumultuous nature expressed in these lines that converted Yeats from a minor into a major poet, and, indeed, there are traces of the minor poet in his early work that only fiery passion could have burnt away. If he had lived in an atmosphere free from political turmoil, he might easily have made an aesthetic cult of Beauty with a capital B; and for the making of great poetry Beauty with a capital B is not enough.

If you compare a fairly early poem of Yeats's, 'He gives his Beloved certain Rhymes', with 'No Second Troy', a poem written later, you will see how he succeeded in ridding his work of its aesthetic embroideries. The first poem runs:

> Fasten your hair with a golden pin,
> And bind up every wandering tress;
> I bade my heart build these poor rhymes:
> It worked at them, day out, day in,
> Building a sorrowful loveliness
> Out of the battles of old times.
>
> You need but lift a pearl-pale hand,
> And bind up your long hair and sigh;
> And all men's hearts must burn and beat;
> And candle-like foam on the dim sand,
> And stars climbing the dew-dropping sky,
> Live but to light your passing feet.

The second – containing once more a protest against political passion – runs:

> Why should I blame her that she filled my days
> With misery, or that she would of late
> Have taught to ignorant men most violent ways,
> Or hurled the little streets upon the great,
> Had they but courage equal to desire?
> What could have made her peaceful with a mind
> That nobleness made simple as a fire,
> With beauty like a tightened bow, a kind
> That is not natural in an age like this,
> Being high and solitary and most stern?
> Why, what could she have done, being what she is?
> Was there another Troy for her to burn?

There is a vast difference, it will be seen, between the styles in which these poems are written. In the first, we have the beautiful rhetoric of a young aesthete of the nineties; in the second, decoration is no longer sought after for its own sake, and the passion expresses itself in more natural images. Some people would say there has been a gain in sincerity, but Yeats's

early work, too, was sincere. Its fault was rather that it was at times too deliberately beauteous.

In whatever manner he wrote, however, Yeats was always a stylist. He once spoke of 'the fascination of what's difficult', and the very difficulty he met with in putting his thoughts and visions into verse seems to have compelled him to take especial pains in the search for perfect speech. He says somewhere that he found writing blank verse too easy – almost as easy as writing prose – and that he needed difficulty to stir the fire in his imagination.

He was not a natural singer: he could never have said of himself: 'I sing but as the linnets sing.' He says of his early attempts at poetry: 'My lines but seldom scanned, for I could not understand the prosody in the books, although there were many lines that taken by themselves had music.' In later life he said that he could now write more easily – six or seven lines of poetry a day instead of the six or seven lines a week that were his usual output when he was young.

All this may seem to suggest a lack of spontaneity in his genius; but I should prefer to put the matter in this way – that his genius was spontaneous in its activity but that a genius so original had to create laboriously a new and fitting instrument for its expression.

As a man, Yeats – especially in his younger days – looked the part of the poet he was. George Moore[2] has described him sitting in the dress circle of the present Playhouse, 'a long black cloak drooping from his shoulders, a soft black sombrero on his head, a voluminous black silk tie flowing from his collar, long black trousers dragging untidily over his long, heavy feet', and he admits that he conceived such an antipathy to Yeats that he refused to be introduced. Yeats, however, thought of the artist as a man apart – one who was as separate from the common herd as the member of a priesthood – and he dressed accordingly. No student in the Latin Quarter was ever more scornful of the respectable bourgeois world whose very morality he despised.

He sometimes spoke of morality almost as though it were a form of bourgeois cowardice and an enemy of the soul, and his

heresy led him into such extravagances of opinion as we find in his comment on the self-absorption of Synge. 'I have often', he wrote, 'envied him his absorption as I have envied Verlaine³ his vice. Can a man of genius make that complete renunciation of the world necessary to the full expression of himself without some vice or some deficiency?' It is interesting to contrast this attitude of mind with that which he records of an earlier stage in his life when he wanted to go and live in a cabin on Innisfree. 'I thought', he writes, 'that, having conquered bodily desire and the inclination of my mind towards women and love, I should live, as Thoreau⁴ lived, seeking wisdom.'

Luckily, or unluckily, it was not in Yeats's destiny to become a solitary. He was a man of action, a fighter, and even the theatre he did most to build became a battleground. His early play, *The Countess Cathleen*,⁵ was assailed by the orthodox as heretical, and, later on, with the aid of the police, he was throwing men and boys out of the Abbey Theatre for attempts to create a riot over the production of *The Playboy of the Western World*. I think Yeats looked forward to that uproar. Even before *The Playboy* was produced he was relishing the thought that here was something to provoke those who deserved to be provoked. He was a campaigner for art and out for conquests.

The extent of his conquests is obvious to any one who compares the position of Irish literature in the English tongue as it was before Yeats began to write and its position at the time of his death. Ireland before Yeats scarcely existed on the literary map of the world. Under his leadership it became a house of genius. No writer of our time can boast of a more remarkable achievement than this.

Yeats was a man who compelled fascination rather than affection. He had great and noble qualities: he fought for freedom of the arts with the courage of a tigress defending her cubs and he sacrificed every worldly ambition to his zeal for doing the best work of which he was capable. He more than any other man transformed Ireland from a province into a nation in the sphere of modern literature. He founded a national theatre and made one woman an immortal. And he was a faithful friend.

Yet, with all this, he seemed a little inhuman. One thought of him at times as a priest performing magic rites in a temple and the God in whose honour the temple was built did not appear to be the God of the common man. He dabbled in psychical research and theosophy, and in an earlier century might well have been shuddered at as a heretic. His remoteness from common people was increased by his over-endowment with the gift of scorn. His scorn for the middle class and their morality surpassed that of any Marxian. His scorn for the modern English and their love of compromise – he liked to think that the typical Englishman of Shakespeare's day had been 'witty, boastful, and profane' – was extreme. 'You know', he said to me one evening, 'what the Englishman's idea of compromise is. He says: "Some people say there is a God. Some say there is no God. The truth probably lies somewhere between these two statements."'

It is easy to see why a poet of such temper admired Nietzsche and was drawn towards Fascism: he even went so far as to compose songs for the Irish Blueshirts.[6] Yet he was not at his ease among the extremists of his own country. For a time he was a member of the Irish Republican Brotherhood; but, when some of the members decided that Frank Hugh O'Donnell[7] should be murdered, he resigned along with Maud Gonne. More and more he drifted away from politics, realizing that what most politicians, including the extremists, wanted from writers was good propaganda rather than great literature. He began to hate Arthur Griffith,[8] the founder of the Sinn Féin movement, even more bitterly than Griffith hated him.

Yet, when the Irish Insurrection of 1916 failed and the leaders were executed, he was so moved by their courage and self-sacrifice, though he did not agree with them, that he came nearer to being a popular national poet than he had ever been before. After that, however, he seems to have become more interested in the Anglo-Irish civilization into which he was born than in the Gaelic civilization that is reflected in his earlier work. He glorified Bishop Berkeley[9] and the other great Irish writers of the eighteenth century as enemies of the Whiggery and compromise that he hated, and wrote:

> Whether they knew it or not
> Goldsmith and Burke, Swift and the Bishop of Cloyne
> All hated Whiggery; but what is Whiggery?
> A levelling, rancorous, rational sort of mind
> That never looked out of the eye of a saint
> Or out of a drunkard's eye. . . .

It is not here, or in other verse expressive merely of opinions, it seems to me, that we find the inspired Yeats. Yeats is to my mind greatest in the remote solitariness of his art, not in his life and opinions of which we learn so much in his later verse. The enchanted lover who speaks in *The Wind Among the Reeds* enraptures us where Yeats minus his singing robes often puzzles us. Consider, for example, his story of how, crossed in love, he thought of consoling himself with another woman who had been unhappily married. 'I took a fortnight', he wrote afterwards, 'to decide what I should do. I was poor and it would be a hard struggle if I asked her to come away and perhaps after all I would be adding my tragedy to hers, for she might be returning to the evil life, but after all, if I could not get the woman I loved, it would be comfort, even but for a little while, to devote myself to another.'

Unlike the poet of the great love-poems, again, is the Yeats who, when he thought another woman was trying to blackmail him into marrying her, wrote verses about her that Dr Jeffares describes as 'disgusted and disgusting'.[10]

Finally, how strange is the story of his marriage as Dr Jeffares relates it! Maud Gonne having refused to marry him, he fell in love with her daughter, Iseult.

He was told by Maud that she had no objection to his proposing to Iseult but that the young girl would probably not take him very seriously. In fact, it was Iseult who had made the first proposal to him when she was fifteen and had been refused because there was too much Mars in her horoscope.

In 1917 he visited the Gonnes in France, and brought them back to London. He had meanwhile asked Iseult again and again to marry him.

On the boat Yeats had delivered an ultimatum to Iseult: that she must make up her mind one way or the other, that he found the whole business an immense strain, and that if she would not marry him, he had a friend who would be very suitable, a girl strikingly beautiful in a barbaric manner. He must receive her answer within a week at a certain A.B.C. in London. Iseult refused him, and he married Miss Hyde-Lees on 20th October.

What a picture this conjures up of the author of the most beautiful and passionate love-poetry of our time sitting in a tea-shop, waiting for a girl to decide whom he was to marry!

There are probably, however, in biographies of most poets details that seem at variance with the splendour of their finest hours. And, after all, it is by the splendour of their finest hours that they must be judged. The Yeats who wrote that great line about the ageing beloved:

> Time can but make her beauty over again:

is the Yeats who is secure against mortality. Year after year from his twenties till his later life he had one ever recurrent theme in his verse – that lovely lady to whom he addressed the poem beginning, 'When you are old and grey and full of sleep', to whom he wrote, 'Had I the heavens' embroidered cloths', and whom he celebrated in 'No Second Troy'.

Even his railings contribute to her glory. He judges her, he censures her, but always in the end the fire of adoration revives in such a line as

> Was there another Troy for her to burn?

One of the younger writers, writing of Yeats after his death, said that, if Yeats had died at the age of fifty, he would have been remembered only as a minor poet, and that he had become a great poet only in later life. To me it seems, on the contrary, that Yeats's greatest verse was written before he was fifty. Dr Jeffares appears to prefer the later verses and the last sentence of his book runs: 'He had made himself a great poet.' Yet though he quotes freely from the later poems he seems to me to quote little that is on a level with the verse of Yeats's early and middle periods. Yeats himself wrote of his latest period:

You think it horrible that lust and rage
Should dance attendance upon my old age;
They were not such a plague when I was young;
What else have I to spur me into song?

It may be the very harshness of some of the later verse that
commends it to the taste of many readers.

Perhaps one of the things that alienates some readers in
Yeats's earlier work is his excess of decoration in the Pre-
Raphaelite tradition. The people of his dreams lead a decorative
existence, and the perfect life seems to express itself in beau-
tiful gestures. It was in his thirties that he wrote:

The fine life is always a part played finely before fine spectators. . . . When
the fine spectators have ended, surely the fine players grow weary, and the
aristocratic life has ended. When O'Connell covered with a dark glove the
hand that had killed a man in the duelling field, he played his part; and when
Alexander stayed his army marching to the conquest of the world that he
might contemplate the beauty of a plane-tree, he played his part.

That aesthetic attitude to life is no longer fashionable, and,
indeed, in a man of smaller genius than Yeats, would have been
the mark of a minor poet. Aestheticism, however, may have
provided Yeats with a mask behind which he could express
himself more passionately and sincerely than in plainer verse.
We must judge by results, and in the result is not Yeats's love-
poetry as sincere, as passionate, and as moving as Donne's?

JAMES JOYCE AND A NEW KIND OF FICTION

JAMES JOYCE is the only writer in English who has become world famous as a result of writing a book the sale of which was meanwhile forbidden in England. A few – a very few – other authors have had their works suppressed, but none of these has owed the chief part of his fame to his suppressed work. Joyce had undoubtedly won the attention and the praise of critics even before the enormous bulk of *Ulysses* created a sensation among both those who liked it and those who loathed it. But it was only after *Ulysses* appeared that critical circles began to speak of Joyce as a man of genius who had created a new kind of fiction or, alternatively, as one of the literary monsters of a decadent age.

It was only to be expected that on the publication of *Ulysses* Joyce would become the centre of a raging battle of acclamation and denunciation. It was evident to anybody who read him that he was a perfectly sincere artist, in love with truth as he saw it, and no exploiter of obscenity for commercial ends. It was equally undeniable, however, that much of the language that he reproduced in his transcripts from life, or whatever you like to call them, was of a kind that must inevitably shock and outrage ordinary men and women. There are things that even hardened war veterans do not like to see in cold print. This, I think, is the result, not of hypocrisy, but of an instinctive feeling that if this sort of thing goes too far, the baser sort of writers will mingle obscenity with their work for base ends and so lower the code of civilization.

As for Joyce himself, how are we to explain his passion for breaking the conventions of written speech? He is no Rabelais[1]

rioting in buffoonery. When he quotes an obscenity he seldom quotes it with hilarity. He quotes it without prejudice on one side or the other, as an anthropologist might quote the saying of an African tribesman. He has been described as a martyr to truth, a sensitive spirit in love with beauty and therefore doubly wounded by the ugliness of the world around him, compelled to make a faithful report of that ugliness. He may be thought of as a predestined protestant (with a small initial letter) – a protestant who, with the most dutiful zeal in the world, sets to defacing images and wrecking the lovely glass of tradition.

It was once said of Ibsen that he had had a Pegasus shot under him in early life, and Joyce, too, has had a Pegasus shot under him. He began his literary career with a volume of poems, *Chamber Music*, and even his last experiment in language (*Finnegans Wake*) is full of the echoes of poetry. At the same time, as we read *A Portrait of the Artist as a Young Man*, we find that even in Joyce's youth the lyric rapture had to struggle hard for existence against the anger and disillusion of the Ishmaelite. Much of *A Portrait of the Artist* might truthfully be described as a school story. But how little we feel in it of the ecstasy of boyhood. The physical delight of being young, the warmth of hero worship or of friendship, the innocent adoration of first love, the happy holiday laughter – these form a peculiarly small part of the background of the life of the hero, Stephen Daedalus. When the boys laugh, it is not with the infectious laughter of the boys in *Stalky & Co.*;[2] the laughter in *A Portrait of the Artist* is harsh and like the crackling of thorns under a pot. It may seem absurd to compare Kipling's schoolboys with Joyce's; but I sometimes wonder whether, if Kipling had gone to Joyce's school, and Joyce had gone to Kipling's school, Kipling would not still have written a book more or less like *Stalky & Co.* and Joyce a book more or less like *A Portrait of the Artist*. Art, it has been said, is life seen through a temperament, and the temperament contributes as much to the result as the life seen.

Stephen, however, is an infinitely more sensitive boy than any of the young barbarians described by Kipling. He is precocious

both intellectually and emotionally, and being brought up in a religious school, he has a profound consciousness of the sinfulness of sin. Like the character mentioned in *Lavengro*,[3] however, who felt compelled to commit the sin against the Holy Ghost, Daedalus regards sin with a mixture of fascination and repulsion. Flesh and spirit wage a cruel war in him – now the enticement of sin, now the fear of hell dominates his imagination. He is tormented as Bunyan[4] was tormented in the days described in *Grace Abounding to the Chief of Sinners*. Joyce gives a very remarkable account of the spiritual crisis in the life of Stephen Daedalus – a crisis that ended in proud Ishmaelitism, in rebellion alike against faith and fatherland, in courage begotten by despair. 'Look here, Cranly,' he says, towards the end of the book,

you have asked me what I would do and what I would not do. I will tell you what I will do and what I will not do. I will not serve that in which I no longer believe, whether it call itself my home, my fatherland, or my church; and I will try to express myself in some mode of life or art as freely as I can and as wholly as I can, using for my defence the only arms I allow myself to use, silence, exile, and cunning.

That is obviously meant to be read as the confession of an Irishman who could find no rest for his spirit either in the old religious faith or in the new political faith of his country. It is the confession of an Irishman who saw Ireland, not through the eyes of romance, but through the eyes of what is called realism. Stephen Daedalus, it seems to me, was a boy who was so sensitive to things that were unpleasant to the touch and unpleasant to the sense of smell that he could scarcely enjoy the other things that were pleasant to both senses. Similarly, he was more keenly conscious of the flaws than of the virtues of his traditionalist fellow-countrymen. Yeats could write sorrowfully of a world in which 'all things uncomely and broken' are an outrage on the ideal beauty. But in his verse he remained a praiser of the ideal beauty. Joyce could not forget the things that were uncomely and broken. They make up the world in which his characters have their being.

Yet, in the volume of short stories called *Dubliners*, we get glimpses of a more normal country – a country in which

sympathy and pity and disinterested love have their due places. The story called 'The Dead' is remarkable not only for its realism but for the beautiful spirit that hovers in the atmosphere that surrounds it.

As for *Ulysses*, Joyce has described it as 'a modern Odyssey'. He has also said of it that it is the 'epic of the human body'. And in Mr Frank Budgen's book, *James Joyce and the Making of Ulysses*,[5] from which these quotations are taken, he has added: 'I want to give a picture of Dublin so complete that if the city one day suddenly disappeared from the earth, it could be reconstructed from my book.' I do not know how many readers have gone through *Ulysses* and the *Odyssey* in search of parallels but I imagine they must be few. After all, a work of fiction must stand on its own legs, so far as the ordinary reader is concerned, and only scholars have either the time or the taste to pursue remote parallels. Even as a complete picture of Dublin's pre-war life, *Ulysses*, it is probable, will seem grossly libellous to the majority of the inhabitants of Dublin. This would not necessarily prove it untrue, but even in the great funeral scene Joyce has been content to describe grotesque surfaces, and he leaves out of the picture some of the profoundest emotions that make life worth living in Dublin, as well as in other cities in other lands.

It has been said that he merely sets down life without praise or blame, but it seems to me that he cannot help writing as a critic. As a picture of a whole city, *Ulysses* was bound in a measure to be incoherent, and, for the ordinary people, even the character of Bloom cannot give it a unity that prevents it from seeming at times a bewildering maze. It is difficult to believe that it could ever become a work generally understood, even in a world able to wander from the surface into the subconscious more cunningly than the men of today, and more indifferent to the shock of blasphemy and obscenity. The ordinary man, I imagine, will always feel, if he tries to read it, like a man exploring the depths of the Cheddar caves with the aid only of a box of matches.

Joyce has a sense of humour and a sense of beauty; but he is also a determined psychologist. 'I try', he declares, 'to give the

unspoken, unacted thoughts of people in the way they occur.' In this matter he has been followed by other writers; but one cannot help wondering at times whether the unspoken, unacted thoughts occur in real life in the way in which the novelists represent them as occurring. I have my doubts about Mrs Bloom.

After writing *Ulysses*, Joyce engaged on an experiment in a new language, called *Finnegans Wake*. I confess that when I looked at the first parts of it, I could not make head or tail of it. The sentences seemed to mean nothing. I had only the vaguest notion of what the characters were doing or talking about. And yet when I heard a gramophone record of Joyce's own reading of a passage from *Anna Livia Plurabelle* I confess I was attracted, like someone listening to a beautiful foreign language that he does not understand. Spoken by Joyce, the queer, meaningless sentences touch the imagination both in their humour and their music. They can suggest longing and sorrow. I doubt, however, whether, except under the spell of Joyce's incantation, *Anna Livia* will ever convey the musical beauty which his voice gives it. Take the last passage, for example – a passage which a fine modern poet declared in my hearing to an eminent statesman had finally converted him to a belief in the genius of the new Joyce:

Can't hear with the waters of. The chittering waters of. Flittering bats, fieldmice bawk talk. Ho! Are you not gone ahome? What Tom Malone? Can't hear with bawk of bats, all the liffeying waters of. Ho, talk save us! My foos won't moos. I feel as old as yonder elm. A tale told of Shaun or Shem? All Livia's daughtersons. Dark hawks hear us. Night! Night! My ho head halls. I feel as heavy as yonder stone. Tell me of John or Shaun? Who were Shem and Shaun the living sons or daughters of? Night now! Tell me, tell me, tell me, elm! Night, night! Telmetale of stem or stone. Beside the rivering waters of, witherandthithering waters of. Night!

That, I assure you, if read rhythmically, sentence by sentence, has a most musical sound. I cannot explain its meaning. It is obviously meant to touch us through suggestion, not through the intelligence. Whether it is worth writing like this I do not know. It is, at least, the work of a born experimenter of genius.

THE CRITIC AS DESTROYER

IT HAS BEEN said often enough that all good criticism is praise. Pater[1] boldly called one of his volumes of critical essays *Appreciations*. There are, everyone will agree, brilliant instances of hostility in criticism. The best-known of these in English is Macaulay's essay on Robert Montgomery.[2] In recent years we have witnessed the much more significant assault by Tolstoy upon almost the whole army of the authors of the civilized world from Æschylus[3] down to Mallarmé. *What is Art?* was unquestionably the most remarkable piece of sustained hostile criticism that was ever written. At the same time, it was less a denunciation of individual authors than an attack on the general tendencies of the literary art. Tolstoy quarrelled with Shakespeare not so much for being Shakespeare as for failing to write like the authors of the Gospel. Tolstoy would have made every book a Bible. He raged against men of letters because with them literature was a means not to more abundant life but to more abundant luxury. Like so many inexorable moralists, he was intolerant of all literature that did not serve as a sort of example of his own moral and social theories. That is why he was not a great critic, though he was immeasurably greater than a great critic. One would not turn to him for the perfect appreciation even of one of the authors he spared, such as Hugo[4] or Dickens. The good critic must in some way begin by accepting literature as it is, just as the good lyric poet must begin by accepting life as it is. He may be as full of revolutionary and reforming theories as he likes, but he must not allow any of these to come like a cloud between him and the sun, moon and

stars of literature. The man who disparages the beauty of flowers and birds and love and laughter and courage will never be counted among the lyric poets; and the man who questions the beauty of the inhabited world the imaginative writers have made – a world as unreasonable in its loveliness as the world of nature – is not in the way of becoming a critic of literature.

Another argument which tells in favour of the theory that the best criticism is praise is the fact that almost all the memorable examples of critical folly have been denunciations. One remembers that Carlyle dismissed Herbert Spencer as a 'never-ending ass'. One remembers that Byron thought nothing of Keats – 'Jack Ketch',[5] as he called him. One remembers that the critics damned Wagner's operas as a new form of sin. One remembers that Ruskin[6] denounced one of Whistler's[7] nocturnes[8] as a pot of paint flung in the face of the British public. In the world of science we have a thousand similar examples of new genius being hailed by the critics as folly and charlatanry. Only the other day a biographer of Lord Lister[9] was reminding us how, at the British Association in 1869, Lister's antiseptic treatment was attacked as a 'return to the dark ages of surgery', the 'carbolic mania', and 'a professional criminality'. The history of science, art, music and literature is strewn with the wrecks of such hostile criticisms. It is an appalling spectacle for anyone interested in defending the intelligence of the human race. So appalling is it, indeed, that most of us nowadays labour under such a terror of accidentally condemning something good that we have not the courage to condemn anything at all. We think of the way in which Browning was once taunted for his obscurity, and we cannot find it in our hearts to censure Mr Doughty.[10] We recall the ignorant attacks on Manet and Monet, and we will not risk an onslaught on the follies of Picasso and the worse-than-Picassos of contemporary art. We grow a monstrous and unhealthy plant of tolerance in our souls, and its branches drop colourless good words on the just and on the unjust – on everybody, indeed, except Miss Marie Corelli,[11] Mr Hall Caine,[12] and a few others whom we know to be second-rate because they have large circulations. This is really a disastrous

state of affairs for literature and the other arts. If criticism is, generally speaking, praise, it is, more definitely, praise of the right things. Praise for the sake of praise is as great an evil as blame for the sake of blame. Indiscriminate praise, in so far as it is the result of distrust of one's own judgment or of laziness or of insincerity, is one of the deadly sins in criticism. It is also one of the deadly dull sins. Its effect is to make criticism ever more unreadable, and in the end even the publishers, who love foolish sentences to quote about bad books, will open their eyes to the futility of it. They will realize that, when once criticism has become unreal and unreadable, people will no more be bothered with it than they will with drinking lukewarm water. I speak of the publisher in especial, because there is no doubt that it is with the idea of putting the publishers in a good, open-handed humour that so many papers and reviews have turned criticism into a kind of stagnant pond. Publishers, fortunately, are coming more and more to see that this kind of criticism is of no use to them. Reviews in certain papers, they will tell you, do not sell books. And the papers to which they refer in such cases are always papers in which praise is lavishly served out to everybody, like spoonfuls of treacle-and-brimstone to the school-children in *Nicholas Nickleby*.

Criticism, then, is praise, but it is praise of literature. There is all the difference in the world between that and the praise of what pretends to be literature. True criticism is a search for beauty and truth and an announcement of them. It does not care twopence whether the method of their revelation is new or old, academic or futuristic. It only asks that the revelation shall be genuine. It is concerned with form, because beauty and truth demand perfect expression. But it is a mere heresy in aesthetics to say that perfect expression is the whole of art that matters. It is the spirit that breaks through the form that is the main interest of criticism. Form, we know, has a permanence of its own: so much so that it has again and again been worshipped by the idolaters of art as being in itself more enduring than the thing which it embodies. Robert Burns, by his genius for perfect statement, can give immortality to the

joys of being drunk with whiskey as the average hymn-writer cannot give immortality to the joys of being drunk with the love of God. Style, then, does seem actually to be a form of life. The critic may not ignore it any more than he may exaggerate its place in the arts. As a matter of fact, he could not ignore it if he would, for style and spirit have a way of corresponding to one another like health and sunlight.

It is to combat the stylelessness of many contemporary writers that the destructive kind of criticism is just now most necessary. For, dangerous as the heresy of style was forty or fifty years ago, the newer heresy of stylelessness is more dangerous still. It has become the custom even of men who write well to be as ashamed of their style as a schoolboy is of being caught in an obvious piece of goodness. They keep silent about it as though it were a kind of powdering or painting. They do not realize that it is merely a form of ordinary truthfulness – the truthfulness of the word about the thought. They forget that one has no more right to misuse words than to beat one's wife. Someone has said that in the last analysis style is a moral quality. It is a sincerity, a refusal to bow the knee to the superficial, a passion for justice in language. Stylelessness, where it is not, like colour-blindness, an accident of nature, is for the most part merely an echo of the commercial man's world of hustle. It is like the rushing to and fro of motor-buses which save minutes but waste our peace. It is like the swift making of furniture with unseasoned wood. It is a kind of introduction of the quick-lunch system into literature. One cannot altogether acquit Mr Masefield[13] of a hasty stylelessness in some of those long poems which the world has been reading in the last year or two. His line in 'The Everlasting Mercy':

> And yet men ask, 'Are barmaids chaste?'

is a masterpiece of inexpertness. And the couplet:

> The Bosun turned: 'I'll give you a thick ear!
> Do it? I didn't. Get to hell from here!'

is like a Sunday-school teacher's lame attempt to repeat a blasphemous story. Mr Masefield, on the other hand, is, we

always feel, wrestling with language. If he writes in a hurry, it is not because he is indifferent, but because his soul is full of something that he is eager to express. He does not gabble; he is, as it were, a man stammering out a vision. So vastly greater are his virtues than his faults as a poet, indeed, that the latter would only be worth the briefest mention if it were not for the danger of their infecting other writers who envy him his method but do not possess his conscience. One cannot contemplate with equanimity the prospect of a Masefield school of poetry with all Mr Masefield's ineptitudes and none of his genius.

Criticism, however, it is to be feared, is a fight for a lost cause if it essays to prevent the founding of schools upon the faults of good writers. Criticism will never kill the copyist. Nothing but the end of the world can do that. Still, whatever the practical results of his work may be, it is the function of the critic to keep the standard of writing high – to insist that the authors shall write well, even if his own sentences are like torn strips of newspaper for commonness. He is the enemy of sloppiness in others – especially of that airy sloppiness which so often nowadays runs to four or five hundred pages in a novel. It was amazing to find with what airiness so promising a writer as Mr Compton Mackenzie[14] gave us some years ago *Sinister Street*, a novel containing thousands of sentences that only seemed to be there because he had not thought it worth his while to leave them out, and thousands of others that seemed to be mere hurried attempts to express realities upon which he was unable to spend more time. Here is a writer who began literature with a sense of words, and who is declining into content with wordiness. It is simply another instance of the ridiculous rush of writing that is going on all about us – a rush to satisfy a public which demands quantity rather than quality in its books. I do not say that Mr Mackenzie consciously wrote down to the public, but the atmosphere obviously affected him. Otherwise he would hardly have let his book go out into the world till he had rewritten it – till he had separated his necessary from his unnecessary sentences and given his conversations the tones of reality.

There is no need, however, for criticism to lash out indiscriminately at all hurried writing. There are a multitude of books turned out every year which make no claim to be literature – the 'thrillers', for example, of Mr Phillips Oppenheim[15] and of that capable firm of feuilletonists, Coralie Stanton and Heath Hosken. I do not think literature stands to gain anything even though all the critics in Europe were suddenly to assail this kind of writing. It is a frankly commercial affair, and we have no more right to demand style from those who live by it than from the authors of the weather reports in the newspapers. Often, one notices, when the golden youth, fresh from college and the reading of Shelley and Anatole France, commences literary critic, he begins damning the sensational novelists as though it were their business to write like Jane Austen. This is a mere waste of literary standards, which need only be applied to what pretends to be literature. That is why one is often impelled to attack really excellent writers, like Sir Arthur Quiller-Couch[16] or Mr Galsworthy,[17] as one would never dream of attacking, say, Mr William Le Queux.[18] To attack Sir Arthur Quiller-Couch is, indeed, a form of appreciation, for the only just criticism that can be levelled against him is that his later fiction does not seem to be written with that singleness of imagination and that deliberate rightness of phrase which made *Noughts and Crosses* and *The Ship of Stars* books to be kept beyond the end of the year. If one attacks Mr Galsworthy, again, it is usually because one admires his best work so wholeheartedly that one is not willing to accept from him anything but the best. One cannot, however, be content to see the author of *The Man of Property*[19] dropping into the platitudes and the false fancifulness of *The Inn of Tranquillity*.[20] It is the false pretences in literature which criticism must seek to destroy. Recognizing Mr Galsworthy's genius for the realistic representation of men and women, it must not be blinded by that genius to the essential second-rateness and sentimentality of much of his presentation of ideas. He is a man of genius in the grey humility with which he confesses the injustice of an age through the figures of men and women. He achieves too much

of a pulpit complacency – therefore of condescendingness – therefore of falseness to the deep intimacy of good literature – when he begins to moralize about time and the universe. One finds the same complacency, the same condescendingness, in a far higher degree in the essays of Mr A. C. Benson.[21] Mr Benson, I imagine, began writing with a considerable literary gift, but his later work seems to have little in it but a good man's pretentiousness. It has the air of going profoundly into the secrecies of love and joy and truth, but it contains hardly a sentence that would waken a ruffle on the surface of the shallowest spirit. It is not of the literature that awakens, indeed, but of the literature that puts to sleep – a danger to the simple unless it is properly labelled and recognizable. Sleeping-draughts may help a sick man through a bad night, but one does not praise them as a general substitute for wine or water. Nor will Mr Benson escape just criticism on the score of his manner of writing. He is a master of the otiose word, the superfluous sentence. He pours out pages as easily as a bird sings, but, alas! it is a clockwork bird in this instance. He lacks the true innocent absorption in his task which makes happy writing and happy reading.

It is not always the authors, on the other hand, whose pretences it is the work of criticism to destroy. It is frequently the wild claims of the partisans of an author that must be put to the test. This sort of pretentiousness often appears during 'booms', when some author is talked of as though he were the only man who had ever written well. How many of these booms have we had in recent years – booms of Wilde, of Synge, of Donne, of Dostoevsky! On the whole, no doubt, they do more good than harm. They create a vivid enthusiasm for literature that affects many people who might not otherwise know that to read a fine book is as exciting an experience as going to a horse-race. Hundreds of people would not have the courage to sit down to read a book like *The Brothers Karamazov* unless they were compelled to do so as a matter of fashionable duty. On the other hand, booms more than anything else make for false estimates. It seems impossible with many people to praise

Dostoevsky without saying that he is greater than Tolstoy and Turgenev. Oscar Wilde enthusiasts, again, invite us to rejoice, not only over that pearl of triviality, *The Importance of Being Earnest*, but over a blaze of paste jewellery like *Salomé*. Similarly, Donne worshippers are not content to ask us to praise Donne's gifts of fancy, analysis and idiosyncratic music. They insist that we shall also admit that he knew the human heart better than Shakespeare. It may be all we like sheep have gone astray in this kind of literary riot. And so long as the exaggeration of a good writer's genius is an honest personal affair, one resents it no more than one resents the large nose or the bandy legs of a friend. It is when men begin to exaggerate in herds – to repeat like a lesson learned the enthusiasm of others – that the boom becomes offensive. It is as if men who had not large noses were to begin to pretend that they had, or as if men whose legs were not bandy were to pretend that they were, for fashion's sake. Insincerity is the one entirely hideous artistic sin – whether in the creation or in the appreciation of art. The man who enjoys reading *The Family Herald*, and admits it, is nearer a true artistic sense than the man who is bored by Henry James and denies it: though, perhaps, hypocrisy is a kind of homage paid to art as well as to virtue. Still, the affectation of literary rapture offends like every other affectation. It was the chorus of imitative rapture over Synge a few years ago that helped most to bring about a speedy reaction against him. Synge was undoubtedly a man of fine genius – the genius of gloomy comedy and ironic tragedy. His mind delved for strangenesses in speech and imagination among people whom the new age had hardly touched, and his discoveries were sufficiently magnificent to make the eyes of any lover of language brighten. His work showed less of the mastery of life, however, than of the mastery of a theme. It was a curious by-world of literature, a little literature of death's-heads, and, therefore, no more to be mentioned with the work of the greatest than the stories of Villiers de l'Isle-Adam.[22] Unfortunately, some disturbances in Dublin at the first production of *The Playboy* turned the play into a battle-cry, and the artists, headed by Mr Yeats, used

Synge to belabour the Philistinism of the mob. In the
excitement of the fight they were soon talking about Synge as
though Dublin had rejected a Shakespeare. Mr Yeats even used
the word 'Homeric' about him – surely the most inappropriate
word it would be possible to imagine. Before long Mr Yeats's
enthusiasm had spread to England, where people who ignored
the real magic of Synge's work, as it is to be found in *Riders to
the Sea*,²³ *In the Shadow of the Glen*, and *The Well of the Saints*,
went into ecstasies over the inferior *Playboy*. Such a boom
meant not the appreciation of Synge but a glorification of his
more negligible work. It was almost as if we were to boom
Swinburne on the score of his later political poetry. Criticism
makes for the destruction of such booms. I do not mean that
the critic has not the right to fling about superlatives like any
other man. Criticism, in one aspect, is the art of flinging about
superlatives finely. But they must be personal superlatives, not
boom superlatives. Even when they are showered on an author
who is the just victim of a boom – and, on a reasonable
estimate, at least fifty per cent of the booms have some justifi-
cation – they are as unbeautiful as rotten apples unless they
have this personal kind of honesty.

It may be though that an attitude of criticism like this may
easily sink into Pharisaism – a sort of 'superior-person' aloofness
from other people. And no doubt the critic, like other people,
needs to beat his breast and pray, 'God be merciful to me, a –
critic.' On the whole, however, the critic is far less of a
professional fault-finder than is sometimes imagined. He is first
of all a virtue-finder, a singer of praise. He is not concerned
with getting rid of the dross except in so far as it hides the
gold. In other words, the destructive side of criticism is purely a
subsidiary affair. None of the best critics have been men of
destructive minds. They are like gardeners whose business is
more with the flowers than with the weeds. If I may change the
metaphor, the whole truth about criticism is contained in the
Eastern proverb which declares that 'Love is the net of Truth.'
It is as a lover that the critic, like the lyric poet and the mystic,
will be most excellently symbolized.

PART TWO

WRITERS AND THEIR TRADE

JOHN DONNE[1]

IZAAK WALTON[2] in his short life of Donne has painted a figure
of almost seraphic beauty. When Donne was but a boy, he
declares, it was said that the age had brought forth another
Pico della Mirandola.[3] As a young man in his twenties, he was
a prince among lovers, who by his secret marriage with his
patron's niece – 'for love', says Walton, 'is a flattering mischief' –
purchased at first only the ruin of his hopes and a term in
prison. Finally, we have the later Donne in the pulpit of St
Paul's represented, in a beautiful adaptation of one of his own
images, as 'always preaching to himself, like an angel from a
cloud, though in none; carrying some, as St Paul was, to
Heaven in holy raptures, and enticing others by a sacred art
and courtship to amend their lives'. The picture is all of noble
charm. Walton speaks in one place of 'his winning behaviour –
which, when it would entice, had a strange kind of elegant
irresistible art'. There are no harsh phrases even in the
references to those irregularities of Donne's youth, by which he
had wasted the fortune of £3000 – equal, I believe, to more
than £30,000 of our money – bequeathed to him by his father,
the ironmonger. 'Mr Donne's estate', writes Walton gently,
referring to his penury at the time of his marriage, 'was the
greatest part spent in many and chargeable travels, books, and
dear-bought experience.' It is true that he quotes Donne's own
confession of the irregularities of his early life. But he counts
them of no significance. He also utters a sober reproof of
Donne's secret marriage as 'the remarkable error of his life'.
But how little he condemned it in his heart is clear when he

goes on to tell us that God blessed Donne and his wife 'with so mutual and cordial affections, as in the midst of their sufferings made their bread of sorrow taste more pleasantly than the banquets of dull and low-spirited people'. It was not for Walton to go in search of small blemishes in him whom he regarded as the wonder of the world – him whose grave mournful friends 'strewed . . . with an abundance of curious and costly flowers', as Alexander the Great strewed the grave of 'the famous Achilles'. In that grave there was buried for Walton a whole age magnificent with wit, passion, adventure, piety and beauty. More than that, the burial of Donne was for him the burial of an inimitable Christian. He mourns over 'that body, which once was a Temple of the Holy Ghost, and is now become a small quantity of Christian dust', and, as he mourns, he breaks off with the fervent prophecy, 'But I shall see it reanimated.' That is his valediction.

If Donne is esteemed three hundred years after his death less as a great Christian than as a great pagan, this is because we now look for him in his writings rather than in his biography, in his poetry rather than in his prose, and in his *Songs and Sonnets* and *Elegies* rather than in his *Divine Poems*. We find, in some of these, abundant evidence of the existence of a dark angel at odds with the good angel of Walton's raptures. Donne suffered in his youth all the temptations of Faust. His thirst was not for salvation but for experience – experience of the intellect and experience of sensation. He has left it on record in one of his letters that he was a victim at one period of 'the worst voluptuousness, an hydroptic, immoderate desire of human learning and languages'. Faust in his cell can hardly have been a more insatiate student than Donne. 'In the most unsettled days of his youth,' Walton tells us, 'his bed was not able to detain him beyond the hour of four in the morning; and it was no common business that drew him out of his chamber till past ten; all which time was employed in study; though he took great liberty after it.' His thoroughness of study may be judged from the fact that 'he left the resultance of 1400 authors, most of them abridged and analyzed with his own

hand'. But we need not go beyond his poems for proof of the wilderness of learning that he had made his own. He was versed in medicine and the law as well as in theology. He subdued astronomy, physiology, and geography to the needs of poetry. Nine Muses were not enough for him, even though they included Urania.[4] He called in to their aid Galen[5] and Copernicus.[6] He did not go to the hills and the springs for his images, but to the laboratory and the library, and in the library the books that he consulted to the greatest effect were the works of men of science and learning, not of the great poets with whom London may almost be said to have been peopled during his lifetime.

I do not think his verse or correspondence contains a single reference to Shakespeare, whose contemporary he was, having been born nine years later. The only great Elizabethan poet whom he seems to have regarded with interest and even friendship was Ben Jonson.[7] Jonson's Catholicism may have been a link between them. But, more important than that, Jonson was, like Donne himself, an inflamed pedant. For each of them learning was the necessary robe of genius. Jonson, it is true, was a pedant of the classics, Donne of the speculative sciences; but both of them alike ate to a surfeit of the fruit of the tree of knowledge.

It was, I think, because Donne was to so great a degree a pagan of the Renaissance, loving the proud things of the intellect more than the treasures of the humble, that he found it easy to abandon the Catholicism of his family for Protestantism. He undoubtedly became in later life a convinced and passionate Christian of the Protestant faith, but at the time when he first changed his religion he had none of the fanaticism of the pious convert. He wrote in an early satire as a man whom the intellect had liberated from dogma-worship. Nor did he ever lose this rationalist tolerance. 'You know', he once wrote to a friend, 'I have never imprisoned the word religion. . . . They [the churches] are all virtual beams of one sun.' Few converts in those days of the wars of religion wrote with such wise reason of the creeds as did Donne in the lines:

> To adore, or scorn an image, or protest,
> May all be bad. Doubt wisely; in strange way
> To stand inquiring right is not to stray;
> To sleep or run wrong is. On a huge hill,
> Craggèd and steep, Truth stands, and he that will
> Reach her, about must and about must go;
> And what the hill's suddenness resists, win so.

This surely was the heresy of an inquisitive mind, not the mood of a theologian. It betrays a tolerance springing from ardent doubt, not from ardent faith.

It is all in keeping with one's impression of the young Donne as a man setting out bravely in his cockle-shell on the oceans of knowledge and experience. He travels, though he knows not why he travels. He loves, though he knows not why he loves. He must escape from that 'hydroptic, immoderate' thirst of experience by yielding to it. One fancies that it was in this spirit that he joined the expedition of Essex[8] to Cadiz in 1596 and afterwards sailed to the Azores. Or partly in this spirit, for he himself leads one to think that his love-affairs may have had something to do with it. In the second of those prematurely realistic descriptions of storm and calm relating to the Azores voyage, he writes:

> Whether a rotten state, and hope of gain,
> Or to disuse me from the queasy pain
> Of being belov'd, and loving, or the thirst
> Of honour, or fair death, out pusht me first.

In these lines we get a glimpse of the Donne that has attracted most interest in recent years – the Donne who experienced more variously than any other poet of his time 'the queasy pain of being belov'd, and loving'. Donne was curious of adventures of many kinds, but in nothing more than in love. As a youth he gives the impression of having been an Odysseus of love, a man of many wiles and many travels. He was a virile neurotic, comparable in some points to Baudelaire,[9] who was a sensualist of the mind even more than of the body. His

sensibilities were different as well as less of a piece, but he had something of Baudelaire's taste for hideous and shocking aspects of lust. One is not surprised to find among his poems that 'heroical epistle of Sappho to Philaenis',[10] in which he makes himself the casuist of forbidden things. His studies of sensuality, however, are for the most part normal, even in their grossness. There was in him more of the Yahoo than of the decadent. There was an excremental element in his genius as in the genius of that other gloomy dean, Jonathan Swift. Donne and Swift were alike satirists born under Saturn. They laughed more frequently from disillusion than from happiness. Donne, it must be admitted, turned his disillusion to charming as well as hideous uses. 'Go and Catch a Falling Star' is but one of a series of delightful lyrics in disparagement of women. In several of the *Elegies*, however, he throws away his lute and comes to the satirist's more prosaic business. He writes frankly as a man in search of bodily experiences:

> Whoever loves, if he do not propose
> The right true end of love, he's one that goes
> To sea for nothing but to make him sick.

In 'Love's Progress' he lets his fancy dwell on the detailed geography of a woman's body, with the sick imagination of a schoolboy, till the beautiful seems almost beastly. In 'The Anagram' and 'The Comparison' he plays the Yahoo at the expense of all women by the similes he uses in insulting two of them. In 'The Perfume' he relates the story of an intrigue with a girl whose father discovered his presence in the house as a result of his using scent. Donne's jest about this is suggestive of his uncontrollable passion for ugliness:

> Had it been some bad smell, he would have thought
> That his own feet, or breath, that smell had wrought.

It may be contended that in 'The Perfume' he was describing an imaginary experience, and indeed we have his own words on record: 'I did best when I had least truth for my subjects.' But even if we did not accept Mr Gosse's[11] commonsense

explanation of these words, we should feel that the details of the story have a vividness that springs straight from reality. It is difficult to believe that Donne had not actually lived in terror of the gigantic manservant who was set to spy on the lovers:

> The grim eight-foot-high iron-bound serving-man,
> That oft names God in oaths, and only then,
> He that to bar the first gate, doth as wide
> As the great Rhodian Colossus stride,
> Which, if in hell no other pains there were,
> Makes me fear hell, because he must be there.

But the most interesting of all the sensual intrigues of Donne, from the point of view of biography, especially since Mr Gosse gave it such eminent significance in that *Life of John Donne* in which he made a living man out of a mummy, is that of which we have the story in 'Jealousy' and 'His Parting from Her'. It is another story of furtive and forbidden love. Its theme is an intrigue carried on under a

> Husband's towering eyes,
> That flamed with oily sweat of jealousy.

A characteristic touch of grimness is added to the story by making the husband a deformed man. Donne, however, merely laughs at his deformity, as he bids the lady laugh at the jealousy that reduces her to tears:

> O give him many thanks, he is courteous,
> That in suspecting kindly warneth us.
> We must not, as we used, flout openly,
> In scoffing riddles, his deformity;
> Nor at his board together being sat,
> With words, nor touch, scarce looks adulterate.

And he proposes that, now that the husband seems to have discovered them, they shall henceforth carry on their intrigue at some distance from where

> He, swol'n and pampered with great fare,
> Sits down, and snorts, cag'd in his basket chair.

It is an extraordinary story, if it is true. It throws a scarcely less extraordinary light on the nature of Donne's mind, if he invented it. At the same time, I do not think the events it relates played the important part which Mr Gosse assigns to them in Donne's spiritual biography. It is impossible to read Mr Gosse's two volumes without getting the impression that 'the deplorable but eventful liaison', as he calls it, was the most fruitful occurrence in Donne's life as a poet. He discovers traces of it in one great poem after another – even in the 'Nocturnal upon St Lucy's Day', which is commonly supposed to relate to the Countess of Bedford, and 'The Funeral', the theme of which Professor Grierson[12] takes to be the mother of George Herbert.

I confess that the oftener I read the poetry of Donne the more firmly I become convinced that, far from being primarily the poet of desire gratified and satiated, he is essentially the poet of frustrated love. He is often described by the historians of literature as the poet who finally broke down the tradition of Platonic love. I believe that, far from this being the case, he is the supreme example of a Platonic lover among the English poets. He was usually Platonic under protest, but at other times exultantly so. Whether he finally overcame the more consistent Platonism of his mistress by the impassioned logic of 'The Ecstasy' we have no means of knowing. If he did, it would be difficult to resist the conclusion that the lady who wished to continue to be his passionate friend and to ignore the physical side of love was Anne More, whom he afterwards married. If not, we may look for her where we will, whether in Magdalen Herbert (already a young widow who had borne ten children when he first met her) or in the Countess of Bedford or in another. The name is not important, and one is not concerned to know it, especially when one remembers Donne's alarming curse on

> Whoever guesses, thinks, or dreams he knows
> Who is my mistress.

One sort of readers will go on speculating, hoping to discover real people in the shadows, as they speculate about Swift's Stella and Vanessa and his relations to them. It is enough for

us to feel, however, that these poems railing at or glorying in Platonic love are no mere goldsmith's compliments, like the rhymed letters to Mrs Herbert and Lady Bedford. Miracles of this sort are not wrought save by the heart. We do not find in them the underground and sardonic element that appears in so much of Donne's merely amorous work. We no longer see him as a sort of Vulcan hammering out the poetry of base love, raucous, powerful, mocking. He becomes in them a child of Apollo, as far as his temperament will allow him. He makes music of so grave and stately a beauty that one begins to wonder at all the critics who have found fault with his rhythms – from Ben Jonson, who said that 'for not keeping accent, Donne deserved hanging', down to Coleridge, who declared that his 'muse on dromedary trots', and described him as 'rhyme's sturdy cripple'. Coleridge's quatrain on Donne is, without doubt, an unequalled masterpiece of epigrammatic criticism. But Donne rode no dromedary. In his greatest poems he rides Pegasus like a master, even if he does weigh the poor beast down by carrying an encyclopaedia in his saddle-bags.

Not only does Donne remain a learned man on his Pegasus, however: he also remains a humorist, a serious fantastic. Humour and passion pursue each other through the labyrinth of his being, as we find in those two beautiful poems, 'The Relic' and 'The Funeral', addressed to the lady who had given him a bracelet of her hair. In the former he foretells what will happen if ever his grave is broken up and his skeleton discovered with

> A bracelet of bright hair about the bone.

People will fancy, he conjectures, that the bracelet is a device of lovers

> To make their souls, at the last busy day,
> Meet at the grave, and make a little stay?

Bone and bracelet will be worshipped as relics – the relics of a Magdalen and her lover. He declares with a quiet smile:

> All women shall adore us, and some men.

He warns his worshippers, however, that the facts are far
different from what they imagine, and tells the miracle-seekers
'What miracles we harmless lovers wrought':

> First we lov'd well and faithfully,
> Yet knew not what we lov'd, nor why;
> Difference of sex no more we knew,
> Than our guardian angels do;
> Coming and going, we
> Perchance might kiss, but not between those meals;
> Our hands ne'er touch'd the seals,
> Which nature, injur'd by late law, sets free:
> These miracles we did; but now, alas!
> All measure, and all language, I should pass,
> Should I tell what a miracle she was.

In 'The Funeral' he returns to the same theme:

> Whoever comes to shroud me, do not harm
> Nor question much
> That subtle wreath of hair, which crowns my arm;
> The mystery, the sign you must not touch,
> For 'tis my outward Soul.

In this poem, however, he finds less consolation than before in
the too miraculous nobleness of their love:

> Whate'er she meant by it, bury it with me,
> For since I am
> Love's martyr, it might breed idolatry,
> If into other hands these relics came;
> As 'twas humility
>
> To afford to it all that a Soul can do,
> So, 'tis some bravery,
> That, since you would save none of me, I bury some
> of you.

In 'The Blossom' he is in a still more earthly mood, and
declares that, if his mistress remains obdurate, he will return to
London, where he will find another mistress:

> As glad to have my body as my mind.

'The Primrose' is a further appeal for a less intellectual love:

> Should she
> Be more than woman, she would get above
> All thought of sex, and think to move
> My heart to study her, and not to love.

If we turn back to 'The Undertaking', however, we find Donne boasting once more of the miraculous purity of a love which it would be useless to communicate to other men, since, there being no other mistress to love in the same kind, they 'would love but as before'. Hence he will keep the tale a secret:

> If, as I have, you also do
> Virtue attir'd in woman see,
> And dare love that, and say so too,
> And forget the He and She;

> And if this love, though placèd so,
> From profane men you hide,
> Which will no faith on this bestow,
> Or, if they do, deride:

> Then you've done a braver thing
> Than all the Worthies did;
> And a braver thence will spring,
> Which is, to keep that hid.

It seems to me, in view of this remarkable series of poems, that it is useless to look in Donne for a single consistent attitude to love. His poems take us round the entire compass of love as the work of no other English poet – not even, perhaps, Browning's – does. He was by destiny the complete experimentalist in love in English literature. He passed through phase after phase of the love of the body only, phase after phase of the love of the soul only, and ended as the poet of the perfect marriage. In his youth he was a gay – but was he ever really gay? – free-lover, who sang jestingly:

> How happy were our sires in ancient times,
> Who held plurality of loves no crime!

But even then he looks forward, not without cynicism, to a
time when he

> Shall not so easily be to change dispos'd,
> Nor to the arts of several eyes obeying;
> But beauty with true worth securely weighing,
> Which, being found assembled in some one,
> We'll love her ever, and love her alone.

By the time he writes 'The Ecstasy' the victim of the body has
become the protesting victim of the soul. He cries out against a
love that is merely an ecstatic friendship:

> But, O alas! so long, so far
> Our bodies why do we forbear?

He pleads for the recognition of the body, contending that it is
not the enemy but the companion of the soul:

> So soul into the soul may flow
> Though it to body first repair.

The realistic philosophy of love has never been set forth with
greater intellectual vehemence:

> So must pure lovers' souls descend
> To affections, and to faculties,
> Which sense may reach and apprehend,
> Else a great Prince in prison lies.

> To our bodies turn we then, that so
> Weak men on love reveal'd may look;
> Love's mysteries in souls do grow
> But yet the body is his book.

I, for one, find it impossible to believe that all this passionate
verse – verse in which we find the quintessence of Donne's
genius – was a mere utterance of abstract thoughts into the
wind. Donne, as has been pointed out, was more than most
writers a poet of personal experience. His greatest poetry was
born of struggle and conflict in the obscure depths of the soul
as surely as was the religion of St Paul. I doubt if, in the history

of his genius, any event ever happened of equal importance to
his meeting with the lady who first set going in his brain that
fevered dialogue between the body and the soul. Had he been
less of a frustrated lover, less of a martyr, in whom love's

> Art did express
> A quintessence even from nothingness,
> From dull privations and lean emptiness,

much of his greatest poetry, it seems to me, would never have
been written.

One cannot, unfortunately, write the history of the progress of
Donne's genius save by inference and guessing. His poems were
not, with some unimportant exceptions, published in his lifetime.
He did not arrange them in chronological or in any sort of order.
His poem on the flea that has bitten both him and his inamorata
comes after the triumphant 'Anniversary', and but a page or two
before the 'Nocturnal upon St Lucy's Day'. Hence there is no
means of telling how far we are indebted to the Platonism of one
woman, how much to his marriage with another, for the enrich-
ment of his genius. Such a poem as 'The Canonization' can be
interpreted either in a Platonic sense or as a poem written to
Anne More, who was to bring him both imprisonment and the
liberty of love. It is, in either case, written in defence of his love
against some who censured him for it:

> For God's sake hold your tongue, and let me love.

In the last verses of the poem Donne proclaims that his love
cannot be measured by the standards of the vulgar:

> We can die by it, if not live by love,
> And if unfit for tombs or hearse
> Our legend be, it will be fit for verse;
> And, if no piece of chronicle we prove,
> We'll build in sonnets pretty rooms;
> As well a well-wrought urn becomes
> The greatest ashes, as half-acre tombs;
> And by these hymns all shall approve
> Us canoniz'd by love;

And thus invoke us: 'You, whom reverend love
 Made one another's hermitage;
You, to whom love was peace, that now is rage;
Who did the whole world's soul extract, and drove
 Into the glasses of your eyes
 (So made such mirrors, and such spies,
That they did all to you epitomize),
 Countries, towns, courts. Beg from above
 A pattern of your love!'

According to Walton, it was to his wife that Donne addressed the beautiful verses beginning:

 Sweetest love, I do not go
 For weariness of thee;

as well as the series of 'Valedictions'. Of many of the other love-poems, however, we can measure the intensity but not guess the occasion. All that we can say with confidence when we have read them is that, after we have followed one tributary and another leading down to the ultimate Thames of his genius, we know that his progress as a lover was a progress from infidelity to fidelity, from wandering amorousness to deep and enduring passion. The image that is finally stamped on his greatest work is not that of a roving adulterer, but of a monotheist of love. It is true that there is enough Don-Juanism in the poems to have led even Sir Thomas Browne[13] to think of Donne's verse rather as a confession of his sins than as a golden book of love. Browne's quaint poem, 'To the deceased Author, before the Promiscuous printing of his Poems, the Looser Sort, with the Religious', is so little known that it may be quoted in full as the expression of one point of view in regard to Donne's work:

When thy loose raptures, Donne, shall meet with those
 That do confine
 Tuning unto the duller line,
And sing not but in sanctified prose,
 How will they, with sharper eyes,
 The foreskin of thy fancy circumcise,

And fear thy wantonness should now begin
Example, that hath ceased to be sin!
 And that fear fans their heat; whilst knowing eyes
 Will not admire
 At this strange fire
 That here is mingled with thy sacrifice,
 But dare read even thy wanton story
 As thy confession, not thy glory;
 And will so envy both to future times,
 That they would buy thy goodness with thy crimes.

To the modern reader, on the contrary, it will seem that there is as much divinity in the best of the love-poems as in the best of the religious ones. Donne's last word as a secular poet may well be regarded as having been uttered in that great poem in celebration of lasting love, 'The Anniversary', which closes with so majestic a sweep:

 Here upon earth we're Kings, and none but we
 Can be such Kings, nor of such subjects be;
 Who is so safe as we, where none can do
 Treason to us, except one of us two?
 True and false fears let us refrain;
 Let us love nobly, and live, and add again
 Years and years unto years, till we attain
 To write three-score: this is the second of our reign.

Donne's conversion as a lover was obviously as complete and revolutionary as his conversion in religion.

It is said, indeed, to have led to his conversion to passionate religion. When his marriage with Sir George More's sixteen-year-old daughter brought him at first only imprisonment and poverty, he summed up the sorrows of the situation in the famous line – a line which has some additional interest as suggesting the correct pronunciation of his name:

<p align="center">John Donne; Anne Donne; Undone.</p>

His married life, however, in spite of a succession of miseries due to ill-health, debt and thwarted ambition, seems to have

been happy beyond prophecy; and when at the end of sixteen years his wife died in childbed, after having borne him twelve children, a religious crisis resulted that turned his conventional churchmanship into sanctity. His original change from Catholicism to Protestantism has been already mentioned. Most of the authorities are agreed, however, that this was a conversion in a formal rather than in a spiritual sense. Even when he took Holy Orders in 1615, at the age of forty-two, he appears to have done so less in answer to any impulse to a religious life from within than because, with the downfall of Somerset, all hope of advancement through his legal attainments was brought to an end. Undoubtedly, as far back as 1612, he had thought of entering the Church. But we find him at the end of 1613 writing an epithalamium for the murderers of Sir Thomas Overbury.[14] It is a curious fact that three great poets – Donne, Ben Jonson, and Campion – appear, though innocently enough, in the story of the Countess of Essex's sordid crime. Donne's temper at the time is still clearly that of a man of the world. His jest at the expense of Sir Walter Raleigh,[15] then in the Tower, is the jest of an ungenerous worldling.

Even after his admission into the Church he reveals himself as ungenerously morose when the Countess of Bedford, in trouble about her own extravagances, can afford him no more than £30 to pay his debts. The truth is, to be forty and a failure is an affliction that might sour even a healthy nature. The effect on a man of Donne's ambitious and melancholy temperament, together with the memory of his dissipated health and his dissipated fortune, and the spectacle of a long family in constant process of increase, must have been disastrous. To such a man poverty and neglected merit are a prison, as they were to Swift. One thinks of each of them as a lion in a cage, ever growing less and less patient of his bars. Shakespeare and Shelley had in them some volatile element that could, one feels, have escaped through the bars and sung above the ground. Donne and Swift were morbid men suffering from claustrophobia. They were pent and imprisoned spirits, hating the walls that seemed to threaten to close in on them and crush them.

In his poems and letters Donne is haunted especially by three images – the hospital, the prison, and the grave. Disease, I think, preyed on his mind even more terrifyingly than warped ambition. 'Put all the miseries that man is subject to together,' he exclaims in one of the passages in that luxuriant anthology that Mr Logan Pearsall Smith[16] has made from the *Sermons*; 'sickness is more than all. . . . In poverty I lack but other things; in banishment I lack but other men; but in sickness I lack myself.' Walton declares that it was from consumption that Donne suffered; but he had probably the seeds of many diseases. In some of his letters he dwells miserably on the symptoms of his illnesses. At one time, his sickness 'hath so much of a cramp that it wrests the sinews, so much of tetane that it withdraws and pulls the mouth, and so much of the gout . . . that it is not like to be cured. . . . I shall', he adds, 'be in this world, like a porter in a great house, but seldomest abroad; I shall have many things to make me weary, and yet not get leave to be gone.' Even after his conversion he felt drawn to a morbid insistence on the details of his ill-health. Those amazing records which he wrote while lying ill in bed in October, 1623, give us a realistic study of a sick-bed and its circumstances, the gloom of which is hardly even lightened by his odd account of the disappearance of his sense of taste: 'My taste is not gone away, but gone up to sit at David's table; my stomach is not gone, but gone upwards toward the Supper of the Lamb.' 'I am mine own ghost,' he cries, 'and rather affright my beholders than interest them. . . . Miserable and inhuman fortune, when I must practise my lying in the grave by lying still.'

It does not surprise one to learn that a man thus assailed by wretchedness and given to looking in the mirror of his own bodily corruptions was often tempted, by 'a sickly inclination', to commit suicide, and that he even wrote, though he did not dare to publish, an apology for suicide on religious grounds, his famous and little-read 'Biathanatos'. The family crest of the Donnes was a sheaf of snakes, and these symbolize well enough the brood of temptations that twisted about in this unfortunate Christian's bosom. Donne, in the days of his salvation,

abandoned the family crest for a new one – Christ crucified on an anchor. But he might well have left the snakes writhing about the anchor. He remained a tempted man to the end.

One wishes that the *Sermons* threw more light on his later personal life than they do. But perhaps that is too much to expect of sermons. There is no form of literature less personal except a leading article. The preacher usually regards himself as a mouthpiece rather than as a man giving expression to himself. In the circumstances what surprises us is that the *Sermons* reveal, not so little, but so much of Donne. Indeed, they make us feel far more intimate with Donne than do his private letters, many of which are little more than exercises in composition. As a preacher, no less than as a poet, he is inflamed by the creative heat. He shows the same vehemence of fancy in the presence of the divine and infernal universe – a vehemence that prevents even his most far-sought extravagances from disgusting us as do the lukewarm follies of the Euphuists.[17] Undoubtedly the modern reader smiles when Donne, explaining that man can be an enemy of God as the mouse can be an enemy to the elephant, goes on to speak of 'God who is not only a multiplied elephant, millions of elephants multiplied into one, but a multiplied world, a multiplied all, all that can be conceived by us, infinite many times over; nay (if we may dare to say so) a multiplied God, a God that hath the millions of the heathens' gods in Himself alone'. But at the same time one finds oneself taking a serious pleasure in the huge sorites of quips and fancies in which he loves to present the divine argument.

Nine out of ten readers of the *Sermons*, I imagine, will be first attracted to them through love of the poems. They need not be surprised if they do not immediately enjoy them. The dust of the pulpit lies on them thickly enough. As one goes on reading them, however, one becomes suddenly aware of their florid and exiled beauty. One sees beyond their local theology to the passion of a great suffering artist. Here are sentences that express the Paradise, the Purgatory, and the Hell of John Donne's soul. A noble imagination is at work – a grave-digging

imagination, but also an imagination that is at home among the stars. One can open Mr Pearsall Smith's anthology almost at random and be sure of lighting on a passage which gives us a characteristic movement in the symphony of horror and hope that was Donne's contribution to the art of prose. Listen to this, for example, from a sermon preached in St Paul's in January, 1626:

Let me wither and wear out mine age in a discomfortable, in an unwholesome, in a penurious prison, and so pay my debts with my bones, and recompense the wastefulness of my youth with the beggary of mine age; let me wither in a spittle under sharp, and foul, and infamous diseases, and so recompense the wantonness of my youth with that loathsomeness in mine age; yet, if God withdraw not his spiritual blessings, his grace, his patience, if I can call my suffering his doing, my passion his action, all this that is temporal is but a caterpillar got into one corner of my garden, but a mildew fallen upon one acre of my corn: the body of all, the substance of all is safe, so long as the soul is safe.

The self-contempt with which his imagination loved to intoxicate itself finds more lavish expression in a passage in a sermon delivered on Easter Sunday two years later:

When I consider what I was in my parents' loins (a substance unworthy of a word, unworthy of a thought), when I consider what I am now (a volume of diseases bound up together; a dry cinder, if I look for natural, for radical moisture; and yet a sponge, a bottle of overflowing Rheums, if I consider accidental; an aged child, a grey-headed infant, and but the ghost of mine own youth), when I consider what I shall be at last, by the hand of death, in my grave (first, but putrefaction, and, not so much as putrefaction; I shall not be able to send forth so much as ill air, not any air at all, but shall be all insipid, tasteless, savourless, dust; for a while, all worms, and after a while, not so much as worms, sordid, senseless, nameless dust), when I consider the past, and present, and future state of this body, in this world, I am able to conceive, able to express the worst that can befall it in nature, and the worst that can be inflicted on it by man, or fortune. But the least degree of glory that God hath prepared for that body in heaven, I am not able to express, not able to conceive.

Excerpts of great prose seldom give us that rounded and final beauty which we expect in a work of art; and the reader of Donne's *Sermons* in their latest form will be wise if he comes to them expecting to find beauty piecemeal and tarnished

though in profusion. He will be wise, too, not to expect too many passages of the same intimate kind as that famous confession in regard to prayer which Mr Pearsall Smith quotes, and which no writer on Donne can afford not to quote:

I throw myself down in my chamber, and I call in, and invite God, and his angels thither, and when they are there, I neglect God and his Angels, for the noise of a fly, for the rattling of a coach, for the whining of a door. I talk on, in the same posture of praying; eyes lifted up; knees bowed down; as though I prayed to God; and, if God, or his Angels should ask me, when I thought last of God in that prayer, I cannot tell. Sometimes I find that I had forgot what I was about, but when I began to forget it, I cannot tell. A memory of yesterday's pleasures, a fear of to-morrow's dangers, a straw under my knee, a noise in mine ear, a light in mine eye, an anything, a nothing, a fancy, a chimera in my brain troubles me in my prayer.

If Donne had written much prose in this kind, his *Sermons* would be as famous as the writings of any of the saints since the days of the Apostles.

Even as it is, there is no other Elizabethan man of letters whose personality is an island with a crooked shore, inviting us into a thousand bays and creeks and river-mouths, to the same degree as the personality that expressed itself in the poems, sermons, and life of John Donne. It is a mysterious and at times repellent island. It lies only intermittently in the sun. A fog hangs around its coast, and at the base of its most radiant mountain-tops there is, as a rule, a miasma-infested swamp. There are jewels to be found scattered among its rocks and over its surface, and by miners in the dark. It is richer, indeed, in jewels and precious metals and curious ornaments than in flowers. The shepherd on the hillside seldom tells his tale uninterrupted. Strange rites in honour of ancient infernal deities that delight in death are practised in hidden places, and the echo of these reaches him on the sighs of the wind and makes him shudder even as he looks at his beloved. It is an island with a cemetery smell. The chief figure who haunts it is a living man in a winding-sheet.

It is, no doubt, Walton's story of the last days of Donne's life that makes us, as we read even the sermons and the love-

poems, so aware of this ghostly apparition. Donne, it will be remembered, almost on the eve of his death, dressed himself in a winding-sheet, 'tied with knots at his head and feet', and stood on a wooden urn with his eyes shut, and 'with so much of the sheet turned aside as might show his lean, pale, and death-like face', while a painter made a sketch of him for his funeral monument. He then had the picture placed at his bedside, to which he summoned his friends and servants in order to bid them farewell. As he lay awaiting death, he said characteristically, 'I were miserable if I might not die,' and then repeatedly, in a faint voice, 'Thy Kingdom come, Thy will be done.' At the very end he lost his speech, and 'as his soul ascended and his last breath departed from him he closed his eyes, and then disposed his hands and body into such a posture as required not the least alteration by those that came to shroud him'.

It was a strange chance that preserved his spectral monument almost uninjured when St Paul's was burned down in the Great Fire,[18] and no other monument in the cathedral escaped. Among all his fantasies none remains in the imagination more despotically than this last fanciful game of dying. Donne, however, remained in all respects a fantastic to the last, as we may see in that hymn which he wrote eight days before the end, tricked out with queer geography, and so anciently egotistic amid its worship, as in the verse:

> Whilst my Physicians by their love are grown
> Cosmographers, and I their Map, who lie
> Flat on this bed, that by them may be shown
> That this is my South-west discovery
> *Per fretum febris*, by these straits to die.

Donne was the poet-geographer of himself, his mistresses, and his God. Other poets of his time dived deeper and soared to greater altitudes, but none travelled so far, so curiously, and in such out-of-the-way places, now hurrying like a nervous fugitive, and now in the exultation of the first man in a new-found land.

MOLIÈRE[1]

THE WAY OF ENTERTAINERS is hard. It is a good enough world for those who entertain us no higher than the ribs, but to attempt to entertain the mind is another matter. Comedy shows men and women (among other things) what humbugs they are, and, as the greatest humbugs are often persons of influence, the comic writer is naturally hated and disparaged during his lifetime in some of the most powerful circles. That Molière's body was at first refused Christian burial may have been due to the fact that he was an actor – in theory, an actor was not allowed even to receive the Sacrament in those days unless he had renounced his profession – but his profession of comic writer had during the latter part of his life brought him into far worse disrepute than his profession of comic actor. He was the greatest portrayer of those companion figures, the impostor and the dupe, who ever lived, and, as a result, every kind of impostor and dupe, whether religious, literary, or fashionable, was enraged against him. That Molière was a successful author is not disputed, but he never enjoyed a calm and unchallenged success. He had the support of Louis XIV[2] and the public, but the orthodox, the professional and the high-brow lost no opportunity of doing him an injury.

Molière was nearly forty-two when he produced *L'École des femmes*. He had already, as Mr Tilley[3] tells us, in his solidly instructive study, 'become an assured favourite with the public', though *Les Précieuses ridicules* had given offence in the salons, and performances were suspended for a time. With the appearance of *L'École des femmes* he at length stood forth a great

writer, and the critics began to take counsel together. A ten
months' war followed, in the course of which he delivered two
smashing blows against his enemies, first in *La Critique de
l'École des femmes* and *L'Impromptu de Versailles*. Then in 1664,
he produced at Versailles the first three acts of *Tartuffe*. This
began a new war which lasted, not merely ten months, but five
years. It was not until 1669 that Molière received permission to
produce in public the five-act play that we now know. The
violence of the storm the play raised may be gauged from a
passage in a contemporary pamphlet, which describes Molière
as 'un démon vêtu de chair et habillé en homme, un libertin,
un impie digne d'un supplice exemplaire'. Mr Shaw himself
never made people angrier than Molière. Having held a religious
hypocrite up to ridicule, Molière went on to paint a comic
portrait of a freethinker. He gave the world *Dom Juan*, which
was a great success – for a week or two. Suddenly, it was with-
drawn, and Molière never produced it again. Nor did he
publish it. It had apparently offended not only the clergy but
the great nobles, who disliked the exposure of a gentleman on
his way to Hell.

It was, we may presume, these cumulative misfortunes that
drove him into the pessimistic mood out of which *Le Misan-
thrope* was born. He had now written three masterpieces for the
purpose of entertaining his fellows, and he was being treated,
not as a public benefactor, but as a public enemy. One of the
three had been calumniated; one was prohibited; the third had
to be withdrawn. And in addition to being at odds with the
world, he was at odds with his wife. He had married her, a girl
under twenty, when he himself was forty, and she apparently
remained a coquette after marriage. One could not ask for
clearer evidence of the sanity of Molière's genius than the fact
that he was able to make of his bitter private and public
quarrels one of the most delightful comedies in literature.
Alceste, it is true, with his desire to quit the insincere and
fashionable world and to retire into the simple and secluded life,
is said to be a study, not of Molière himself, but of a mis-
anthropic nobleman. But, though Molière may have borrowed a

few features of the nobleman's story, he undoubtedly lent the nobleman the soul of Molière. He had the comic vision of himself as well as of the rest of humanity. He might mock the vices of the world but he could also mock himself for hating the world, in the spirit of a superior person, on account of its vices. He could even, as a poet, see his wife's point of view, though he might quarrel with her as a husband. Célimène, that witty and beautiful lady who refuses to retire with Alceste into his misanthropic solitude, has had all the world in love with her ever since. Molière, we may be sure, sympathized with her when she protested:

La solitude effraye une âme de vingt ans.

Molière himself played the part of Alceste, and his wife played Célimène. The play, we are told, was not one of his greatest popular successes. As one reads it, indeed, one is puzzled at times as to why it should be giving one such exquisite enjoyment. There is less action in it than in any other great play. The plot never thickens, and the fall of the curtain leaves us with nothing settled as to Alceste's and Célimène's future. To write a comedy which is not very comic and a drama which is not very dramatic, and to make of this a masterpiece of comic drama, is surely one of the most remarkable of achievements. It can only be explained by the fact that Molière was a great creator and not a great mechanician. He gives the secret of life to his people. His success in doing this is shown by the way in which men have argued about them ever since, as we argue about real men and women. There are even critics who are unable to laugh at Molière, so overwhelming is the reality of his characters. M. Donnay says, 'Aujourd'hui nous ne rions pas de Tartuffe ni même d'Orgon'; and Mr Tilley, discussing *Le Malade imaginaire*, observes that we realize that Argan – Argan of the clysters – is 'at bottom a tragic figure'. Again, he sees a 'tragic element' in the characterization of Harpagon in *L'Avare*, and, speaking of Alceste in *Le Misanthrope*, he observes that, 'though we may be sure that [Molière] fully realized the tragic side of his character, it was not this aspect that he wished to

present to the public'. It seems to me that there is a good deal
of unreality in all this. It is as though the errors of men were
too serious things to laugh at – as though comedy had not its
own terrible wisdom and must not venture into the depths of
reality. Molière would probably have had a short way with
those who cannot laugh at *Tartuffe*, as Cervantes would have
had a short way with those who cannot laugh at *Don Quixote*.
There is as much imagination – as much sympathy, even,
perhaps – in the laughter of the great comic writers as in the
tears of the sentimentalist. And Molière's aim was laughter
achieved through an exaggerated imitation of reality. He was
the poet of good sense, and he felt that he had but to hold up
the mirror of good sense in order that we might see how
absurd is every form of egotism and pretentiousness. He took
the side of the simple dignity of human nature against all the
narrowing vices, the anti-social vices, whether of avarice, licen-
tiousness, self-righteousness or precosity. He has written the
smiling poetry of our sins. Not that he is indulgent to them,
like Anatole France, whose view of life is sentimental. Molière's
work was a declaration of war against all those human beings
who are more pleased with themselves than they ought to be,
down to that amazing coterie of literary ladies in *Les Femmes
savantes*, concerning whose projected academy of taste one of
them announces in almost modern accents:

> Nous serons par nos lois les juges des ouvrages;
> Par nos lois, prose et vers, tout nous sera soumis;
> Nul n'aura de l'esprit hors nous et nos amis;
> Nous chercherons partout à trouver à redire,
> Et ne verrons que nous qui sache bien écrire.

Molière has been accused of writing an attack on the higher
education of women in *Les Femmes savantes*. What we see in it
today is an immortal picture of those intellectual impostors of
the drawing-room – the not-very-intelligentsia, as they have
been wittily called – who exist in every civilized capital and in
every generation. The vanities of the rival poets, it is true, are
caricatured rather extravagantly, but the caricature is essentially

true to life. This is what men and women are like. At least, this is what they are like when they are most exclusive and most satisfied with themselves. Molière knew human nature. That is what makes him so much greater a comic dramatist than any English dramatist who has written since Shakespeare.

Molière has been taken to task by many critics since his death. He has been accused even of writing badly. He has been told that he should have written none of his plays in verse, but all of them, as he wrote *L'Avare*, in prose. All these criticisms are nine-tenths fatuous. Molière by the use of verse gave comic speech the exhilaration of a game, as Pope did, and literature that has exhilarating qualities of this kind has justified its existence, whether or not it squares with some hard-and-fast theory of poetry. If we cannot define poetry so as to leave room for Molière and Pope, then so much the worse for our definition of poetry. As for padding, I doubt whether any dramatist has ever kept the breath of life in his speech more continuously than Molière. His dialogue is not a flowing tap but a running stream. That Molière's language may be faulty I will not dispute, as French is an alien and but little-known tongue to me. He produces his effects, whatever his grammar. He has created for us a world, delicious even in its insincerities and absurdities – a world seen through charming, humorous, generous, remorseless eyes – a world held together by wit – a world in which the sins of society dance to the ravishing music of the alexandrine.[4]

13

HENRY FIELDING[1]

WHEN I WAS A BOY in Belfast and frequented the Linen Hall Library, the reader himself picked from the shelves the books he wished to take away with him. There was one locked book-case, however, containing books for which the borrower had to make an application to the librarian – books of doubtful morality, presumably, not to be left lying about with a possibility of their getting into the 'wrong hands' – and there, imprisoned behind wire netting, were handsome editions of the novels of Richardson[2] and Fielding.

Tom Jones[3] may seem a harmless and even a healthy book today, when standards both of conduct and of speech have altered; but the Victorian elders felt more responsible for the morals of the young than their modern successors do, and many of them no doubt were uneasy lest so attractive a young scapegrace as Tom should mislead their sons by his example. J. M. Dent[4] once told me that he had had qualms about admitting the book into Everyman's Library, and how it was only after he had consulted the scholarly congregationalist divine, Dr R. F. Horton,[5] on the matter and obtained his approval that he decided to do so.

There is no need to be censorious of the Victorians and their dread of the influence of doubtful books on the young. Fielding himself would to some extent have agreed with them. In one of his best essays in *The Covent Garden Journal* he recommends to his readers 'a total abstinence from all bad books', and adds:

I do therefore most earnestly entreat all my young readers that they would cautiously avoid the perusal of any modern book till it has first had the

sanction of some wise and learned man; and the same caution I propose to all fathers, mothers, and guardians. 'Evil communications corrupt good manners' is a quotation of St Paul from Menander.[6] *Evil books corrupt at once both our manners and our taste.* (The italics are Fielding's.)

And Fielding, in speaking of 'bad books', was not referring merely to the scribblers of his own time. He included two acknowledged authors of genius in his condemnation. After praising Shakespeare and Molière for the use they made of their talents, he went on:

There are some, however, who, though not void of these talents, have made so wretched a use of them that, had the consecration of their labours been committed to the hands of the hangman, no good man would have regretted their loss; nor am I afraid to mention Rabelais[7] and Aristophanes[8] himself in this connection. For, if I may speak my opinions freely of these two last writers and of their works, their design appears to me very plainly to have been to ridicule all sobriety, modesty, decency, virtue, and religion of the world.

Even when we have agreed that books may have an influence either for good or for evil, however, it is not easy to agree which are the good and which the bad books. A book that merely inflames the bodily passions of one reader may inflame the heart of another reader with charity. There is such a thing as a bad reader as well as a bad book.

If we judge literature from a moral point of view – as Fielding himself did – all that we can reasonably ask of a book is that it shall enlarge the sympathy of the ordinary reader, give him a healthy view of life, or fortify his spirit. Dr Johnson would not apparently have admitted that *Tom Jones* passed any of these tests. Boswell tells us that he quoted with approval a saying of Richardson's that 'the virtues of Fielding's heroes were the vices of a really good man', surely a foolish and even meaningless judgment. Boswell himself seems to me to have gone to the heart of the matter with much greater wisdom. 'I will venture to add', he wrote,

that the moral tendency of Fielding's writing, though it does not encourage a strained and rarely possible virtue, is ever favourable to honour and honesty, and cherishes the benevolent and generous affections. He who is as good as Fielding would make him is an amiable member of society and may be led on by more regular instructors to a higher degree of ethical perfection.

Buoyant with vitality, he was evidently a man who made others feel that it was a good thing to be alive in the same world with him. Lady Mary Wortley Montagu[9] in one of her letters gives us a vivid impression of him as a practitioner of the virtue of enjoyment. 'His happy constitution', she says,

(even when he had with great pains half demolished it), made him forget everything when he was before a venison pasty or even a flask of champagne, and I am persuaded he has known more happy moments than any prince upon the earth. His natural spirits gave him rapture in his cook-maid, and cheerfulness when he was fluxing. There was a great similitude between his character and that of Sir Richard Steele.[10] He had the advantage both in learning, and, in my opinion, in genius; they both agreed in wanting money in spite of all their friends, and must have wanted it if their hereditary lands had been as extensive as their imaginations; yet each of them was so formed for happiness it is a pity he was not immortal.

In spite of the charm of his character and its exuberant vitality, however, Fielding has left no legend behind him as Pope and Swift, Johnson and Goldsmith and many others of the great writers of the century have done. Living in an age of gossip, he is the theme of few anecdotes, and his conversation, good as it must have been, had no Boswell to record it. Yet he did not live in obscurity. He was at Eton with the great Chatham[11] and remained intimate enough with him to consult him as to the advisability of publishing *Tom Jones*. He lived for years in the blazing light of the theatrical world. He won immediate fame as a novelist. He was a famous figure in the small London dominated by Dr Johnson. He was the friend of Hogarth[12] and Garrick.[13] He ended his life as the most humane, efficient, and progressive magistrate in London. All this we know, but we do not know Fielding the man in the details of his daily life and conversation as his contemporaries knew him.

At the age of eighteen Henry made a romantic beginning in an attempt to abduct a fifteen-year-old heiress at Lyme Regis; but there was little romance in the long story that follows of his career as a hack-writer for the stage. The most interesting thing we know about Fielding's career as a dramatist is that his attacks on Sir Robert Walpole[14] were the direct cause of a

censorship of plays and – whether a censorship is a good thing or a bad one – what a benefit it turned out to be to English literature! It drove Fielding out of the theatre, where he was only a man of talent, and impelled him to seek a new literary outlet in fiction in which he proved to be a man of genius.

Journalism and study for the bar occupied him for some years before the publication of Richardson's *Pamela or Virtue Rewarded* in 1740 tickled him by its solemnity and prudential morality into attempting a burlesque of it. In Richardson's novel a housemaid, pursued by her unprincipled master, shows that honesty is the best policy and ends by marrying him. In *Joseph Andrews* Fielding gives Pamela an equally chaste 'brother', a footman, on whom his employer, Lady Booby, has designs. Having begun the story as a burlesque, however, he gives his invention rein and ends by writing the first comic novel in English with the quixotic Parson Adams as a character that was to become immortal.

There are certainly, by Victorian standards, coarse touches in *Joseph Andrews*, but there is no laughing at the expense of genuine goodness. As in *Don Quixote*, we laugh at the ills that befall the virtuous, but that does not lessen our affection for them. It is the mean, false, and hypocritical characters who are held up not only to ridicule but to contempt. And what an easy and quick flow of narrative was Fielding's! How pleasant and refreshing the current of his prose! I have been dipping into *Joseph Andrews* again, and its humour and humanity seem to me to be as likely to captivate the right sort of reader today as two hundred years ago.

That Fielding outraged some of the standards of his own time as well as the Victorians is clear from the history of the reception of *Tom Jones*. In 1752, a year after it was published, when two earthquakes occurred in England, they were regarded by the strict as Heaven's condemnation of *Tom Jones* and similar lewd publications, and it was pointed out that Paris, where (it was said) the book had been refused publication, was not affected by the earthquakes. Richardson naturally regarded it as 'a dissolute book', and some years afterwards Johnson was

still censorious enough to dismiss Fielding as 'a blockhead', explaining: 'What I mean by his being a blockhead is that he was a barren rascal,' and suggesting that Fielding took 'an ostler's low view of life'. I sometimes wonder whether, if Johnson had met Fielding, he might not have been charmed by him as he was by Wilkes,[15] or even been converted to Gibbon's opinion that the romance of *Tom Jones*, that exquisite picture of human manners, 'will outlive the palace of the Escorial and the Imperial Eagle of the House of Austria'. Still, the whitewashing of *Tom Jones* has perhaps been overdone by its defenders, and there is one incident with Molly Seagrim which not only a novelist but a man of ordinary feeling for the decencies of ordinary life would think pretty low.

On the other hand, only a man of a twisted mind could regard Fielding as a corrupter of human nature. Expecting little sanctity from it, he was nevertheless a preacher of the more pedestrian and attainable virtues, and both as a writer and as a magistrate was a model of honesty. Refusing to enrich himself with the normal though not quite honest perquisites of office, he inaugurated a campaign against crime that had lasting effects on London life. Whether overwork or over-indulgence played the chief part in his early death at the age of forty-seven it is hard to say, but we know from his *Voyage to Lisbon*, written on his last journey in search of health, that even in his last moments he maintained his gallantry of spirit.

The *Voyage* contains one paragraph which seems to me a perfect revelation of the smiling truthfulness of the man. Fielding tells how he had a quarrel with the captain, who was a bully, and how by threatening him with the law he reduced the man to begging for mercy. 'I immediately forgave him,' he writes,

and here, that I may not be thought the silly trumpeter of my own praises, I do utterly disclaim all praise of the occasion. Neither did the greatness of my mind dictate, nor the grace of my Christianity exact this forgiveness. To speak truth I forgave him from a motive which would make men much more forgiving if they were much wiser than they are, because it was convenient for me to do so.

Who could help loving a man so unpretentious, so good-humouredly candid, so worldly-wise and at the same time so wise?

BOSWELL[1]

'BETWEEN OURSELVES,' wrote Boswell to his friend Temple,[2] complaining that Johnson, having published a book on the Hebrides, did not wish him to publish another on the same theme – 'between ourselves, he is not apt to encourage one to *share* reputation with himself.' If this is a true account of Johnson, how miserable his ghost must be if it ever revisits the earth, for no man of letters has ever 'shared reputation' with another to a greater extent than he with Boswell! They are as inseparable in our imaginations as Castor and Pollux.[3] Each, lacking the other, would lack half himself.

This is not to deny that they were both men of extra-ordinary original genius. It used to be imagined that Boswell was merely a lucky fool who owed everything to his having attached himself as a parasite to Johnson. More recently, however, we have come to see that Boswell was a man of genius who would have interested the world, though not per-haps so greatly, even if he had never met Johnson. If he had not written a great book on Johnson he would have written a great book on somebody else – possibly on himself. For while Johnson and Paoli[4] were Boswell's heroes, Boswell was also Boswell's hero. He may be said to have been divided into two persons, one of whom was never tired of gazing at the other and taking down notes of his doings and experiences. At the age of twenty-one he published anonymously 'An Ode to Tragedy', and dedicated it to 'James Boswell, Esq.' as to an admired friend, and we may be sure there was no one whom he loved better.

Luckily, even when he makes himself his hero, his genius remains predominantly comic. When, as president of the Soaping Club at Edinburgh in his youth, he writes some verses about himself, affirming that

> In short, to declare the plain truth,
> There is no better fellow alive,

he is candid enough to portray himself not only as a good fellow but as a ridiculous fellow:

> Boswell is pleasant and gay,
> For frolic by nature designed;
> He heedlessly rattles away
> When the company is to his mind.

> 'This maxim,' he says, 'you may see,
> We ne'er can have corn without chaff';
> So not a bent sixpence cares he
> Whether *with* him or *at* him you laugh.

Even when he describes his personal appearance, as he does in 'The Cub at Newmarket' (a poetical account of himself among members of the Jockey Club, written during his first visit to London and the south), he sees himself, not in the mirror of self-flattery, but in the mirror of caricature: 'Plumpness', he writes, describing the 'cub', who was himself –

> Plumpness shone in his countenance;
> And Belly prominent declared
> That he for Beef and Pudding cared;
> He had a large and prom'nent head,
> That seemed to be composed of lead.

And, in dedicating this poem to the Duke of York,[5] he writes: 'Permit me to let the world know that the same cub has been laughed at by the Duke of York.' Boswell from the first did not mind if he cut a ridiculous figure so long as he cut a figure.

All through his letters to his old college friend, the Rev. William Temple – letters far more intimate than any he ever

wrote to Johnson – we can see him watching himself like a spectator in a theatre, and inviting Temple to be his fellow-spectator. It is, to change the image slightly, as though he were the showman of himself, saying: 'Now see Boswell drunk. Now see him repentant. Now see him in love. Now see him disgracing himself with some "infamous creature". Now see him in the best society in the world.' He cannot conceive that any one else can be less interested in him than he is in himself. And, indeed, he is right. He is the rare kind of egotist that seldom bores us. He is an egotist who is in love, not only with himself, but with other people.

Nor is this the only respect in which he is a bundle of contradictions and, because of this, a continuous and fascinating puzzle. He is at once a man who yields to every temptation and a staunch friend of religion and morality. He is addicted to the most eloquent repentance and at the same time to explanations that the sins of which he repents were not, after all, very serious. He chuckles amid his pious groans. He is like a man married both to vice and to virtue and enjoying playing the one off against the other. While he is infatuated with a new mistress in Edinburgh he gets drunk, and, while drunk, is faithless to her. He hastens to his mistress to confess, to beg forgiveness, and to palliate his frailty. 'I gloried', he reports to Temple ingenuously, 'that I had ever been firmly constant to her while I was myself.' Boswell, however, finds it so difficult to remain faithful to any one woman that he writes to Temple advocating concubinage and asking: 'If it was *morally* wrong, why was it permitted to the most pious men under the Old Testament?' It was in the same easy-going mood that he defended his drunkenness to Mrs Stuart[6] on the ground that 'intoxication might happen at a time to any man'. 'Yes,' she replied, 'to any man but a Scotsman, for what with another man is an accident, is in him a habit.' On another occasion, however, we find the genial defender of the vices going to St Paul's and making a vow to abstain for six months from licentious connections, and again giving General Paoli his word of honour that he will abstain from fermented liquor for a year. There was not, indeed, in all

Great Britain a more ardent friend of religion and good conduct than this mercurial reprobate. It was he who wrote, when Hume[7] died: 'It has shocked me to think of his persisting in infidelity. . . . I am of Dr Johnson's opinion, that those who write against religion ought not to be treated with gentleness.'

Yet with all the discrepancies between his conduct and his professions, and with all the fluctuations of his heart, his appetites, and his opinions, Boswell was no hypocrite. It was in perfect sincerity that, when going to Utrecht to study law, he wrote to a friend: 'My great object is to attain a proper conduct in life. How sad it will be if I turn no better than I am! . . . I must, however, own to you that I have at bottom a melancholy cast; which dissipation relieves by making me thoughtless, and therefore an easier, though a more contemptible, animal.' The truth is, Boswell was not only a man who, as he confessed, 'talked at random', but a man whose destiny it was to live at random, and who found all the excitements of experience equally irresistible. But he never pretended to be other than he was. He was naturally too candid to be able to play the hypocrite and to conceal his shortcomings, even if he had wished to do so. Hence, when he fell in love with Miss Blair and, wishing to marry her, sent Temple as a kind of ambassador to her, he wrote out a series of instructions to be followed during the visit, bidding his friend hint the worst as well as the best. 'Praise me', he wrote, 'for my good qualities – you know them; but tell also how odd, how inconstant, how impetuous, how much accustomed to women of intrigue. Ask gravely, "Pray don't you imagine there is something of madness in that family!"' Was ever woman in such manner wooed? Yet the instructions are characteristic of Boswell in his readiness to appear at a disadvantage, whether from the love of showing himself as he really was or from the love of being a figure in an interesting situation.

Boswell's candour and his dramatic sense always, fortunately for us, went hand in hand. He saw himself perpetually as a man in a dramatic situation, and he had perpetually to find a confidant to whom he could describe the latest situation in which he

found himself. He could not even ask Miss Blair if she loved him without instantly scribbling to Temple an account of the interview in dialogue form, not even omitting his squeeze of her 'firm hand' or her remark: 'I wish I liked you as well as I do Auchinleck' (his father's estate). Similarly, when he was in love with Zélide[8] of Utrecht, he felt that the situation was so interesting that he sent her letters to Rousseau,[9] whom he scarcely knew, with the remark: 'If you care to amuse yourself by reading some pieces by this young lady, you will find them in a small separate parcel. I should like to have your sentiments on her character.' Boswell, in all his amusing love-affairs, was not only a man who kissed and told, but a man to whom telling gave a deeper and more lasting pleasure than kissing.

And his friendship with great men had the same dramatic quality as his love-affairs. He was not one of those hero-worshippers who obliterate themselves and prostrate themselves before greatness. He was as susceptible to genius as to a pretty face, but in his meetings with genius he was always as conscious of the presence of James Boswell as of that of the man of genius in the scene. Both in love and in acquaintanceship, he continually paused to call attention to the fact that he, James Boswell, was, if not the chief actor, at least an actor worth some attention. When, as a young man of twenty-four, he wrote to Rousseau, requesting an interview, he introduced himself as 'a man of singular merit', adding: 'Although but a young man, I have had a variety of experiences, with which you will be impressed.' 'Open your door, then, sir,' he wrote, 'to a man who dares to say that he deserves to enter there. Trust a unique foreigner. You will never repent it.' He thrust his company with as little appearance of ordinary sensitiveness on Voltaire,[10] on Wilkes,[11] and on Horace Walpole.[12] 'He forced himself upon me', wrote Walpole to Gray,[13] 'in spite of my teeth and my doors,' and in that phrase we have a measure of the impudence and persistence of Boswell.

It would be absurd, none the less, to describe Boswell, in his approaches to the great, as a 'climber', for 'climber' is a word used of men who climb from one rank of society into another,

and Boswell, as a descendant of Robert Bruce[14] and a son of Lord Auchinleck, had no feeling of social inferiority in his intercourse with the great. He was undoubtedly pushful, but the men into whose presence he forced himself with the greatest sense of triumph were not men of rank or wealth, but men of genius. When he was a youth of twenty, he besought Temple to 'consider my situation', and he describes it as that of a young fellow in love with the delights of London – 'getting into the Guards, being about Court, enjoying the happiness of the *beau monde*, and the company of men of Genius'. And, if one may judge by his writings, he found the company of men of genius the supreme delight of them all. It is characteristic of him that, as Professor Tinker[15] observes, while he met and conversed with King George III, he has left us no dialogues to record his talk with the King to set beside the dialogues that record his talk with Dr Johnson.

When he first met Johnson at Tom Davies's[16] house, he was a young man of twenty-two, while Johnson was fifty-three. Their first meeting, with Johnson's two overwhelming snubs, has been described elsewhere.[17] It was an introduction, most people would have thought, of two incompatibles in age, temperament, nationality, and almost everything else. They had humour, sociability, and orthodoxy in common, however, and Johnson had a passion for making acquaintances. 'Sir,' he confided to Boswell at one of their early meetings, 'I love the acquaintance of young people; because, in the first place, I don't like to think of myself growing old. In the next place, young acquaintances must last longest, if they do last; and then, sir, young men have more virtue than old men; they have more generous sentiments in every respect.' Boswell does not tell us what he replied to this tribute to the virtue of the younger generation. But, in a whirl of excitement over his new friendship, he wrote off to Sir David Dalrymple[18] with modest exultation: 'You will smile to think of the association of so enormous a genius with one so slender.' In the same month he wrote to Temple, telling how he had supped *tête-à-tête* with Johnson till between two and three. 'He took me by the hand

cordially and said: "My dear Boswell, I love you very much." Now, Temple, can I help indulging vanity?' The meetings between Johnson and Boswell after this have been recorded with such vividness that we are tempted to think of the two men at times as inseparable cronies who till the death of Johnson were parted from each other only by accident and for short periods. It is difficult to realize that the months in which they did not see each other were far more numerous than the months in which they were together. Their friendship, if we date its beginning in May 1763, when they first met, lasted more than twenty-one years, yet, according to the estimate of Dr Birkbeck Hill,[19] all the periods of time during which they were living near each other if added together would amount only to about two years, and on most days in those two years they probably did not see each other. Croker[20] estimated that Boswell and Johnson spent two hundred and seventy-six days together in all, and that Boswell met Johnson only one hundred and eight times during his twelve visits to England in the period of their friendship. Boswell was unique among Johnson's friends, not so much because of the closeness of his friendship as because of the glorious uses to which he turned it. It is as though in the present century an enthusiastic young inhabitant of New York who paid a dozen visits to England were to write the most intimate biography of the greatest living English writer, who happened incidentally to be a man with a strong anti-American bias.

Boswell did not at once dedicate his life to Johnson as to a demigod in a world of ordinary men. When he wrote to Temple in 1768, excitedly triumphing in his social success in London, Johnson was only one of the great men whom he boasted of having captured. 'I am really the *Great Man* now,' he wrote with charming self-adulation.

I have had David Hume in the forenoon and Mr Johnson in the afternoon of the same day visiting me. Sir John Pringle,[21] Dr Franklin[22] and some company dined with me today; and Mr Johnson and General Oglethorpe[23] one day, Mr Garrick[24] alone another, and David Hume and some more literati another, dine with me next week. I give admirable dinners and good claret, and the moment I go abroad again, which will be in a day or two, I set up

my chariot. This is enjoying the fruit of my labours and appearing like the friend of Paoli.

Again when, during the same year, Boswell makes one of his frequent moral slips, he bewails in a letter to Temple conduct 'so unworthy of the friend of Paoli', as though Paoli rather than Johnson were the man to whom he most looked up. Nor, as has already been suggested, do the surviving letters to Johnson convey the impression that Johnson was the friend to whom he loved most to confide the entire circle of his follies and aspirations. Candid though he was, he showed only a crescent of himself to Johnson, while he was all but a full moon to Temple. He never forgot that Johnson was a sage and moralist, but he addressed Temple as a friend of his youth to whom he could boast of his sins as well as repent of them.

At the same time, it is clear that, even in the year in which he first met Johnson, he realized that the most important thing in his life had happened to him. He tells us that in the early days of their friendship he used sometimes to sit up all night, writing in his journal an account of everything in Johnson's talk worth preserving. 'I remember', he declares, 'having sat up four nights in one week, without being much incommoded in the day time.' I doubt if in the annals of literature there is another example of such frenzied conscientiousness on the part of a lively and dissipated young man with a weak will that could scarcely resist a bottle of a 'Circean charmer'. Drunken and dissipated men have, contrary to the modern notion, frequently been hard and conscientious workers, but seldom on this scale. Note-taking, however, was to Boswell more than meat and drink. Robert Barclay[25] said that he had seen 'Boswell lay down knife and fork and take out his tablets in order to register a good anecdote', and Mrs Thrale[26] complained that he had a trick of 'sitting steadily down at the other end of the room to write at the moment what should be said in company, either *by* Dr Johnson or *to* him'. This she condemned as ill bred and treacherous. Johnson apparently did not share Mrs Thrale's dislike of Boswell's note-taking. He was at once flattered and

entertained. We have an account of his going into Boswell's bedroom one morning, during the Scottish tour, in order to read the latest additions to the reports of his conversations, which were at that time always submitted to him, and of his saying commendingly: 'You improve: it grows better and better. . . . It might be printed, were the subject fit for printing.' And on another occasion he helped Boswell to fill up some blanks 'which I had left when first writing it, when I was not quite sure of what he had said'. If Boswell was the perfect portrait-painter, Johnson, it is clear, was the perfect sitter.

Many of the dialogues in which they took part might almost have been deliberately arranged with a view to handing down a perfect portrait to future ages. We know that Boswell used sometimes to ask questions 'with an assumed air of ignorance in order to incite Johnson to talk', and obviously many of his questions were asked, not for the purpose of obtaining information, but with the object of starting a game of dramatic dialogue. 'Boswell's conversation', Bennet Langton[27] once declared impatiently, 'consists entirely in asking questions, and it is extremely offensive.' Never, assuredly, was a man questioned on a greater variety of topics than Johnson. 'I put a question to him', writes Boswell, describing one conversation, 'upon a fact in common life, which he could not answer, nor have I found any one else who could. What is the reason that women servants, though obliged to be at the expense of purchasing their own clothes, have much lower wages than men servants, to whom a greater proportion of that article is furnished, and when in fact our female house-servants work much harder than the male?' I imagine that, if Johnson did not reply to this question, it was not because he was unable, but because he was exhausted. Much as he loved to be drawn out on all manner of topics, he must often have felt like a baited witness in a law court, and more than once he protested against the torture. 'I will not be put to the question,' he cried angrily one evening, when he was being 'teased with questions'. 'Don't you consider, sir, that these are not the manners of a gentleman? I will not be baited with *what* and *why*: What is this? What is that? Why is a cow's

tail long? Why is a fox's tail bushy?' And, another day, when he heard Boswell asking Levett[28] a long series of questions about him, Johnson became similarly exasperated. 'Sir,' he declared, 'you have but two topics, yourself and me. I am sick of both.' Boswell's frankness failed him when he was recording these reproofs in the Life of Johnson, and in each case he attributed vaguely to an unnamed 'gentleman' the questions that had given offence.

On the whole, however, it is safe to conclude that Johnson enjoyed being put to the question as much as Boswell enjoyed questioning him. If he had found Boswell a bore he would not have described him as 'the best travelling companion in the world'. Boswell was too eagerly devoted to his great object of giving pleasure both to other people and to himself to be anything but good company. He was despised and disparaged after his death, but during his life he was a general favourite. 'If general approbation will add anything to your enjoyment,' Johnson wrote to him from London in 1778, 'I can tell you that I have heard you mentioned as *a man whom everybody likes*. I think, life has little more to give.' Even Hannah More,[29] when she first met him, wrote of him as 'a very agreeable and good-natured man' – a good impression which he helped to destroy by getting drunk at Bishop Shipley's.[30] 'I was heartily disgusted', she wrote on the second occasion, 'with Mr Boswell, who came upstairs after dinner, disordered with wine, and addressed me in a manner which drew from me a sharp rebuke, for which I fancy he will not easily forgive me.' It is true that Mrs Thrale hated him, that Miss Hawkins[31] asked concerning him: 'Was this man a safe member of Society?', that Baretti[32] was his enemy, and that there was no love lost between him and Goldsmith; but the general opinion of him seems to have agreed with that of Sir Joshua Reynolds:[33] 'He thaws reserve wherever he comes and sets the ball of conversation rolling,' and it is said that Sir Joshua was never happier, if Boswell was present, than when he was sitting near him. Burke[34] had opposed his admission to the Club, but, after his admission, changed his opinion of him and declared that Boswell was a man of so much natural

good humour that good humour was scarcely a virtue to him. 'Society', it was said after his death, 'was his idol; to that he sacrificed everything; his eye glistened, and his countenance brightened up, when he saw the human face divine, and that person must have been very fastidious indeed who did not return him the same compliment when he came into a room.' Johnson affirmed that, during their travels in Scotland, Boswell 'never left a house without leaving a wish for his return'. So entertaining a companion was Boswell, indeed, that Dugald Stuart [35] maintained that his conversation was even more amusing than his writings, owing to 'the picturesque style of his conversational or rather his convivial diction' and to 'the humorous and somewhat whimsical seriousness of his face and manner'. The truth is, Boswell was an enthusiast for the social life and was endowed with most of the gifts that make it agreeable, and this alone would have won him the affection of Johnson.

But Johnson's affection for Boswell went deeper than the love of an entertaining companion. 'I love you', he once told him, 'as a kind man, I value you as a worthy man, and hope in time to reverence you as a man of exemplary piety. I hold you, as Hamlet has it, "in my heart of hearts".' To Johnson Boswell was a kind of favourite nephew – an excellent young man at heart, who, as the saying is, was his own worst enemy. Johnson always spoke to Boswell as to a fellow-Christian, at least in the making. 'My dear Sir,' he wrote to him, 'mind your studies, mind your business, make your lady happy, and be a Christian.' And when Boswell, who lived on bad terms with his father and would often have gladly exchanged his wife's company for that of Johnson, wrote complaining indirectly of his imprisonment in Scotland, Johnson reproved him for his love of London, adding: 'I am now writing, and you, when you read this, are reading under the Eye of Omnipotence.' We shall only half understand Boswell if we do not realize that he, as well as Johnson, was in a great measure a pious man. He enjoyed going to St Clement Danes [36] Church with Johnson no less than sitting late with him over a bottle of port at the Mitre. [37] It is

said that, when he was a student at Glasgow University, Boswell
was all but converted to Catholicism; and his attitude to reli-
gion is shown in a letter which he wrote to Sir David Dalrymple
after getting to know Johnson. 'I thank God', he wrote, 'that I
have got acquainted with Mr Johnson. He has done me infinite
service. He has assisted me to obtain peace of mind. He has
assisted me to become a rational Christian.'

Had Johnson not been a pious man, it is certain that Boswell
would never have held him in the same reverence. They were
both pious men even to the point of conventional orthodoxy.
Boswell would talk seriously to Johnson of the scandal of
having shops open on Good Friday, and would read *Ogden on
Prayer* aloud to him and a Scottish professor of divinity, while
Johnson, in Boswell's presence, would gravely advocate the
strict observance of Sunday, maintaining: 'It should be different
from another day. People may walk, but not throw stones at
birds. There may be relaxation, but there should be no levity.'
There is nothing more conspicuous in the *Life* and *Journal*
than Boswell's veneration for Johnson as a Christian. We see
this even in his account of Johnson's eccentric habit of uttering
pious ejaculations. 'Dr Johnson', Boswell wrote in the *Journal*,
'is often uttering pious ejaculations, when he appears to be
talking to himself, for sometimes his voice grows stronger, and
parts of the Lord's Prayer are to be heard. I have sat beside
him with more than ordinary reverence on such occasions.' It
was because Johnson knew that Boswell shared his faith that,
when writing a letter introducing him to John Wesley,[38] he
used the expression: 'I think it very much to be wished that
worthy and religious men should be acquainted with each
other.' There is something comical in the coupling of John
Wesley and Boswell as 'worthy and religious men'. Super-
ficially, the combination is ridiculous. If Johnson had not had
the genius of humanity to regard it as natural, however, he
would have been less than Johnson.

Nor was it only in creeds and observances that the religion
of Johnson and Boswell expressed itself. They were both men
who lived largely in their affections – men who could scarcely

live without affection. Boswell's cousin,[39] whom he married, may not have shared his 'roving disposition', or his tastes, or his regard for Johnson, and he may have caused her many uneasy hours, but his affection is clear in all his references to her. There is nothing uncommon in Boswell's affection for his children, but it is impossible not to like him better for the affectionate delight he shows in the way in which his infant daughter, Veronica, and Johnson got on together in Scotland. 'Mr Johnson', he records,

was pleased with my daughter, Veronica. . . . She had the appearance of listening to him. His motions seemed to her to be intended for her amusement; and when he stopped, she fluttered, and made a little infantine noise, and a kind of signal for him to begin again. She would be held close to him; which was a proof, from simple nature, that his figure was not horrid. Her fondness for him endeared her still more to me, and I declared she should have five hundred pounds of additional fortune.

At the same time he would be a rash man who attempted to put Boswell on a moral and domestic pedestal. He was a sentimentalist who could easily break the Ten Commandments he respected and neglect the wife and children to whom he was devoted. Johnson once said to him, referring to Mrs Boswell: 'In losing her you would lose your sheet-anchor, and be tossed without stability by the waves of life.' And, even with Mrs Boswell to look after him, Boswell was always one who was 'tossed without stability by the waves of life'.

It is all the more marvellous that a man of such incurable instability of character persisted in so single-minded a fashion with his task of giving the world the perfect life of Johnson. One could almost believe that, like Socrates,[40] he lived under the guidance of a 'demon', and that his very gaucheries and follies were inspired. He was inspired, it must be remembered, not only to write about Johnson, but to persuade Johnson continually to act and talk in such a fashion as would provide material for good writing. He was not merely the reporter of conversations that would have taken place even without his prompting: he was, as has been said, the originator of many of the conversations he reported. He was in many of those

conversations like a man in a bull-ring whose task it was, at whatever risk to himself, to prick the bull into fighting spirit. He himself more than once pictured Johnson as a bull, and in a conversation with Reynolds expressed his readiness, up to a point, to be the victim. 'I don't care', he said, 'how often or how high he tosses me, when only friends are present, for then I fall on soft ground; but I do not like falling on stones, which is the case when enemies are present.' It is sometimes suggested that Boswell was so thick-skinned that he suffered no pain in the course of these encounters, but in point of fact he combined a great deal of real sensitiveness with his apparent insensitiveness to rebuff. Once, after Johnson had tossed him, as we have seen, he would not go near him for a week, and was on the point of returning to Scotland without seeing him again when a chance meeting reconciled them. He found even the memory of his fall so painful that he did not describe the occasion of it in the biography. We learn the circumstances from another source. During a dinner at Sir Joshua's, at which the wits of Queen Anne's reign were being discussed, Boswell remarked in picador fashion: 'How delightful it must have been to have lived in the society of Pope, Swift, Arbuthnot,[41] Gay,[42] and Bolingbroke![43] We have no such society in our days.' 'I think, Mr Boswell,' said Sir Joshua, 'you might be satisfied with your great friend's conversation.' 'Nay, sir,' said Johnson, 'Mr Boswell is right. Every man wishes for preferment, and if Boswell had lived in those days he would have obtained promotion.' 'How so, sir?' said Reynolds. 'Why, sir,' said Johnson, 'he would have had a high place in the *Dunciad*.'[44] The way of the picador biographer is hard.

Ridiculously as Boswell often behaved, however, and irritating as an insect's buzz though his method of conversation must have sometimes been, we now realize that, as biographer elect, he made few mistakes. If at times he exasperated his contemporaries, it was for our benefit. If he asked absurd questions and laid himself open to snubs and ridicule, it was for our pleasure. 'Who is this Scotch cur at Johnson's heels?' someone asked. 'He is not a cur,' said Goldsmith; 'you are too severe.

He is only a burr. Tom Davies flung him at Johnson in sport, and he has the faculty of sticking.' Bennet Langton, too, complained that Boswell 'carried a night-cap in his pocket, so to speak, was blind to the inconvenience he caused, and deaf to hints that his departure would be a blessing'. But from our point of view this is evidence of Boswell's genius. If Hawkins was an unclubbable man, Boswell was an unsnubbable man – a quality essential for the work for which he was sent into the world. His endurance of snubs, like his note-taking, was part of a tenacity of purpose astonishing in one who was temperamentally irresolute. If he was a burr, it was his demon that told him to stick to Johnson.

How ridiculous he appeared to a good many others as he stuck to Johnson during his visits to London we may gather from Fanny Burney's [45] account of him. She tells us that when he visited Streatham on one occasion, he 'stared amazed' on finding the seat next to Johnson given to her instead of to himself, and that he immediately 'got another chair and placed it at the back of the shoulder of Dr Johnson'. If Johnson was present, according to Miss Burney, Boswell listened to no one else as he waited for the great man to speak, and, at the first word, 'his eyes goggled with eagerness; he leant his ear almost on the shoulder of the doctor; and his mouth dropped open to catch every syllable that might be uttered'. He gave the impression that so slavish was his worship of Johnson that he unconsciously imitated him in the mock-solemnity of his manner, his slouching gait, his large loose clothes, and his untidy wig. It is clear to all the world today, however, that, if Boswell made himself appear a slave, it was his means of becoming a prince among biographers. A dinner at Mrs Thrale's was not merely a momentary entertainment at which good manners were all important, but a potential scene in a masterpiece, demanding the mannerless application of an artist.

Nor did he ever make a mistake in so far as he stage-managed and directed Johnson's life for him. He brought about the meeting with Wilkes at Mr Dilly's. [46] He brought about the visit of Johnson, at the age of sixty-four, to Scotland. Here, as

in the conversations, we need not suspect Boswell of always consciously arranging events in such a way as to provide himself with copy. Even if he had not been a biographer, it is clear that he was a man who would have enjoyed immensely the game of bringing Johnson and Wilkes together and seeing how they would behave. Even so, it is a legitimate fancy that, in 'negotiating' the meeting, he was inspired by his demon.

And his demon stood him in good stead, not only in his collection of the materials for the *Life*, but in the compilation of it. 'Many a time', he told Temple, five years after Johnson's death, 'have I thought of giving it up.' With a temperament that swung like a pendulum between cheerfulness and depression, with political ambitions that continually came to nothing, with a tendency, especially after his wife's death in 1789, to 'seek relief in dissipation and in wine' with loss of health in consequence, with money troubles that did not cease when he became Laird of Auchinleck, he nevertheless persisted with his great task, buoyed up by the belief that it would be the most remarkable book of its kind ever written. 'I think', he wrote to Temple, 'it will be without exception the most entertaining book you ever read.'

In this faith he laboured at his book with the double assiduity of an historian and an artist. As a chronicler, he would 'run half over London in order to fix a date correctly'. As an artist he did not merely report Johnson's conversation: he remoulded it in order that it might live the more brightly and dramatically in literature. Many writers have commented on the liberties he took with Johnson's observation on Tom Sheridan's [47] attempt to improve the English language by teaching oratory. In the *Life* Johnson is represented as saying: 'What influence can Mr Sheridan have upon the language of this great country? Sir, it is burning a farthing candle at Dover to show light at Calais!' In Boswell's notes, however, what Johnson said appears as: 'He is like a man attempting to stride the English Channel. Sir, the cause bears no proportion to the effect. It is setting up a candle at Whitechapel to give light at Westminster.' Artistic liberties of this kind must be judged by their results, and who can

doubt that the more liberties Boswell took with Johnson's phrases the more truthfully he portrayed Johnson? His mind, as he himself said, was 'strongly impregnated with the Johnsonian ether', and the veracity of the portraiture is proved by the fact that the Johnson of the *Life* is in all essentials the same man as the Johnson of the *Journal of a Tour to the Hebrides* – 'the very same journal', as Boswell described it, 'which Dr Johnson read'.

Boswell, indeed, was more often accused of excessive frankness by Johnson's friends than of inaccuracy. When he was publishing the *Tour to the Hebrides*, Hannah More begged him to 'mitigate' some of Johnson's asperities, and he replied – 'roughly', according to her – that 'he would not cut off his claws, nor make his tiger a cat, to please anybody'. Boswell was determined to be as candid about Johnson as he was about himself, realizing that, if Johnson with his claws uncut was good enough to know and love in life, he must also be good enough to know and love in a biography. There may be something to be said for concealing the faults of a great man who had himself concealed them. But Johnson's 'asperities' were open and public 'asperities', and Boswell showed genius as well as courage, not in dragging secret and scandalous things to light, but in perpetuating the living Johnson as his friend had known and loved him.

Happily, when the *Life* was published in April 1791, the world agreed with Boswell's own estimate of it. A few months after its appearance, he who had begged for appointments all his life and obtained but few was rewarded with an appointment as secretary for foreign correspondence to the Royal Academy. He enjoyed the success of his book with his customary innocent vanity. When Wilkes met him and praised it, he wrote off to him on the following day: 'You said to me yesterday of my *magnum opus*, "It is a wonderful book." Do confirm this to me, so as I may have your *testimonium* in my archives at Auchinleck.' There you have the old Boswell – the Boswell who treasured every little candle that had helped to light up the figure of James Boswell, the 'Great Man', during his appearances on the social and literary stage. He never changed indeed. During the last year of his life he was still troubled

about his debts; he was still drinking – 'I do resolve anew to be on my guard,' he wrote repentantly to Temple; he was still 'presenting his compliments' to eminent men – the month before his death he wrote from his bed to congratulate Warren Hastings[48] on his acquittal; he was still the disciple of Johnson, and was still engaged in revising the *Life* when he died. He died in 1795 at the age of fifty-four. The manuscript materials for the *Life* of Johnson, which he intended for posterity, were, through the negligence of his executors, handed over to his family, who destroyed them.[49] It was an impious act of piety, but perhaps we are not greatly the losers by it. We know both Boswell and Johnson almost as well as human beings can be known more than a century after they are dead. Of all the men whose lives have been recorded for us, there is no other pair whom, with a knowledge of every peak and inlet of their characters, we find such perpetually good company.

CHARLES LAMB[1]

CHARLES LAMB was a small, flat-footed man whose eyes were of different colours and who stammered. He nevertheless leaves on many of his readers the impression of personal beauty. De Quincey[2] has told us that in the repose of sleep Lamb's face 'assumed an expression almost seraphic, from its intellectual beauty of outline, its childlike simplicity, and its benignity'. He added that the eyes 'disturbed the unity of effect in Lamb's waking face', and gave a feeling of restlessness, 'shifting, like Northern lights, through every mode of combination with fantastic playfulness'.[3] This description, I think, suggests something of the quality of Lamb's charm. There are in his best work depths of repose under a restless and prankish surface. He is at once the most restful and the most playful of essayists. Carlyle,[4] whose soul could not find rest in such quietistic virtue as Lamb's, noticed only the playfulness and was disgusted by it. 'Charles Lamb', he declared, 'I do verily believe to be in some considerable degree insane. A more pitiful, rickety, gasping, staggering, stammering tomfool I do not know. He is witty by denying truisms and abjuring good manners.' He wrote this in his Diary in 1831 after paying a visit to Lamb at Enfield. 'Poor Lamb!' he concluded. 'Poor England, when such a despicable abortion is named genius! He said: "There are just two things I regret in England's history: first, that Guy Fawkes' plot did not take effect (there would have been so glorious an *explosion*); second, that the Royalists did not hang Milton (then we might have laughed at them), etc., etc." *Armer Teufel!*[5]

Carlyle would have been astonished if he had foreseen that it would be he and not Lamb who would be the 'poor devil' in the eyes of posterity. Lamb is a tragically lovable figure, but Carlyle is a tragically pitiable figure. Lamb, indeed, is in danger of being pedestalled among the saints of literature. He had most of the virtues that a man can have without his virtue becoming a reproach to his fellows. He had most of the vices that a man can have without ceasing to be virtuous. He had enthusiasm that made him at home among the poets, and prejudices that made him at home among common men. His prejudices, however, were for the most part humorous, as when, speaking of L. E. L.,[6] he said: 'If she belonged to me I would lock her up and feed her on bread and water till she left off writing poetry. A female poet, a female author of any kind, ranks below an actress, I think.' He also denounced clever women as 'impudent, forward, unfeminine, and unhealthy in their minds'. At the same time, the woman he loved most on earth and devoted his life to was the 'female author'[7] with whom he collaborated in the *Tales from Shakespeare*. But probably there did exist somewhere in this nature the seeds of most of those prejudices dear to the common Englishman – prejudices against Scotsmen, Jews, and clever women, against such writers as Voltaire and Shelley, and in favour of eating, drinking and tobacco. He held some of his prejudices comically, and some in sober earnest, but at least he had enough of them mixed up in his composition to keep him in touch with ordinary people. That is one of the first necessities of a writer – especially of a dramatist, novelist or essayist, whose subject-matter is human nature. A great writer may be indifferent to the philosophy of the hour, but he cannot safely be indifferent to such matters as his neighbour's love of boiled ham or his fondness for a game of cards. Lamb sympathized with all the human appetites that will bear talking about. Many noble authors are hosts who talk gloriously, but never invite us to dinner or even ring for the decanter. Lamb remembers that a party should be a party.

It is not enough, however, that a writer should be friends with our appetites. Lamb would never have become the most

beloved of English essayists if he had told us only such things as that Coleridge 'holds that a man cannot have a pure mind who refuses apple dumplings', or that he himself, though having lost his taste for 'the whole vegetable tribe', sticks, nevertheless, to asparagus, 'which still seems to inspire gentle thoughts'. He was human elsewhere than at the table or beside a bottle. His kindness was higher than gastric. His indulgences seem but a modest disguise for his virtues. His life was a life of industrious self-sacrifice. 'I am wedded, Coleridge,' he cried, after the murder of his mother, 'to the fortunes of my sister and my poor old father'; and his life with his sister affords one of the supreme examples of fidelity in literary biography. Lamb is eminently the essayist of the affections. The best of his essays are made up of affectionate memories. He seems to steep his very words in some dye of memory and affection that no other writer has discovered. He is one of those rare sentimentalists who speak out of the heart. He has but to write, 'Do you remember?' as in *Old China*, and our breasts feel a pang like a home-sick child thinking of the happiness of a distant fireside and a smiling mother whom it will see no more. Lamb's work is full of this sense of separation. He is the painter of 'the old familiar faces'. He conjures up a Utopia of the past, in which aunts were kind and Coleridge, the 'inspired charity-boy', was his friend, and every neighbour was a figure as queer as a witch in a fairy-tale. 'All, all are gone' – that is his theme.

He is the poet of town-bred boyhood. He is a true lover of antiquity, but antiquity means to him not merely such things as Oxford and a library of old books: it means a small boy sitting in the gallery of the theatre, and the clerks (mostly bachelors) in the shut-up South-Sea House, and the dead pedagogue with uplifted rod in Christ's Hospital, of whom he wrote: 'Poor J. B.![8] May all his faults be forgiven; and may he be wafted to bliss by little cherub boys, all head and wings, with no *bottoms* to reproach his sublunary infirmities.'[9] His essays are a jesting elegy on all that venerable and ruined world. He is at once Hamlet and Yorick in his melancholy and his mirth. He has obeyed the injunction: 'Let us all praise famous men,'[10] but he

has interpreted it in terms of the men who were famous in his own small circle when he was a boy and a poor clerk.

Lamb not only made all that world of school and holiday and office a part of antiquity; he also made himself a part of antiquity. He is himself his completest character – the only character, indeed, whom he did not paint in miniature. We know him, as a result of his letters, his essays, and the anecdotes of his friends, more intimately even than we know Dr Johnson. He has confessed everything except his goodness, and, indeed, did his reputation some harm with his contemporaries by being so public with his shortcomings. He was the enemy of dull priggishness, and would even set up as a buffoon in contrast. He earned the reputation of a drunkard, not entirely deserved, partly by his 'Confessions of a Drunkard',[11] but partly by his habit of bursting into singing 'diddle, diddle, dumpling', under the influence of liquor, whatever the company. His life, however, was a long, half-comic battle against those three friendly enemies of man – liquor, snuff and tobacco. His path was strewn with good resolutions. 'This very night,' he wrote on one occasion, 'I am going to *leave off tobacco*! Surely there must be some other world in which this unconquerable purpose shall be realized.' The perfect anecdote of Lamb's vices is surely that which Hone[12] tells of his abandonment of snuff:

One summer's evening I was walking on Hampstead Heath with Charles Lamb, and we had talked ourselves into a philosophic contempt of our slavery to the habit of snuff-taking, and with the firm resolution of never again taking a single pinch, we threw our snuff-boxes away from the hill on which we stood, far among the furze and the brambles below, and went home in triumph. I began to be very miserable, and was wretched all night. In the morning I was walking on the same hill. I saw Charles Lamb below, searching among the bushes. He looked up laughing, and saying, 'What, you are come to look for your snuff-box too!' 'Oh, no,' I said, taking a pinch out of a paper in my waistcoat pocket, 'I went for a half-pennyworth to the first shop that was open.'[13]

Lamb's life is an epic of such things as this, and Mr Lucas[14] is its rhapsodist. He has written an anthological biography that will have a permanent place on the shelves beside the works of Lamb himself.

HAZLITT[1]

THERE HAS BEEN some interesting discussion lately about the prospects of young writers of talent in an increasingly socialistic state. A very important question is how the young writers will be able to preserve their freedom of speech when everything, or nearly everything, has been nationalized. Some people, however, seem to be more concerned with the question of how they will be able to earn a living; and Rupert Brooke's suggestion that the State should subsidize a considerable number of selected writers (as well as practitioners of the other arts) without imposing any conditions on them has been a good deal talked about.

It seems to me that the problem of providing the good writer with an income would be unlikely to present any more difficulties in a socialist state than it did under the various regimes of the past. It is true that the writer with private means would vanish; but the majority of good writers for centuries have lived by giving pleasure to their patrons, and the Russian experiment proves that they can do so even under socialism when their patron is the public.

I do not believe that the good writer of the future will find it half so hard to earn an income by his books as did the good writers, for instance, of Wordsworth's day. Think of the constellation of men of genius who wrote at that time, and inquire how many of them, out of the books they published, made as good an income as a small shopkeeper's. Wordsworth himself had to be found a government job; Coleridge lived largely on his friends; Shelley would have starved but for having private means; Keats, if he had lived, could never have supported

Fanny Brawne[2] by his poetry alone; Charles Lamb's *Essays of Elia* earned him only £30 when published in book form, and even this was never paid to him; and Hazlitt, though he did not die destitute as has sometimes been said, certainly died hard up. Scott and Byron and Moore were more fortunate; but the genius of the age was more commonly rewarded with fame than with pounds, shillings, and pence – fame, too, within a comparatively small circle.

How Hazlitt remained a struggling author all his life is made clear in P. P. Howe's biography.[3] Hazlitt's original ideas of authorship, it must be admitted, did not promise a future of affluence. As a schoolboy of about fourteen he meditated writing a work to be entitled *Project for a New Theory of Civil and Criminal Legislation*, and at the age of eighteen he was planning an *Essay on the Principles of Human Action*. Two years later he was still engaged on this essay, but then gave it up in despair. He wrote in later life of his disappointment:

After trying in vain to pump up some words, images, notions, apprehensions, or observations, from the gulf of abstraction in which I had plunged myself for four or five years preceding, [I] gave up the attempt as labour in vain, and shed tears of helpless despondency on the blank, unfinished paper.

He then decided to become a professional painter like his brother John; but his genius craved for fuller expression than it could achieve on canvas. His ambition outran his accomplishment, and he ultimately realized with sorrow that he could not be a second Titian. 'I flung away my pencil in disgust and despair,' he has told us. 'Otherwise I might have done as well as others, I dare say, but for a desire to do too well.' He took his brushes up again, however, and continued to paint till, at the age of thirty-four, he got his first regular job in journalism as parliamentary reporter for the *Morning Chronicle*.

That, unpromising though it may seem, was the beginning of Hazlitt as the writer of genius we know. Before long he was contributing articles on all manner of subjects – the drama, art, politics, and things in general – though, according to Miss Mitford,[4] his editor 'used to execrate "the d——d fellow's d——d

stuff" for filling up so much of the paper in the very height of the advertising season'. Hazlitt was still far from prosperous, however. 'It is quite painful', Crabb Robinson[5] wrote at the time,

to witness the painful exertions for a livelihood which H is condemned to make, and how strongly it shows that a modicum of talent outweighs an ample endowment of original thought and the highest power of intellect, when a man does not add to that endowment the other of making it turn to account. How many men are there connected with newspapers who live comfortably with not a tithe of H's powers as a writer.

Hazlitt, however, was not born for good fortune. Apart from the fact that he was never rewarded according to his merits, he was the possessor of a demon that fought against his happiness. He was like the Saul who flung a spear at David.[6] He separated from both of the women whom he married, and he seems to have quarrelled at some time or other with all his friends. I doubt whether any one who knew him well ever praised him without reservation. Coleridge wrote:

His manners are ninety-nine in a hundred singularly repulsive; brow-hanging, shoe-contemplating, strange . . . he is, I verily believe, kindly-natured; is very fond of, attentive to, and patient with, children; but has a jealous, gloomy and an irritable pride.

Leigh Hunt[7] drew a similarly black and white portrait:

I have often said I have an irrepressible love for Hazlitt on account of his sympathy for mankind, his unmercenary disinterestedness, and his suffering; and I should have a still greater affection for him if he would let me; but I declare to God I never seem to know whether he is pleased or displeased, cordial or uncordial – indeed, his manners are never cordial.

Even Lamb's noble tribute to him when he wrote: 'I think W. H. to be in his natural state one of the wisest and finest spirits breathing,' contains the reservation 'in his natural state', as though Hazlitt had black moods for which he was scarcely responsible and which called for forgiveness like the temper of a passionate but fundamentally generous-hearted child.

Hazlitt's very virtues, it must be remembered, brought upon his head floods of malignant calumny of a kind to destroy the temper even of a fairly good-tempered man. It was not his

faults, but his 'unmercenary disinterestedness' as a democrat and defender of the French Revolution that incited the thugs of reaction to assault him. 'I could swear (were they not mine)', he wrote of the essays in *Table Talk*, 'the thoughts in many of them are founded as the rock, free as air, the tone like an Italian picture. What then? Had the style been like polished steel, as firm and as bright, it would have availed me nothing, for I am not a Government tool.' His *Characters of Shakespeare's Plays*[8] was damned for the same reason.

Our anti-Jacobin and anti-Gallican writers soon found out that I had said and written that Frenchmen, Englishmen, men were not slaves by birthright. This was enough to *damn* the work. Such has been the head and front of my offending.

It is evidence of the power and permanence of Hazlitt's love of liberty that 'probably his last written words' were an expression of joy at the success of the minor French Revolution of 1830. 'The Revolution of the Three Days',[9] he wrote from his sick room, 'was like a resurrection from the dead, and showed plainly that liberty, too, has a spirit of life in it; and that hatred of oppression is "the unquenchable flame, the worm that dieth not".'

Hazlitt was a great hater. There has never been another essayist of comparable genius so prone to hate and to confess his hatred. The fire in his soul that gave birth to his hatreds, however, was the same fire that burned in him as a lover of many of the things that make life worth living – a fine picture, the enchantment of a landscape, a good book, great acting, the wisdom of a profound thinker, walking, liberty, and the energy and skill of a manly game. He is the essayist of ecstasies and of raptures, and this without a tinge of insincerity – a rare achievement in an essayist of the kind.

A recent writer has questioned the authenticity of the tradition that Hazlitt's last words were: 'Well, I've had a happy life'; but certainly he could look back on great feasts of happiness – happiness such as he experienced in youth especially before the world had 'grown old and incorrigible'.

It might be said that Hazlitt was born with a superlative gift for enjoyment, but that, as he grew older, enjoyment and dis-illusionment took their turns with him. In his essays the sun shines on the past oftener than on the present or the future. It was of a long-past walk on the road to Llangollen on his way to visit Coleridge that he wrote: 'Besides the prospect which opened beneath my feet, another also opened to my inward sight, a heavenly vision, on which was written in letters large as Hope could make them these four words: Liberty, Genius, Love, Virtue: which have since faded into the light of common day and mock my idle page.' The pleasures of hope became more and more illusive with the years, and were faint by the time he wrote 'On the fear of death':

My public and private hopes have been left a ruin. . . . I should like to leave some sterling work behind me. I should like to have some friendly hand to consign me to the grave. On these conditions, I am ready, if not willing, to depart. I shall then write on my tomb – Grateful and Contented. But I have thought and suffered too much to be willing to have thought and suffered in vain.

These conditions at least were satisfied. Lamb was there at the end, and, as for having left some sterling work behind him, it is clear that a growing number of people regard him as having done so, since three biographies of him have appeared in the present century.

P. P. Howe's is a book full of good matter, devotedly collected and set in order; but Hazlitt the man, in his exultations, his wraths, and his suffering does not quite come to life in it. If Howe had lived to rewrite it I think he would have made more use of *Liber Amoris*[10] as a revelation of the sombre fires that burned in Hazlitt's soul. *Liber Amoris* is not important as literature; but we know Hazlitt better when we have read it. Good men in the last century wished it had never been written as they wished Keats's letters to Fanny Brawne had never been written. For my part I cannot see how it is possible to read either without a deepening of sympathy and understanding.

KEATS IN HIS LETTERS[1]

ONE OF THE THINGS about which the present generation differs widely from the Victorians is the need for reticence. Respectable Victorians regarded it as indecent, not merely to write obscenely, but to publish the whole truth about the illustrious dead if the publication seemed to them likely to be derogatory. A belief in the decency and duty of reticence did not, of course, make its first appearance during the reign of Victoria. After all, Hannah More[2] was concerned some time before that lest Boswell should be over-realistic in his biography of Johnson. Still, I think it must be admitted that the nineteenth century was particularly addicted to the *de mortuis nil nisi bonum* attitude to biography. Tennyson seems to have regarded biography itself as a violation of the sanctities of private life, and Thackeray, dreading that this might happen, left instructions that no biography of him was to be written.

As a result of this attitude, the two-volume Victorian biography frequently was little more than a funeral oration in two volumes. And this naturally led to a violent reaction, in the course of which good men were 'debunked' without mercy and reticence was thrown overboard.

The new school of biography flourished, partly through the desire for truth and partly because it is a human weakness to gloat over the faults, real or imaginary, of those who are our betters. I have known men who were never more gleeful than when attributing some purely conjectural vice to one of the mighty dead, explaining in that way why he was deaf or blind or remained unmarried. Perhaps it was the resolve to crush this

instinct that was at the root of the excessive reticence of the Victorians which turned many a biographical tome into a tombstone.

So hostile were some of the finest Victorians to the revelation of a man's private life that there was a protesting outcry even over the publication of Keats's letters to Fanny Brawne.[3] Buxton Forman has told us that, when he made up his mind to publish these in 1878, he was 'fully alive to the risk of vituperation', and that half the press regarded their publication as 'an outrage unheard of'. What is particularly astonishing in all this to the reader today is that the critics protested largely on the ground that it was cruel to expose Keats as a man, sick unto death, wracked with the torments of a hopeless passion. These letters, which now seem to many of us to be among the most beautiful love-letters ever written, were looked on as somehow disgraceful and unmanly; and when Sir Sidney Colvin[4] wrote his monumental life of Keats, Fanny Brawne, poor girl, had taken the place of the *Quarterly*[5] as the enemy of Keats's life, happiness, and genius. She was a siren, a vampire, a woman unworthy of his love.

I remember, when Colvin published his biography, challenging this view and arguing that, far from Keats's genius having been ruined by his love for Fanny Brawne, it was the passion for this 'minx' that 'transformed him, in a few months, from a poet of doubtful fame into a master and an immortal'. The evidence for this seemed to me overwhelming. Keats first met Fanny Brawne in 1818, and he became engaged to her in December. In the following month he wrote 'The Eve of St Agnes'. In April 1819 he wrote 'La Belle Dame Sans Merci', 'Ode to Psyche', 'Ode on a Grecian Urn'. In May he wrote 'Ode to a Nightingale'. In June he wrote 'Lamia Part I'. Then came the 'Bright Star' sonnet, work on *The Fall of Hyperion*, and 'Ode to Autumn'.

At an earlier date Keats had written in a letter: 'I have the same idea of all our passions as of Love: they are all, in their sublime, creators of essential beauty'; and this was surely true of his love for Fanny Brawne.

When I made these points in a review, Sir Sidney wrote to me to say that, if I were right, this would knock the bottom out of his biography – or some such phrase – and that he intended to publish an answer to me. The only answer he ever published, however, was in the preface to the third edition of his biography, where he wrote: 'Now it is, of course, true that most of Keats's best work was done after he had met Fanny Brawne. But it was done – and this is what is really unquestionable – not because of her but in spite of her.' And he maintained that not to see this is 'to misunderstand Keats's whole career'.

I do not think I have ever come upon a more questionable use of the word 'unquestionable'; and I can see no explanation of Sir Sidney's logic except that in his sympathy with Keats's sufferings he disliked Fanny as though she were the only cause of them and, in his dislike, came more and more to look on her as Keats's destroying angel. It is symptomatic of his hostility to Fanny, I think, that, in quoting Keats's last letter but one to Charles Brown, he omits the deeply moving appeal: 'My dear Brown, for my sake be her advocate for ever.' I wonder why he omitted that sentence. Was it a mere accident of abbreviation? Or did he feel that, after his indictment of Fanny, he dared not quote a sentence in which Keats himself was a witness in her favour?

The Letters of John Keats are among the greatest letters ever written by an English poet, and it is an interesting fact that nearly all the best English letters were written by poets. In fact, Horace Walpole[6] is the only prose-writer who has written letters that will stand comparison with those of Gray,[7] Cowper,[8] Byron, Charles Lamb (for he, too, was a poet), and FitzGerald.[9] It is also interesting to remember that all these men were unmarried or lived most of their lives as bachelors.

Keats, to my mind, excels the others as an autobiographer. He reveals the depths of his soul and lays bare the twin passions of his life – the passion of a poet and the passion of a lover – to an extent that none of the others do. The first letters that have survived date from his earliest twenties, when we find him writing to Reynolds: 'I cannot exist without Poetry –

without eternal Poetry – half the day will not do – the whole of it.' About the same time he wrote to Leigh Hunt:[10]

I have asked myself so often why I should be a Poet more than other Men, seeing how great a thing it is – how great things are to be gained by it, What a thing to be in the Mouth of Fame – that at last the Idea has grown so monstrously beyond my seeming Power of attainment that the other day I nearly consented with myself to drop into a Phaeton. Yet, 'tis a disgrace to fail even in a huge attempt, and at this moment I drive the thought from me.

To Haydon[11] he writes:

I hope for the support of a High Power while I clime this little eminence and especially in my Years of more momentous Labor. I remember your saying that you had notions of a good Genius presiding over you. I have of late had the same thought. . . . Is it too daring to Fancy Shakespeare this Presider?

Even at this early date he seems to have accustomed himself to the thought of death. 'I am never alone', he writes,

without rejoicing that there is such a thing as death. . . . I have two Brothers; one is driven by the 'burden of Society' to America; the other, with an exquisite love of Life, is in a lingering state. My Love for my Brothers, from the early loss of our parents and even from earlier misfortunes has grown into a affection 'passing the Love of Women' . . . I have a sister too and may not follow them, either to America or to the Grave. Life must be undergone, and I certainly derive some consolation from the thought of writing one or two more Poems before it ceases.

Poetry to Keats was a religion. 'I am convinced', he declares, 'more and more every day (excepting the human friend Philosopher) a fine writer is the most genuine Being in the World. Shakespeare and the *Paradise Lost*[12] every day become greater wonders to me. I look upon fine Phrases like a Lover.' And again: 'I am convinced more and more every day that fine writing is next to fine doing the top thing in the world; the *Paradise Lost* becomes a greater wonder.'

One cannot help thinking of him as other than a man burnt up by the ardour of his imagination. His sorrows as well as his joys are the result of this. 'I carry all matters to an extreme,' he writes to Bailey – 'so that when I have any little vexation it grows in five Minutes into a theme for Sophocles.'[13] Life tortured him long before he met Fanny Brawne, and told her:

'A person in health as you are can have no conception of the horrors that nerves and a temper like mine go through.'

When Keats first met Fanny Brawne he was nearly twenty-three years old and she was close upon nineteen. Not long before this he had declared that he had never been in love. Even a month after he had met Fanny he wrote to his brother: 'I hope I shall never marry. . . . The roaring of the wind is my wife and the stars through the window-pane are my children.' His chief ambition was still to perform the great work he was sent into the world to do. 'I am ambitious', he declared, 'of doing the world some good if I should be spared, that may be the work of maturer years. . . . The faint conceptions I have of poems to come bring the blood frequently into my forehead.' His first impression of Fanny was that she was 'beautiful and elegant, graceful, silly, fashionable, and strange', and that she was a minx – 'not from any innate vice but from a penchant she has of acting stylishly'.

That Fanny was something better than a minx and that her love for Keats was unselfish seems to me to be proved by her engaging herself to one who was an impecunious poet with no prospect of being able to support her – an unknown youth whose work had brought him more derision than praise. Keats's love of her certainly was a source of exquisite happiness as well as of exquisite pain. 'I have been astonished', he wrote in one of his letters to her, 'that Men should die Martyrs for religion – I have shudder'd at it. I shudder no more – I could be martyr'd for my Religion – Love is my religion – I could die for it – I could die for you. My Creed is Love and you are its only tenet.'

In his feverish state he was often tortured with jealousy as we see in the letter in which he wrote: 'My greatest torment since I have known you has been the fear of you being a little inclined to the Cressid';[14] and, as his health grew worse, his jealousy drove him to utter cries of anguish. 'I appeal to you', he wrote to her, 'by the blood of that Christ you believe in: Do not write to me if you have done anything this month which it would have pained me to have seen. You may have altered – if you have not – if you still behave in dancing rooms and other

204 • ROBERT LYND

societies as I have seen you – I do not want to live – if you have
done so I wish this coming night may be my last. I cannot live
without you, and not only you but *chaste you*; *virtuous you*.'

In his fits of jealousy he demanded that Fanny should abjure
all ordinary pleasures as he himself was forced by his debili-
tating illness to do. 'Your going to town alone', he once wrote
to her, 'was a shock to me – yet I expected it – *promise you will
not for some time till I get better.*' Let us remember along with
these miseries of love the ecstasy of devotion in which he wrote:
'I will imagine you Venus to night and pray, pray, pray to your
star like a Hethen.' Let us remember, too, the letter in which
he wrote:

> You are always new. The last of your kisses was ever the sweetest; the last
> smile the brightest; the last movement the gracefullest. When you pass'd my
> window home yesterday, I was fill'd with as much admiration as if I had then
> seen you for the first time. . . . I never felt my Mind repose upon anything
> with complete and undistracted enjoyment – upon one person but you. When
> you are in the room my thoughts never fly out of the window: you always
> concentrate my whole senses.

All this seems to me to give us good reason for regarding
Keats's devotion to Fanny not as a disaster, but as the greatest
piece of good fortune that ever befell him both as a man and
as a poet. With him the height of love more than compensated
for the depth of despair. 'I think', he wrote to Brown when he
was leaving England to die in Italy, 'without my mentioning it
you would be a friend to Miss Brawne when I am dead. You
think she has many faults – but, for my sake, think she has
not one' – a passage, it is only fair to say, that Colvin quotes.

Then there is the last simple farewell letter to Mrs Brawne:

> I dare not fix my mind on Fanny, I have not dared to think of her. The only
> comfort I have had that way has been thinking for hours together of having
> the knife she gave me put in a silver case – the hair in a Locket – and the
> Pocket Book in a gold net. Show her this. I dare say no more.

There is nothing more heart-rending in the history of poets
than is contained in these letters, and nothing more revealing of
a beautiful spirit in the toils of tragic circumstance.

TURGENEV[1]

MR EDWARD GARNETT[2] has recently collected his prefaces to the novels and stories of Turgenev, and refashioned them into a book in praise of the genius of the most charming of Russian authors. I am afraid the word 'charming' has lost so much of its stamp and brightness with use as to have become almost meaningless. But we apply it to Turgenev in its fullest sense. We call him charming as Pater[3] called Athens charming. He is one of those authors whose books we love because they reveal a personality sensitive, affectionate, pitiful. There are some persons who, when they come into a room, immediately make us feel happier. Turgenev seems to 'come into the room' in his books with just such a welcome presence. That is why I wish Mr Garnett had made his book a biographical, as well as a critical, study.

He quotes Turgenev as saying: 'All my life is in my books.' Still, there are a great many facts recorded about him in the letters and reminiscences of those who knew him (and he was known in half the countries of Europe), out of which we can construct a portrait. One finds in the *Life of Sir Charles Dilke*,[4] for instance, that Dilke considered Turgenev 'in the front rank' as a conversationalist. This opinion interested one all the more because one had come to think of Turgenev as something of a shy giant. I remember, too, reading in some French book a description of Turgenev as a strange figure in the literary circles of Paris – a large figure with a curious chastity of mind who seemed bewildered by some of the barbarous jests of civilized men of genius.

There are, indeed, as I have said, plenty of suggestions for a portrait of Turgenev, quite apart from his novels. Mr Garnett refers to some of them in two excellent biographical chapters. He reminds us, for example, of the immense generosity of Turgenev to his contemporaries and rivals, as when he introduced the work of Tolstoy to a French editor. 'Listen,' said Turgenev. 'Here is "copy" for your paper of an absolutely first-rate kind. This means that I am not its author. The master – for he is a *real* master – is almost unknown in France; but I assure you, on my soul and conscience, that I do not consider myself worthy to unloose the latchet of his shoes.' The letter he addressed to Tolstoy from his death-bed, urging him to return from propaganda to literature, is famous, but it is a thing to which one always returns fondly as an example of the noble disinterestedness of a great man of letters. 'I cannot recover,' Turgenev wrote:

That is out of the question. I am writing to you specially to say how glad I am to be your contemporary, and to express my last and sincere request. My friend, return to literary activity! That gift came to you whence comes all the rest. Ah, how happy I should be if I could think my request would have an effect on you! . . . I can neither walk, nor eat, nor sleep. It is wearisome even to repeat it all! My friend – great writer of our Russian land, listen to my request! . . . I can write no more; I am tired.

One sometimes wonders how Tolstoy and Dostoevsky could ever have quarrelled with a friend of so beautiful a character as Turgenev. Perhaps it was that there was something barbarous and brutal in each of them that was intolerant of his almost feminine refinement. They were both men of action in literature, militant, and by nature propagandist. And probably Turgenev was as impatient with the faults of their strength as they were with the faults of his weakness. He was a man whom it was possible to disgust. Though he was Zola's[5] friend, he complained that *L'Assommoir* left a bad taste in the mouth. Similarly, he discovered something almost Sadistic in the manner in which Dostoevsky let his imagination dwell on scenes of cruelty and horror. And he was as strongly repelled by Dostoevsky's shrieking Pan-Slavism[6] as by his sensationalism among horrors.

One can guess exactly the frame of mind he was in when, in the course of an argument with Dostoevsky, he said: 'You see, I consider myself a German.' This has been quoted against Turgenev as though he meant it literally, and as though it were a confession of denationalization. His words were more subtle than that in their irony. What they meant was simply: 'If to be a Russian is to be a bigot, like most of you Pan-Slav enthusiasts, then I am no Russian, but a European.' Has he not put the whole gospel of nationalism in half a dozen sentences in *Rudin*?[7] He refused, however, to adopt along with his nationalism the narrowness with which it has been too often associated.

This refusal was what destroyed his popularity in Russia in his lifetime. It is because of this refusal that he has been pursued with belittlement by one Russian writer after another since his death. He had that sense of truth which always upsets the orthodox. This sense of truth applied to the portraiture of his contemporaries was felt like an insult in those circles of mixed idealism and make-believe, the circles of the political partisans. A great artist may be a member – and an enthusiastic member – of a political party, but in his art he cannot become a political partisan without ceasing to be an artist. In his novels, Turgenev regarded it as his lifework to portray Russia truthfully, not to paint and powder and 'prettify' it for show purposes, and the result was an outburst of fury on the part of those who were asked to look at themselves as real people instead of as the masterpieces of a professional flatterer. When *Fathers and Children* was published in 1862, the only people who were pleased were the enemies of everything in which Turgenev believed. 'I received congratulations,' he wrote,

almost caresses, from people of the opposite camp, from enemies. This confused me, wounded me; but my conscience did not reproach me. I knew very well I had carried out honestly the type I had sketched, carried it out not only without prejudice, but positively with sympathy.

This is bound to be the fate of every artist who takes his political party or his church, or any other propagandist group

to which he belongs, as his subject. He is a painter, not a vindicator, and he is compelled to exhibit numerous crooked features and faults in such a way as to wound the vanity of his friends and delight the malice of his enemies. Artistic truth is as different from propagandist truth as daylight from limelight, and the artist will always be hated by the propagandist as worse than an enemy – a treacherous friend. Turgenev deliberately accepted as his lifework a course which could only lead to the miseries of being misunderstood. When one thinks of the long years of denunciation and hatred he endured for the sake of his art, one cannot but regard him as one of the heroic figures of the nineteenth century. 'He has', Mr Garnett tells us, 'been accused of timidity and cowardice by uncompromising Radicals and Revolutionaries. . . . In an access of self-reproach he once declared that his character was comprised in one word – "poltroon!"' He showed neither timidity nor cowardice, however, in his devotion to truth. His first and last advice to young writers, Mr Garnett declares, was: 'You need truth, remorseless truth, as regards your own sensations.' And if Turgenev was remorseless in nothing else, he was remorseless in this – truth as regards both his own sensations and the sensations of his contemporaries. He seems, if we may judge from a sentence he wrote about *Fathers and Children*, to have regarded himself almost as the first realist. 'It was a new method', he said, 'as well as a new type I introduced – that of Realizing instead of Idealizing.' His claim has, at least, this truth in it: he was the first artist to apply the realistic method to a world seething with ideas and with political and philosophical unrest. His adoption of the realistic method, however, was the result of necessity no less than of choice. He 'simply did not know how to work otherwise', as he said. He had not the sort of imagination that can invent men and women easily. He had always to draw from the life. 'I ought to confess', he once wrote, 'that I never attempted to create a type without having, not an idea, but a living person, in whom the various elements were harmonized together, to work from. I have always needed some groundwork on which I could tread firmly.'

When one has praised Turgenev, however, for the beauty of his character and the beautiful truth of his art, one remembers that he, too, was human and therefore less than perfect. His chief failing was, perhaps, that of all the great artists, he was the most lacking in exuberance. That is why he began to be scorned in a world which rated exuberance higher than beauty or love or pity. The world before the war was afraid above all things of losing vitality, and so it turned to contortionists of genius such as Dostoevsky, or lesser contortionists, like some of the Futurists,[8] for fear restfulness should lead to death. It would be foolish, I know, to pretend to sum up Dostoevsky as a contortionist; but he has that element in him. Mr Conrad suggests a certain vice of misshapenness in Dostoevsky when he praises the characters of Turgenev in comparison with his. 'All his creations, fortunate or unfortunate, oppressed and oppressors,' he says in his fine tribute to Turgenev in Mr Garnett's book, 'are human beings, not strange beasts in a menagerie, or damned souls knocking themselves about in the stuffy darkness of mystical contradictions.' That is well said. On the other hand, it is only right to remember that, if Turgenev's characters are human beings, they (at least the male characters) have a way of being curiously ineffectual human beings. He understood the Hamlet in man almost too well. From Rudin to the young revolutionist in *Virgin Soil*, who makes such a mess of his propaganda among the peasantry, how many of his characters are as remarkable for their weakness as for their unsuccess! Turgenev was probably conscious of this pessimism of imagination in regard to his fellow-man – at least, his Russian fellow-man. In *On the Eve*, when he wished to create a central character that would act as an appeal to his countrymen to 'conquer their sluggishness, their weakness and apathy' (as Mr Garnett puts it), he had to choose a Bulgarian, not a Russian, for his hero. Mr Garnett holds that the characterization of Insarov, the Bulgarian, in *On the Eve*, is a failure, and puts this down to the fact that Turgenev drew him, not from life, but from hearsay. I think Mr Garnett is wrong. I have known the counterpart of Insarov among the members of

at least one subject nation, and the portrait seems to me to be essentially true and alive.

Luckily, if Turgenev could not put his trust in Russian men, he believed with all his heart in the courage and goodness of Russian women. He was one of the first great novelists to endow his women with independence of soul. With the majority of novelists, women are sexual or sentimental accidents. With Turgenev, women are equal human beings – saviours of men and saviours of the world. *Virgin Soil* becomes a book of hope instead of despair as the triumphant figure of Marianna, the young girl of the Revolution, conquers the imagination. Turgenev, as a creator of noble women, ranks with Browning and Meredith.[9] His realism was not, in the last analysis, a realism of disparagement, but a realism of affection. His farewell words, Mr Garnett tells us, were: 'Live and love others as I have always loved them.'

TCHEHOV:
THE PERFECT STORY-TELLER[1]

IT IS THE CUSTOM when praising a Russian writer to do so at the expense of all other Russian writers. It is as though most of us were monotheists in our devotion to authors, and could not endure to see any respect paid to the rivals of the god of the moment. And so one year Tolstoy is laid prone as Dagon,[2] and, another year, Turgenev. And, no doubt, the day will come when Dostoevsky will fall from his huge eminence.

Perhaps the luckiest of all the Russian authors in this respect is Tchehov. He is so obviously not a god. He does not deliver messages to us from the mountain-top like Tolstoy, or reveal himself beautifully in sunset and star like Turgenev, or announce himself now in the hurricane and now in the thunderstorm like Dostoevsky. He is a man and a medical doctor. He pays professional visits. We may define his genius more exactly by saying that his is a general practice. There has, I think, never been so wonderful an examination of common people in literature as in the short stories of Tchehov. His world is thronged with the average man and the average woman. Other writers have also put ordinary people into books. They have written plays longer than *Hamlet*, and novels longer than *Don Quixote*, about ordinary people. They have piled such a heap of details on the ordinary man's back as almost to squash him out of existence. In the result the reader as well as the ordinary man has a sense of oppression. He begins to long for the restoration of the big subject to literature.

Henry James[3] complained of the littleness of the subject in *Madame Bovary*.[4] He regarded it as one of the miracles of art

that so great a book should have been written about so small a woman. *Tom Jones*,[5] on the other hand, is a portrait of a common man of the size of which few people complain. But then *Tom Jones* is a comedy, and we enjoy the continual relief of laughter. It is the tragic realists for whom the common man is a theme so perilous in its temptations to dullness. At the same time he is a theme that they were bound to treat. He is himself, indeed, the sole source and subject of tragic realism in literature. Were it not for the oppression of his futile and philo-progenitive present, imaginative writers would be poets and romancers.

The problem of the novelist of contemporary life for whom ordinary people are more intensely real than the few magnificent personalities is how to portray ordinary people in such a way that they will become better company than they are in life. Tchehov, I think, solves the problem better than any of the other novelists. He sees, for one thing, that no man is uninteresting when he is seen as a person stumbling towards some goal, just as no man is uninteresting when his hat is blown off and he has to scuttle after it down the street. There is bound to be a break in the meanest life.

Tchehov will seek out the key situation in the life of a cabman or a charwoman, and make them glow for a brief moment in the tender light of his sympathy. He does not run sympathy as a 'stunt' like so many popular novelists. He sympathizes merely in the sense that he understands in his heart as well as in his brain. He has the most unbiassed attitude, I think, of any author in the world. Mr Edward Garnett, in his introduction to Mrs Garnett's translation of Tchehov's tales, speaks admirably of his 'profundity of acceptation'. There is no writer who is less inclined to use italics in his record of human life. Perhaps Mr Garnett goes too far when he says that Tchehov 'stands close to all his characters, watching them quietly and registering their circumstances and feelings with such finality that to pass judgment on them appears supererogatory'. Tchehov's judgment is at times clear enough – as clear as if it followed a summing-up from the bench. He portrays his characters instead of labelling

them; but the portrait itself is the judgment. His humour makes him tolerant, but, though he describes moral and material ugliness with tolerance, he never leaves us in any doubt as to their being ugly. His attitude to a large part of life might be described as one of good-natured disgust.

In one of the newly translated stories, 'Ariadne', he shows us a woman from the point of view of a disgusted lover. It is a sensitive man's picture of a woman who was even more greedy than beautiful. 'This thirst for personal success . . . makes people cold, and Ariadne was cold – to me, to nature, and to music.' Tchehov extends towards her so little charity that he makes her run away to Italy with a bourgeois who had 'a neck like goose-skin and a big Adam's apple', and who, as he talked, 'breathed hard, breathing straight in my face and smelling of boiled beef'. As the more sensitive lover who supplanted the bourgeois looks back, her incessant gluttony is more vivid in his thoughts than her charm:

She would sleep every day till two or three o'clock; she had her coffee and lunch in bed. At dinner she would eat soup, lobster, fish, meat, asparagus, game, and after she had gone to bed I used to bring up something, for instance, roast beef, and she would eat it with a melancholy, careworn expression, and if she waked in the night she would eat apples or oranges.

The story, it is only fair to say, is given in the words of a lover dissatisfied with lust, and the judgment may therefore be regarded as the lover's rather than as Tchehov's. Tchehov sets down the judgment, however, in a mood of acute perceptiveness of everything that is jarring and vulgar in sexual vanity. Ariadne's desire to please is never permitted to please us as, say, Beatrix Esmond's[6] is. Her will to fascinate does not fascinate when it is refracted in Tchehov's critical mind:

She waked up every morning with the one thought of 'pleasing'. It was the aim and object of her life. If I told her that in such a house, in such a street, there lived a man who was not attracted by her, it would have caused her real suffering. She wanted every day to enchant, to captivate, to drive men crazy. The fact that I was in her power and reduced to a complete nonentity before her charms gave her the same sort of satisfaction that victors used to get in tournaments. . . . She had an extraordinary opinion of her own charms; she

imagined that if somewhere, in some great assembly, men could have seen how beautifully she was made and the colour of her skin, she would have vanquished all Italy, the whole world. Her talk of her figure, of her skin, offended me, and observing this, she would, when she was angry, say all sorts of vulgar things taunting me.

A few strokes of cruelty are added to the portrait:

Even at a good-humoured moment, she could always insult a servant or kill an insect without a pang; she liked bull-fights, liked to read about murders, and was angry when prisoners were acquitted.

As one reads 'Ariadne', one feels that those who say the artist is not a judge are in error. What he must avoid becoming is a prosecuting – perhaps even a defending – counsel.

Egotism seems to be the quality which offends Tchehov most. He is no more in love with it when it masquerades as virtue than when it parades as vice. 'An Artist's Story' – a beautiful sad story, which might almost have been written by Turgenev – contains a fine critical portrait of a woman absorbed in the egotism of good works. She is always looking after the poor, serving on committees, full of enthusiasm for nursing and education. She lacks only that charity of the heart which loves human beings, not because they are poor, but because they are human beings. She is by nature a 'boss'. She 'bosses' her mother and her younger sister, and when the artist falls in love with the latter, the stronger will of the woman of high principles imme-diately separates lovers so frivolous that they had never sat on a committee in their lives. When, the evening after the artist confesses his love, he waits for the girl to come to him in the garden of her house, he waits in vain. He goes into the house to look for her, but does not find her. Then through one of the doors he overhears the voice of the lady of the good works:

' "God . . . sent . . . a crow," ' she said in a loud, emphatic voice, probably dictating – ' "God sent a crow a piece of cheese. . . . A crow. . . . A piece of cheese. . . . " Who's there?' she called suddenly, hearing my steps.

'It's I.'

'Ah! Excuse me, I cannot come out to open this minute; I'm giving Dasha her lesson.'

'Is Ekaterina Pavlovna in the garden?'

'No, she went away with my sister this morning to our aunt in the province of Penza. And in the winter they will probably go abroad,' she added after a pause. ' "God sent . . . the crow . . . a piece . . . of cheese . . ." Have you written it?'

I went into the hall and stared vacantly at the pond and the village, and the sound reached me of 'A piece of cheese . . . God sent the crow a piece of cheese.'

And I went back by the way I had come here for the first time – first from the yard into the garden past the house, then into the avenue of lime-trees. . . . At this point I was overtaken by a small boy who gave me a note.

'I told my sister everything and she insisted on my parting from you,' I read. 'I could not wound her by disobeying. God will give you happiness. Forgive me. If only you knew how bitterly my mother and I are crying!'

The people who cannot wound others – those are the people whose sharp pangs we feel in our breasts as we read the stories of Tchehov. The people who wound – it is they whom he paints (or, rather, as Mr Garnett suggests, etches) with such felicitous and untiring irony.

But, though he often makes his people beautiful in their sorrow, he more often than not sets their sad figures against a common and ugly background. In 'Anyuta', the medical student and his mistress live in a room disgusting in its squalor:

Crumpled bed-clothes, pillows thrown about, boots, clothes, a big filthy slop-pail filled with soap-suds in which cigarette-ends were swimming, and the litter on the floor – all seemed as though purposely jumbled together in one confusion. . . .

And, if the surroundings are no more beautiful than those in which a great part of the human race lives, neither are the people more beautiful than ordinary people. In 'The Trousseau', the poor thin girl who spends her life making a trousseau for a marriage that will never take place becomes ridiculous as she flushes at the entrance of a stranger into her mother's house: 'Her long nose, which was slightly pitted with small-pox, turned red first, and then the flush passed up to her eyes and her forehead.' I do not know if a blush of this sort is possible, but the thought of it is distressing.

The woman in 'The Darling', who marries more than once and simply cannot live without some one to love and to be an echo to, is 'not half bad' to look at. But she is ludicrous even

when most unselfish and adoring – especially when she rubs with eau-de-Cologne her little, thin, yellow-faced, coughing husband with 'the curls combed forward on his forehead', and wraps him in her warm shawls to an accompaniment of endearments. ' "You're such a sweet pea!" she used to say with perfect sincerity, stroking his hair. "You're such a pretty dear!" '

Thus sympathy and disgust live in a curious harmony in Tchehov's stories. And, as he seldom allows disgust entirely to drive out sympathy in himself, he seldom allows it to do so in his readers either. His world may be full of unswept rooms and unwashed men and women, but the presiding genius in it is the genius of gentleness and love and laughter. It is a dark world but Tchehov brings light into it. There is no other author who gives so little offence as he shows us offensive things and people. He is a writer who desires above all things to see what men and women are really like – to extenuate nothing and to set down naught in malice. As a result, he is a pessimist, but a pessimist who is black without being bitter. I know no writer who leaves one with the same vision of men and women as lost sheep.

We are now apparently to have a complete edition of the tales of Tchehov in English from Mrs Garnett. It will deserve a place, both for the author's and the translator's sake, beside her Turgenev and Dostoevsky. In lifelikeness and graciousness her work as a translator always reaches a high level. Her latest volumes confirm one in the opinion that Tchehov is, for his variety, abundance, tenderness and knowledge of the heart of the 'rapacious and unclean animal' called man, the greatest short-story writer who has yet appeared on the planet.

THE LABOUR OF AUTHORSHIP

LITERATURE MAINTAINS an endless quarrel with idle sentences.
Twenty years ago this would have seemed too obvious to bear
saying. But in the meantime there has been a good deal of
dipping of pens in chaos, and authors have found excuses for
themselves in a theory of literature which is impatient of
difficult writing. It would not matter if it were only the
paunched and flat-footed authors who were proclaiming the
importance of writing without style. Unhappily, many excellent
writers as well have used their gift of style to publish the praise
of stylelessness. Within the last few weeks I have seen it
suggested by two different critics that the hasty writing which
has left its mark on so much of the work of Scott and Balzac
was a good thing and almost a necessity of genius. It is no
longer taken for granted, as it was in the days of Stevenson,[1]
that the starry word is worth the pains of discovery. Stevenson,
indeed, is commonly dismissed as a pretty-pretty writer, a
word-taster without intellect or passion, a juggler rather than
an artist. Pater's bust also is mutilated by irreverent school-
boys: it is hinted that he may have done well enough for the
days of Victoria, but that he will not do at all for the world of
George.[2] It is all part of the reaction against style which took
place when everybody found out the aesthetes. It was, one may
admit, an excellent thing to get rid of the aesthetes, but it was
by no means an excellent thing to get rid of the virtue which
they tried to bring into English art and literature. The aesthetes
were wrong in almost everything they said about art and
literature, but they were right in impressing upon the children

of men the duty of good drawing and good words. With the condemnation of Oscar Wilde,[3] however, good words became suspected of kinship with evil deeds. Style was looked on as the sign of minor poets and major vices. Possibly, on the other hand, the reaction against style had nothing to do with the Wilde condemnation. The heresy of stylelessness is considerably older than that. Perhaps it is not quite fair to call it the heresy of stylelessness: it would be more accurate to describe it as the heresy of style without pains. It springs from the idea that great literature is all a matter of first fine careless raptures, and it is supported by the fact that apparently much of the greatest literature is so. If lines like

> Hark, hark! the lark at Heaven's gate sings,[4]

or

> When daffodils begin to peer,[5]

or

> His golden locks time hath to silver turned,[6]

shape themselves in the poet's first thoughts, he would be a manifest fool to trouble himself further. Genius is the recognition of the perfect line, the perfect phrase, the perfect word, when it appears, and this perfect line or phrase or word is quite as likely to appear in the twinkling of an eye as after a week of vigils. But the point is that it does not invariably so appear. It sometimes cost Flaubert three days' labour to write one perfect sentence. Greater writers have written more hurriedly. But this does not justify lesser writers in writing hurriedly too.

Of all the authors who have exalted the part played in literature by inspiration as compared with labour, none has written more nobly or with better warrant than Shelley. 'The mind', he wrote in the *Defence of Poetry*[7] —

the mind in creation is as a fading coal, which some invisible influence, like an inconstant wind, awakens to transitory brightness; the power arises from within, like the colour of a flower which fades and changes as it is developed, and the conscious portions of our natures are unprophetic either of its approach or its departure. Could this influence be durable in its original purity and force, it is impossible to predict the greatness of the results; but when composition begins, inspiration is already on the decline, and the most

glorious poetry that has ever been communicated to the world is probably a feeble shadow of the original conceptions of the poet. I appeal to the greatest poets of the present day, whether it is not an error to assert that the finest passages of poetry are produced by labour and study.

He then goes on to interpret literally Milton's reference to *Paradise Lost* as an 'unpremeditated song' 'dictated' by the Muse, and to reply scornfully to those 'who would allege the fifty-six various readings of the first line of the *Orlando Furioso*'.[8] Who is there who would not agree with Shelley quickly if it were a question of having to choose between his inspirational theory of literature and the mechanical theory of the arts advocated by such writers as Sir Joshua Reynolds? Literature without inspiration is obviously even a meaner thing than literature without style. But the notion that any man can become an artist by taking pains is merely an exaggerated protest against the notion that a man can become an artist without taking pains. Anthony Trollope,[9] who settled down industriously to his day's task of literature as to bookkeeping, did not grow into an artist in any large sense; and Zola, with the motto 'Nulla dies sine linea'[10] ever facing him on his desk, made himself a prodigious author, indeed, but never more than a second-rate writer. On the other hand, Trollope without industry would have been nobody at all, and Zola without pains might as well have been a waiter. Nor is it only the little or the clumsy artists who have found inspiration in labour. It is a pity we have not first drafts of all the great poems in the world: we might then see how much of the magic of literature is the result of toil and how much of the unprophesied wind of inspiration. Sir Sidney Colvin recently published an early draft of Keats's sonnet, 'Bright star, would I were steadfast as thou art', which showed that in the case of Keats at least the mind in creation was not 'as a fading coal', but as a coal blown to increasing flame and splendour by sheer 'labour and study'. And the poetry of Keats is full of examples of the inspiration not of first but of second and later thoughts. Henry Stephens, a medical student who lived with him for some time, declared that an early draft of *Endymion* opened with the line:

A thing of beauty is a constant joy

– a line which, Stephens observed on hearing it, was 'a fine line, but wanting something'. Keats thought over it for a little, then cried out, 'I have it,' and wrote in its place:

A thing of beauty is a joy for ever.

Nor is this an exceptional example of the studied miracles of Keats. The most famous and, worn and cheapened by quotation though it is, the most beautiful of all his phrases –

magic casements, opening on the foam
Of perilous seas, in faery lands forlorn –

did not reach its perfect shape without hesitation and pondering. He originally wrote 'the wide casements' and 'keelless seas':

the wide casements, opening on the foam
Of keelless seas, in fairy lands forlorn.

That would probably have seemed beautiful if the perfect version had not spoiled it for us. But does not the final version go to prove that Shelley's assertion that 'when composition begins, inspiration is already on the decline' is far from being true for all poets? On the contrary, it is often the heat of labour which produces the heat of inspiration. Or rather it is often the heat of labour which enables the writer to recall the heat of inspiration. Ben Jonson, who held justly that 'the poet must be able by nature and instinct to pour out the treasure of his mind', took care to add the warning that no one must think he 'can leap forth suddenly a poet by dreaming he hath been in Parnassus'. Poe[11] has uttered a comparable warning against an excessive belief in the theory of the natural inspiration of poets in his *Marginalia*, where he declares that 'this untenable and paradoxical idea of the incompatibility of genius and *art*' must be 'kick[ed] out of the world's way'. Wordsworth's saying that poetry has its origin in 'emotion recollected in tranquillity' also suggests that the inspiration of poetry is an inspiration that may be recaptured by contemplation and labour. How eagerly

one would study a Shakespeare manuscript, were it unearthed, in which one could see the shaping imagination of the poet at work upon his lines! Many people have the theory – it is supported by an assertion of Jonson's – that Shakespeare wrote with a current pen, heedless of blots and small changes. He was, it is evident, not one of the correct authors. But it seems unlikely that no pains of rewriting went to the making of the speeches in *A Midsummer Night's Dream* or Hamlet's address to the skull. Shakespeare, one feels, is richer than any other author in the beauty of first thoughts. But one seems to perceive in much of his work the beauty of second thoughts too. There have been few great writers who have been so incapable of revision as Robert Browning, but Browning with all his genius is not a great stylist to be named with Shakespeare. He did indeed prove himself to be a great stylist in more than one poem, such as *Childe Roland*[12] – which he wrote almost at a sitting. His inspiration, however, seldom raised his work to the same beauty of perfection. He is, in point of mere style, the most imperfect of the great poets. If only Tennyson had had his genius! If only Browning had had Tennyson's desire for golden words!

It would be absurd, however, to suggest that the main labour of an author consists in rewriting. The choice of words may have been made before a single one of them has been written down, as tradition tells us was the case with Menander,[13] who described one of his plays as 'finished' before he had written a word of it. It would be foolish, too, to write as though perfection of form in literature were merely a matter of picking and choosing among decorative words. Style is a method, not of decoration, but of expression. It is an attempt to make the beauty and energy of the imagination articulate. It is not any more than is construction the essence of the greatest art: it is, however, a prerequisite of the greatest art. Even those writers whom we regard as the least decorative labour and sorrow after it as eagerly as the aesthetes. We who do not know Russian do not usually think of Tolstoy as a stylist, but he took far more trouble with his writing than did Oscar Wilde (whose chief fault

is, indeed, that in spite of his theories his style is not laboured and artistic but inspirational and indolent). Count Ilya Tolstoy, the son of the novelist, recently published a volume of reminiscences of his father, in which he gave some interesting particulars of Tolstoy's energetic struggle for perfection in writing:

When *Anna Karénina* began to come out in the *Russki Vyéstnik* [he wrote], long galley-proofs were posted to my father, and he looked them through and corrected them. At first, the margins would be marked with the ordinary typographical signs, letters omitted, marks of punctuation, and so on; then individual words would be changed, and then whole sentences; erasures and additions would begin, till in the end the proof-sheet would be reduced to a mass of patches, quite black in places, and it was quite impossible to send it back as it stood because no one but my mother could make head or tail of the tangle of conventional signs, transpositions, and erasures.

My mother would sit up all night copying the whole thing out afresh.

In the morning there lay the pages on her table, neatly piled together, covered all over with her fine, clear handwriting, and everything ready, so that when 'Lyóvotchka' came down he could send the proof-sheets out by post.

My father would carry them off to his study to have 'just one last look', and by the evening it was worse than before; the whole thing had been rewritten and messed up once more.

'Sonya, my dear, I'm very sorry, but I've spoilt all your work again; I promise I won't do it any more,' he would say, showing her the passages with a guilty air. 'We'll send them off tomorrow without fail.' But his tomorrow was put off day by day for weeks or months together.

'There's just one bit I want to look through again,' my father would say; but he would get carried away and rewrite the whole thing afresh. There were even occasions when, after posting the proofs, my father would remember some particular words next day and correct them by telegraph.

There, better than in a thousand generalizations, you see what the artistic conscience is. In a world in which authors, like solicitors, must live, it is, of course, seldom possible to take pains in this measure. Dostoevsky used to groan that his poverty left him no time or chance to write his best as Tolstoy and Turgenev could write theirs. But he at least laboured all that he could. Novel-writing has since his time become as painless as dentistry, and the result may be seen in a host of books that, while affecting to be literature, have no price except as merchandise.

PART THREE

THE WITNESS

'THE WITNESS'

I WAS RECENTLY SENT a cutting announcing the end of the famous weekly paper, *The Witness*. Fame is, of course, a relative matter, and it may be that *The Witness* was not so well known outside the north of Ireland as it ought to have been, and, even inside the north of Ireland, it was little read except by Presbyterians whose church news it published and whose views it did its best to represent. I cannot say that I always read it myself as closely as it deserved to be read, but I retain a special affection for it as it was the first paper in which I appeared in print. One of its more worldly features was a Children's Corner, to which ambitious young Presbyterians still in the nursery frequently contributed, signing their names and giving their ages in brackets. It consisted mostly of puzzles – Decapitations, Anagrams, and so forth, and, after seeing a Decapitation signed 'Agnes McIlwrath (aged 7¾)', an Anagram signed 'Joseph McCandless (aged 8)', and many similar works of art by my infant contemporaries, I was stung to emulation and resolved that I too would turn author. I imagine I must have been a poet by instinct, for the form in which I chose to write was that of the rhymed puzzle known as the Riddle-me-ree.

I do not know whether this form is still cultivated in days in which poetry has so strangely altered; but it was of a Wordsworthian simplicity. A typical Riddle-me-ree would begin in some such way as:

> My first is in plum but not in jam;
> My second is in bacon but not in ham;

and at the end of a number of lines composed on this pattern a clever reader could discover that the answer to the riddle was 'Portrush'. I cannot quote my own Riddle-me-ree, as I did not keep a copy of it and it has slipped my memory. But I can remember the excitement with which I opened *The Witness* one Friday and saw my poem there and, after it, the boastful '(aged 7½)' or whatever age I was at the time. Then in church on Sunday, after the morning service, how intoxicating, though also how embarrassing, it was, to have old gentlemen – they were probably not nearly so old as I thought them – coming up to me, as I was preparing to leave the family pew, and wringing me warmly by the hand. Everybody seemed to have seen my Riddle-me-ree in *The Witness*, and by everybody I do not mean all the inhabitants of Europe, Asia, Africa, America, and Australia, but everybody who mattered. Byron, on the morning after the publication of *Childe Harold*, must have felt much as I felt as I received those congratulatory handshakes.

Regarding myself now as an established writer of Riddle-me-rees, and looking round for new worlds to conquer, I turned my eyes towards London, where a children's magazine called *Little Folks* and containing a monthly page of puzzles was published. Never did neophyte author sit down with greater ardour to carve a way to wider recognition. Month after month I bombarded *Little Folks* with Riddle-me-rees, and month after month *Little Folks* appeared without any sign that the editor was aware that a new master of the form had arrived in literature. Yet it seemed to me that the Riddle-me-rees he published were, to put it modestly, not so good as those I submitted to him. Ultimately I decided it was a waste of stamps to send my work to such an editor. Perhaps I was too easily discouraged; but I had a profound sense of failure. A few years later one of my favourite books became *Sorrow and Song*. All those other poets seemed to have had unhappy experiences too.

Even though I abandoned the Riddle-me-ree in the same despairing spirit in which Thomas Hardy[1] abandoned the novel, however, the *cacoethes scribendi* continued. I went on lisping in numbers, for the numbers came, and wrote what I thought an

excellent poem on St Peter. I forget what it was about, but I think I reproached him. I had ceased to write for publication, however; I sang but as the linnets sing. Not that poetry occupied all my energies. I turned to prose with almost equal enthusiasm, and began with knitted brows to write a commentary on the Book of Esther. I had always been fond of commentaries and theological works of every kind. Not that I ever read them, but I cut their pages for my father, who brought them into the house in a perpetual stream. It was his custom, when he had a few more pounds to spare than usual, to buy large numbers of theological books, sometimes translations from the German in three or four volumes, and I opened the parcels as eagerly as if they had been Christmas presents. To see and touch new books, and, still more, to cut their pages, was to me a pleasure second in intensity only to watching a Rugby football match. And so it came about that, although I never read the pages I was cutting, I reached my teens steeped as it were in theology.

And it seemed to me, after many a casual glance at the theological books that passed through my hands, that, of all theological books, commentaries were the easiest to write. I could not write a defence of infant baptism, as my great-uncle had done, nor did I know enough to fill a book, or even a page, with an exposition of St Paul's attitude to justification by faith. To write a commentary, however, was simplicity itself. All one had to do was to take down from the shelves a commentary or two on any book in the Bible and to rewrite the commentators' notes that appeared at the foot of the pages. I was not so immodest as to believe myself the superior in scholarship of the commentators who had gone before me: I was content to accept what they said and to improve on it.

Thus, having chosen the Book of Esther as my subject – probably, because of its brevity – I looked up what the other commentators had to say about the opening words: 'Then it came to pass in the days of Ahasuerus'.[2] I did not know who Ahasuerus was or when his days were; but the other commentators seemed to know, and, when I had embodied their

knowledge in a footnote, it seemed to me that the footnote was indistinguishable in merit from theirs. Exciting though it was to begin writing a commentary, however, it became less and less exciting to continue it; and I doubt whether in the end I got beyond the first two chapters of Esther, or even beyond the first chapter. I had not failed with theology, perhaps, as dishearteningly as I had failed with Riddle-me-rees; but I had found it stiff going compared with reading about Red Indians, and I had failed.

In spite of the path of failure along which the Children's Corner in *The Witness* enticed me during those critical years, there is no tinge of bitterness in my recollections of that noble paper. No one could help liking *The Witness* – not even those who derisively called it '*The Wutness*', or those who criticized it for denouncing betting while the evening paper published by the same firm made profits out of racing news. I had a remarkable example at a railway station one day of the affection in which *The Witness* was held. A stout middle-aged man, a son of a friend of the family, used to turn up in town on periodic drinking bouts, and, when his money was done and he had reached the stage of repentance, he would call for assistance and be bundled back as quickly as possible to the bosom of his own people. One day, though I was only a boy, I was deputed to take him to the railway station, buy him a single ticket, and see him off by the train, but was warned on no account to give him any money. After I had given him his ticket, he cleared his throat and said to me with a look in which a half-hope fluttered: 'I suppose your father said nothing about – er – letting me have a small sum – say, half a crown – for the journey.' 'No,' I said woodenly. 'You wouldn't', he said, looking at me as Montagu Tigg must have looked at Mr Pecksniff[3] on a similar occasion, 'feel like letting me have sixpence on your own account?' 'I was told not to,' I said. He thought for a moment, and then said: 'There wouldn't be the same objection, would there, to buying me a copy of *The Witness* to read on the journey?' I bought him a *Witness* and went with him along the platform. 'I never like to miss *The Witness*,' he said with a sigh, '– the dear old

Witness.' Of how many papers can it be said that they have this consoling power?

And now this fountain of consolation is no more. It is a mere theme for memories and a few anecdotes. The cutting that was sent me – there was no mention of the paper from which it came – contained one anecdote about *The Witness* told on the authority of that brilliant journalist, J. W. Good,[4] who till his death was the Irish correspondent of the *New Statesman*. It runs:

At the turn of the century the bulk of the contributors were clergymen, whose literary style scarcely ever met with the approval of the then foreman printer, who could usually be heard snorting about what he described as 'th' effusions o' thon amachoo-ir journalists'.

On one occasion one of these amateur journalists, flying higher into rhetoric than usual, wrote in an obituary of a colleague that he had been 'for 25 years a watcher on Zion's hills' – which, no doubt, he felt proud of as a euphemism for the plain fact that the gentleman in question had for 25 years been a Methodist clergyman.

By some mischance the printer set it up that the gentleman had for 25 years been a 'watchman' on Zion's hills. This was then corrected by the proof-reader (a man of vast geographical knowledge if ever there was one) into 'he was for 25 years a watchman at Sion Mills'.

When the proof at last reached the foreman printer, he exploded. 'You'd think', he exclaimed, 'the whole world knew where Sion Mills was.'

Whereupon he himself corrected the proof, so that, when the obituary finally appeared, it contained the statement that the late 'Rev. Mr.' had 'for 25 years been a watchman at Sion Mills, County Tyrone'.

One might compose an epitaph for *The Witness* itself out of that anecdote. For of it it might be said that during its long life it brought together the celestial and the local – that it was not only a watcher on Zion's hills but a watchman at, among other places, Sion Mills, County Tyrone.

WHITE CITIZENS

AT THE LAST DOOR on the left my papers were taken from me, and I was told to sit down and wait. There was a flat wooden form outside the door. Down the middle of the hall other long seats had been laid back to back, and a hundred or more weary-looking men sat on them, some of them talking to each other, some of them silently gazing into space or shifting their thin legs on the uncomfortable seats. They had, all of them, I think, been medically rejected at a previous examination. Some of them certainly did not look the part – at least, not in their clothes. But most of them had the wasted appearance, so common in London, of half-sucked pear-drops. Among them a little hunchback sat, dangling his feet solitarily; another man sat at the far side of the hall, a well-dressed man, his shoulders and head twitching beyond control. On the whole, they were a lean and depressed company. A lean man in a bowler-hat and glasses, who sat beside me, told me that he had just recovered from pleuro-pneumonia. The sun came swelteringly in on us through the glass roof where the awning had fallen to pieces and hung down ragged and dirty. Everywhere one had a vision of melting brows, of veins swelling on temples, of veins swelling on hands. One turned one's eyes from the men to the walls and read an endless number of ugly yellow posters giving particulars about separation allowances for soldiers' wives and blazoning forth mottoes such as: 'You are helping the Germans if you use a motor-car for pleasure.' One waited for something to happen, but for a long time nothing happened. Occasionally a soldier or an old wrinkled clerk would come out of a door

with a paper in his hand and walk leisurely to another door. He would be watched on his passage as by Argus. He would disappear and leave us in dullness. He would reappear and a crowd of eyes would once more follow him from door to door. Sometimes a fat, bright-eyed young Jew, with a smile that never changed either to spread or diminish, would stop one of these people in order to make sure that his case had not been missed. . . .

One hoped it would be all over by lunch-time. The dapper man, tall as a tree and thin as a skeleton, who had brought *The Times* with him and was working through it column by column, would soon have reached the last page. At length a soldier with a big stomach came out of a room with an armful of papers and began calling out names. People rose from all sides and gathered round him like hens hurrying to a meal. He shouted them back to their seats and ordered that none but those he named should approach him. Then he called out another name. 'Here!' answered a voice sharp as a rifle-shot. The soldier paused and looked at the little man running up to him. 'You've been in the Army before,' he said. 'Yes, sergeant,' the little man admitted. 'I knew it,' said the sergeant; 'no place like the Army for learning manners.' He then began to march down the hall roaring names, as it were, out of the back of his head, like a railway-porter shouting out a list of stations. He was followed by a draggle of men anxiously listening in the hope of recognizing their own names amid the inarticulate bellowing. Another soldier began to call out other names at the far end of the hall. After each list was ended, the men who had not been mentioned sat back and shook their heads at each other with resigned smiles. An official passing by stooped down and commented: 'It's a bloody farce. They'll examine a hundred men and not get ten. You'll see.'

For a farce, I confess, I found it dull. I thought that cattle penned up closely at a fair and left unsold till the end of a hot day must feel very much as we did. In the end the soldier with the big stomach came out and told us that we shouldn't be examined before lunch now, and that we might go away for

three-quarters of an hour and have something to eat. I went
into the street and bought a *Star* to see what had happened in
the outside world. I felt that a great battle might easily have
been won while I was waiting on the hard bench outside the
wooden room in the hall of the White City.[1] I saw a Lyons tea-
shop[2] and suggested to the man who had had pneumonia that
we might go and have some coffee. 'I have never been in a
Lyons's shop,' he said hesitatingly, 'what is it like?' I did not
know that such innocence existed in London. 'I always prefer a
cook-shop myself,' he said, with a sad look up and down, and
he walked across the road to a public-house.

When I got back to the White City I ran into another man
who had also had pneumonia. He drew a little square figure in
the air with his forefinger and told me that there was a patch of
that size missing from his right lung. I sat down on a bench
beside him. 'Do you mind if I smoke an asthma cigarette?' he
said, as though it were a jest, and lit one. We had hardly begun
to talk when a man with heart disease came up – a tall, pallid
young man, very straight in the back, with a man-of-the-world
smile and a man-of-the-world cigarette. He said that he had just
been examined and had been ordered to undergo a special
examination at a heart hospital. 'I regard that as a distinctly
hopeful sign,' he said. Soldiers and clerks continued to walk at
intervals from door to door, and occasionally one of the soldiers
would march off with a brood of invalids to the dressing-room.
The rest of us said, 'Hard luck!' and waited prostrate with the
heat for the next roll-call. A man at the far end of the hall
opened a lemonade stall. I took Scott's *Lives of the Novelists*[3] out
of my pocket and tried to read it. In five minutes I put it back
again, yawning. I continued to yawn for three solid hours –
hours as solid and heavy as lead. I had arrived at eleven in the
morning. It was half-past four before I heard my name called,
and was taken with a number of other men into a wooden hutch
and told to undress. Clothes were lying all about as in a
bathing-box. Some men were struggling into their trousers;
others were clambering out of them. One little man who had
just been examined was the skinniest human being I ever saw.

He had not enough flesh on his bones to make a decent-sized chicken. He was as bald as a block of ice save for a fringe of grey hairs on each side of his skull, and altogether he looked in his glasses like a little wizened creature of seventy. Other men were to be seen wearing belts, bands and trusses round various parts of their bodies. One felt at times as though one must be at a holy well among people who were awaiting miraculous cures rather than among young men in the prime of life about to be chosen as warriors in a great war. Horace Walpole[4] once declared, on an occasion when every invalid and cripple in the House of Commons had been whipped up to vote against John Wilkes,[5] that the floor of the House looked like nothing so much as the Pool of Bethesda.[6] Here was London's Pool of Bethesda, with the sick and the maimed cursing the whole business indignantly under their breath.

Through a doorway one had a view of the examination-room, which was full of naked men, with doctors listening at their chests or making them dance before them with strange gestures. We were permitted to wear our jackets as a part-covering till the actual examination should begin. Suddenly the half-naked man beside me, an attractive-looking youth with delicately curved nose and a wing of gravel-coloured hair, closed his eyes and drooped his head like a dying chicken. He began to gasp, and his head swayed backwards and forwards over his chest like a ship plunging in a heavy sea. I wondered if he was about to have a fit or was dying. I saw myself skipping forth, a pard-like spirit beautiful and swift, in my little short jacket and with my long hairy legs, to summon the assistance of the doctors in the next room. 'Are you feeling ill?' I inquired. 'No, no,' he answered, opening his eyes wearily; 'it's only asthma. Haven't you ever seen it before?' Other men tripped back from being examined: some of them with patient, contemptuous smiles; others flushed with indignation and sprinkling the already foul air with 'bloodies', all of them rather like undergraduates exchanging expriences after an 'oral'. I watched a bearded doctor in his shirt-sleeves through the doorway, as he popped his stethoscope over a chest that seemed to me to be the chest of an athlete.

The examination-room itself was a long wooden room, with a row of tables littered with books of official forms and papers, and with clerks writing slowly at them as though each separate letter were a work of national importance. The room was divided into sections by red screens. In every section a man stood in his skin while a doctor examined his teeth or palpated his chest or jigged him in the groin, calling out such things as 'varicocele left' to the clerks, who solemnly wrote it all down. The doctors, I must say, were a good-humoured lot. If one was disgusted, it was when one's eye travelled round the room and fell on a back with a large sore patch running across the small of it, or on a bucket of dirty slops with matches and cigarette-ends floating in it near a man who was being tested for Bright's disease.[7] I confess I could not help laughing as some long string of misery was ordered to prance on the floor, the doctor bidding him, 'Now swing your arms – now rise on your toes – now hop.' It was as though a company of Spanish beggars had suddenly reverted to the conditions of the Garden of Eden and had then been bitten by the tarantula. How indignantly some of them danced! 'You say you have a discharge from the right ear?' the doctor would say. Then he would turn to one of the clerks and repeat to him: 'Discharge from the right ear.' 'Now cough,' he would add, seizing the recruit by the crutch. Once more, as I looked round, I thought of the men who had been called up as cattle at a fair and of the doctors as butchers and farmers going the rounds and prodding the beasts with sticks, sizing up their value as flesh.

My own turn came. A little doctor with a gentle light on his face like a Christian's and a stethoscope hanging round his neck like a scapulary called me over. I had to write my name once or twice. He asked me gently about my health. I ran down a list of diseases, curable and incurable, with which various doctors had strewed my path, dogmatically contradicting one another. One of them, alas! was written on me like a crooked note of exclamation. The doctor examined my heart, my pulse, my tongue. He made me do gymnastics for him. He looked down my throat and said, 'Pharyngitis.'[8] As the clerk seemed to

hesitate, he began to spell it: 'P—h—a—r—y——'. He covered my right eye with a piece of cardboard and made me read P B N T from a card hanging on the wall. He covered my left eye and made me read O S Q D F. 'Sight 66,' he said to the clerk. He weighed me, he took my height, he measured my chest when it was full and when it was empty. He asked me if I had ever had rheumatic fever or a pain in my ears. He then bade me wait while a deaf man was being examined and, after him, a healthy-looking man who kept putting a queer instrument up his nose.

I then had to go to another table where a sturdy, cheerful doctor in khaki was sitting – a whitening-haired man in gold-rimmed glasses with a gift for making diseased and naked persons smile as they passed under his inquisition. His eyebrows rose as he looked at my figure. 'How did you come to get like that?' he asked in amazement. I told him that it was the result of an idle and misspent youth. 'Are you an Irishman?' was his next question. I admitted it. 'Thy speech betrayeth thee,' he said. He then examined my heart, and showed me so much considerateness that I thought it must be very seriously affected indeed.

Back at last to the dressing-room, where men were asking each other, 'Did they pass you?' and blaspheming. A long, black, consumptive Scotsman was saying: 'It's a bloody disgrace to call up a man wi' lungs at all.' Attendants began to wash down the hall with a hose, and the water crept in along the floor of the dressing-room. We were taken across the hall to another room and told to sign our names in a book in order that we might be given 2s. 9d. I signed, but forgot the 2s. 9d. A Scottish soldier ran after me with it. 'What do you mean by leaving your money behind you?' he asked warmly. We were then taken to yet another room and left at the door, while two aged men crouched over a table within and wrote out rejection certificates. At the end of half an hour or so my turn to go in came. One of the clerks wrote out my certificate, and another wrote the same details in a book. It was apparently to be a certificate of identity as well as of rejection. 'Complexion –

fresh,' they wrote down. 'Eyes – what colour are your eyes?'
They asked me had I any scars or marks on my body. I told
them no, nothing but a mole or two. 'Moles will do,' they said,
'where are they?' I said that I really wasn't quite sure. I was
almost certain there was one on my right side, and I thought –
though I wouldn't swear it – there was one on my left. They
nodded as though to say that was enough, and wrote down on
my card, 'Moles on right and left flanks.'

I had been at the White City since the morning. When at
last I escaped into the street it was close upon half-past six. I
felt that the certificate did not exaggerate in describing me as
'permanently and totally disabled'.

I suddenly remembered the two-and-ninepence.

I hailed a taxi and got into it, moles and all.

ON NEVER GOING TO THE BRITISH MUSEUM

How ENTHUSIASTIC the natural man is over museums and art galleries! Something in me responds as I read in a leading article in *The Times* that 'there is no reason why almost any Londoner should not, if the museums and galleries were always open for nothing, be able to constitute himself a connoisseur of beauty'. Not for me, I know, to constitute myself a connoisseur of beauty after this fashion, but even I, who seldom enter a museum or art gallery except during a visit to a foreign town, have dreamed of spending long days in public buildings, from the walls of which the world's genius looked down on me, a trembling initiate, or in which the world's knowledge was preserved in glass cases to be passed on to me as an almost private possession. Before I came to London I thought of it chiefly as a city of theatres, concert halls, and museums and galleries of the arts. I imagined that any sane Londoner, outside his working hours, would be either listening to music or looking at pictures on such occasions as he was not reading a book or seeing a play. It is odd what a hunger for the arts one had at that age, as though perpetually hoping to discover in a book or a picture the keys of Heaven. The very names of certain authors and artists made one vibrate with a sense of impending revelation, even if one had never read or seen a line of their work. I remember my excitement on first hearing the name of Walter Savage Landor,[1] and how I went out with the first shillings I had and bought his verse in the Canterbury Poets and his prose in the Camelot Classics and all but persuaded myself for months,

though with more and more difficulty, that here were the keys,
or were going to be the keys, at last. Then there was Schubert.
Then there was Wagner. One went to one's first Wagner opera
in the sure and certain hope that a new door would be opened
and lo! doors vaster even than one had dreamed swung wide on
their hinges. Those were days in which it was possible to go to
the opera twice in a day and not feel weary – to sit through
Mignon[2] in the afternoon and to go to *Lohengrin*[3] in the
evening. If London seemed desirable then, it was chiefly as a
city in which the opera lasted, not for a week only, but for a
season. Had it been foretold me that a time would come when
'The Ring'[4] would be produced in London and when I, though
a Londoner by settlement, would remain away from it, not
merely with cheerfulness, but almost with a feeling of relief, I
should have laughed at the falsehood. But 'The Ring' has been
produced in London more than once since then, and I have not
heard it yet. I doubt if I shall ever hear it. I no longer expect to
find the keys just there. I do not even buy Wagner rolls for the
piano-player. Yet I would once have sworn that Wagner was
greater than St Paul or Robert Louis Stevenson.

As for the museums and picture galleries, how great was
their lure three hundred miles away! The picture galleries, per-
haps, were less exciting in prospect than the concert rooms,
and the British Museum than the picture galleries. But, as at
least half of my friends were painters, I had an ardent enough
faith in Turner and Rembrandt and Velazquez to believe that
they were the possessors of the keys if I could but find them. I
had always felt a foreigner and an ignoramus in the presence of
pictures, enjoying them rather as one enjoys a strange town
in which a language is being spoken that one does not under-
stand, but I had no doubt that I had only to become familiar
with them in order to be as powerfully affected by them as I
was by music. The British Museum, too, would disclose to me
the secrets of Greece, where there was beauty not only in the
faces of men and women but in their words – nay (which is most
difficult of all), in their very actions. More than this, the reading-
room was there to convert me into a scholar, if I wished, with

shelves of learning that Faust might have envied. To go to
London, indeed, was to go on a pilgrimage to a city which was
a vast storehouse of beauty and wisdom that were to be had
almost for the asking. It may seem all the more unaccountable
that, on arriving in London, a lonely loafer in a lonely attic in
Pimlico, I immediately went out and bought a map of the town
and spent my first evening in a seat in the gallery of the old
Gaiety Theatre.[5] Had you been as deeply in love with Miss
Marie Studholme as I was in my teens, I do not think you
would have regarded this as too base a declension from the
ideal. Love transforms even *The Toreador* into something more
charming and desirable than the lost plays of Menander.[6] The
next day a man whom I had known as a medical student and
who was acting as *locum tenens* somewhere in the East End called
on me, and, after showing me the house where the Baroness
Burdett-Coutts[7] lived (which everybody, for some strange reason,
used to show me) and the house where the Duke of Devon-
shire lived, and Buckingham Palace and St James's Palace and
Mooney's, took me off later in the day to Whitechapel, where,
after a dish of tripe, we spent the evening getting into the way
of actors and actresses behind the scenes at the Christmas
pantomime. I confess I should have preferred to buy a seat,
and I should have preferred still more not to see the pan-
tomime at all, but I was in the hands of fate, which seemed to
be bearing me further and further away from Schubert and
G. F. Watts[8] – how we worshipped him in those days! – and
Phidias.[9] Next to call on me was a painter whom I had known
since we were small boys. He took me out and put me on to the
top of a horse-bus, pointed out the house where the Baroness
Burdett-Coutts lived and the house where the Duke of Devon-
shire lived, and ultimately led me into a public-house in Fleet
Street, explaining as we went in: 'Old Johnson used to come
here.' Well, an association with Dr Johnson was at least
ennobling, but this was not the reading-room of the British
Museum. Then my friend took me out to Hampstead and into
an inn, afterwards famous in song as the Old Bull and Bush,
explaining after the fashion of a man of letters, 'Old Hazlitt[10]

used to come here.' That night I spent with him at Hampstead. On the next afternoon he proposed that we should go to Battersea on a visit to the studio of another artist whose name has become a household word since then. When we reached the Pier Hotel at Albert Bridge, he said, 'Let's go in here,' and, as we waited to be served, he speculated on the possibility that 'old Whistler[11] used to come here' when he was painting his 'Battersea Bridge'. Never before had I lived in such a whirl of literary and artistic associations. I might not be seeing many pictures or reading many books, but I was following in the footsteps of the great painters and the great writers with an almost dog-like fidelity. My friend was a perfect master of the literary geography of London, though, indeed, when he led me into a most unpromising-looking tavern in St Martin's Lane on the plea that 'old Stevenson used to come here', I began to suspect that he was playing on my credulity. Still, there were pauses between the lessons, during which we did visit the Turner rooms in the National Gallery and gaze at 'Rain, Steam and Speed' as at one of the wonders of the world in ruins. My friend's chief method of expressing his enthusiasm, as he stood before a picture he liked, was to say merely, 'By God, old chap!' or 'By God, Willie!' or 'By God, Rupert!' and to nod his head, as if in despair of ever rivalling so great a miracle. And so he spoke before the blue cloak of the Mother of God in a Titian, or before the ox and the ass and the divine nursery under a hill of roads winding among cypresses in a Fra Filippo Lippi,[12] or before a base king portrayed by Velazquez or before a Rembrandt portrayed by himself. And, indeed, if we idled a good deal of our time in other places, he talked by preference even there of writers and artists – of Hazlitt and Lamb and Sir Thomas Browne,[13] of Turner and Corot[14] and Millet,[15] and above all of Wordsworth, whom he revered as a poet but detested as a man. I cannot, by an odd chance, remember his ever once saying, 'Old Wordsworth used to come here.'

Thus my pilgrimage to London was, as it were, defeated at the very outset. And even today I have heard little of that music and seen few of those pictures and read few of those books that

were once like the stars circling round the star of guidance in a dark world. I seldom hear any good music except such as I play with my own feet. I do not go to one opera in a year. I have been once in the Tate Gallery since the war, and not even once in the National Gallery. I have been in the British Museum, but only in order to see a civil servant. I am always on the point of breaking through this indolence and taking up the pilgrimage at the point at which I dropped out of it so many years ago, but, when it comes to the practical issue whether I shall go to a picture gallery or go home, I invariably find myself mounting a bus and going home. Theoretically, I still haunt museums and galleries and concert halls. If they were closed I should feel an infinitely poorer man, as though my income of possible pleasures had been cut down. I love the National Gallery and the British Museum, indeed, as noble reserves of pleasure on which I can draw at need. I can bear not visiting them, but I could not bear so easily not having them to visit.

Hence I join ardently in every protest against closing a museum or charging for admission to it. I do not like the potential I who visits such places to be hampered. It is not that I myself mind paying sixpence, but the potential I (who, as I have said, frequents museums much more than I do) might not have a sixpence. And, after all, the museums and art galleries exist for potential visitors as well as for actual visitors. They are a part of the rich surroundings of our lives. They make London almost worth living in, whereas without them it would be a wilderness. I like to feel that somewhere or other in the neighbourhood troops of people are shuffling round high rooms, peering at pictures and staring at statues and paying a puzzled reverence to antiquity. They are our representatives in the public appreciation of the arts just as the people who attend political meetings are our representatives in keeping alive the flame of democratic government. Do not think that one enjoys a picture or a statue the less for never having seen it. The 'Mona Lisa' never seemed so wonderful as before one had been to Paris, and the 'Winged Victory'[16] would have been as lovely as winds and waters in the imagination even though one had

never been to the Louvre or seen so much as a photograph of it. There is a pleasure in knowing that a thing exists in the same world with us. There is another pleasure in knowing that a thing exists in the same neighbourhood with us. London does not mean to me merely the people and the plane-trees I see from the top of the bus on my way to the office, or the pavements and policemen, the lamps and the loiterers, I see out of the window of a taxi on my way to dinner. It means all the great composers constantly coming to life again in concert halls and theatres, all the great painters surviving in the quiet paradise of the National Gallery, all the great sculptors and all the great authors, a majestic congregation in the British Museum. Why, it is a pleasure, when walking along Adelphi Terrace, to feel 'Bernard Shaw lives there,' even though he is not to be seen at the window. It is a pleasure, too, to enjoy the art of the day by proximity and to know that somewhere or other the pictures of Mr Augustus John[17] and Mr Henry Lamb[18] and Mr Nevinson[19] are being exhibited, though the show is usually over before one has had time to go to it. And it is a pleasure to be contemporary with Mr Arnold Bax[20] and Mr Arthur Bliss[21] and to live in a constant anticipation of hearing their work otherwise than through one's admirable representative, the regular concert-goer. The pleasures of proximity have never yet had justice done to them. It is chiefly they, however, that make London so much more desirable a city to live in than Birmingham or Manchester. It is because they mean so much to us that, if the British Museum or National Gallery were burnt down, we should regard it not only as a public calamity but as one of the great personal calamities of our lives.

FAREWELL TO TOBACCO

BOSWELL TOLD DR JOHNSON that Steele published his *Christian Hero*[1] 'with the avowed purpose of obliging himself to lead a religious life'. It is evidence of a touching faith in the power of the printed word that Steele should have thought that he had only to commit himself to a better life on paper in order to be forced into leading it for the rest of his days. Or, perhaps, he may have reasoned more subtly than this. He may have said to himself: 'I will write such a book that, as the author, I shall be unable to fall from grace without exciting universal ridicule'; and, having failed to keep upright by any other means, he hoped to terrorize himself into doing so by creating a situation in which he could not slip without becoming the butt of every fool. The experiment, it is to be feared, was not a success, and for two centuries fools and wise men have smiled though without malice at stories of the Christian hero in his cups. 'Steele, I believe,' said Dr Johnson, 'practised the lighter vices.' Steele himself, it is said, was bitterly offended by the way in which his fellow-officers subjected 'the least levity' in his words or actions to criticism as being incongruous in the author of *The Christian Hero*. The publication of his treatise, evidently, brought him not the piety he hoped but the ridicule he feared. With such a warning from the past it seems madness in any writer who is not a saint to commit himself in public to a life of virtue. I have at times been timid of praising virtue even in other people lest I should afterwards seem a humbug measured by a standard that I had rallied to at least in words. And yet, like Steele, I am tempted at times to commit myself publicly – to

commit myself publicly, say, to one of the lighter virtues so that I may know that I cannot become a backslider – strange word! – without also becoming an object of derision to my friends.

Today, for example, I wish to give up tobacco. I do not mean that I wish to give it up as other men do, but give it up finally. I have given it up as other men do again and again. I have trifled with abstinence for a lunar month at a time. If at the end of the month I yielded to temptation, however, I did not feel humiliated in the company of my fellow-mortals. I was merely amused, and regarded my lapse as a checkmate that must sooner or later have brought the game to an end. I am not sure that I did not even like myself a little better for having made a concession to the weakness of human nature. All men idealize themselves, and in the mirror of self-satisfaction weakness of will seems an unusually attractive form of good humour. I do not know how in the world men are ever to become virtuous if they remain so fatuously in love with themselves as they make it up with their sins. I should like to be able to say good-bye to tobacco in such a way that, if ever I reverted to it, I should feel so ashamed that I should have to leave Europe and begin life over again in the colonies under an assumed name. When I sat down to write this morning, it was in the hope that I might be able to utter a good-bye so terrible that tobacconists would grow pale when I walked past the doors of their shops. But how can I? Smoking, I am convinced, is for me a vice, because I cannot smoke without smoking to excess. But I cannot regard it as a vice in other people, so that it is difficult to denounce tobacco as a weed in the Devil's garden. If I could only hate it as Ruskin[2] hated it, I might be able to write a new version of *The Christian Hero*, depicting a man who was too proud to smoke. But how can I hate tobacco when I think of all the pleasures with which it has been associated ever since I can remember? I grew up in the smell of it – pipe-smoke in my father's study and snuff in the nursery. My nurse was a good-natured Christian widow who every Saturday night went off in her jet-black bonnet and beaded cape to see her daughter, and who always brought back a little bag of pear or

acid drops for me, and for herself a little bag of snuff shaped like the horn of plenty. She usually left the snuff on the corner of the mantelpiece, whence it overflowed, as it were, and permeated the room with the smell of a pleasant kind of pepper. How often have I sat on her knee, listening to the tale of the last agonies of the Protestant martyrs and sneezing where less fortunate children would have wept! How anyone can regard snuff-taking as a disgusting habit I have never since been able to understand. I associate it myself with the infinite kindness of a woman who would never admit that anything that I did was wrong and to whom I was so devoted that I remember arguing doggedly with my father that the correct pronunciation of 'teaspoon' was 'tayspun' and that 'bread' should be pronounced 'braid'. It was with the smell of snuff in my infant nostrils that I first learned to admire a heroism that I have never been able to emulate, as I listened to stories of the relief of Kandahar[3] and of the slave war in America (in both of which relatives of hers had taken part) and enjoyed at times the back-straightening happiness of having a soldier's medal pinned to my breast. It was in a cloud of snuff that I first heard of King William and the battle of the Boyne and was inducted into music with 'The Protestant Boys', 'Dare to be a Daniel', 'Ye Banks and Braes' and 'Old Dog Tray'. In later years, when I became a journalist, I tried to acquire a taste for snuff myself, for the printers in the case-room in Manchester were constantly holding out a hospitable snuff-box. On one occasion I even took to it as a means of giving up smoking, but a printer warned me that it was a still more enslaving habit. 'I have seen myself', he said, 'getting up out of bed in the middle of the night for a pinch of snuff.' I suggested that at least it had not such a bad effect on the health as smoking. 'I have seen', he replied, 'a compositor falling on the floor in a fit in Manchester, and *he* was a great snuff-taker.' It is lamentable that, just when you have at last discovered what seems a perfectly innocent habit, someone invariably comes along with a raven's warning. It is almost impossible to become virtuous, indeed, merely by changing one's vice.

As for smoking, how can anyone even regard it as a vice? It was only after years of thought about the matter that I was able to persuade myself that abstinence from tobacco was not a defect of manhood in a grown-up man. To have abolished tobacco would have seemed in my first years like banishing the clouds from the summer sky. There are two sights of which I never grew tired as a child – the sight of tobacco-smoke issuing from a man's mouth and the sight of a man shaving. How like Zeus in an armchair a man appears with those fragrant clouds about his head! How delightful it is in his absence for a child to take down his pipes and look at them – the crooked briar, and the long straight clay with the white hand embossed on the bowl – and to open the tobacco-jar and smell the most delicious of the herbs! Alas, it is impossible to admire such things for long without desiring to produce those magical clouds oneself and to taste the sweetness of that honeydew, as all tobacco seemed to be called in those days. I cannot have been more than five years old when, finding myself alone in the study, I made the great experiment. I remember, after a few minutes of it, creeping away to die in the hollow under the desk, flanked on each side by drawers full of sermons. I needed no sermons just then any more than the damned, and, indeed, I got none when I was discovered and carried gently to bed. There may be men who would have forsworn tobacco after such an experience, but, though I did not attempt a pipe again for a year or two, I was already a slave to the idea of smoking, and, even while I was still attending a dame's school, I used often to go into a spirit grocery on the way home and buy cinnamon cigarettes with another boy, which we smoked among the flower-beds and the glass frames in a nursery-man's garden. We frequently discussed whether it was wrong, for we both had consciences, but we decided without difficulty that, as cinnamon was not tobacco, to smoke cinnamon cigarettes was not smoking. 'This is sappy good,' the boy would say as he puffed at his cigarette. 'Put your hand there' – and he would point to a waistcoat button – 'and I'll show you the smoke coming out of my eyes.' But, if you did what he said, he would

suddenly bring the lighted end of his cigarette down on your hand, and two young smokers would find themselves tussling on the box-bordered path. I have heard of other boys smoking such things as tea and brown paper, but I remained faithful to cinnamon until I was old enough to smoke tobacco. Duke's Cameo cigarettes – you remember the little boxes, each containing the picture of a Parisian dancer or a statuette – are there any cigarettes like them nowadays? They had only one drawback: they left a smell of tobacco on the breath. I used, on reaching home after smoking them, to make stealthily for the pantry and to drink a large draught of milk, little though I liked it, in the hope that a smell of milk might deceive members of the family. I was convinced that the smell of cachous merely gave one away, and I had not the desperate courage of a fellow-schoolboy who used to chew the heads of matches and soap for the purpose of sparing his mother the knowledge that he was a smoker. What kind of drug-fiend she must have thought him, I cannot imagine; but it is a miracle that he did not die untimely of phossy-jaw. Even when we had taken to real tobacco, however, we did not at first smoke very much except during the holidays, and I should not describe myself as having been a regular smoker until the age of sixteen. By that time I smoked a pipe and one ounce of tobacco a week - Log Cabin or Pioneer or Tortoiseshell – which I always bought at the same shop from a very tall and beautifully dressed lady whose trembling slave I was. I thought she was like a Spaniard, for she had glorious black hair and glorious red lips and glorious white teeth when she smiled. I liked her to be alone in the shop when I went in. I always meant to talk to her. But somehow I never could say anything but 'An ounce of Log Cabin, please,' and then 'Thank you' as I took off my cap and went out. Thus I have also an association of love with tobacco. . . . But, if I were to tell you all the associations I have with tobacco, I should find myself writing an autobiography in ten volumes, for, save for a few brief periods of austerity, I have been smoking continuously ever since. That is why I am now so eager to say farewell to tobacco – to say such a farewell as will

do no dishonour to a herb that has given me so much pleasure and at the same time will commit me to treating it with heartless indifference for the rest of my days. I doubt if Einstein himself could solve such a problem. All the same, I will try. Steep and difficult is the hill of virtue, and on the distant summit of it I descry the tiny figure of a man who does not smoke.

THE PROMENADE

IF YOU ARE STAYING in a strange town, in which you do not know anybody, it is not always easy to decide how to spend the evening. In the larger towns and cities, you can solve the problem by going to a theatre or a cinema. But in many of the smaller towns there is no theatre, and, though you get as far as the steps of each of the two cinemas, a glance at the posters makes it impossible to enter. Yet you cannot go back and spend the evening in the hotel. There is a musty and stagnant atmosphere in the sitting-rooms of second-rate hotels, with a guest drifting in now and then like a lost soul or a character in *Outward Bound*,[1] that makes it impossible to sit and read in comfort. Even the exploits of Bulldog Drummond[2] – it was from Bulldog Drummond, I fancy, that the Home Secretary learned all that he knows about communism – lose their power to thrill in that shabby and soporific mockery of a drawing-room. The bar may be brighter, but one cannot spend an evening alone in a bar. In the end one usually has to fall back on the spectacle provided by the streets.

I found myself recently in a town in Ireland with the evening before me and not an acquaintance within fifty miles. There was nothing to do that any sane human being would have cared to do. It was depressing to look even at the outside of the cinema: it would, I feel sure, have been doubly depressing to go in. A concert party was giving an entertainment in a small hall. I went as far as the door, but could not persuade myself to enter. There was an infernal air of hopelessness about its portals. Nothing remained but the streets, and it was clear that

hundreds of others had also been driven there in search of pastime. There were middle-aged men smoking pipes under lampposts at the street corners. There were young men sauntering in twos and threes and fours. There were girls, all wearing the same kind of hat and the same kind of stockings, promenading arm-in-arm. There were solitaries ambling slowly. There were lovers, some talking happily, some contentedly silent. The chief sounds in the dark streets were the click of shoes on the pavement, and the shouting of newsboys selling evening papers. Hour after hour the parade went on, streams of shadows flowing in opposite directions on the dark footwalks. As I listened to the endless noise of the feet, with no traffic of vehicles to drown it, life in the town seemed extraordinarily empty and pleasureless. Here was a large population with nothing to do and nowhere to go, engaged (one told oneself) simply in killing time till it would be time to go to bed.

And then I remembered the time when I, too, used to walk up and down the streets, and I remembered that I did not then look on it as a last resource but as one of the chief of pleasures. I have long since lost the habit of walking aimlessly along the pavements, but I am not sure that in this I have not given up one of the eternal amusements of mankind. How good it was as a schoolboy to leave the house to meet the friend who was waiting under a lamppost, and to set off through the streets as though they were enchanted! We did not then think them dull. The gloomiest street of shut warehouses was good enough to walk and talk in. There was no avenue of villas too unsightly to be the setting of an argument. There was no back street of evil fame that did not stir the imagination like foreign travel. All places were alike to us if there was room for boys to walk in them. We could go down to the docks and watch the lights of the departing ships. We could walk up and down North Street,[3] with its innumerable twopenny shows – sword-swallowers, dwarfs, mermaids, marionettes – lit up with invitation. We could go out beyond the trams and the lamps into the darkness of the country. But, wherever we went, it was not the scene that mattered to us. It was walking and talking and being alive.

Sometimes there were two of us, sometimes three, sometimes a crowd. When there was a crowd, we often gathered in the doorway of an empty house, and, when we did this, there was usually some member of the company, little given to conversation, whose chief means of self-expression lay in attempting to wrench off the door-knocker. I have never myself wrenched off a knocker, or even tried to do so, but I have known men – we were all men in those days – who seemed to have a craving for knockers like a drunkard's craving for whiskey. They attended to them even at the height of the conversation, while a young atheist might be quoting Tom Paine[4] with relish, or while a youth who had just been converted to Catholicism was asking helplessly: 'But have you ever read *The Grammar of Assent*?'[5] Religious controversies, stories without a moral, denunciations of Sir John Millais[6] as a pot-boiler, talk about the twin gods, Robert Louis Stevenson and Rudyard Kipling, quotations of the opinions of an old soldier on Majuba,[7] the latest Limerick, the sad confession of a shilling lost on a horse – none of these things could ultimately hold the attention of a confirmed knocker-wrencher to such a point that he would forget that here was an opportunity to practise his craft. There is one door that I remember on which the knocker seemed to have withstood the attempts of adepts for years: it hung twisted like a stick of barley-sugar, bent out of all shape and comeliness.

These things were done, however, as a rule, by some casual and alien member of the company. The rest of us needed no such diversions. We asked nothing better than to be in the streets, talking or listening under the lamps, discussing all things under the sun as though we knew about them, happy to be in company, content if the streets in which we walked and talked had gone on into eternity. What we talked about I remember only vaguely, and I suppose it meant about as much or as little as the flutterings of young birds. There is no utility in most of the movements of birds; they fly, for the most part, I fancy, simply in order to keep in motion. A great part of the pleasure of being alive is in that; and it can be had in the streets of a town. Gossip, argument, anecdote – it was all idle

enough, but no idler than nine-tenths of the conversations in which we take part in later life. In later life we confine ourselves in rooms, and invite other people to join us there, only to recover the pleasure we once knew in the purer air of the pavement. The best party is but a kind of promenade, in which we circle in a room instead of hailing one another in the street. I am not sure that it would not be a good thing if the people who give parties, instead of inviting their guests to their houses, appointed a rendezvous on the pavements. How much pleasanter King's Road in Chelsea would be if it became thronged with promenaders every evening like a Paris boulevard! The young and the poor, however, are the only people who nowadays make a wise use of the streets. Compare a street in White-chapel with a street in Mayfair after sunset, and you will see how much Mayfair has given away.

The rich, indeed, are in danger of losing the use of their legs. Were it not for the sports in which they indulge, they would be in even a worse case than they are. They seem at times to realize that the promenade is something not to be parted with lightly, and in Hyde Park on Sunday morning, in the paddock at Ascot, and in other resorts of pleasure, we see them reverting to type and parading as cheerfully as ordinary human beings. They have, for the most part, however, got into an intolerable habit of sitting down. To be overfond of sitting down is a mark of senility, whether in a society or in an individual. Even the promenader wishes to sit down now and then – wishes it so ardently that in the streets of a small town you will sometimes see rows of spikes on many of the window-sills of the houses to keep strangers from sitting on them – but the session is regarded only as a break in the walk, and the ideal aimed at is motion, not rest. I am sure the eminence of Greece in philosophy is largely due to the fact that so many of the Greek philosophers, instead of sitting down, walked back-wards and forwards during their teaching. The modern philosopher is a man in a chair: the Greek philosopher at his greatest was peripatetic. To be peripatetic is to be alive. The Greeks alone understood this.

To sit down, save as an interlude, is to do violence to nature. Great speeches cannot be delivered from a chair. I doubt whether even great business can be transacted in a chair. If you visit the Manchester Cotton Exchange, what most impresses you is the movement hither and thither of a thousand men, perpetually restless as a cloud of gnats. I fancy most of the business of the world is done by men on their feet, not by men in a sitting position. One way, indeed, of getting the better of another man in business is to persuade him to sit down and to walk up and down as you talk to him.

Hence, I do not think that we need pity a small town for having no cinemas or theatres or artificial amusements. Most people resort to indoor amusements only because they are no longer capable of amusing themselves in the natural way – walking up and down and talking in the open air. They are prematurely decrepit, wishing to be passive rather than active, to be spectators, not actors. And, alas! I am one of them. I have now only a limited appetite for the streets. Even in Paris or in Rome I find myself looking for a chair in an outdoor café, and watching the promenaders instead of becoming a living part of the promenade myself. And in London there is not a single street in which I should dream of walking to and fro even for half an hour.

It is a confession of increasing years. I have become addicted to the armchair. It was not thus that Aristotle became a great philosopher.[8]

ARGUING

IF THERE IS ONE THING for which I honour the human race more than for another, it is the way in which it goes on arguing. A visitor from another planet, landing on earth, would be amazed at the extent to which controversy flourishes everywhere except in those ultra-modern countries in which it is forbidden. He would say to himself: 'Why do these people argue so hotly? Those who argue were not converted to their beliefs by reason, so why should they hope to convert others by arguments that would not have convinced themselves? The human being seems to be a person who jumps mystically to conclusions, yet who never loses hope of being able to reason others into the same conclusions.' The fact that, in spite of the obvious truth of this, men go on arguing, is a proof of the unquenchable optimism of the human race.

Consider for a moment. You who are middle-aged must have taken part in thousands of arguments. You argued in the nursery and you won, though your nurse did not admit it. You argued with uncles and aunts, with great-uncles and great-aunts, and thrashed them all without making the slightest impression on them. You argued triumphantly at school without ever converting a schoolfellow. Later, your college rang with your incontrovertible statements on matters religious, political, literary, and metaphysical; and not a single contemporary of the opposite opinion even knew that you had won. In the wide world you continued to fight for the truth like a skilled fencer – in your and other people's homes, in offices, in restaurants, in the streets, perhaps in public-houses. You have been arguing,

say, for forty years, and how many converts have you made? You will be lucky, I think, if you can name three.

I do not mean to make the absurd suggestion that people never change their opinions. I doubt, however, whether they often change them in consequence of an argument. I myself became a socialist in my teens, but I was no more reasoned into it than into smoking. The thing simply happened without my knowing how or why it had happened. Yet no sooner was I mystically converted to a belief in socialism than I began to badger all my friends and acquaintances with arguments that, sound as they were, I should have laughed at a month or two before. In vain did they try not to listen or to turn the subject. To me they were brands to be plucked from the burning by controversy. I plucked my hardest, but how merrily they all continued to burn!

My conversion to nationalism was more rational, but, even so, it was not the result of other people's arguments. I had come to England from the north of Ireland, believing in my simplicity that the English spent their days and nights thinking out plans for the welfare of Ireland – for improving the land system and the education system, and for draining the regions of the Bann and the Barrow. To my surprise, I found that the English were a very practical people who had enough problems of their own to solve without spending sleepless nights over the drainage of the Bann. Most of them seemed to look on the Irish as a pampered people living largely at the expense of the English taxpayer. Finding that they regarded Ireland mainly as a nuisance, I concluded in the course of a few months that it would be better for the country to be governed by people who were, at least, interested in it. That, however, was the beginning, not the end, of my conversion. The conversion became complete only on the day on which I went to see Synge's *Riders to the Sea* at the Royalty Theatre. That, again, was a mystical experience, but, none the less, I immediately set out to try to convert everybody I knew to my opinion by process of argument. My arguments, I may say without vanity, were so convincing that they would have got through the hide of a



afraid of their own past, and are glad to feel that what they say in 1936 is different from the nonsense they talked in 1913. Their opponents do not feel like this, however. They say, 'Just for a handful of silver he left us,' or something of that kind. They say it sometimes with truth, but, whether it is true or not, they say it.

Considering the number of wobblers there are in the world, it is perhaps not surprising that we go on arguing as we do in parliaments and on platforms. A large audience will probably contain at least one or two reasonable men. What particularly astonishes me, however, is that we go on arguing just as hotly in private life – arguing with people who have not the remotest resemblance to reasonable men – people who would not show the faintest sign of wobbling if Socrates[5] and St Thomas Aquinas[6] made a combined and overwhelming assault on them. Again and again I find myself arguing passionately with men who are not open to argument and whom I know I could no more convert by argument than I could turn a stone into butter. They are men, I tell myself, so steeped in illusion that they can believe almost anything so long as it is not quite true. Yet I go on trying, vainly, to outshout them, and to blow down the flag of illusion with a mighty wind of argument. In cold blood I realize that this is very foolish – that, for all the effect my arguments produce, I might as well be the street evangelist whom I once saw preaching salvation with no audience but a lamppost.

No doubt they feel much the same about me. I, too, am not exactly open to argument – at least, not to the only sort of arguments other people seem to be able to think of. Yet who that is of an argumentative disposition has ever given up hope? To the genuinely argumentative man every other human being remains a potential convert while alive. I have known enthusiastic youths who would spend a whole evening trying to convert an octogenarian miser to the moral beauty of socialism. I have heard a Free Trader in a public-house fanatically expounding the case for Free Trade to a tipsy bookmaker who could scarcely pronounce the word 'whiskey'. We are all born

canvassers for our causes, and are all the more deserving of admiration because we go on canvassing without ever turning a vote.

Is controversy entirely useless, then? I do not think so. For one thing, it clears the controversialist's mind and so enables him gradually to become a more lucid exponent of his creed. For another thing, it keeps ideas in the air; and it is by these ideas, not by immediate arguments, that men in the end are mystically converted, or, if you prefer the word, infected. Finally, controversy is a very good sport. It is because it is a good sport that I wish a referee had been present in my house on Sunday night to decide who won in the great welterweight argument between Paddy Freeman and Al Communismo.

THE DRAW

ONCE MORE the great prize has eluded me. Once more the draw for the Irish Sweep has taken place and the result has been as before. Nearly two million pounds has been allotted to all kinds of deserving and undeserving people, but not a groat to me. Which of us are the more enviable, I wonder, the winners or the losers? I have often read letters in the press on the demoralizing effect of sweepstakes, and I have tried to come to a decision as to whether it is more demoralizing to win £30,000 or to lose ten shillings. All I am sure of is that it is not very demoralizing to lose ten shillings. Life goes on as usual. The sky has not fallen. It may be that it is better to have loved money and lost it than never to have loved money at all.

As the sweepstake has recently been under discussion in Parliament, with the blood of the peerage boiling at the iniquity of gambling in any part of the British Commonwealth except England or Tasmania, I was glad to take advantage of an opportunity to go over to Dublin and see the draw which was causing so much distress among the dukes. As one approached the Irish shore, the whole island was bathed in the innocence of sunshine. It was as lovely as an island seen in the West in a dream. When I arrived in the city and went out for a walk round Stephen's Green, birds were singing above children at play, and the world was in flower in the still evening. Could it be that a serpent was lurking somewhere in this green and gold paradise? Was that young father, as he pushed his infant son along past the ducks in a go-cart, dreaming the poisonous dreams of avarice? I cannot say. I saw only the surface of things, and no serpent was visible to the naked eye.

The next day was the Sabbath, and through the gentle Sabbath sunshine I went out to Croke Park to see a hurling match between Dublin and Limerick. How charming the teams looked in the brilliant green of Limerick and the brilliant blue of Dublin! A pipers' band came out, dressed in green kilts and with flowing saffron robes, many of the pipers wearing feathers in their caps. They marched round the field, followed by the teams, the players walking two by two, as in the march on to the Ark, a green-shirted man beside a blue-shirted man, each carrying a hurley, the weapon used in the game. As the procession marched round the field over the green grass to the accompaniment of ancient, warlike airs, one could not help regretting that no Irish painter had ever arisen to perpetuate on canvas the colours of the hurling field as Degas[1] perpetuated the colours of the racecourse and the ballet. Beside the leader of the band marched a midget boy in the pride of green kilt and saffron, stretching his legs into impossible strides in order to keep in step with heroes. How vast and determined was his stride as the pipers burst out into 'The Bold Fenian Men'! Then the pipers ceased and the police band played 'The Soldiers' Song', and the game began.

I do not know the rules of hurling, but, as a moral equivalent to war, it seems to me to be about the only rival to Rugby football. It is said to be the original form of hockey: some people have described it as hockey without rules. It is rather like a mixture of hockey and lacrosse. Hurleys, as the clubs are called, rise into the air like weapons of war, and the player is allowed to do almost anything he likes with his hurley except deliberately hit a player on the other side. The unaccustomed spectator cannot but feel apprehensive as he sees the players wielding their weapons among the skulls and limbs of their opponents, lest some mortal injury may result. Hurleys meet in the air with a wild crashing of wood: one of them is broken into two pieces, and small boys rush on to the field in a struggle to retrieve a broken blade as a memento. The rate of stick-smashing was so rapid that I was reminded of a game I once played as a boy when we smashed the entire set of a

respectable householder's croquet mallets in a game resembling hurling on a lawn. The casualties to sticks certainly went into double figures. The casualties to players were less numerous, but the ambulance men must have been on the field seven or eight times, and I could not help feeling glad that there were no international hurling matches. Imagine a game of hurling played between France and Scotland. Yet, after all, only one of the injured players had to leave the field. Possibly even hurling is not so dangerous as it looks.

It is certainly a swift and beautiful game, calling into play all the skill of eye and hand and foot. To see a good player catching the ball on his hand amid a mob of stick-whirling opponents and striking it through the air half-way up the field into the goal-mouth is an experience worth crossing the Irish Sea to enjoy. On the whole, the Limerick men seemed to be about a quarter of a second faster than the Dublin men in everything they did, and it looked at half-time as if they were certain to run through them. There was a Dublin back, however, who played like a demi-god, and who was always a quarter of a second faster than any Limerick man who was near him. Even when a game is one-sided, an invincible player can keep it exciting to the end. Knowing nothing about the game, I do not know whether it was a good match or not; but it was a good match for me. As I left the ground a friend who was with me said: 'After this, I don't think you need feel nervous about going to a bull-fight.'

One curious thing about the spectacle of physical prowess such as this is that it makes one forget all about money. While I was watching the game, and for a considerable time afterwards, the ten shillings that I had invested in the sweepstake was less than the dust beneath your taxi wheels.

Even the next morning, when I set out to see the draw in the Plaza, I felt curiously indifferent to the fate of the ten shillings. I had always felt a little nervous of being present at the draw. What would happen, I asked myself, if I heard my pseudonym announced as having drawn the favourite? I have never swooned in public, but should I not swoon if I suddenly

found myself named in the presence of the multitude as the potential possessor of £30,000? A poor man could do a lot with £30,000. He could vegetate for the rest of his life, and who except the saints does not long to be able to afford to vegetate? There is much to be said, after one has passed middle age, for the life of a vegetable.

I confess, however, when I arrived at the Plaza, I ceased to care whether I won £30,000 or not. The atmosphere was too unreal, too like an enchanted Elstree.[2] Fierce lights blazed down upon us from all parts of the hall, turning us into film supers. The monstrous blue-and-white drum on the stage that held all our counterfoils was painted in the image of a river flowing under a bridge on which stood a sweep with his broom and various national characters. Round the walls were pictures by Mr Keating,[3] retelling the great treasure stories of the world, from 'Ali Baba' to 'Treasure Island'. Above the stage was the inscription, 'The World's Greatest Treasure Story – the Irish Sweep'. A band in the gallery played Irish airs, and hundreds of girls in every kind of treasure-story costume filled the central aisle and ranged themselves like a chorus across the stage. The Lord Mayor[4] in his robes, Colonel Broy[5] (the head of the police) and Lord Powerscourt[6] marched through the cinema scene to the platform. Hospital nurses took their places beside the drum. A very small glass drum was brought out, containing the names of the horses. Auditors, linguists, messenger-boys, telegraphists, men in medieval costumes, helped to crowd the scene. We had speeches telling us how the sweep had helped Irish employment, English trade and the hospitals; and how it had sent £11,000,000 to England in prize-money; and then the drum began to revolve with a noise.

Six nurses, their arms bare beyond the elbow, sitting sideways to it, rose from their chairs as it stopped. Six portholes were opened in the side of the drum. Each nurse put her hand into a porthole, drew out a counterfoil and held it high above her head, as though announcing to the world that in this business there was no chance of conjuring tricks. Colonel Broy stepped across the stage and took the counterfoils from the hands of the

six nurses and then delivered them to the clerk's table. The little glass drum was revolved, and out of this a nurse took out the name of a horse. Mr O'Sheehan, the secretary and announcer, read the name of the horse and of the pseudonyms on the six counterfoils that had been drawn – 'About Time', 'Luck at Last', 'White Cat', and so forth; and when an Irish address was announced, a crowded hall cheered loudly. There must also have been some Somersetshire people present, for there was an unexpected ovation when the name and address of a Somersetshire man were read out.

So all day long the noise of drawing rolled, with the floor of the building shaking under the feet of the innumerable messenger-boys who hurried with typed lists of the winners to the Press and the telegraphists. One became hypnotized as the stream of luck flowed on under the heat of the lamps. But the audience never tired. The plot of the play they were witnessing was not particularly coherent, but it was a transformation scene for a great number of eager human beings. It was a dazzling costume-play of hope, admirably staged. If there is anything much more innocent than this in this far from innocent world, I do not know it. But then, I was brought up in an age which looked on it as a virtue not as a vice to live in obedience to the precept: 'If you don't at first succeed, try, try, try again.'

AUNTS

I HAVE HAD a charming letter from a lady reproaching me because recently, in making a list of classes of human beings whom everybody agrees to make fun of, I omitted to mention the long-suffering class to which she herself belongs.

'Why,' she asks me, 'when writing of the caricatured, did you leave out the most universal and innocent victim of odious jokes – I mean aunts? A peer can drop his title, like B. R., a workman drop his job and go on the dole; but we – what can we do? If you are a parent or a husband, it is your own fault, but surely no one is an aunt by choice. . . . Every week we are represented in pictures and print as either silly old sentimental noodles, afraid to cross the street with our dogs and cats, or detestable, cross killjoys, giving or getting mean and incongruous presents and paying unwished for and uninvited visits. Why, indeed, should we be all Aunt Sallies, just to be thrown insults at? Why Aunt, not Mother or Mrs or Lady, Sally? For my own part, I have little to complain of. The numerous clan to whom I am aunt treat me with civil indifference – some even go so far as to appear to regard me as one of themselves – of course, the greatest of compliments. When rather puffed up with this condescension, I remember that being easily taken in is the mark of all my tribe and debunk myself.'

When I read this, my first impulse was to make a collection of all the nice things that have been written about aunts and to send them to the lady for her consolation. For this purpose I took down Sir Gurney Benham's[1] *Book of Quotations* and opened it at the index. My eye fell on a column of references to

'Angels'. 'Ah,' I thought, 'if there are all these references to angels, there must be still more references to those angels in human form – aunts.' What was my astonishment on turning to the word 'Aunt' to find that there were only two references to aunts in the whole dictionary. One of them ran: 'If my aunt had been a man, she'd have been my uncle.' The other, apparently a translation of a German proverb, ran: 'If my aunt had wheels, she would be an omnibus.' Neither of these proverbs can be said to be derogatory to aunts, but, on the other hand, neither of them is a compliment of the kind of which I was in search.

I then turned to the index of the *Encyclopaedia Britannica*. Alas, the only aunt who gets a section to herself in the *Encyclopaedia* is Aunt Sally: 'a grotesque female figure' with a pipe stuck in her mouth or her forehead – as like a real aunt as I to Hercules. There is one other aunt mentioned in the index – the Aunt Judy of *Aunt Judy's Magazine*, a children's magazine edited by Mrs Gatty.[2] 'Aunt Judy', we are told, 'was the nickname given by her daughter, Juliana Horatia Ewing.'[3] One cannot help wondering whether it was the young Juliana's retort discourteous to the names that had been given to herself in baptism.

Have aunts, then, never been estimated at their true worth? Has the truth never been told about them in print? I have a chaotic memory for literature, and it may be that there have been more famous eulogies of aunts than I can remember. I can remember but two. First, there is that splendid Aunt Jobiska[4] who looked after the welfare of the Pobble Who Had No Toes – who gave him lavender water tinged with pink, and who 'made him a feast, at his earnest wish, of eggs and buttercups fried with fish', combining the virtues of a good nurse and a fairy godmother. Equally perceptive as a tribute to auntship are Robert Louis Stevenson's lines, *To Auntie*:

> *Chief of my aunts* – not only I
> But all your dozen of nurslings cry -
> *What did the other children do?*
> *And what were childhood, wanting you?*

266 · ROBERT LYND

That, it seems to me, is the way in which every nephew should address his aunt. Yet you would imagine from their writings that most men of letters had never had such a relation.

Even Lamb, despite his profoundly affectionate nature, never quite understood the essential golden-heartedness of aunts. He begins well: 'I had an aunt, a dear and a good one,' but he goes on disappointingly: 'She was one whom single blessedness had soured to the world.' His Aunt Sarah cuts a rather grotesque figure as she irritates Mr Billett[5] at table by pressing a second helping of pudding on him in the sentence: 'Do take another slice, Mr Billett, for you do not get pudding every day.' 'The old gentleman', writes Lamb, 'said nothing at the time – but he took occasion in the course of the evening, when some argument had intervened between them, to utter with an emphasis which chilled the company, and which chills me now as I write it – "Woman, you are superannuated."' Had Lamb been a more loyal nephew, he would have drawn a veil over a scene in which his aunt met merely with insult and humiliation as a reward for her reckless hospitality with the pudding.

Outside literature, I am sure, most of us are devoted to our aunts. I have never met one of those Gorgon aunts whom Mr P. G. Wodehouse has invented for the chastisement of Bertie Wooster and Ukridge. Some of my earliest memories are of going down into the country and being met at the railway station by an aunt of the angelic order who drove me to my grandfather's farm. How delighted she seemed to see me! How expertly she held the reins! What an entrancing world she seemed to live in as she talked! How beautiful sounded her laughter! And, at the door of the farmhouse, another aunt was waiting to greet us, making us feel with her welcome that we had arrived at the capital of earthly bliss. The tea that followed increased, if possible, the illusion of being in paradise. To be young among three kinds of jam, four kinds of baked bread, and all manner of cakes, including slim-cake, was certainly something approaching very heaven. It is one of the great virtues of aunts that they have no scruples about encouraging one to overeat at an age at which one is able to overeat. How

often have I felt like a purring cat at the sound of those blessed words: 'You're eating nothing, Y,'[6] and gone on valiantly with another farl of hot and delicious bakery trebly fortified with home-made strawberry jam!

Nor did this lavish hospitality cease with tea. Before going to bed, those treasures from tins – animal biscuits and letter biscuits – appeared on the table with milk that even a town child could realize was, unlike most milk, something to store in a gourmet's memory; and, if I ate through the entire Noah's Ark and the alphabet, there was none to say me nay. I shall always associate aunts with animal biscuits and letter biscuits. What finer compliment could we pay any one than that?

There is something in the relationship between aunts and their nephews and nieces that is quite unlike any other. In the company of their aunts, nephews and nieces know that they are privileged persons. The bonds of duty are somehow relaxed: they have no obligations but to be happy. They have, in the country, the freedom of the farmyard and the freedom of the fields, which is considerably nearer heaven than the freedom of the streets or the freedom of a town garden. They are permitted to feed hens and to collect eggs, and to ride horses to the drinking-pond, and to talk on equal terms with those mighty men, farm labourers. I never knew an aunt to interfere with my happiness except on Sunday, when it was generally thought to be a sin to go into the fruit garden and eat gooseberries. It was in accordance with the Ten Commandments to eat gooseberries from a dish in the house but not to eat them from a bush. Even then, when in a state of revolt I would entangle one of my aunts in a theological argument at the tea-table and counter her appeal to the name of John Knox[7] with the passionate declaration: 'John Knox was a scoundrel,' she would turn aside my blasphemy with angelic forgiveness and tell me a fascinating, if harrowing, story about the death of Voltaire.[8] I knew nothing about either Knox or Voltaire, but I resented not being able to go out to the gooseberries. Ungracious boy! Had I forgotten that that very afternoon I had been given a shilling for learning by heart the rhymed version of the shortest of the Psalms?

Looking back, I can see that there is nothing but good to be said of aunts. They have at once the intimacy of relations and the charm of strangers. They are grown up and yet without authority. They are perfect conversationalists. And they give animal biscuits to their nephews.

Why men took to jeering at them I cannot imagine. I think it can be explained only by the innate and cynical anti-feminism of most of our sex. As for myself, I would rather have missed St Peter's and the Louvre and the Prado and the Pavilion at Brighton than the noble and two-shilling-bit-giving galaxy of my aunts. I suspect I must be one of Nature's nephews.

RAILWAY STATIONS I HAVE LOVED

TURNING THE KNOB of the wireless set, I paused at Athlone[1] on hearing it announced that they were about to broadcast the arrival of the last mail-train at Broadstone Station,[2] in Dublin, before the station was closed for ever.

I had myself no sentimental recollections of Broadstone Station. I remembered it mainly as a station which the trains left at an unreasonably early hour in the morning. One left one's bedroom half-awake and one's hotel half-breakfasted and drove for what seemed miles through the chill morning air behind a horse that seemed even more anxious than oneself – unnervingly anxious, indeed – to reach the station in time for the train. At the station itself I never cast a glance; there was no time for anything except to clamber into one's seat. The first time I did so I found myself in a compartment with a middle-aged woman who, as soon as the train moved, produced a spirit-stove, set it on the floor and lit it, and began to boil a kettle to make herself a cup of tea. She had little paper packages of all kinds, containing bread, butter, tea, sugar, and a medicine bottle filled with milk, and, as in her fussiness she kept constantly dropping paper within inches of the flame, I felt reasonably confident that she would end by setting the train on fire. As she picked the paper up, her skirt would catch the kettle and all but overturn both kettle and spirit-stove, and I began to feel more than reasonably confident that both she and I would in the not far distant future be reduced to ashes. The very motion of the train, which every now and then gave a vicious wobble that compelled her to keep the kettle and the

stove steady by main force, increased my confidence. Never
have I known a small kettle take so long to boil. Never have I
so longed to hear the first faint note of a kettle beginning to
sing. If I could have sung myself I should have felt like joining
in the singing. How good it was at last to see the kettle boiling,
the tea wet, and the woman enjoying a cup of it. She did not
enjoy her cup of tea, however, half so much as I did.

The last time I travelled from Broadstone Station the journey
was even less serene. At Athenry a number of policemen with
rifles boarded the train, and the engine-driver, as the custom
was in those revolutionary days, refused to budge an inch
farther unless the policemen got out. The policemen lay back
in their seats, laughing and smoking. Under the orders of the
local Volunteers, the engine was then uncoupled from the rest
of the train, and drove off by itself into the distance, hooting
defiance. The police sat on; the rest of us got out, wondering
what chance there was of ever reaching Galway. As the police
remained perfectly, and not surprisingly, obstinate, the Volun-
teers then set about commandeering all the motor vehicles in
the town, however ancient, and putting them at our service
without payment. I myself was one of the last to leave, and had
to be content with a place on what must have been a springless
milk lorry put together by a mad amateur in the first days of
motor-building. As I took my place in it, I almost envied the
police, marooned in their comfortable seats in the engineless
train. As the lorry bumped westward, making those who were
standing perform a St Vitus's dance and those who were sitting
feel that at any moment they might be shot skywards from
their seats by the bucking motion of the lorry on the uneven
road, most of us must have felt that the police had the laugh of
us. I confess that in some ways I was enjoying myself because
of the novelty of the thing, but there were moments – volcanic,
bone-shaking moments – at which I had no kindly thoughts of
Broadstone Station for having set me forth on such a journey.

And yet how tenderly everybody spoke of it during the
broadcast! How haunted with memories of happiness it seemed!
Old servants of the railway company came into the signal-box

from which the broadcast was given and spoke of the closing of the station as if for them it was the end of a world. Never again would the Galway mail arrive there in its midnight glory. Never again would a signalman give the signal that all was clear. A banquet-hall deserted – Broadstone Station would henceforth be only that to thousands for whom it had for long been associated with happiness – the happiness of the day's work, the happiness of companionship, the happiness of simply being alive on a fine day. There was a note of exile in the voices of the old railway servants who came to the microphone to say good-bye to the station. 'How do you feel about it?' an old ex-signalman of eighty was asked. 'Very sad,' he said, and he could say little more. They all felt very sad; a glory had departed from their earth. Then came the great moment when for the last time on this side of paradise the Galway mail was signalled into Broadstone Station. A hush fell. We heard the rumble of the approaching train. 'There she goes,' cried the announcer; and we could almost see the lights in the carriages as she passed. Then there were more valedictory speeches, concluding with one from an official who addressed the station in the noble apostrophe: 'Farewell, a long farewell, to all thy greatness.' At that moment it was difficult not to feel that one of the world's lights had gone out.

Moved by the occasion, I could not help wondering whether I myself could be stirred by sentiment so profound over the closing of any existing railway station. Euston has often been for me the scene of a jail-delivery into happiness – via Holyhead, via Liverpool, and via Fleetwood – but Euston itself by its very appearance seemed to be a part of the jail. A gloomy-fronted station with a particular fondness for making the holiday-maker set out from platform thirteen. And, if Euston cannot win the heart, what about King's Cross, what about Liverpool Street? Is it conceivable that, if one of these joyless stations were closed, any sane human being would give expression to a bleeding heart in the words: 'Farewell, a long farewell, to all thy greatness'? I doubt it. If Charing Cross Station were moved south of the Thames, it would not cost me a pang. I should not

· ROBERT LYND

care if Marylebone Station were turned into a cinema. I have no
sentiment about any station in London, except Matthew
Arnold's Fenchurch Street.

I fancy that the only stations I could ever really love were
small stations – not these roofed-in affairs smelling of some
strange and unpleasant drug, but little stations open to the sun
and rain – wayside stations or termini that look like wayside
stations. I certainly felt a twinge of sorrow when the old
Portrush Station was destroyed to make room for a roofed
building like any other important terminus. When I knew it
first, it was bathed in sea air, with the sea excitingly visible
from the platform. The engine and the engine-driver, as one
walked down the platform, were a part of nature. Now every-
thing is mechanical, hidden from the eye of day. Nor was
Portrush Station in those days the only beautiful station on the
line. Every station at which we stopped was beautiful. How
enviable the people who got out at Cullybackey seemed! How
enviable the country people on the platform! It is one of the
curiosities of railways that if you are in the train, the people on
the platform seem to be leading extraordinarily interesting lives,
and, if you are on the platform, the people in the train seem to
be leading extraordinarily interesting lives. It is much the same
with harbours: if you are on the boat, the people remaining
behind look enviable, and if you are on the quay, the people
who are on the boat seem enviable. That is one reason why the
young used to frequent railway stations and quays when
everybody was admitted freely. They were suffering from – or
enriched by – a Ulysses complex. They were enjoying travel
by proxy – which is a much better way of enjoying travel than
many pleasure cruisers realize till the pleasure cruise begins.

Ruskin would surely have been surprised if he had been told
that a time would come when railway stations, like lakes and
mountains, would become a part of the imaginative life of men,
and when the sounding express engine no less than the
sounding cataract would rouse in them a noble delight. He
would have been still more surprised if he had been told that
the closing of an old railway station would one day move men

to sadness no less than the demolition of a Gothic church or the violation of a landscape. Yet how natural it is! Life is brief, and the removal of a long-tolerated equally with a long-loved landmark alters and injures the world in which we have been happier than we have deserved to be. There are, I am sure, cricket enthusiasts who would mourn over the disappearance of the eyesore gasometer overlooking Kennington Oval.[3] They have got used to it, and under its shadow many a boundary has been scored by Abel and Hobbs.[4] 'Farewell, a long farewell, to all thy greatness' – so they might well apostrophize its ruins. If you have tears to shed, then, spare a few of them for Broadstone Station. Without it – for better or for worse – Dublin will never be the same again.

SPADE AND BUCKET

I HAD A LETTER the other day about one of my grand-nieces,[1] not yet three years old, who had just paid her first visit to the seaside. 'Lucy', it said, 'took a day or two to get used to the feel of sand under her feet, so did not paddle at first, as she refused to take off her sandals. But now she loves it, writes A's and T's and some of the letters with her toes (quite good for not quite three) and paddles, not only in the pools, but in the whole sea. As I couldn't get her a spade and bucket, she had a wooden spoon and patty-pans, so was able to do some very genuine cooking in the sand, even washing her sultanas (small stones) before putting them into her puddings. After picking up shells and then trying to pick the limpets off the rocks, she said they were "rather stuck".'

This was the first news I had heard of a shortage of spades and buckets, but, as life always moves, not chaotically, but in a pattern, I was not surprised when, opening the *Daily Mirror* on the next day, I came on a news story, headed: 'Seaside Ramp in Buckets and Spades', and learned that 'the shortage of children's seaside spades and buckets has led to a ramp in wooden spoons, cake tins, and enamel pudding basins, which the children are using as substitutes'. 'Shopkeepers, at some holiday towns,' the article went on, 'are now charging 1s. 6d. for spoons which a few weeks ago cost a maximum of 9½d. Cake tins and pudding basins have rocketed from 1s. 3d. to 2s. 6d. In some cases the traders have tried to justify the prices by sawing the round ends off the bowls of the spoons and advertising them as "utility spades". Cake tins have holes drilled in

the tops and wide handles of string or wire fitted, converting them into "buckets".'

Some people, reading this, might see in it a condemnation of the capitalist system; but to me it merely caused a pang – not a very serious one – at the thought that the long arm of austerity had reached out to obliterate even the toy spade and bucket – those essentials of a child's holiday at the summer seaside. For essentials they were to the younger inhabitants of that now ruined paradise – the age of Queen Victoria. (Not so much of a paradise for everybody, perhaps, but a paradise for those whose parents were unpoor enough to take them to the seaside.) I doubt whether the parents of any previous era ever had the charming notion of taking their broods annually to dig beside the sea. There is no word of an annual migration from ancient Babylon to a neighbouring Margate. There must have been many good fathers in Greece and Rome, but I do not think – I speak under correction – that classical literature contains a single reference to a child's spade and bucket. The sea-dogs of Elizabethan England went to sea themselves, but they never, so far as I know, played with their children on the sands, though many of them were Devonshire men. Even when Englishmen discovered the seaside as a pleasure resort, they seem for a long time to have regarded such places as Margate as watering-places merely for adults – salt-water spas comparable to Bath and Tunbridge Wells rather than to the Walton-on-the-Naze that we know today.

The name of the man who first took his children to the seaside is lost to us in the mists of antiquity. The name of the man who, having taken his children to the seaside, first thought of providing each of them with a spade and bucket is equally forgotten. Yet he was a great inventor – a greater contributor to human happiness, probably, even than the man who invented the aeroplane. Who that was lucky enough to be born in the golden age – when dates cost a halfpenny for a quarter of a pound and many people could not afford the halfpenny – can ever recall his childhood at its most golden except as a spade-and-bucket childhood? To arrive at Portrush, to be led by the

hand along Main Street – I think Miss Rose Macaulay[2] once raised the question whether Ireland is the only country among these islands where Main Streets are common – to the toy shop with its cornucopia of little sailing boats, shrimp nets, fishing rods, pencils looking through the end of which you could see a picture of Dunluce Castle,[3] mugs bearing an inscription in gold letters: 'A Present from Portrush' or 'A Present for a Good Boy', dolls, photographs, penknives, and everything that the soul of man in the tadpole stage could desire – above all, spades and buckets, iron spades and wooden spades, blue buckets, red buckets, and green. In Mr Priestley's[4] play *They Came to a City*, some of the visitors to the ideal city are disappointed and repelled. No child was ever disappointed in Portrush as he received his first spade and bucket from the hands of the man in the toy shop. He knew – even if only subconsciously – that he was in heaven. With a shrimp net and a sailing boat (price 4d.) added, he knew that he was in the seventh heaven.

How charming, then, was the descent to the sands. There are three stretches of sand in Portrush – the White Strand, the Black Strand, and the Ladies' Strand. As Mr Shaw's Androcles[5] would have done, I frequented in those days the Ladies' Strand. There ladies, waterlogged in extraordinary heavy blue costumes that seemed more suitable for keeping an Arctic explorer warm than for enabling a lady to enjoy a swim, bobbed up and down a few feet out during the best part of the day, as clamorous as sea-gulls. We paid little attention to them, however. We were intent on our own pleasures. To fill a bucket slowly with sand, to turn the bucket upside down and, removing it, to see a castle built, as it were, with one's own hands – it was to feel for the first time the joy of artistic creation. One was not content with one's first efforts, however. The restless spirit of creation grew, as one advanced from a small size of spade to a larger, until at last one was old enough to possess an iron spade. How furiously we would then dig, throwing up a round wall of sand around our deepening dwelling, hollowing a moat outside it, and digging a channel along which the incoming tide could pour into the moat! We

knew that the sea would make short work of our hard-won architecture; but we welcomed the destruction and prepared the way for it. The more the salt water poured along the channel into the moat, the more it seemed for us a personal triumph. As our Atlantis succumbed before the advancing ocean, we felt no grief but only happiness. Being optimists, we knew that we could and should rebuild Atlantis[6] another day.

Not that we spent all our time with spades and buckets. There was also the pleasure of paddling or, as we called it, wading. To wander along the edge of the ocean in bare feet and to feel the crisp crystal wavelets breaking coolly over one's ankles is a luxury that still gives pleasure in the memory, even though – for some obscure reason – we never think of paddling in later life. The sea delights at least four of our senses – touch, smell, sight, and hearing. Of how few of the things that came into existence in the first chapter of Genesis can we say as much! I could sit for hours in those days watching other people diving into the sea and swimming among the billows – great men who, despising the spring board at the Blue Pool,[7] would climb up to a high ledge among the rocks and precipitate themselves as if to death or glory into the deep water.

From the shore-child's point of view there is nothing about the sea that is not lovely and lovable. The wildest storm-breakers pouring in from Greenland and tossing manes of foam into the air, filled with a hundred rainbows in the fitful sunshine, exhilarated the blood, even though one had heard of some poor wretch who, bathing in the bay against all advice the day before, had been carried out to sea like a piece of sea-wrack. The noise of a crane unloading a ship in the harbour was music. The very smell of the coal on the harbour side was (being a seaside smell) sweeter than the scent of a flower garden. Seaside bread – baps and the rest of it – and seaside plum-tarts were ambrosia. Seaside tea was nectar.

I trust that my grand-niece has by now been initiated into some of these essentials of perfect happiness. I confess, however, that I feel some misgivings when I think of her, deprived of spade and bucket, going down to the sands with a

wooden spoon and patty-pans. Someone, it seems to me, ought to do something about it. Spades and buckets can hardly be accounted luxuries. As a child at the seaside, I should have preferred a spade and bucket to black-currant juice. And, after all, let us consider the educational value of a spade and bucket. I for one learned more from digging in the sands with a spade and bucket than I ever learned from algebra.

NOTES AND REFERENCES

PART ONE IRELAND AND HER AUTHORS

1 The Orange Idealist (*Irish and English*, 1908)

1. Slaughter of French Huguenots on 24 August 1572 at the instigation of Catherine de Medici (1519-89), regent of her son, Charles IX of France. Of special interest to Lynd as he was of Huguenot extraction.
2. Carthaginian general (247-152 BC) who threatened Rome after a brilliant crossing of the Alps but was finally beaten by the 'Fabian' tactics of Quintus Fabius Maximus, 'The Delayer'.
3. Now a popular shopping street but still as then a symbol of Orange 'No Surrender'. It lay on the route between Lynd's boyhood home and his school 'Inst'.
4. Russian city, prime military target of the Crimean War. It was besieged by a total of 65,000 troops for nearly a year from September 1854.

2 Hibernia Rediviva (*Irish and English*, 1908)

1. Tír Eoghain (lit. translation).
2. Dulse is a very tasty, edible seaweed (Ir. *duileasg*), 'yellow man' a lethal sweet rock. Both are traditionally associated with the annual Lammas Fair in Ballycastle, Co. Antrim.
3. Erected in 1860 by eccentric philanthropist John Cary (1800-91), now demolished. A Fountain of Liberty can still be seen outside the village.
4. Henry (1746-1820), Leader of the Irish Parliament (1793-1800) to which he gave his name, strongest opponent of the Act of Union.
5. Richard (1804-65), English MP, apostle of Free Trade and strong opponent of the Corn Laws.
6. Tadeusz Andrey (1746-1817), Polish patriot who led a revolution against Russia in 1793.

3 Galway of the Races (*Rambles in Ireland*, 1912)

1. George Chapman (*c*. 1560-1634), English poet and dramatist, now mainly known for his translation of Homer (1611-15) which inspired Keats's most famous sonnet, 'On First Looking into Chapman's Homer'.
2. William Makepeace (1811-63), English novelist and journalist, author of *Henry Esmond* (1852) and *Vanity Fair* (1848-50). The description comes from *The Irish Sketchbook* (1843).

3. Samuel Carter (1800-89) and Anna Maria Fielding (1800-81), journalists and editors, joint authors of *Ireland, Its Scenery, Character, Etc.* (1841-3).
4. Alice Stopford (1847-1929), daughter of Archdeacon Stopford, married John Richard Green in 1877. Strong nationalist, friend of Lynd and with him active agitator for Roger Casement's reprieve in 1916. *The Making of Ireland and its Undoing* was published in 1908 and violently attacked by English reviewers because of its supposed inaccuracy.
5. The story is told in the Halls' book (op. cit.), Vol. III.
6. Writer (1814-87) of melodramatic novels, famous as the author of *East Lynne* (1861).
7. Russian cavalry, noted for their horsemanship and intermittent cruelty, who received extra grants of land in return for twenty years of army service.
8. Fairground game in which balls were thrown at the wooden figure of a woman's head, the object being to break the pipe stuck in the figure's mouth.

4 James Connolly: An Appreciation (Introduction to *Labour in Irish History*, October 1916)

1. James Connolly (1868-1916), revolutionary socialist.
2. Young Irelander (1807-49), deeply interested in agrarian reform and active agitator in spite of poor health. He was editor of *The Irish Felon*.
3. Founder (1816-1903), with Davis and Dillon, of *The Nation* (1842) and historian of the Young Ireland movement. His knighthood was granted in 1873 when he was Prime Minister of Victoria, Australia.
4. Standish James O'Grady (1846-1928), not to be confused with his cousin Standish Hayes O'Grady, the Gaelic scholar, historian and novelist. Called the father of the Irish Literary Revival.
5. John (1815-75), assistant editor of Gavan Duffy's *Nation* and author of *Jail Journal* (1854). Sentenced in 1848 to fourteen years' transportation to Van Diemen's Land (Tasmania) for treason-felony, he escaped to America and became a vigorous supporter of the Confederacy in the American Civil War.
6. American economist (1839-97), author of *Our Land and Land Policy* (1887) and *Progress and Poverty* (1879).
7. Battles in the American War of Independence (1775-82).
8. Labour leader (1876-1947), famous for his ITGWU agitation which led to the lock-out of 1913.
9. *Nom de plume* of George Russell (1867-1935), writer, painter, economist and mystic, and one of the leading figures of the Irish Literary Revival.
10. St John Brodrick (1856-1942), leader of Southern unionists who advocated repression of the IRB and afterwards helped negotiate the Truce in 1921.

11. From Edward Henry, First Baron Carson (1854-1935), organizer of the Ulster Volunteers in opposition to Home Rule.
12. From William Martin Murphy (1844-1919), founder of Independent Newspapers and leader of the employers in the 1913 lock-out.
13. Called now by historians the Curragh Incident, since it was not strictly a mutiny. In 1914 fifty-seven officers of the cavalry in the Curragh Camp under General Gough announced they would prefer dismissal if ordered north to quell Protestant agitation against the Home Rule Bill.
14. Labour activist and journalist (1878-1916), brother-in-law of Tom Kettle (see notes below), who though having taken no part in the Easter Rising was arrested and shot by Captain Bowen Colthurst in Portobello Barracks.
15. Irish agricultural reformer (1854-1922), founder of the Irish Agricultural Organization Society, which brought the Co-operative Movement to Ireland.
16. See note 4, p.280 ('Galway of the Races').
17. Poet (1862-1903), born in Malta of Scottish parents. Most of his verse was written for the *Sydney Bulletin* of which he was a staff-writer. He committed suicide because of an incurable lung complaint.
18. Seán MacDiarmada (1884-1916), one of the signatories of the 1916 Proclamation and earlier, like Lynd, a member of Bulmer Hobson's Dungannon Club.

5 The Work of T. M. Kettle (*Old and New Masters*, 1919)

1. Thomas Michael Kettle (1880-1916), MP, essayist and nationalist. A friend of Lynd and shocked, like him, by the Easter Rising which 'spoiled his dream of a free united Ireland in a free Europe'. He was killed at Ginchy during the battle of the Somme in September 1916.
2. English evolutionary philosopher (1820-1903).
3. François Marie (1772-1837), French social theorist.
4. Prince Peter (1842-1921), Russian savant and revolutionary, he returned to Russia after the October Revolution in 1917 having spent many years in exile.
5. Pseudonym of Anatole François Thibault (1844-1924), French writer.
6. Collection of Kettle's writings published 1918.
7. Auguste, Comte de (1838-89), French Catholic aristocrat, founder of the Symbolist movement and writer of macabre tales.
8. The letter was written on 2 September 1916. The rest of the sentence reads, 'my poor wife has broken down'.

6 Arthur Griffith: The Patriot (*Both Sides of the Road*, 1934)

1. Arthur Griffith (1872-1922), founder of Sinn Féin (1905) and first President of the Dáil.

2. *The United Irishman* ceased publication in 1906 after a libel action.
3. That which established Grattan's Parliament.
4. See note 5, p.280 ('James Connolly: An Appreciation').

7 G. B. S. as Idol (*Books and Writers*, 1952)

1. Alexander (1861-1948), journalist, founder of the *Clarion* (1891), author of *Dangle's Mixture*, etc.
2. British statesman (1836-1930), founder of the Liberal Unionist Party and anti-Home Ruler.
3. John Vedrenne (1867-1930), English theatre manager best known for his collaboration with Harley Granville-Barker (1877-1946), during their management of the Court Theatre from 1904 to 1907. Barker was also an actor and playwright and sensitive writer on the plays of Shakespeare.
4. Sidney James, Baron Passfield (1859-1946), and Beatrice *née* Potter (1858-1943), English social reformers, Fabians and founders of the *New Statesman* (1913) to which Lynd contributed his weekly essay as 'YY'.
5. Charlotte Payne-Townshend (1857-1943), with whom Shaw had a *mariage blanc*.

8 William Butler Yeats (*Books and Writers*, 1952)

1. Fenian (1830-1907), who after years of imprisonment and exile returned to Dublin in 1885 and gathered a coterie of young writers and artists around him, chief among them Yeats.
2. Irish writer (1852-1933), mordant friend of Yeats and Edward Martyn and co-founder with them of the Irish Literary Theatre, the history of which is wittily and maliciously recorded in his memoir trilogy, *Hail and Farewell* (1911-14).
3. Paul (1844-96), self-consciously dissolute French poet.
4. Henry David (1817-62), American essayist and mystic. His famous book, *Walden* (1854), stimulated Yeats to write the much-anthologized 'The Lake Isle of Innisfree'.
5. The play which inaugurated the Irish Literary Theatre, shown in the Antient Concert Rooms, Brunswick Street, Dublin on 8 May 1899. The orthodox objected to the unpunished sale of a soul to the Devil.
6. Irish Fascist movement founded in 1935 by General Eoin O'Duffy (1892-1944).
7. Irish politician (1848-1916), adversary of Parnell.
8. See 'Arthur Griffith: The Patriot' (p.107).
9. George (1685-1753), Anglican Bishop of Cloyne and philosopher especially interested in theories of perception.
10. *W. B. Yeats, Man and Poet*, Norman Jeffares (1949). The verses are versions of 'The Witch' written in his diary (1910).

9 James Joyce and a New Kind of Fiction (*Books and Writers*, 1952)

1. François (?1494-?1553), French satirist noted for the riotous licence of his work.
2. Kipling's famous school story based upon his own experiences, published 1899.
3. Fictionalized autobiography written in 1851 by George Borrow (1803-81), the great wanderer, Romany-lover and linguist. (Lavengro= philologist in Romany.)
4. John (1628-88), Nonconformist preacher and writer, author of *The Pilgrim's Progress* (1678-84). *Grace Abounding* (1666) is his spiritual autobiography.
5. Published 1934.

10 The Critic as Destroyer (*The Art of Letters*, 1920)

1. Walter (1839-94), essayist and art critic, founder of the Aesthetic Movement and influencer of Oscar Wilde. *Appreciations* was published in 1889.
2. Thomas Babington, Lord Macaulay (1800-59), Whig historian, pungent essayist and writer of fine jogging verse, attacked the religious rhymes of Robert Montgomery in the *Edinburgh Quarterly* (April 1830), with such remarks as: 'His writing bears the same relation to poetry which a Turkey carpet bears to a picture,' and '[his] readers must take such grammar as they can get and be thankful'. Montgomery (1807-55) was a lay preacher and natural son of a circus clown called Gomery.
3. Father of Greek tragedy (*c.* 525-456 BC), seven of whose plays have survived including the famous *Oresteia* trilogy.
4. Victor (1802-85), French novelist and radical, author of *Notre Dame de Paris* (1831) and *Les Misérables* (1862).
5. Notorious hangman and headsman (d. 1686).
6. John (1819-1900), English critic of art, architecture and society.
7. James McNeil (1834-1903), American artist and wit, litigant against Ruskin and painter of his mother as 'An Arrangement in Grey and Black'.
8. 'Nocturne in Black and Gold' (1877), a view of Battersea Bridge.
9. Joseph, First Baron (1827-1912), surgeon, virtual inventor of antisepsis and formulator of the theory of micro-organisms.
10. Charles Montague (1843-1926), travel-writer and poet, author of *Arabia Deserta* (1888) and noted for his self-consciously archaic style.
11. Novelist (1855-1924), famous for her over-romantic style, author of *The Sorrows of Satan* (1895). She spent her last years in Stratford-upon-Avon constituting a rival tourist attraction.

12. Sir Thomas Henry (1853-1931), of Manx extraction, author of a series of wildly popular, lush, melodramatic novels set mainly on the Isle of Man (1887-1913).
13. John (1878-1967), Poet Laureate (1930-67). 'The Everlasting Mercy' (1911), a long poem about sin and redemption, used at times rough and profane language.
14. Real name Mackenzie Compton (1883-1972), novelist, humorist and discographer, author of many novels including *Whisky Galore* (1947). *Sinister Street* (1914-15), a vivid picture of adolescence, is regarded as his finest work.
15. Prolific writer (1866-1946), pioneer of the novel of espionage and diplomatic intrigue, author of over 150 books.
16. Anthologist (1863-1944), novelist (known as 'Q') and first King Edward Professor of English Literature in Cambridge. His novels, set in 'Troy Town', portrayed the village of Fowey in Cornwall.
17. John (1867-1933), novelist and dramatist, author of *The Forsyte Saga* (1906-21).
18. Author (1864-1927) of many detective stories who described himself in *Who's Who* as 'novelist and traveller'.
19. First of the 'saga' published in 1906.
20. Volume of sketches published in 1911.
21. Arthur Christopher (1862-1925), poet and essayist, son of Archbishop of Canterbury, and older brother of novelists E. F. Benson and the Rev. R. H. Benson.
22. See note 7, p.281 ('The Work of T. M. Kettle').
23. See 'Arguing' (p.254).

PART TWO WRITERS AND THEIR TRADE

11 John Donne (*The Art of Letters*, 1920)

1. English poet (1572-1631).
2. Biographer and fisherman (1593-1683), famous for his *Life of Donne* (1640) and *The Compleat Angler* (1655).
3. Italian philosopher and poet (1463-94), noted for his beauty as a young man.
4. The muse of astrology.
5. Greek physician (AD 130-201), first to diagnose by using the pulse.
6. Nicolas (1473-1543), founder of modern astronomy.
7. Dramatist (?1572-1637), inventor of the 'comedy of humours', author of *Volpone* (1610) and *The Alchemist* (1610).
8. Robert Devereux (1566-1601), Earl of, favourite of Elizabeth I, parleyer with Hugh O'Neill and beheaded for treason. Cadiz was captured but the 'Islands Voyage' was a financial failure.

9. Charles Pierre (1821-67), French Symbolist poet, infamous for the sensuality of his imagery.

10. Poem of lesbian passion.

11. Sir Edmund (1849-1928), English critic, famous as the author of *Father and Son* (1907), 'a study of two temperaments'. The Donne biography was written in 1899.

12. Sir Herbert (1866-1960), Professor of English Literature and Rhetoric at Edinburgh (1915-35), editor of Donne's *Poems* (1912).

13. Scholar and physician (1605-82), author of *Religio Medici* (1635) and *Hydrotaphia* (1658), works showing much curious and fantastic knowledge.

14. English poet and courtier (1581-1613), poisoned by Frances Howard, Countess of Essex, and her lover, Robert Carr, Earl of Somerset, because of a slight against her honour. Overbury, having acted as go-between for the liaison, had said that she might do for a mistress but not for a wife. They were found guilty but released from the Tower after some years.

15. Courtier and explorer (1552-1618), favourite of Elizabeth I but not of James I, who after a failed expedition had him executed.

16. US essayist and bibliophile (1865-1946), who lived most of his life in England, a conscious defender of the English language.

17. Inferior imitators of the antithetical style of *Euphues* (1578), a prose romance by John Lyly (?1554-1606).

18. London, September 1666, in which St Paul's, 89 other churches and 13,200 houses were destroyed.

12 Molière (*Books and Authors*, 1922)

1. Stage-name of Jean-Baptiste Poquelin (1622-73).

2. 'Le Roi Soleil' (1638-1715), autocratic but aesthetically inclined king of France for seventy-two years.

3. Arthur A. (1851-1942), writer on French literature.

4. Six-foot iambic line.

13 Henry Fielding (*Books and Writers*, 1952)

1. English playwright and novelist (1707-54). His satiric dramas led to the Licensing Act.

2. Samuel (1689-1761), moralistic writer whose epistolary work, *Pamela* (1747-8), is regarded as the first modern novel.

3. Fielding's greatest novel, written in 1749.

4. Joseph Mallaby (1849-1926), founder of the Everyman's Library and Lynd's last publisher.

5. Minister (1855-1934) of Lyndhurst Church, Hampstead.

6. Athenian dramatist (*c.* 343-291 BC), leader of the post-Aristophanic 'new comedy' movement.

7. See note 1, p.283 ('James Joyce and a New Kind of Fiction').

8. Greatest Greek comic writer (*c.* 448-*c.* 388 ᴊC), noted for political comment and ribaldry. *Lysistrata* (411), an early feminist play, is regularly performed today.
9. Friend (1689-1762) and later butt of Alexander Pope, famous for her *Letters* (1763) and the first to introduce smallpox inoculation into England.
10. Dublin-born essayist and dramatist (1672-1729), partner of Joseph Addison in writing the essays for *The Tatler* (1709-11) and *The Spectator* (1711-12).
11. William Pitt, first Earl of Chatham (1708-78), known as 'The Great Commoner'.
12. William (1679-1764), English painter famous for his series of moralistic engravings which inspired many plays and novels.
13. David (1717-79), actor and recoverer of Shakespeare, townsman and pupil of Samuel Johnson who wrote that his death 'eclipsed the gaiety of nations'.
14. Earl of Orford (1676-1745), George I's chief political adviser, England's first prime minister in all but name.
15. John (1727-97), political firebrand and for years enemy of George III and his ministers.

14 Boswell (*Dr Johnson and Company*, 1927)

1. James (1740-95), biographer of Samuel Johnson.
2. William Johnson (1739-96), later Rev., close friend of Boswell and grandfather of Frederick (1821-1902), Archbishop of Canterbury.
3. Twin sons of Zeus and Leda, astronomized as Gemini.
4. General Pasquale (1725-1807), Corsican patriot.
5. Frederick (1763-1827), George III's second son.
6. Sister of Francis Stuart, porter-drinking friend of Johnson.
7. David (1711-76), Scottish empirical philosopher, author of *A Treatise on Human Nature* (1739-40); his scepticism did not please the orthodox Johnson.
8. Self-inflicted soubriquet of Isabella Van Tuyll Van Serooskerken (1740-1805), a cultivated lady of Utrecht.
9. Jean-Jacques (1712-78), Genevan political philosopher and educationalist, author of *Contrat Social* (1762), the opening sentence of which reads, 'Man is born free; and everywhere he is in chains.'
10. François Marie Arouet de (1694-1778), French writer, epitome of eighteenth-century Enlightenment. *Candide* (1760), his most famous work, describes the progress of a hopeless innocent squired by a hopeless optimist.
11. See note 15 above.

12. Son (1717-97) of Sir Robert Walpole (see note 14, p.286 ['Henry Fielding']), famous as the author of *The Castle of Otranto* (1764), one of the best of the English 'Gothic' novels, as a letter-writer and as builder of Strawberry Hill, Twickenham, 'my little Gothic mansion'.
13. Thomas (1716-71), English poet, author of 'Elegy Written in a Country Churchyard' (1750).
14. King of Scotland and national hero (1274-1329), famous for the story of the spider in Rathlin Island and defeater of the English at Bannockburn (1314).
15. Chauncey Brewster (1876-1963), Professor of English Literature at Yale and author of *Young Boswell* (1924).
16. Actor and bookseller (1712-85), author of a *Life of Garrick* (1780).
17. 'At the beginning of the interview he admitted nervously to Johnson that he came from Scotland, saying in extenuation: "I do indeed come from Scotland, but indeed I cannot help it." "That, sir, I find," said Johnson with fierce jocularity, "is what a great many of your countrymen cannot help." It was an unpropitious beginning for one of the great friendships of history, but worse was to follow. Upon Johnson's beginning to complain of Garrick and of his failure to send him a pass for a new play, Boswell, eager to please, interrupted with: "Oh, sir, I cannot think Mr Garrick would grudge such a trifle to *you*." "Sir," declared Johnson sternly, "I have known David Garrick longer than you have done; and I know no right you have to talk to me on the subject"' (Chapter 1, *Dr Johnson and Company*, 1927).
18. Lord Hailes (1726-92), Scottish historian and one of Boswell's most admired models.
19. Scholar (1835-1903). Authority on Johnson and editor of Boswell's *Life*.
20. John Wilson (1780-1857), politician, member for Downpatrick, who opposed all reform and coined the word 'conservative'. His book, *Boswell's Johnson*, was written in 1831. He is infamous for his attack on Keats in the *Quarterly Review*.
21. Army physician (1707-82), founder of 'modern military medicine'.
22. Benjamin (1706-90), American statesman and scientist, close friend of Pringle.
23. James Edward (1696-1785), philanthropist, colonial governor of Georgia. According to Boswell, 'he never completed anything that he said'.
24. See note 13, p.286 ('Henry Fielding').
25. Partner of Henry Thrale, who was husband of Johnson's patron.
26. Hester (1741-1821), friend of Johnson, often to the bemusement of her brewer husband, and publisher of anecdotage about him. Johnson stayed in their house for long periods and was unreasonably enraged when three years after Thrale's death she fell in love with and married Gabriel Piozzi.
27. Lincolnshire gentleman (1737-1801) and close friend of Johnson.

28. Robert (1705-82), surgeon of grotesque appearance and unruly habits who treated the London poor gratis and won the admiration of Johnson.

29. The first 'bluestocking' (1745-1833), friend of Johnson.

30. Jonathan (1714-88), Bishop of St Asaph, friend of Benjamin Franklin.

31. Laetitia-Matilda (1758-1835), daughter of Sir John Hawkins, Johnson's literary executor and memoirist, but herself a much more reliable source of information on his life.

32. Giuseppe (1719-89), Italian critic, who on stabbing a Haymarket bully in self-defence was acquitted of murder, Johnson, Burke and Garrick acting as character witnesses.

33. English painter (1723-92) mainly of portraits, friend of Johnson and one of the founders of the Royal Academy.

34. Edmund (1729-97), Dublin-born politician and rhetorician, intimate of Johnson and bitter enemy of the French Revolution 'Terror'.

35. Scottish philosopher (1753-1828) who met Boswell in Edinburgh.

36. Church in the Strand, now the RAF chapel.

37. Johnson's 'local', a Fleet Street tavern, closed in 1788.

38. Evangelist (1703-91) and founder of Methodism.

39. Margaret Montgomerie, married Boswell in 1769, died in 1789.

40. Greek philosopher and teacher (c. 469-399 BC), master of Plato, famous for his 'dialectic' method of seeking truth.

41. John (1667-1735), Scottish physician and wit, friend of Swift and Johnson and author of the satirical *Martinus Scriblerus* (1741).

42. John (1685-1732), English poet and librettist of *The Beggar's Opera* (1728).

43. Henry St John (1678-1751), friend of Swift and Pope, author of *The Idea of a Patriot King*.

44. Mock-heroic satire (composed 1743) in which Pope castigated the scribblers of his day.

45. Novelist (1752-1840), author of *Evelina* (1778).

46. Charles (1739-1807), publisher of Boswell's works.

47. Irish actor and writer (1719-88), father of Richard Brinsley Sheridan, the Irish dramatist (1751-1816), and procurer of a pension for Johnson.

48. Governor-General of India (1732-1818), impeached on a charge of corruption, exonerated but financially ruined (1795).

49. A large collection of Boswell's papers since unexpectedly came to light at Malahide, Co. Dublin (see *The Treasures of Auchinleck*, David Buchanan, 1975).

15 Charles Lamb (*Books and Authors*, 1922)

1. English essayist (1775-1834), known as Elia.

2. Thomas (1785-1859), writer and essayist, author of *Confessions of an English Opium Eater* (1821). He was noted for changing lodgings as each

grew crowded with his papers. At the time of his death he was paying the rent for six apartments.

3. From *Literary Reminiscences* (1834-40).
4. Thomas (1795-1881), Scottish essayist and historian, husband of Jane Welsh (1801-66), famous as the author of *The History of the French Revolution*, written in 1824 but not published till 1827 because the first draft was accidentally burnt at the house of his friend John Stuart Mill.
5. (German) 'Poor devil!'
6. The title used by Letitia Elizabeth Landon (1802-38), poet and novelist, who supported herself from an early age and whose reputation suffered thereby. Prolific and popular in her day, she died of an overdose of prussic acid, which she was accustomed to taking medicinally.
7. His sister, Mary Ann (1764-1847), who in a fit of insanity killed their mother (1796) and to care for whom Lamb forewent the prospect of marriage. She is referred to as his cousin, 'Bridget Elia', in the essays.
8. The Rev. James Boyer, Classics master at Christ's Hospital.
9. From 'Christ's Hospital 35 Years Ago' (*London Magazine*, November 1820).
10. Slight misquotation from Ecclesiasticus 44:1.
11. First published in *The Philanthropist* (1813).
12. William (1780-1842), essayist and compiler of the *Every-Day Book* (1826-7) dedicated to Lamb.
13. Op. cit.
14. Edward Verrall (1868-1938), novelist, essayist (one of Lynd's few rivals) and leading authority on Lamb, whose work he edited.

16 Hazlitt (*Books and Writers*, 1952)

1. Essayist and critic (1778-1830).
2. The girl (1800-65) with whom Keats fell in love and who wore mourning for him for several years after his death.
3. Published 1922.
4. Mary Russell (1787-1855), author of *Our Village* (1832), sketches of the sedate village life of Three Mile Cross, near Reading. She worked on a number of London magazines when her father's gambling addiction left her penniless.
5. Henry (1775-1807), diarist, friend of most of the famous writers of his time, and best authority for the last days of William Blake.
6. 1 Samuel 19:10.
7. James Henry (1784-1859), poet and essayist, first publisher of Keats, chronic mismanager of his large family and source of the nicer elements of Harold Skimpole in *Bleak House*. His house in Hampstead attracted all that was notable in London's literary life, as did Lynd's a century later.

8. Published 1817 and containing some of the finest Shakespearean criticism ever written, still relevant today.
9. July Revolution which displaced Charles X (1757-1836) from the throne of France and set up Louis-Philippe (1773-1850), 'The Citizen King', in his place.
10. Published 1823, an account of his passion for his landlord's daughter, Sarah Walker.

17 Keats in His Letters (*Books and Writers*, 1952)

1. John Keats (1795-1821).
2. See note 29, p.288 ('Boswell').
3. See note 2, p.289 ('Hazlitt').
4. Critic (1845-1927), biographer and friend of Robert Louis Stevenson and Joseph Conrad. His life of Keats was written in 1887.
5. See note 20, p.287 ('Boswell').
6. See note 12, ibid.
7. See note 13, ibid.
8. William (1731-1800), gentle English poet who fought madness for most of his life.
9. Edward (1809-83), translator and adaptor of *The Rubáiyát of Omar Khayyám*. He was famous for his letters, which were published in 1901.
10. See note 7, p.289 ('Hazlitt').
11. Benjamin (1786-1846), English painter, friend of Keats, Wordsworth and Hazlitt, whom he included in his painting, *Christ's Entry into Jerusalem*. He committed suicide.
12. John Milton's (1608-74) English epic poem, 'of Man's first disobedience and the Fall'.
13. Greatest of the Athenian dramatists (*c.* 495-406 BC), author of *Oedipus the King*, the finest of his seven extant plays.
14. Ultimately faithless lover of Troilus, the son of King Priam of Troy.

18 Turgenev (*Old and New Masters*, 1919)

1. Ivan (1818-83), Russian novelist.
2. Reader for Jonathan Cape (1868-1937), who encouraged Conrad, Lawrence and Forster, husband of Constance (1862-1946) whose translations introduced the Russian classics to the English-speaking world.
3. See note 1, p.283 ('The Critic as Destroyer').
4. English politician (1843-1911) whose brilliant career was retarded by his being named in a divorce case.
5. French realist novelist (1840-1902) author of *Nana* (1880) about prostitution, and *L'Assommoir* ('the shebeen') (1877) about drunkenness. Famous for his pro-Dreyfus agitation.

6. Late-nineteenth-century movement emphasizing Russia's historical mission to liberate the Slav people of south-eastern Europe from the Ottoman and Hapsburg empires and secure their union under Russian control and protection.

7. Novel (1856) which advocates the need for Russia to learn from the West.

8. Early-twentieth-century literary movement which rejected Russia's literary past and advocated a new and experimental approach to language.

9. George (1828-1909), Victorian novelist and poet, author of *Modern Love* (1862) and *Diana of the Crossways* (1885).

19 Tchehov: The Perfect Story-Teller (*Old and New Masters*, 1919)

1. Anton (1860-1904), strongly influential short-story writer and in English translation Russia's most produced dramatist.

2. God of the Philistines whose temple Samson destroyed (Judges 16:30).

3. American writer (1843-1916), critic and stylist, author of many novels, including *The Portrait of a Lady* (1881) and *The Golden Bowl* (1904), and over a hundred short stories.

4. Famous novel by Gustave Flaubert (1821-80), written 1856-7, about a heart fed on fantasies.

5. See note 3, p.285 ('Henry Fielding').

6. Wilful heroine of Thackeray's novel *The History of Henry Esmond* (1852); reappears as Baroness Bernstein in *The Virginians* (1857).

20 The Labour of Authorship (*The Art of Letters*, 1920)

1. Robert Louis (1850-94), poet, novelist, essayist and author of the widely differing *Treasure Island* (1883) and *Dr Jekyll and Mr Hyde* (1886). One of Lynd's favourite authors.

2. George V (1865-1936), who became king on the death of his father Edward VII in 1910.

3. Sentenced in 1895 to two years' penal servitude in Reading Gaol for homosexual acts.

4. Cloten's song from *Cymbeline*, II, 2.

5. Autolycus' song from *The Winter's Tale*, IV, 3.

6. First line of a sonnet by George Peele (?1558-?96), published 1590.

7. Published 1820.

8. Epic poem by Ludovico Ariosto (1474-1535), written to exalt the family of his patron, Duke d'Este.

9. Irascible novelist (1815-82) of large output, famous for the *Chronicles of Barset* (1855-67) and the *Pallisers* (1869-73).

10. From the Latin: 'Never a day without a line'.

11. Edgar Allan (1809-49), American writer of poetry and macabre tales and pioneer of the modern detective story. *Marginalia* was a collection of snippets of comment and erudition.

12. Poem published in *Men and Women* (1855), an imaginative piece of verse based upon Edgar's mad song as Tom a'Bedlam in *King Lear*, III, 4.

13. Athenian poet (*c*. 343-291 BC). Many of his 'lost' plays have been found in this century.

PART THREE THE WITNESS

21 'The Witness' (*Life's Little Oddities*, 1941)

1. English novelist and poet (1840-1928), whose 'Wessex' novels about his native Dorset are among the finest in English literature. *Tess of the D'Urbervilles* (1891) was assailed as immoral but it was the outrage which followed *Jude the Obscure* (1895) that caused Hardy to relinquish the form.

2. Xerxes I (?519-465 BC), King of Persia, who fought the battle of Thermopylae in Sparta but saw his hopes of conquering Greece drift away at the sea battle of Salamis (480). Said to be the husband of the biblical Esther; murdered by Artabazus.

3. Characters in Dickens's *Martin Chuzzlewit* (1843-4).

4. James Winder (1877-1930), Lynd's closest friend. Acted as non-confessional godfather to Lynd's daughters, Sigle and Máire, and, like Lynd, was a nationalist. He worked as editorial writer for the *Irish Independent* and was Irish correspondent for the *New Statesman*.

22 White Citizens (*If the Germans Conquered England*, 1917)

1. West London Sports Stadium.

2. Chain of famous tea-shops founded by the caterer Sir Joseph Lyons (1848-1917). The green-uniformed waitresses were known as 'nippies'. Discontinued in the sixties and an attempt to revive the famous Charing Cross 'Corner Shop' in the eighties was unsuccessful.

3. Written in the years 1821-4, a series of introductions to novels published by Ballantyne, the firm whose bankruptcy caused Scott such labour to redress.

4. See note 12, p.287 ('Boswell').

5. See note 15, p.286 ('Henry Fielding').

6. Pool in Jerusalem with five porticos perpetually surrounded by the sick. 'For an angel went down at a certain season into the pool and troubled the water: whosoever then first after the troubling of the water stepped in was made whole of whatever disease he had' (John V:4).

7. Inflammation of the kidneys.
8. This diagnosis may have been conditioned by Lynd's soft, scarcely audible voice.

23 On Never Going to the British Museum (*The Blue Lion*, 1923)

1. Irascible, radical poet and prose stylist (1775-1864), whose fame rests on his books *Imaginary Conversations* (1824-9), and whose tranquil old age in Florence was overseen by Robert and Elizabeth Browning.
2. Opera (1866) by Ambroise Thomas (1811-96) based on Goethe's *Wilhelm Meister* (1796), 'the first German novel'.
3. Opera (1850) by Wagner.
4. The four-opera cycle, first produced in Bayreuth in 1876 and Wagner's most sumptuous artistic achievement.
5. Aldwych Theatre (1868-1902) which closed with a production of *The Toreador* that starred Marie Studholme, Lynd's theatrical idol.
6. See note 13, p.292 ('The Labour of Authorship').
7. Angela Georgina (1814-1906), English philanthropist, granddaughter of the banker Thomas Coutts.
8. George Frederick OM (1817-1904), English portrait-painter and briefly husband of the actress Ellen Terry.
9. Athenian golden age sculptor (*c*. 490-*c*. 430 BC) who designed the Parthenon frieze.
10. See 'Hazlitt' (p.194).
11. See note 7, p.283 ('The Critic as Destroyer').
12. Florentine painter (*c*. 1409-69) of Nativities, master of Botticelli.
13. See note 13, p.285 ('John Donne').
14. Jean Baptiste (1796-1875), French painter of blurry landscapes.
15. Jean François (1814-75), painter of the once very popular pair of peasant scenes, *The Angelus* and *The Gleaners*.
16. Alias *The Victory of Samothrace*, celebrating the sea victory of the Rhodians at the end of the second century BC. In the Louvre.
17. Vigorous, dramatic, Welsh painter, best known for his turbulent life and splendid portraits.
18. English portrait-painter (1883-1960), one of whose subjects was Lynd himself.
19. Christopher (1889-1946), English futurist painter and official war artist (1914-15).
20. English composer (1883-1953), knighted in 1937, Master of the King's Musick (1942-53), wrote poetry and stories under the name of 'Dermot O'Byrne', was a friend of Pearse and other 1916 leaders and died in Cork.
21. English composer (1891-1975), knighted in 1950 and appointed Master of the Queen's Musick in 1953.

24 Farewell to Tobacco (*The Peal of Bells*, 1924)

1. See note 10, p.286 ('Henry Fielding'). *Christian Hero* (1707) was among other things an anti-duelling tract.
2. See note 6, p.283 ('The Critic as Destroyer').
3. City of Afghanistan relieved by Lord Roberts in 1880.

25 The Promenade (*The Goldfish*, 1927)

1. Play (f. p. London 1923) by Sutton Vane, in which the passengers on board an ocean liner do not realize that they are dead and on the way to judgment.
2. Character created by 'Sapper' (H. C. McNeile, 1888-1937), a kind of twenties James Bond, more carelessly xenophobic and anti-Semitic but also more of a gentleman.
3. Belfast city-centre street, its waste ground formerly used for carnivals.
4. Thomas (1737-1809), English political writer, whose book *The Rights of Man* (1791-2) became the Bible of radicalism. His bones were brought home from New Rochelle, NY, by William Cobbett (1763-1835), a radical admirer, but they were mislaid before they could be memorially re-interred.
5. John Henry, Cardinal Newman's (1801-90) examination of the nature of belief (1870).
6. Pre-Raphaelite painter (1829-96) of pictures as diverse as *Christ in the House of His Parents* (1850) and *Bubbles* (1886), which became an advertisement for Pears Soap; husband of John Ruskin's ex-wife, Effie Grey.
7. Scene of the defeat of the British forces by the Boers in 1881.
8. Greek philosopher (384-22 BC), pupil of Plato and tutor of Alexander the Great. He established his own school, the Lyceum, in Athens in 335. His followers were known as the Peripatetics from the *peripatos* where, pacing up and down, he taught.

26 Arguing (*I Tremble to Think*, 1936)

1. Stanley (1867-1947), underrated Tory politician, three times Prime Minister, forever associated with the policy of appeasement.
2. Clement (1883-1969), leader of the British Labour Party from 1935 to 1955, Churchill's deputy in the wartime Coalition and Prime Minister of the post-war Labour government (1945-51).
3. Famous Athenian politician and orator (*c.* 384-22 BC), especially against Philip of Macedon (382-36) from the virulence of whose speeches the English word 'philippic' was coined.

4. Demosthenes' rival (*c.* 389-14 BC) and appeaser of Philip.
5. See note 40, p.288 ('Boswell').
6. 'The Angelic Doctor' (*c.* 1225-74), theologian and philosopher, reconciler of Aristotelian teachings with Christianity and the writer of *Summa Theologica*.

27 The Draw (*Both Sides of the Road*, 1934)

1. Edgar (1834-1917), French Impressionist painter, famous for his theatrical and sporting pictures.
2. Film studios in Hertfordshire.
3. Sean (1889-1977), RHA, Irish painter, noted especially for his Aran Island studies.
4. Alfred (Alfie) Byrne (1882-1956), TD, Mayor of Dublin from 1930-9 and 1954-5. His three sons became TDs.
5. Eamonn (1887-1972), Garda Síochána Commissioner, retired 1938; recruited armed auxiliaries (the 'Bray Harriers') to counter O'Duffy's Blueshirts.
6. Mervyn Richard Wingfield, eighth Viscount.

28 Aunts (*In Defence of Pink*, 1937)

1. Journalist and editor (1859-1944), famous for his excellent compilation *A Book of Quotations, Proverbs and Household Words* (1907).
2. Margaret (1809-73). The magazine was founded in 1865.
3. Moralistic children's author (1841-85), daughter of the above.
4. In nonsense poem by Edward Lear (1812-88).
5. From the essay 'Poor Relations', published *London Magazine*, May 1823.
6. Presumably the aunt used 'YY's Christian name.
7. Founder of Presbyterianism (?1513-72), a name certainly revered in Lynd's boyhood circle.
8. See note 10, p.286 ('Boswell').

29 Railway Stations I Have Loved (*In Defence of Pink*, 1937)

1. Radio Eireann's main transmitter.
2. Now a bus depot.
3. Surrey County Cricket Ground, in Lynd's day the venue for the Fifth Test.
4. Sir John (Jack) (1882-1963), one of England's greatest batsmen and first cricketer to be knighted (1953). Scored 61,237 runs with 197 centuries.

30 Spade and Bucket (*Things One Hears*, 1945)

1. Lucy Gaster, daughter of Lynd's second daughter, Máire. Lynd always referred to his two daughters as nieces in his writings.
2. English novelist (1881-1958) and friend of the Lynds, author of *The Towers of Trebizond* (1956) and for many years lover of the novelist Gerald O'Donovan (1871-1942), who had in his time been a priest and administrator of Loughrea, Co. Galway.
3. Ruinous fourteenth-century castle on the north Antrim coast near Bushmills, stronghold of the McQuillans and later the McDonnells.
4. John Boynton (1894-1984), friend of the Lynds, writer of sixty books and forty plays, some comedies, some preoccupied with time. *They Came to a City* (1943) was almost a socialist tract.
5. Eponymous hero of *Androcles and the Lion* (f. p. St James's Theatre, London 1913) who was 'to be thrown to the lion with the lady'.
6. Drowned land, sited usually at Scilly, but also associated with Minoan Crete.
7. Deep natural bathing-place, on the east side of the Portrush peninsula.